F.H. VARLEY

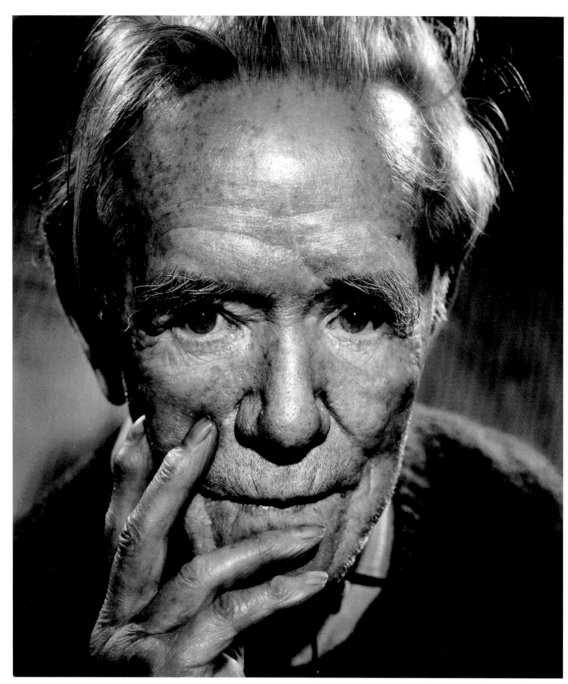

Yousuf Karsh
F.H. Varley, 1964
Art Gallery of Ontario, Toronto

F.H. VARLEY

Portraits into the Light | Mise en lumière des portraits

KATERINA ATANASSOVA

DUNDURN PRESS
TORONTO

Published in conjunction with the exhibition *F.H. Varley: Portraits into the Light*, organized and circulated by the Varley Art Gallery of Markham, Ontario. The exhibition opens in Markham on May 25, 2007, and continues to September 3, 2007.

All works of art by Frederick Horsman Varley copyright © Varley Art Gallery of Markham/Town of Markham.

Quotations from the Varley Collection, Library and Archives, National Gallery of Canada, reproduced with the kind permission of Julie Varley.

Photographs have been provided by the owners or custodians of the works reproduced, unless indicated otherwise.

Fig. 8 and Fig. 17 copyright © Family of Lawren S. Harris.
Fig. 33, 34, 35, 37, 56 and Pl. 36 reproduced from The Vanderpant Collection with the kind permission of Catharin Vanderpant.

Photographs have been provided by the owners or custodians of the works reproduced, unless indicated otherwise. On p. 2 by Yousuf Karsh, p. 34 by George Lobb, p. 83 and 85 by John Vanderpant, p. 101 by John Goldie, p. 103 by Gabriel Desmarais (1926–1991), known as Gaby: Gaby Estate, and p. 105 by Catharina Vanderpant-Shelly. Pl. 21 by Teresa Healy, Pl. 32 by Ernest Mayer, Pl. 34 by John Dean, Pl. 35 and 37 by Henri Robideau, Pl. 53 by Nancy Ranija, Pl. 57 by Marilyn Aitken.

Cover: *Jess*, 1950
Private Collection (Cat. 74)

Editor: Lynda Muir Copy-editor: Andrea Waters
French Translation: Lucie Chevalier Design: Jennifer Scott
Picture Editor: Sandra Damiani Printer: Friesens

National Library of Canada Cataloguing in Publication

Atanassova, Katerina, 1965-
 F.H. Varley : portraits into the light = Mise en lumière des portraits / Katerina Atanassova.

Text in English and French.
Includes bibliographic references.
ISBN 978-1-55002-675-7

1. Varley, Frederick Horsman, 1881-1969. 2. Portraits, Canadian--20th century--Pictorial works. 3. Portrait painters--Canada. 4. Painters--Canada. I. Title. II. Title: Portraits into the light. III. Title: Mise en lumière des portraits.

ND1329.V37A83 2007 759.11 C2006-906824-0E

Catalogage avant publication de Bibliothèque et Archives Canada

Atanassova, Katerina, 1965-
 F.H. Varley : portraits into the light = Mise en lumière des portraits / Katerina Atanassova.

Texte en anglais et en français.
Comprend des références bibliographiques.
ISBN 978-1-55002-675-7

 1. Varley, Frederick Horsman, 1881-1969. 2. Portraits canadiens--20e siècle--Ouvrages illustrés. 3. Portraitistes--Canada. 4. Peintres--Canada. I. Titre. II. Titre: Portraits into the light. III. Titre: Mise en lumière des portraits.

ND1329.V37A83 2007 759.11 C2006-906824-0F

Dundurn Press acknowledges the support of the **Canada Council for the Arts** and the **Ontario Arts Council** for our publishing program. We also acknowledge the financial support of the **Government of Canada** through the **Book Publishing Industry Development Program** and **The Association for the Export of Canadian Books**, and the **Government of Ontario** through the **Ontario Book Publishers Tax Credit** program and the **Ontario Media Development Corporation**.

The Varley Art Gallery of Markham acknowledges the support for this publication and research of the Varley-McKay Art Foundation, Town of Markam, and the Government of Canada through the Department of Canadian Heritage Museum Assistance Programme.

La Galerie Varley est redevable à la Fondation d'art Varley-McKay, à la Ville de Markham et au gouvernement du Canada par l'entremise du ministère du Patrimoine canadien, dans le cadre du Programme d'aide aux musées, pour leur appui financier à la recherche et à la publication de ce catalogue.

Care has been taken to trace the ownership of copyright material used in this book. The author and the publisher welcome any information enabling them to rectify any references or credits in subsequent editions.

J. Kirk Howard, President

Printed and bound in Canada
www.dundurn.com

1 2 3 4 5 11 10 09 08 07

ITINERARY | ITINÉRAIRE

Beaverbrook Art Gallery, Fredericton, New Brunswick

September 22–November 4, 2007

Art Gallery of Alberta, Edmonton, Alberta

December 7, 2007–February 17, 2008

Kelowna Art Gallery, Kelowna, British Columbia

March 8–May 4, 2008

National Portrait Gallery, Ottawa, Ontario

May 14–June 29, 2008

Beaverbrook Art Gallery, Fredericton (Nouveau-Brunswick)

22 septembre–4 novembre 2007

Art Gallery of Alberta, Edmonton (Alberta)

7 décembre 2007–17 février 2008

Kelowna Art Gallery, Kelowna (Colombie-Britannique)

8 mars–4 mai 2008

Musée du portrait du Canada, Ottawa (Ontario)

14 mai–29 juin 2008

In memory of Frederick Varley,
a remarkable artist and visionary.

À la mémoire de Frederick Varley,
un artiste remarquable et un visionnaire.

CONTENTS | SOMMAIRE

LENDERS TO THE EXHIBITION | LISTE DES PRÊTEURS

Agnes Etherington Art Centre, Queen's University, Kingston

Art Gallery of Alberta, Edmonton

Art Gallery of Greater Victoria

Art Gallery of Ontario, Toronto

Arts and Letters Club, Toronto

Canadian War Museum, Ottawa

Carleton University Art Gallery, Ottawa

Hart House, University of Toronto

McCord Museum of Canadian History, Montreal

McMichael Canadian Art Collection, Kleinburg

The Montreal Museum of Fine Arts

National Gallery of Canada, Ottawa

RiverBrink Gallery, Queenston

Roberts Gallery, Toronto

Trinity College, University of Toronto

University of Alberta, Edmonton

Vancouver Art Gallery

Winnipeg Art Gallery

and various private collections

Agnes Etherington Art Centre, Université Queen's, Kingston

Art Gallery of Alberta, Edmonton

Art Gallery of Greater Victoria

Arts and Letters Club, Toronto

Collection McMichael d'art canadien, Kleinburg

Galerie d'art de l'Université Carleton, Ottawa

Hart House, Université de Toronto

Musée canadien de la guerre, Ottawa

Musée des beaux-arts de l'Ontario, Toronto

Musée des beaux-arts de Montréal

Musée des beaux-arts du Canada, Ottawa

Musée McCord d'histoire canadienne, Montréal

RiverBrink Gallery, Queenston

Roberts Gallery, Toronto

Trinity College, Université de Toronto

Université de l'Alberta, Edmonton

Vancouver Art Gallery

Winnipeg Art Gallery

ainsi que plusieurs collections particulières

MESSAGE FROM THE DIRECTOR | PRÉFACE DU DIRECTEUR

When the human spirit rises to excellence it can inspire you and leave you breathless. Good paintings do that; so do good stories. F.H. Varley was Canada's leading portrait painter, as you will discover through the memorable images he created, the wonderful stories from his long and complex life and career, and the amazing people he met along the way, many of whom he immortalized in his portraits.

The Varley Art Gallery began with the dream of Kathleen Gormley McKay and the efforts of many of the Town of Markham's political and community leaders. The quality of the gallery and the level of support it receives speak volumes about Markham's high standards and achievements. Now in our tenth anniversary year, we celebrate our creation, our namesake, and our future with the exhibition *F.H. Varley: Portraits into the Light* and its companion publication. This is our first national touring show, and it will be seen from east to west, in Fredericton, Ottawa, Edmonton, and Kelowna.

The curator of the exhibition and author of the catalogue, Katerina Atanassova, is a dedicated researcher who approaches the subject of F.H. Varley with passion and insight. We believe that museum-goers and readers across the country will enjoy this opportunity to share in her findings.

Thank you to the Varley–McKay Art Foundation and the many volunteers who have built up resources for three years to make this exhibition and book possible. I also wish to convey our deep appreciation to the Museums Assistance Program of the Department of Canadian Heritage for their support of the research, touring costs, and publication.

John Ryerson
Director
Varley Art Gallery of Markham

Lorsque l'esprit humain atteint à l'excellence, c'est à la fois inspirant et à couper le souffle. Il en va de même pour les grands tableaux, les grands récits. Les images inoubliables que nous a léguées F.H. Varley, les anecdotes sur sa vie et sa carrière, et les gens remarquables qu'il a recontrés et, dans bien des cas, immortalisés, sont autant d'éléments qui permettent d'affirmer qu'il était le portraitiste le plus en vue du Canada.

La Galerie Varley est née du rêve de Kathleen Gormley McKay et des efforts conjugués de nombreuses personnalités politiques et publiques de la ville de Markham. La qualité de la galerie et le soutien dont elle bénéficie témoignent des critères d'excellence et des réalisations de Markham. En cette année de dixième anniversaire, l'exposition *F.H. Varley : Mise en lumière des portraits* et la publication qui l'accompagne célèbrent à la fois

la création et l'avenir de la galerie, de même que celui qui lui a donné son nom. C'est la première fois qu'une de nos expositions est présentée d'est en ouest. Elle fera étape à Fredericton, Ottawa, Edmonton et Kelowna.

S'appuyant sur une recherche fouillée, Katerina Atanassova, commissaire de l'exposition et auteur du catalogue, aborde son sujet avec passion et perspicacité. Nous sommes convaincus que les visiteurs de l'exposition et les lecteurs du catalogue apprécieront cette occasion de partager ses conclusions.

Je remercie la Fondation d'art Varley–McKay et les nombreux bénévoles qui, au cours des trois dernières années, ont manifesté leur appui à la réalisation de l'exposition et du catalogue. Je suis également redevable au ministère du Patrimoine canadien, dans le cadre du Programme d'aide aux musées, pour son appui financier à la recherche, la mise en tournée de l'exposition et la publication.

John Ryerson
Directeur
Galerie Varley de Markham

FOREWORD | AVANT-PROPOS

There is an extraordinary gap in Canada's art history, and it seems entirely fitting that an admirable exhibition such as *F.H. Varley: Portraits into the Light* should set out to address the same gap in the understanding of Frederick Horsman Varley's art. Surprisingly, that gap is portraiture. Our country's long and merited love affair with landscape has allowed our equally fine and complex history of portraiture to be largely underestimated. Hence, the Portrait Gallery of Canada, a program of the Library and Archives Canada, responded with undiluted pleasure when approached by the Varley Art Gallery of Markham to support this venture to spotlight the Cinderella in Varley's art and, indeed, in the history of Canadian art.

It may seem at first paradoxical, if not unfair, to say that Varley, long known as the one member of the Group of Seven who "did portraiture," is in fact not properly acknowledged as a great portraitist. But even as fine resumés of his life as those penned by his grandson, Christopher Varley, for the National Gallery of Canada's Canadian Artists Series in 1979 and for the Edmonton Art Gallery's exhibition catalogue of 1981, leave a sense that his portraits were often expedients to which F.H. Varley resorted when in need of funds. The landscapes tend to find a preferred place in the extended critical discourse of his most accomplished work.

If a national history of portraiture were more developed, might Maria Tippett's essential biography of Varley, published in 1998, have been able to make more than one brief reference to portrait photographer Alex Castonguay? He was a friend of Varley's during the Ottawa years of 1936 to 1940, a time in which Yousuf Karsh recalled Castonguay's expressed admiration for his own youthful work. Was there any contact between the flamboyant middle-aged painter who admired Augustus John and the equally flamboyant young Armenian immigrant who was bringing a new Art Deco sensibility and psychological incisiveness to photographic portraiture? It would not have been unusual, given Varley's connections with photographer John Vanderpant and erstwhile photographer Harold Mortimer-Lamb in British Columbia. But such a question needs the context that a history of Canadian portraiture might furnish.

Varley painted an impressive variety of portraits, and as much as his landscapes and narrative works, they pulse with the life of his ideas and intuitions, his obdurate, unbreakable spirit, and his profound engagement with the life around him. He stands between the tender insight of Ozias Leduc in the nineteenth century and the unique expressionism of Harold Town in the modern era, two other Canadian artists whose portraiture is honoured more in the breach. This enticing gathering and review of his portraits by Katerina Atanassova, curator of the exhibition, unveils much that is new and shows how greatly such a reassessment was needed, and how richly rewarding the project has been. The Portrait Gallery of

Canada is delighted to have been able to participate in this fresh and fruitful look at one of our own great portrait masters — F.H. Varley.

Lilly Koltun, PhD
Director General
Portrait Gallery of Canada

———————————

L'histoire de l'art du Canada présente une grave lacune. Il est donc particulièrement pertinent qu'une exposition hors du commun comme *F.H. Varley : Mise en lumière des portraits* aborde cette même lacune dans la connaissance de l'art de Frederick Horsman Varley. Chose étonnante, c'est du portrait dont il s'agit. La passion durable que nous éprouvons à juste titre pour le paysage nous a amené à sous-estimer l'art du portrait canadien, qui mérite pourtant toute notre attention. D'où l'acquiescement pur et simple du Musée du portrait du Canada, une initiative de Bibliothèque et Archives Canada, à la requête de la Galerie Varley de Markham d'appuyer cette initiative destinée à mettre en valeur un aspect négligé de l'art de Varley et, partant, de l'histoire de l'art canadien.

Il peut sembler paradoxal, sinon injuste, d'affirmer que Varley, longtemps connu comme le membre du Groupe des Sept qui « s'adonnait au portrait », n'est pas reconnu comme un grand portraitiste. Même les résumés biographiques préparés par son petit-fils, Christopher Varley, en 1979 dans le cadre d'une série consacrée aux artistes canadiens au Musée des beaux-arts du Canada et en 1981 pour le catalogue accompagnant l'exposition tenue à l'Edmonton Art Gallery, donnent l'impression que F.H. Varley n'hésitait pas à recourir au portrait par nécessité financière. Le discours critique exhaustif de son travail le plus accompli accorde une place de choix aux paysages plutôt qu'aux portraits.

Une véritable histoire de l'art du portrait canadien aurait-elle permis à Maria Tippett de ne pas s'en tenir à une brève mention du photographe portraitiste Alex Castonguay dans sa biographie essentielle de Varley publiée en 1998? Varley s'était lié avec le photographe durant son séjour à Ottawa de 1936 à 1940. Yousuf Karsh se rappelait qu'à l'époque Castonguay lui avait fait part de son admiration pour ses premières œuvres. Y a-t-il eu contact entre le peintre haut en couleur dans la cinquantaine, admirateur d'Augustus John, et le jeune immigrant arménien, lui aussi haut en couleur, dont les portraits photographiques se distinguaient par leur sensibilité « art déco » et leur acuité psychologique? C'est très plausible, compte tenu des relations de Varley avec le photographe John Vanderpant et l'ancien photographe Harold Mortimer-Lamb en Colombie-Britannique. Cette question s'inscrit dans le cadre d'une histoire de l'art du portrait canadien qui reste à élaborer.

Varley a exécuté une gamme impressionnante de portraits qui, à la manière de ses paysages et œuvres narratives, sont animés par ses idées et ses intuitions, son caractère indomptable et son engagement profond envers son environnement. Il se situe entre la sensibilité subtile d'Ozias Leduc au dix-neuvième siècle et l'expressionisme unique d'Harold Town à l'ère moderne, deux artistes canadiens dont les portraits sont davantage célébrés dans la brèche. Le choix et l'examen éclairés des portraits proposés par Katerina Atanassova, la commissaire de l'exposition, mettent en lumière de nouvelles données et témoignent de la nécessité d'effectuer une telle réévaluation et de la pertinence de cette démarche. Le Musée du portrait du Canada se réjouit de participer à cette réinterprétation féconde d'un de nos maîtres portraitistes – F.H. Varley.

Lilly Koltun
Directrice
Musée du portrait du Canada

ACKNOWLEDGEMENTS | REMERCIEMENTS

This publication and the touring exhibition *F.H. Varley: Portraits into the Light* could not have happened without the help and generosity of many individuals. The initial spark came from a lecture on the Group of Seven's first exhibition, delivered by Dennis Reid, Director, Collections and Research and Senior Curator of Canadian Art at the Art Gallery of Ontario. The idea lay dormant until 2004 when plans were being made for the tenth anniversary of the Varley Art Gallery of Markham. These plans were strongly supported by the Gallery Board and by Director John Ryerson, to whom I owe my deepest gratitude. I also wish to acknowledge Joan Murray, who was the designated curator for this project at its inception, and Andrea Kirkpatrick, whose extensive research on Varley's portraits from 1919 to 1926 provided the basis for my further study of the subject.

During the later stages of my research, I had an opportunity to examine the wealth of archival material compiled by the artist's son Peter Varley and deposited at the Archives of the National Gallery of Canada, including the complete inventory of works and the oral history interviews recorded in 1969–70. My deepest gratitude to Julie Varley for granting access and allowing me to quote from the interviews in this publication.

I am grateful to many scholars and colleagues across the country, from whom I have learned a great deal about Fred Varley and the development of Canadian art: Chris Varley, whose guidance, wisdom, and cooperation during all stages of my research and preparation for the exhibition never failed; Charles C. Hill, Curator of Canadian Art at the National Gallery of Canada, for invaluable advice and encouragement; the friendly and capable staff of the NGC Library and Archives, in particular Cyndie Campbell, Head of Archives Documentation, for facilitating my extensive research in the Varley Fonds; and Philip Dombowsky for contributing to the list of works and exhibition history. I am also indebted to Lilly Koltun, Director of the National Portrait Gallery of Canada; the staff at Library and Archives Canada; Amy Marshall, Archivist at the Art Gallery of Ontario; Cheryl Siegel and Lynn Brockington at the Library of the Vancouver Art Gallery; and Et van Lingen, Registrar at the Canadian War Museum. I cannot overlook the kind people at the Heffel Auction House, in particular Robert Heffel; the staff at Sotheby's, especially Beverly Schaeffer; Linda Cobon at the Canadian National Exhibition Archives; Jeanny and Paul Wildridge at the Roberts Gallery; Arlene and Duncan McLean; Bruce McLean; Myfanwy and James Douglas; George Lobb; Richard and Collin Deacon; William Withrow; Gillian Pearson at Victoria College; Sheryl Salloum; and Catharin Vanderpant.

The collaboration of private collectors and the staff at the lending institutions was most welcome. I would mention Gerald McMaster and Marcie Lawrence at the Art Gallery of Ontario; Jim Corrigan at the University of Alberta; Dorothy Farr at the

Agnes Etherington Art Centre; Stephen Topfer at the Art Gallery of Greater Victoria; Laura Brandon, Helen Holt, and George Barnhill at the Canadian War Museum; Judith Schwartz and her successor, Barbara Fisher, at the J.B. Barnicke Gallery; Sandra Dyck at the Carleton University Art Gallery; Gary Esser at the RiverBrink Gallery; Henry Pillon at Trinity College; Rosemary Muir at Woodbridge Company; Rod Green at the Masters Gallery; and Donna and Ed Andrew.

The personnel at each touring venue have been a delight to work with: Catherine Crowston, chief curator of the Art Gallery of Alberta, in Edmonton; the curatorial staff of the Beaverbrook Art Gallery, in Fredericton; Linda Schewyn, curator of the Kelowna Art Gallery; and Theresa McIntosh, Johanna Mizgala, and Yves Théoret at the National Portrait Gallery, in Ottawa.

For the film production, I am grateful to producer Barbara Arsenault and cinematographer Lee Rickwood, as well as to the interviewees, Erica Leach, Nancy Robinson, Florence Deacon, Peter Garstang, and Judith Livingston, and the experts, Lilly Koltun and Rosemarie Tovell of Ottawa. Karen Close provided much appreciated assistance with the filming in Kelowna.

A valuable contribution to this endeavour was made by the many private collectors, friends, and supporters of Varley who took part in the extensive Oral History Project, including Luciana Benzi, Irma Coucil, Allan Wargon, Esther Beaupré, Gloria Varley, and Fred and Beverly Shaeffer.

At the Varley Art Gallery, special thanks to Elizabeth Zimnica and Corrinne Fairbanks for their help in securing the loans for the show; contract researchers Tara Marshall and Jaleen Grove; co-op student Alessandra Trimarchi; and our able volunteers, Lynda Leaf, Irene Emig, Alice Hannon, and Christina Assman, for their enthusiastic support.

My heartfelt appreciation to those friends in Kelowna, Ottawa, and Montreal who made my visits so enjoyable: to Beate Stock for taking me under her wing; to Julia Antonoff for her proofreading of the manuscript; and Anna Hudson for the many insightful discussions on the subject.

Warm thanks to Lynda Muir, English editor, who approached the task with poise and precision, never losing her patience and sense of humour; to Lucie Chevalier, for her excellent work on the French translation; and to the staff at Dundurn Press for producing such a fine catalogue.

Last, but far from least, a sincere thank you to the staff at my alma mater, the Pontifical Institute for Mediaeval Studies, Toronto, especially to Father James Farge and Caroline Suma for providing the much needed research environment for the completion of this book.

Katerina Atanassova, MA
Curator
Varley Art Gallery

La préparation d'un catalogue et d'une exposition itinérante de l'envergure de *F.H. Varley : Mise en lumière des portraits* résulte du soutien et de la générosité de nombreux individus. L'idée de cette exposition est née suite à une conférence de Dennis Reid, directeur des collections et de la recherche, et conservateur principal de l'art canadien au Musée des beaux-arts de l'Ontario, sur la première exposition du Groupe des Sept. Elle s'est concrétisée en 2004 dans le cadre des projets entourant le dixième anniversaire de la Galerie Varley de Markham. Le projet a été favorablement accueilli par le conseil d'administration et le directeur John Ryerson, qu'ils trouvent ici l'expression de ma profonde reconnaissance. Je suis également redevable à Joan Murray, initialement désignée pour assurer le commissariat de l'exposition, et à Andrea Kirkpatrick, dont la recherche exhaustive sur les portraits de Varley exécutés entre 1919 et 1926 a donné à ma démarche son orientation.

Dans le cadre de ma recherche, il m'a été donné de consulter l'abondante documentation compilée par le fils de l'artiste, Peter Varley, et déposée aux Archives du Musée des beaux-arts du Canada, y compris l'inventaire complet des œuvres et des entrevues

enregistrées en 1969–1970. Je tiens à exprimer ma profonde gratitude à Julie Varley qui m'a autorisé à citer des extraits des entrevues dans la présente publication.

Je suis redevable aux nombreux universitaires et collègues à travers le pays qui ont volontiers partager leurs connaissances sur Fred Varley et le développement de l'art canadien. Je suis reconnaissante à Chris Varley de sa générosité d'esprit et de sa collaboration soutenue à toutes les étapes de la recherche préparatoire à l'exposition. Au Musée des beaux-arts du Canada, je tiens à exprimer ma reconnaissance à Charles C. Hill, conservateur de l'art canadien, pour son appui et ses conseils éclairés, au personnel chaleureux et compétent de la Bibliothèque et des Archives, plus particulièrement à Cyndie Campbell, chef, Archives, documentation et ressources visuelles, qui a facilité l'accès au fonds Varley, et à Philip Dombowsky pour sa contribution à l'établissement de la liste des œuvres et de l'historique des expositions. Je remercie Lilly Koltun, directrice du Musée du portrait du Canada; le personnel de Bibliothèque et Archives Canada; Amy Marshall, archiviste au Musée des beaux-arts de l'Ontario; Cheryl Siegel et Lynn Brockington, bibliothécaires à la Vancouver Art Gallery; et Et van Lingen, registraire au Musée canadien de la guerre. Ont également ma gratitude, le personnel de la Heffel Auction House, en particulier Robert Heffel; le personnel de Sotheby's, notamment Beverly Schaeffer; Linda Cobon des Archives du CNE; Jeanny et Paul Wildridge de la Roberts Gallery; Arlene et Duncan McLean; Bruce McLean; Myfanwy et James Douglas; George Lobb; Richard et Collin Deacon, William Withrow, Gillian Pearson du Victoria College; ainsi que Sheryl Salloum et Catharin Vanderpant.

Je suis particulièrement redevable aux collectionneurs privés et au personnel des diverses institutions qui ont collaboré à l'organisation de cette exposition. Je tiens à remercier Gerald McMaster et Marcie Lawrence du Musée des beaux-arts de l'Ontario; Jim Corrigan de l'Université de l'Alberta; Dorothy Farr de l'Agnes Etherington Art Centre; Stephen Topfer de l'Art Gallery of Greater Victoria; Laura Brandon, Helen Holt et George Barnhill du Musée canadien de la guerre; Judith Schwartz et son successeur Barbara Fisher de la J.B. Barnicke Gallery; Sandra Dyck de la Galerie d'art de l'Université Carleton; Gary Esser de la RiverBrink Gallery; Henry Pillon du Trinity College; Rosemary Muir de la Woodbridge Company; Rod Green de la Masters Gallery; de même que Donna et Ed Andrew.

Je tiens à exprimer ma gratitude aux membres du personnel des musées qui accueilleront l'exposition : Catherine Crowston, conservatrice en chef de l'Art Gallery of Alberta; le personnel de la Galerie d'art Beaverbrook; Linda Schewyn, conservatrice à la Kelowna Art Gallery; ainsi que Theresa McIntosh, Johanna Mizgala et Yves Théoret du Musée du portrait du Canada.

Je suis redevable à la réalisatrice Barbara Arsenault et au vidéaste Lee Rickwood de leur contribution au volet visuel de l'exposition. Je remercie également de leur participation Erica Leach, Nancy Robinson, Florence Deacon, Peter Garstang, Judith Livingston, ainsi que les spécialistes Lilly Koltun et Rosemarie Tovell. Je tiens à exprimer ma reconnaissance à Karen Close, la responsable du tournage à Kelowna.

Le projet a bénéficié de l'apport précieux des nombreux collectionneurs privés, amis et défenseurs de Varley qui ont participé au Projet d'histoire orale, y compris Luciana Benzi, Irma Coucil, Allan Wargon, Esther Beaupré, Gloria Varley, et Fred et Beverly Shaeffer.

À la Galerie Varley, je tiens à remercier Elizabeth Zimnica et Corrinne Fairbanks qui ont coordonné le prêt des œuvres en vue de l'exposition. Ont également ma gratitude Tara Marshall et Jaleen Grove, recherchistes, Alessandra Trimarchi, stagiaire, Lynda Leaf, Irene Emig, Alice Hannon et Christina Assman, bénévoles, pour leur enthousiasme inépuisable.

Je tiens tout particulièrement à exprimer ma reconnaissance à mes amis de Kelowna, Ottawa et Montréal qui m'ont accueilli avec empressement. Je remercie Beate Stock de m'avoir pris sous sa coupe, Julia Antonoff pour sa relecture des textes, et Anna Hudson pour ses nombreuses discussions éclairées sur le sujet.

Je suis redevable à Lynda Muir qui a révisé la publication avec efficacité et sérénité, sans se départir de son sens de l'humour, et à Lucie Chevalier qui nous propose une traduction empreinte de sensibilité. Je tiens également à remercier le personnel de Dundurn Press qui a donné à ce livre une présentation raffinée.

J'adresse enfin mes sincères remerciements au personnel de l'Institut pontifical d'études médiévales de Toronto, mon alma mater, et plus particulièrement au père James Farge et à Caroline Suma, dont l'appui généreux m'a permis de faire de ce projet une réalité.

Katerina Atanassova
Conservatrice
Galerie Varley

ABBREVIATIONS

AEAC	Agnes Etherington Art Centre, Kingston	LAC	Library and Archives Canada, Ottawa
AGGV	Art Gallery of Greater Victoria	MCAC	McMichael Canadian Art Collection, Kleinburg
AGO	Art Gallery of Ontario, Toronto	NGC	National Gallery of Canada, Ottawa
AGT	Art Gallery of Toronto	OCA	Ontario College of Art, Toronto
ALC	Arts and Letters Club, Toronto	OSA	Ontario Society of Artists, Toronto
AMT	Art Museum of Toronto	RCA	Royal Canadian Academy of Arts, Toronto
CNE	Canadian National Exhibition, Toronto	UAB	University of Alberta, Edmonton
CWM	Canadian War Museum, Ottawa	VAG	Vancouver Art Gallery
CWMF	Canadian War Memorials Fund	VAGM	Varley Art Gallery of Markham
EAG	Edmonton Art Gallery (now Art Gallery of Alberta)	VSDAA	Vancouver School of Decorative and Applied Arts
		WAG	Winnipeg Art Gallery

INTRODUCTION

Frederick Horsman Varley, one of the greatest Canadian portrait painters in the first half of the twentieth century, is an intriguing example of an artist who, despite his renown as a portraitist, remains better known for his landscapes. This is due mainly to his fame as one of the founding members of the Group of Seven, who made a deliberate attempt to raise awareness of our national identity by depicting the Canadian landscape. Although many public collections across the country, among them the National Gallery of Canada (NGC), the Art Gallery of Ontario (AGO), and the Vancouver Art Gallery (VAG), have in their collections some of Varley's best known portraits, such works do not easily fit into the conventional version of the history of the Group of Seven. Even now, nearly four decades after the artist's death, these portraits are still not fully acknowledged within their context.

Men like Varley are rarely simple. The more closely we scrutinize him, the less he resembles an ordinary person and the more we see a man composed of conflicting elements. The way he led his life, and his strong sense of independence, caused some of his contemporaries to label him a rebel. At least, this seemed to be the image certain commentators tried to create for him in the press, characterizing him as being against the established norms and order and, above all, against traditional culture. This understanding of Varley's character seems far from accurate to me. In my view, he was able to grasp his sitters' complexities because he himself was complex, and perhaps he had something of an outsider's perspective.

Next to nature, Varley delighted in the study of the human form and human nature. His most ardent supporter, Barker Fairley, openly admired the artist's fascination with the humanity of his sitters, once remarking that Varley's response to the people he painted was comparable only to his absorption with the theme of war.[1] If contemporary scholarship failed to establish this truth about Varley, it is now time to state that no other Canadian portrait artist so nearly approached an understanding of the human drama, or of the radiance and mystery of feminine beauty, as Varley did. His portraits of women are not merely romantic tributes to beauty; they are statements of his personal conviction. Rarely do these works lack either some critical spirit or a touch of personal approbation, because Varley understood the balance between the two with a sharp intuition.

The artist's interest in the expressive possibilities of the portrait genre is easily discernible. His portraits are distinguished by their unpretentiousness and psychological directness. Intrigued by the characters of his sitters, he conveys their uniqueness through pose and colour scheme. Varley depicts his subjects in their true likeness, dispensing with flattery. Standing in front of one of his portraits, we feel that we know the sitter well enough to begin a conversation.

The exhibition *F.H. Varley: Portraits into the Light* presents the work of Fred Varley in three novel ways: it highlights his

portraits, it contextualizes them, and it attaches as much importance to his drawings as to his works in oil and watercolour. The majority of Varley's portraits remain in private hands. Although they bring lasting enjoyment to the descendants of the sitters, or to new owners, they remain unseen and unknown to the general public. Since they have been accessible only to a handful of art curators and experts, these portraits have been just partially studied, and information about them has not been published in current art historical studies. Therefore, most of the portraits the viewers will see may be personal revelations to them. We hope the selection of drawings and paintings in the touring exhibition and in this catalogue will give the audience great pleasure, and possibly inspire a more comprehensive study of twentieth-century Canadian portraiture.

During the preparation for this exhibition, I came to regard Varley's letters as a match for his paintings, because of the poetic and expressive quality of his writing. Gradually, I realized that the meaning of the letters did not lie in the actual text. It was only by reading between the lines that I was able to gain a true understanding of what he was trying to convey. As well, I became immersed in the lives and times of the people to whom Varley was baring his soul. For him, the writing of letters was a serious personal undertaking.

His letters represent that elusive component that has often been overlooked by scholars in analyzing the whole man. I would sometimes catch myself making the mistake of extracting a passage from a letter when the whole text should be included. In some instances, even the punctuation — the exclamation marks or the little finials and markings suggestive of a pause — revealed the author's state of mind. For the purpose of this publication, long quotations were not appropriate. It is, however, my sincere wish that a separate project devoted to publishing a volume of Varley's letters will soon come to fruition.

The chronologically arranged presentation of Varley's portrait drawings and paintings is divided into smaller themes, such as war art, university commissions, the gypsy tradition, children's portraits, family portraits, and society portraits. This organization allows for a more detailed study of the artist's versatility, his stylistic development, and his continued exploration of and experimentation with portrait painting. The information about each portrait will focus not only on composition, background, colour scheme, and lighting but also on certain biographical details of the sitter. This balanced approach is intended to be useful to a wide audience.

A close look at the exhibition history of the works (see p. 117) reveals that in all Group of Seven exhibitions Varley liked to have a strong representation of his portraits as well as of his landscapes. Even in the much acclaimed first show of the Group of Seven at the Art Gallery of Toronto in 1920, he entered some of his portraits — as did Lawren Harris. This shows that members of the Group paid special attention to portraiture, in addition to their focus on the Canadian landscape.

In the course of my research, I had the good fortune to interview people who had known Varley, or who had posed for him. These interviews became a mixture of reminiscence, evaluation, and reference, as seen in some of the partial transcripts from the section "Varley's Friends Speak" (see p. 105). Individual comments such as these are added to the great volume of material published on Varley, with the goal of seeking the truth about him as a portraitist and a humanist. There are many others who were acquainted with Varley whose memories are not recorded in these pages. Their recollections are just as precious as the ones shared here with readers. I hope these people will take the opportunity to add their own memories to our study.

Much has been said and written about Fred Varley, the painter and the man. Ultimately, it is the works themselves — the paintings assembled for the touring exhibition and the selected reproductions included in these pages — that make the most convincing statement about Varley's artistic skill. The underlying purpose of the exhibition *F.H. Varley: Portraits into the Light*, and of this companion catalogue, will have been achieved if the viewers and the readers emerge with some insights into Varley's particular accomplishments as a portraitist. We hope that by thus bringing his portraits into the light, we will help to make clear Frederick Varley's rightful place in the history of twentieth-century portrait painting in Canada.

CHAPTER 1

BEGINNINGS IN VICTORIAN ENGLAND, 1881–1912

I have on bended knee prayed to my dear maker to make
me purer, enriching me with love and open my eyes to see
the beauty of his wondrous work in mankind.

— Fred Varley

Frederick Horsman Varley was born on January 2, 1881, in Sheffield, England. He was the youngest in a family of four children. His father, Samuel Joseph Bloom Varley (1849–1934), was a successful lithographer. Born in Islington in 1849, Samuel received his training as a commercial artist in London, prior to his employment with Henry Pawson and Joseph Brailsford in their print and design firm in Sheffield. He was proud to be a descendant of John Varley (1778–1842), a renowned watercolourist of the late Georgian era, and identified with his artistic accomplishments. Among Samuel's best achievements as a draughtsman were some remarkable pen-and-ink sketches of the old city of Sheffield, a drawing of hands for a popular advertisement for Pears Soap, and some colourful book illustrations of birds. Samuel's wife, Lucy Varley (née Barstow, 1851–1936), was born in Sheffield and had a small but self-sustaining business, a dressmaker's and milliner's shop. After her marriage, Lucy gave up her work and dedicated her life to building a cozy and comfortable household for her family.

Samuel believed that his fourth child, Frederick, would follow the family tradition and become a great artist, and he offered his son the support and financial assistance necessary for his schooling. To further encourage the boy's rapidly developing artistic talent, his father often took him on sketching excursions outside the city. This urge to see his son excel in art and become famous may have had a vicarious component: Samuel's desire to have his own ambitions and spontaneous energy live on in his son.[2] Indeed, Frederick Varley brought immense joy to his father from a very early age, by showing a strong interest in and talent for drawing. Family lore has it that at the age of six, young Fred executed his first self-portrait, which his father kept in the family.[3]

His early education included attendance at the free Springfield School and later private tutoring with Professor William Ripper, a science teacher.[4] In 1892, aged eleven, Fred Varley entered the Sheffield School of Art, which at the time was considered one of the finest art schools in Great Britain.[5] During his school days, Varley was exposed to the contemporary Victorian ideas on art and its creation. Among other things, he attended the lectures of some of England's leading authorities on art, including James Orrock and John Ruskin, to name just two.

In addition to later Group of Seven member Arthur Lismer, who enrolled the year after Varley, his contemporaries at the art school included Charles Sargent Jagger, a sculptor, and Dudley Hardy, who became a well-known illustrator and war artist. In his book, *Our Home and Native Land: Sheffield's Canadian Artists*, Michael Tooby examines the group of Sheffield natives who attended the school at the same time as Varley and who later immigrated to Canada, including Elizabeth Styring Nutt, Herbert H. Stansfield, and Hubert Valentine Fanshaw. According to Tooby, the students worked towards a particular level of certificate in a range of subjects based on drawing and technical procedures.[6]

At the Sheffield School of Art, Varley honed his skills of observation and the coordination of hand and eye so important to a good draughtsman. Courses such as Principles of Ornament and Design, Drawing, Shading, and Modelling from Casts were only a few out of a total of eight elementary and twenty-eight advanced subjects offered. These were pre-set by the South Kensington Museum's Science and Art Department in London. While the illustrators and painters who taught the subjects, Henry Archer for one, followed the established guidelines, they also infused their own tastes into their teaching. One of the reasons for the high standards was the awards given to students by the South Kensington Museum. Among the examiners were famous names such as Walter Crane, George Clausen, and Frederick Brown. The winning student works were exhibited at the Mappin Art Gallery during the annual end of school celebrations known as the "conversazione."[7] A year before his graduation, Fred Varley was awarded a Free Studentship, covering fees equivalent to £9.3s.

Varley's focus on portraiture in his subsequent career may have derived from his training in drawing from a cast and a clothed model, where he acquired the precision of line, movement, and shading. One of the exercises at the school was to copy works by the old masters, a practice Varley used to build his portrait painting vocabulary. Another impetus that may have directed Varley's professional interest to portraits was the exercise of sketching from memory. It trained him to study the character of his model in depth and helped him gain a deep psychological understanding of the sitter, characteristic

of his portrait paintings. It is said that one of the instructors, J.T. Cook, had noticed Varley's talent early on and used to take him every morning to a plaster torso kept in the studio and make him feel the forms with his hands until he could draw them from memory.[8]

The only works that survive from Varley's school days in Sheffield are three pen-and-ink drawings, dated around 1897. Among them is *Still-Life, Skull and Lantern* at the McMichael Canadian Art Collection in Kleinburg, Ontario. While it would be interesting to learn more about the artist from his early works, Varley biographer Maria Tippett has rightly observed, "Artists like Fred Varley were made by their life experiences as much as by their instruction in the classroom."[9] Looking back on their art school days, Lismer recalled, "Fred Varley was a rebel who always went the limit."[10]

It is important to acknowledge that Varley's art school training took place at the end of the Victorian era. Although the landscape paintings of Turner and Constable are considered England's major contribution to European painting of the period, portraiture loomed large in nineteenth-century English art. Contemporary studies of the history of British portrait painting suggest that, at the time, the British manifested an unquenchable thirst for portraits, unequalled in any other European nation. The earliest known royal portrait commissions date back to the Tudors and Stuarts, and the custom remained strong during the reign of Queen Victoria (1837–1901).[11] Of course, at the end of the nineteenth century, an art form emerged that would rival portrait painting: photography. However, portraiture has successfully resisted the threat from portrait photography.

In 1900, Fred Varley went to Antwerp to further his training at the Académie Royale des Beaux-Arts. There he studied long hours, according to his older sister Ethel. Varley's dedication to art was due largely to his upbringing, especially to his father's influence. In his every endeavour, the young man was eager to please his father, and careful not to disappoint him. It comes as no surprise that he quickly established himself as one of the Académie's most gifted students, greatly admired by his teachers and fellow students. Despite some later stories about his uncon-

trolled artistic temperament, Varley developed a strong discipline in his artwork. Art was his passion, and his industry was untiring. Over the course of his career, he showed similar behaviour when it came to painting commissions. Never wanting to waste time, he was punctual at his sittings, prompt at answering letters, and precise and gentlemanly in his exchanges.

One of Varley's most striking early portraits, a result of his academic training, was the drawing of his father from around 1900 (fig. 1). This work already reveals his confidence

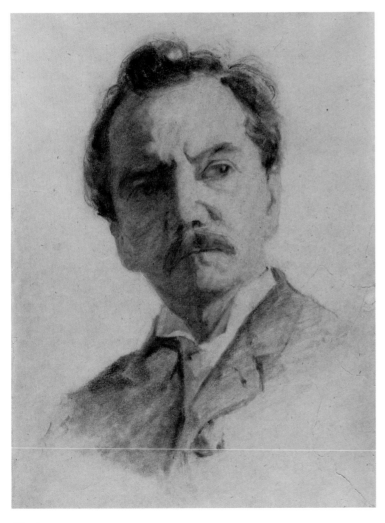

Fig. 1
Portrait of Samuel J.B. Varley
(*The Artist's Father*), c. 1900 (cat. 1)

as a draughtsman and his sensitivity as a portraitist. Samuel Varley was himself a competent draughtsman. But even though his work at Pawson and Brailsford received approval and acceptance, it was still limited to the artistic needs of the company. A kind, soft-spoken man, he liked to spend much of his free time wandering and sketching in the hills around Sheffield, often accompanied by his children.

According to Varley's sister Ethel, one Sunday when the family returned from church, her brother had an urge to draw a portrait of their father. Having kept her memories of her brother alive, at an old age she wrote to him, recalling their happy times together: "We were all in the dining room with our hats on and coats on when you entered with drawing material and abruptly said, 'Dad, I want to draw you.'"[12] Such determination characterizes Varley's approach to many of his subjects. Ethel continued her story: "The kitchen was chosen because no one would disturb [you]. Dad sat on the corner of the kitchen table and soon you were at work. It just seemed as though a Holy Spirit was in the house. None of us in the room felt as though we dare speak above a whisper and the silence was not broken until we heard movement in the kitchen."[13]

The drawing of his father, most likely executed after his return from Antwerp in the spring of 1902, is the earliest surviving example of Varley's portraits. The work shows his enthusiasm for applying the knowledge acquired from his academic training. It demonstrates his assurance in working with light and shade and his attention to careful modelling. Even at that early stage he was able to achieve not just a physical likeness but also a good reading of the character of his subject. In 1983, Fred Varley's youngest son, Peter, published a book in which he offered a new date, 1912, for the same drawing.[14] Since then, Maria Tippett has established that Fred's parents relocated to Bournemouth after Samuel's retirement in 1907 or 1908 and, despite occasional visits to their children, never came back to live in Sheffield.[15] Thus, the earlier date offered by the artist's grandson, Chris Varley, seems to be more applicable, judging from the artist's evident preoccupation with classical drawing in the work.[16]

Varley's subsequent sojourn in London, from 1903 to 1908, marked his official entry into the world of the twentieth-century

artist. In the culturally vibrant English capital, a hub of patronage and style, he was able to learn from the greatest painters of the past, compare his acquired knowledge to contemporary art developments, and enjoy the active art gallery scene. The Tate Gallery opened to the public in 1897, and some of the highlights from its permanent collection on display were the society portraits of John Singer Sargent. The British landscape painting tradition was strongly represented by Turner. In 1903, the Carfax Gallery presented the drawings and etchings of Augustus John and his sister Gwen John. A retrospective of the work of Pre-Raphaelites Edward Burne-Jones, Dante Gabriel Rossetti, and John Millais was being held at various galleries in London, Birmingham, Manchester, and Liverpool.[17] Moreover, a variety of shows introduced the paintings of the Impressionists, with the old Flemish masters often being featured in visiting exhibitions.

Art patronage became a fashionable thing, and new public and private galleries appeared across England. Collecting the art of contemporary artists, as well as commissioning portraits, was a growing trend. In fact, portraits accounted for as much as one-third of the items in a standard auction sale of British painting at the time. The art market expanded as trade with Europe and North America developed. According to Dianne Macleod, the status of art in the late nineteenth century was elevated due to the prevailing Aesthetic Movement and to the new role of the artist as a popular figure.[18] Emerging artists like Varley must have found all of these developments very encouraging.

Although the extent of Varley's commercial work in London has not been determined, it is known that initially he was able to find several commissions as an illustrator. In 1903, he produced a series of watercolours and pen-and-ink drawings for Eden Phillpotts's novel *The Farm of the Dagger*, published in *The Gentlewoman* during the autumn of that year. In 1904, he was working on decorative additions to the architectural drawings of Seppings Wright of Westminster Cathedral, which appeared as illustrations to an article about the cathedral in the *Illustrated London News*. Varley's drawings were used to illustrate the romantic story "The Letter-Box Charm," written by Sidney Hesselrigge and published in *The Idler* in March 1905.[19]

According to Maria Tippett, Varley's wash drawings and watercolours show a strong composition, skilful execution, and masterful handling of the watercolour medium, but his pen-and-ink drawings were too detailed for printing purposes and lacked tonal contrast.[20] This could have been due to the fact that in the process of transferring the original to a print, the image had to be reduced by one-third. Stylistically, his works from the London period are very diverse, because Varley was experimenting and trying to find a suitable medium for himself while learning from the best illustrators of the day. Many years later, he admitted that the life of an illustrator did not really appeal to him, since a commercial artist never produced anything worthy of being treasured.[21]

During a brief visit to Sheffield in 1906, Varley met his future wife, Maud Pinder (1886–1988). Born in Sheffield, Maud worked as a schoolteacher in Doncaster. Along with their common origins and shared love of the Yorkshire countryside, they also discovered similar interests in music and literature. In later years, Maud remembered that from the time of their courtship, Fred always wanted to draw her. She recalled that he made numerous sketches and drawings of her, but none of them has survived. The earliest dated portraits of her are from their first years in Canada.

Despite the fact that both families opposed the union, Fred and Maud were married in April 1910 in Doncaster and then moved to Sheffield, where he found employment with the local newspaper, the *Sheffield Daily Independent*, as a relay man. Varley also worked on occasional black-and-white illustrations, and by 1911 he was making enough to rent a studio outside his home. This was where he began work on an ambitious painting, using as a model the wife of his former classmate David Jagger.[22] On February 29, 1912, Varley appeared in a photo taken in his studio, posing in front of his easel with the work in question in the background. Entitled *Eden*, c. 1912, it depicts a nude female figure painted full-size, standing in an outdoor setting.

The art scene in Sheffield around 1912 was not very promising for young artists. The exodus of trained and talented people, seeking a better life elsewhere, was causing concern. Two of Varley's former classmates, William Broadhead and Arthur Lismer, had already left for Canada.[23] In 1912, Lismer returned briefly to

England to marry his sweetheart, Esther Mawson; while there, he met Varley and described his impressions of the new country and his successful start in the graphic art world. His words stirred Varley's bohemian spirit. Canada could be just the place to launch his artistic career and to earn enough to support his wife and two children, Dorothy, born in 1910, and John, born in 1912.

SETTING OUT, 1912

Thus, in the late summer of 1912, Varley sailed off to Canada. Soon after his arrival in Toronto, he landed a job at the print and engraving company Grip Limited. Maud and the children would follow in a year, so in the meantime he took over Lismer's lodgings at 119 Summerhill Avenue, where he was reunited with William Broadhead. Other young artists were living at the same place, including Tom Thomson, one of Varley's colleagues at the engraving company. Almost daily, Varley and his new friends met at the Arts and Letters Club (ALC) for lunch. Among them were future Group of Seven members J.E.H. MacDonald, Franklin Carmichael, and Frank Johnston. According to some accounts, they usually sat at the "Artists' Table." When they were joined by Lawren Harris and A.Y. Jackson, a lively discussion about new ideas in art would invariably ensue.[24] Club membership also created an opportunity for the young artists to meet members of Toronto's cultural elite, among them Dr. James MacCallum, Vincent Massey, and Sir Edmund Walker, who would become their first patrons.

When Maud and the children finally arrived in Canada, Varley's new friends welcomed them into their midst. In October 1914, the Varleys joined Jackson, Thomson, Beatty, Lismer, and Lismer's family in Algonquin Park, on what was to be Fred Varley's first trip into the wilderness. Except for Jackson and Thomson, the rest of the party settled in the Mowatt Lodge, in close proximity to Thomson's beloved Canoe Lake. Whether the brilliant autumn colours or the work of Tom Thomson and the others brought on a change is hard to determine, but Varley's brighter, more adventurous palette and the use of new colours can be seen in his *Indian Summer*, 1914–15 (pl. 1).

Varley's desire to paint people in the landscape dates back to his younger days in England. The idea derived from the English landscape tradition and the influence of John Ruskin, who insisted that artists give some evidence of human life in their outdoor scenes. In *Indian Summer*, Varley chose to portray his wife, Maud, in the midst of a grove of birch trees. Here, the trees become a decorative element enhancing the middle ground, with the figure standing rather detached.

Varley went back to the city determined to return to the wilderness and paint the figure outdoors. But the failure to secure financial assistance from Dr. James MacCallum, as he had the previous year, forced him to give up the plan. In 1916, Varley was invited to travel to Georgian Bay, and it was during this trip that he first saw the landscape that inspired his iconic work *Stormy Weather, Georgian Bay*, 1920. With it he proved that he was not just a commercial artist or a figure painter but that he shared the ideals of the group of artists he had come to know during his early days in Canada, the future members of the Group of Seven.

During his initial trip to Algonquin Park, the First World War had broken out in Europe. Soon artists were caught up in the spirit of the times, and many of them turned their interest to the training of Canadian troops and the growing support on the home front. The Royal Canadian Academy of Arts (RCA) was organizing an exhibition to help raise money for the Canadian Patriotic Fund. Varley, along with his friends, donated work to the cause. Further submissions to the annual Ontario Society of Artists (OSA) and RCA exhibitions included paintings with a war theme. In 1916, Varley also submitted two portraits to the Canadian National Exhibition (CNE), one of which was a portrait of Captain H.P. Langston.

The idea to establish the Canadian War Records Office and to hire artists to document the activities of Canadian troops originated with Lord Beaverbrook (Max Aitken), the business magnate from New Brunswick, who by 1915 had relocated to England. With the assistance of Lord Rothermere, Beaverbrook devised an elaborate plan to engage the best British artists to create works of art that would serve as a long-lasting memorial

to the Canadian soldiers' contribution to the war.[25] They appointed Paul Konody, critic for *The Observer*, as art adviser. Konody began to commission journalists, photographers, filmmakers, and artists for the purpose of publicizing Canada's role in the war. Within a year, some of England's best-known artists were hired; others were transferred from active service, including Augustus John, Sir William Nicholson, Sir William Rothenstein, D.Y. Cameron, Charles Sims, Percy Wyndham Lewis, Paul Nash, and C.R.W. Nevinson.

While Lord Beaverbrook's office was advertising in England for the Canadian War Memorials Fund, a significant number of Canadian artists were already serving in the war. A.Y. Jackson had enlisted in the spring of 1915; Lawren Harris followed him a year later. Others such as Randolph Hewton, Ernest Fosbery, David Milne, and Varley's old friend from Sheffield, William Broadhead, had also joined the Canadian troops. They objected to the fact that Canadian artists were being overlooked by the program. Beaverbrook's quick response to the complaint was to send an invitation to Eric Brown, Director of the National Gallery of Canada, and Sir Edmund Walker, Chairman of the Board, asking them to recommend four Canadian artists who might be willing to work for the War Office. The invitation was turned over to the OSA and the RCA, who put forward the names of Montreal artists Maurice Cullen and Charles Simpson and Toronto artists William J. Beatty and C.W. Jefferys. When Jefferys declined the offer, the invitation was extended to Fred Varley.

During the first years of the war, Varley had continued his commercial work at Rous and Mann (he had left Grip in around late 1912), undertaking several freelance commissions on the side. He produced a series of portrait drawings for the *Canadian Courier*, which appeared on the front cover. Among others, he drew portraits of the wartime heads of state, Robert Borden, David Lloyd George, and Woodrow Wilson. Employed by the Imperial Royal Flying Corps, he also worked on a series of illustrations for their recruiting manual and often supplied drawings to accompany the publication of short stories in the *Canadian Magazine*.

War Artist, 1918–1919

It came as no surprise when Varley was asked to become a war artist in early 1918, given that he was known to the general readership through his illustrations in the *Canadian Courier*. The invitation came with the military rank of captain and an annual salary, including additional assistance for art supplies. Varley was ecstatic. He left for England towards the end of March and served as a war artist for nearly eighteen months. The experience proved a catalyst in Varley's career, allowing him to identify his true artistic calling. The official commission for four portraits of military officers who had been awarded the Victoria Cross enriched his experience as a portrait artist. A.Y. Jackson was very impressed with Varley's achievement, as was Lord Beaverbrook.

Of the forty-five artists employed by the Canadian War Memorials Fund in 1918, almost half were engaged in portraiture.[26] Their subjects were to be not only generals, admirals, and politicians but also every Canadian soldier who was awarded the Victoria Cross. As they went about their work, some artists were of the opinion that war service had made one soldier indistinguishable from another, while Varley believed that behind the uniform one could easily see the individual man.

The experience of the war made Varley particularly alert to the contrast between the violence on the front line and the excitement of the final victory. He felt that the ordinary soldier was a victim of forces beyond his control, and in his paintings of Captain C.P.J. O'Kelly and Lieutenant George B. McKean, which are among the finest examples of Canadian portraits from the Great War, his aim was to reveal the intimate experience of the individual caught up in a "game of life and death."[27]

The Winnipeg-born Captain O'Kelly (pl. 2) had already received the Military Cross when he won the Victoria Cross for his part in the battle of Passchendaele.[28] His citation, from January 8, 1918, reads: "For conspicuous bravery in an action in which he led his company with extraordinary skill and determination."[29] Varley painted him standing tall against an ambiguous background of pastel colours. The brushwork is bold and pronounced, but applied in a meticulous manner that gives stability to the composition.

The portrait of Lieutenant McKean (pl. 3) is in many respects the polar opposite of that of Captain O'Kelly. McKean was registered as a student at the University of Alberta in Edmonton when the war broke out. He enlisted in the army and was sent to France in June 1916. His conduct during an attack near Cagnicourt, on September 1, 1918, earned him the Victoria Cross "for conspicuous gallantry and devotion to duty."[30] Varley chose to portray Lieutenant McKean seated. He introduces a slight tilt to the man's body, perhaps suggestive of his injury, which immediately creates an impression of compositional instability. The heavy, textural application of paint, reinforced by some additional touches of saturated colour, is in marked contrast to the orderly technique of the previous painting. Behind the figure is an implied studio setting, or perhaps a curtain, which contributes to a successful integration of figure and background. The high-keyed colour scheme is augmented by the artist's agitated brushwork. Lieutenant McKean's face bears an expression of controlled pain, which adds to the psychological intensity of his image. In a study of McKean's portrait, Peter Varley, the artist's youngest son, points to his father's masterful depiction of the subject's shattered soul and his numbed horror: "He is rigid, staring, one eye showing a wild defiance, almost rage; the other guarded, cynical, hiding a storm of hatred."[31]

Varley is also known to have painted a portrait of Lieutenant McLead, VC, and one of an unknown general. Those two works have since disappeared; however, A.Y. Jackson, also an official war artist, left these brief descriptions: "I remember some of his [Varley's] problems: the portrait of a general living a life of ease in London who wanted Varley to make him look like a real soldier; and a V.C. whose portrait Varley painted, who was entertained so much he would fall asleep as soon as he entered the studio."[32] Jackson himself worked on few portraits, including that of Command Sergeant Major Robert Hanna (fig. 2), which shows some similarities to Varley's portrayal of Captain O'Kelly.

During his war service, Varley visited the front line in France twice. The second time, he joined the Canadian troops for their final offensive. Together with Lieutenant Douglas of the Canadian War Records and British war artist Cyril H. Barraud, he was able to gather some crucial material that he later used as the basis for his

most dramatic war canvases, *For What?* and *Some Day the People Will Return*, both dated 1918 (Canadian War Museum). To a certain extent, the wide acclaim these two canvases received over the years overshadows the success of Varley's war portraits. However, in one researcher's view, the two existing war portraits from 1918 — Captain O'Kelly and Lieutenant McKean — demonstrate the range of Varley's ability as a portraitist and serve as the antipodes for his stylistic development in the immediate post-war period.[33]

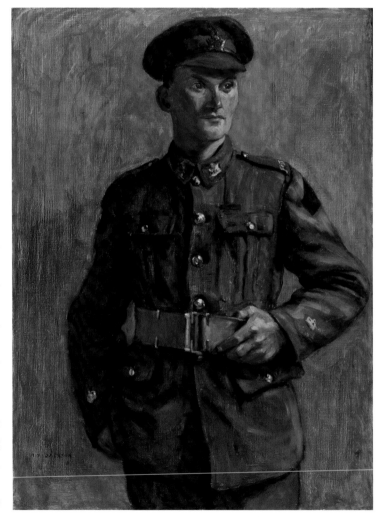

Fig. 2
A.Y. Jackson
C.S.M. Robert Hanna, 1918
Canadian War Museum, Ottawa

Sometime during their stay in France, while stationed at Camblain l'Abbé, Varley painted a small, intimate portrait of Barraud (pl. 4). A friend of Canadian printmaker W.J. Phillips, Barraud had visited him in Winnipeg before the war. (Later, Varley and Phillips would become acquainted.) The light coming from a candle or a glimmering fire gives us a close look at his face. The tones are deliberately dark. Barraud's portrait stayed with his family in England before it went to W.J. Phillips, and it was eventually purchased by the Art Gallery of Ontario.

In 1919, Varley had an opportunity to exhibit some of his war paintings as part of the Canadian War Memorials Fund exhibition at Burlington House in Piccadilly. The press gave outstanding reviews to his work, referring to him as "the most distinguished and forceful of the Canadian official artists."[34] Sir Claude Phillips was quoted as saying, "There is nothing here of sentiment, nothing indeed of personal passion…. We find a massive objectivity, a sense of all-pervading tragedy — of human will overpowered by Fate."[35]

While still in England in the spring of 1919, Varley received his first important private portrait commission. It came from Lord Beaverbrook, who wanted a portrait of his eldest daughter, Janet, then eleven years old. She was later to become the Honourable Janet Aitken, Justice of the Peace. The fact that Lord Beaverbrook chose Fred Varley from so many war artists working for his program was indicative of the growing recognition of his skill as a portrait painter. The deal was sealed, and it was arranged for Varley to visit the Beaverbrook house in Surrey for sitting sessions in the summer of 1919.

The three-quarter portrait of Janet (pl. 6) appears at first glance rather flat and decorative, a look that precludes the sentimentality often seen in portraits of children. Varley chose a sunny outdoor setting for his young subject. An expanse of clear sky behind the figure and the depiction of foliage in the upper-left corner add to the freshness of the overall composition, although an abundance of flowers crowds the space around the girl's head. *Janet*, 1919, was Varley's first society commission, a task that he approached with great excitement and diligence. According to Lord Beaverbrook's personal testimonies, the family was very pleased with the portrait and they paid the artist £100 for it, which was more than he had requested.[36]

Varley set sail for Canada on August 1, 1919. Back home, he was kept on the payroll of the Canadian Expeditionary Force, and entertained thoughts of receiving new war commissions. One prospective project was an eleven-foot-long mural for the future war memorial art gallery, which Paul Konody and the Canadian War Memorials Fund had invited him to paint.[37] However, because of financial restraints, the Fund could not guarantee the commission; they cut their assistance at the end of March 1920.

CHAPTER 2

PORTRAIT PAINTING IN TORONTO IN THE 1920s

You must put your whole being into it.
— Fred Varley

Finding employment as a portraitist in Toronto in the early 1920s was a major challenge, requiring more business acumen than artistic talent. Unfortunately, there is not enough information on Varley's generation of portrait artists in Toronto to allow us to draw conclusions about their work. The lack of individual studies of many of the leading practitioners of the day prevents us from judging what portion of their production was devoted to portraiture or how many of their portrait paintings or drawings derived from commissions. Some portraitists were known to advertise their services in the newspapers, while others relied for commissions entirely on their private connections in certain segments of society. Varley had a strong distaste for self-advertisement for the purpose of obtaining portrait commissions. As he told his wife, "If people will come to me it's alright, but heavens … this selling [of] one's wares."[38]

In that period, however, commissions began to come from new sources, such as the rapidly expanding universities and the burgeoning civil service, as well as the business class, which was growing by leaps and bounds in the post-war industrial boom. New opportunities for exhibiting artworks became available to the city's artists with the opening in the early 1920s of the Art Museum of Toronto, the Art Gallery of Toronto, and the Hart House Gallery. As new tastes and fashions were formed, portrait artists were expected not only to offer a good physical likeness but also to peer deeply into the character of their subject. Some of the best known and most sought-after traditional practitioners were J.W.L. Forster, E. Wyly Grier, Kenneth Forbes, A.C. Williamson, Harry Britton, F.S. Challener, Stanley Gordon Moyer, and Owen B. Staples. These artists actively sought portrait commissions and exhibited regularly in the annual shows of the two powerful art organizations, the OSA and the RCA.

John Wycliffe Lowes Forster (1850–1938) was the senior practising portrait artist in Toronto when Varley appeared on the scene. Born in Norval, Ontario, Foster first studied with J.W. Bridgman in Toronto (1869–72). He went to Europe to further his art education, taking classes with C.S. Millard at the South Kensington Art School in 1879, and with William Bouguereau, Tony Robert-Fleury, G. Boulanger, Jules Lefebvre, and Carolus Duran at the Académie Julian in Paris (1879–83). Around 1879, he spent some time painting with William Blair Bruce in the Barbizon region of

France; he returned to Toronto in 1883. Forster mainly depicted prominent Canadians, but he also painted some historical and religious canvases and landscapes. His approach was academic, and he worked predominantly in oil and pastel.

E. Wyly Grier (1862–1957) was Varley's senior by two decades. Born in Melbourne, Australia, he arrived in Toronto in 1876. He studied in London and Rome before entering the Académie Julian in Paris, under the guidance of Bouguereau and Fleury. Grier held a conservative view of art and strongly defended the traditional way of painting against modernist

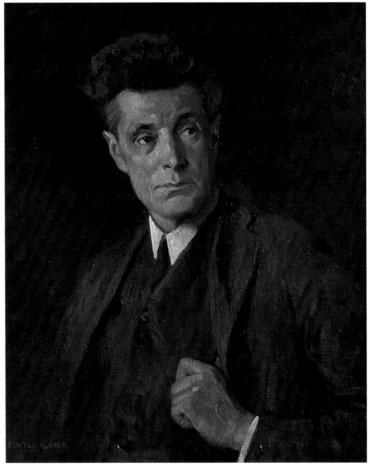

Fig. 3
Sir E. Wyly Grier
Augustus Bridle, 1920
Arts and Letters Club, Toronto

tendencies. Grier's portraits are very expressive, suffused with humanism and warmth.[39] In 1920, he painted a fine portrait of the famed art critic Augustus Bridle (fig. 3), which was acquired subsequently by the Arts and Letters Club of Toronto. Formidable practitioners such as Forster and Grier demonstrate that there was a market for this old-fashioned style of portrait painting in the Toronto community.

Another, older, contemporary portrait artist was A. Curtis Williamson (1867–1944), who began his art education with Forster in Toronto before furthering his training in Europe. Williamson's very traditional approach to portrait painting stemmed from personal conviction, and his consistent and conscious choice of style was greatly influenced by the Dutch masters. He received many commissions from the University of Toronto and members of the social elite, including the Massey family, as Varley would twenty years later. Williamson painted a portrait of his close friend Dr. James MacCallum, who went on to be one of the strongest supporters of the Group of Seven.[40] He also did a portrait of Alexander McPhedran, whose wife Varley would paint in the 1920s.

Kenneth Forbes (1892–1980) was eleven years younger than Varley. He was the son of portrait artist J. Colin Forbes, who was his first teacher. After his initial training, he went to England and remained there for sixteen years, studying and painting in various locations. On his return to Toronto in 1924, he quickly made his name as a portraitist. His portraits show good technical execution, subtlety in modelling, a fine sense of colour and finish. He had great respect for Varley and considered him an artist of superior talent. Forbes's career demonstrates that there was indeed an opportunity for younger artists to establish themselves as portrait painters. His *Mrs. Clifford Sifton*, 1926 (location unknown), displays a certain affinity to the style of painting favoured by the British artist William Orpen in his portrait work. Mrs. Sifton is depicted outdoors, against an open sky.

Worth mentioning are several artists who regularly showed portraits at the CNE and OSA annual exhibitions from the time Varley began to submit his works there. Among them was Allan Robert Barr (1890–1959), who was born in London, England. From 1907 to 1911, he studied under Frank Brangwyn, John M.

Swan, George W. Lambert, and William Nicholson at the London School of Art. In 1922, he came to Canada and settled in Toronto. Oil was Barr's preferred medium for portraits, and he was known for his excellent craftsmanship and treatment of light and shadow. He also painted landscapes, figurative works, and still lifes.

Frederick Sproston Challener (1869–1959) was another artist who made his name as a portraitist in Toronto. He was born in Whetstone, England, and came to Canada with his family in 1870. In 1883, he got a job in a stockbroker's office and began to sketch in his spare time. He attended night school at the Ontario College of Art (OCA), where he studied under George A. Reid. Challener worked with C.W. Jefferys on several murals and did many historical paintings based on Jefferys' sketches. In 1898–99, he travelled to Europe and the Middle East and also served as a war artist during the First World War. He taught at the Central Technical College (1921–24) and the OCA (1927–52). Challener exhibited with the RCA and with the Art Association of Montreal. In the OSA show of 1922, he entered a small, lively portrait of a professional model, *The Blue Hat*, 1922 (fig. 4); the girl appeared to be the same subject as Varley's *Girl in Red* (fig. 5).

Of the younger generation, there was Charles Fraser Comfort (1900–1994), who was born in Cramond, near Edinburgh, Scotland, and moved with his family to Winnipeg in 1912. He won his first art competition at the age of eight, and at fourteen he won a watercolour painting competition at the YMCA, judged by F.H. Brigden. This success later led to employment at Brigden's printing company in Winnipeg. He

Fig. 4
F.S. Challener
The Blue Hat, 1922
Location unknown

Fig. 5
Girl in Red, c. 1920–21
McMichael Canadian Art Collection, Kleinburg

studied at the Winnipeg School of Art, and in 1922–23 at the Art Students' League of New York, under E. Allen Tucker, Vincent Dumond, and Robert Henri.

In 1925, Comfort accepted a transfer from Winnipeg to Brigden's Toronto office. In order to stay involved in the arts through the economic downturn of the 1930s, he joined forces with Will Ogilvie (1901–1989), who had come to Canada from South Africa in 1925, to produce portraits, advertising material, architectural designs and magazine illustrations. He was an official war artist during the Second World War, served as president of the RCA in 1957, and was director of the National Gallery from 1960 to 1965. One of Comfort's most memorable portraits was *Young Canadian*, 1932 (Hart House), depicting his friend and colleague Carl Schaefer (1903–1995).

The artist who had the closest contact with Varley was John William (Bill) Beatty (1869–1941). A painter and printmaker, he studied with J.W.L. Forster, George A. Reid, and William Cruikshank. In 1900, he went to Paris to study at the Académie Julian. As a friend of some of the future members of the Group of Seven, he painted in the Rocky Mountains with A.Y. Jackson and C.W. Jefferys in 1914, and had a space in the Studio Building built by Dr. MacCallum and Lawren Harris. Beatty also taught at the OCA (c. 1919–20), where he shared a studio with Varley. Using the same model as Varley did for his gypsy portraits, Beatty made two thematic portraits in 1922, *Mandolin Player* (fig. 6) and *The Fortune Teller* (private collection), and entered them both in that year's CNE show.[41]

The early twentieth century saw the emergence of a significant number of professionally trained women artists, who often showed a great deal more vigour and range in their output than their male counterparts. Many of these women gravitated to portraiture, leaving the glorification of the Canadian landscape to the men, who were more suited, perhaps, to the demands of outdoor painting. Among the most prominent is Marion Long (1882–1970), almost an exact contemporary of Varley. Long began her training at the OCA, then went to New York, where she studied under William Chase and Robert Henri. Directness and simplicity are the hallmarks of her best-

known portraits from the 1920s, which clearly reflect Robert Henri's teachings and his broad painterly technique.[42] Long painted some society portraits and portraits of faculty members at the University of Toronto. Her *Portrait of Luke Teskey*, 1922 (University of Toronto), for the Royal College of Dental Surgeons, is reminiscent of Varley's earliest known university commission, *W. Theophilus Stuart*, c. 1912–15 (University of Toronto), which is remarkably conservative and conventional in pose and format.

Fig. 6
W.J. Beatty
Mandolin Player, 1922
Varley Art Gallery of Markham

Dorothy Stevens (1888–1966) was a painter, portraitist, etcher, printmaker, illustrator, and art teacher. She studied at the Slade School of Art in London in 1903, and later in Paris. Highly regarded for her etchings, she was president of the Women's Art Association in Toronto. In the 1920s, she developed an interest in the depiction of gypsies; among the portraits she submitted to the 1922 CNE exhibition was *Miss Juanita Cargill*, 1922 (fig. 7). Some of the other women artists from that period who painted portraits include Pegi Nicol MacLeod, Paraskeva Clark, Prudence Heward, Estelle Muriel Kerr, and Kathleen Daly Pepper.

When the Group of Seven's first exhibition opened at the Art Gallery of Toronto in May 1920, both Fred Varley and Lawren Harris submitted portraits. Harris's entry included *Portrait of Bess Housser*, 1920 (AGO) and *Mrs. Oscar Taylor*, 1920 (fig. 8). Varley sent *Portrait of Vincent Massey*, 1920 (pl. 9) and *Winifred Head*, 1920 (location unknown) as well as character sketches of Barker Fairley (pl. 8) and J.E.H. MacDonald (destroyed or lost).[43]

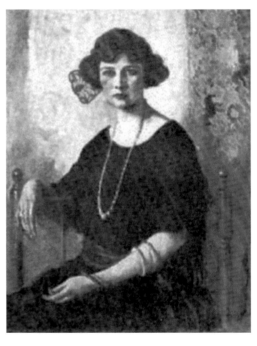

Fig. 7
Dorothy Stevens
Miss Juanita Cargill, 1922
Location unknown

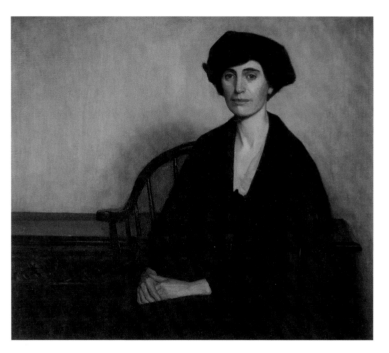

Fig. 8
Lawren Harris
Mrs. Oscar Taylor, 1920
National Gallery of Canada,
Ottawa

THE EVOLUTION OF A PORTRAIT PAINTER

In the period after the war, Varley concentrated mainly on portraiture. Later, he would describe the genre's challenge in these words: "In portraiture you are confined, you can't just go and open the gates."[44] The facility with which he executed portrait after portrait in the early 1920s is astonishing. These early portraits are simple, straightforward statements of humanity. The majority of them display a dual conception of form that combines a sculptural head and a flattened body. In some of his portraits, a characteristic geometric division of space produced a feeling of calm and stability. Generally, Varley tended to use a strong vertical axis and emphatic tonal contrast. Each sitter was painted with a verve, energy, and insight not seen previously in his work.

The background of some is luminous, with the effect of shimmering light, while others feature a landscape or an interior scene painted in a subdued pastel colour. The brushstrokes are broad and long, sometimes meandering in the background, as in *Gypsy Head*, 1919 (pl. 5), or accentuating the compositional structure, as in the portraits of Vincent Massey and Chester Massey, of Sir George Parkin, or of the artist's son John. The application of paint is heavy, with the effect of an encrusted impasto. The flesh tones are almost clay-like.

As Arthur Lismer once observed, "Varley painted a lot of things between 1919 and 1926. Not all were important. Some of them were slight, but all were experiments important to his growth: a woman's head, a group of children, a flicker of light on a ripple of water, a roseate sky, the warm earth, the curve of a breast, a slight charming gesture, the indication of a passing mood."[45] At this stage of his career, even though success may have been within easy reach, Varley was troubled by doubts: "I am a restless lad, too damned impressionable to be healthy in this commercial life."[46]

As a painter, and as a man, Varley was captivated by certain personalities. "My father was a very good reader of character," Peter Varley states, "and certain types caught his interest, no matter what their situation in life. He recognized their inner hidden natures, their affection for living."[47] In his post-war portraits, the artist was obviously experimenting and trying to find his best approach to the genre. For the sake of clarity, the portraits from this period are grouped thematically or according to a common source of commission: university commissions, the gypsy portraits, commissions for members of the Massey family, society portraits, family and friends (including members of the Fairley family), members and associates of the Arts and Letters Club, and selected portraits.

UNIVERSITY COMMISSIONS, 1920–1924

The commissioning of portraits by universities was a common practice in the first decades of the twentieth century. These commissions were often organized informally, with funds being collected by subscription among friends and colleagues of the person to be honoured. Such portraits were usually presented as gifts at retirement or on other special occasions and were expected to remain in the university collection. These types of commissions were rarely documented and for that reason pose a certain challenge to scholars in search of information about the selection of the artist and the logistical arrangements.

In fact, Varley's first official portrait commission in Canada came from Queen's University, to commemorate the retirement, in May 1919, of Professor James Cappon, Dean of Arts (fig. 9). Varley worked on this commission in the late summer and early autumn of 1919, either in Toronto or in Kingston, where some sittings with Dean Cappon likely took place.[48] How this commission came to Varley is not known, but it seems very likely that Varley's old friend Barker Fairley played a key role in procuring it, since he and Professor Cappon both taught literature (Fairley was a Germanist and Goethe expert) and travelled as guest lecturers to each other's place of work. In 1917, Cappon gave a lecture at the University of Toronto, and in 1919, Fairley visited Queen's University as one of the organizers, along with C.W. Jefferys, of an exhibition of Canadian paintings. The two men had mutual friends, among them Dr. John M. MacEachran from Edmonton.

Varley chose to portray Professor Cappon sitting in an armchair. Despite the formal pose, his subject appears relaxed, with his body and gaze turned slightly sideways. The portrait is an

accurate likeness of the sitter, whose pose exudes calm and confidence. The background differs from Varley's war portraits, as it shimmers with light, which strongly outlines the figure. The artist's decision to draw the image rather close to the surface, without much depth of composition, has created an overpowering presence, which is further emphasized by the tight fist formed by Cappon's right hand. That small detail was the artist's way of showing his sitter's strength of character and determination. With his ability to read human nature, Varley perhaps sensed what W.E. McNeil would refer to in his biography of James Cappon: "Many a man and many an argument have wilted

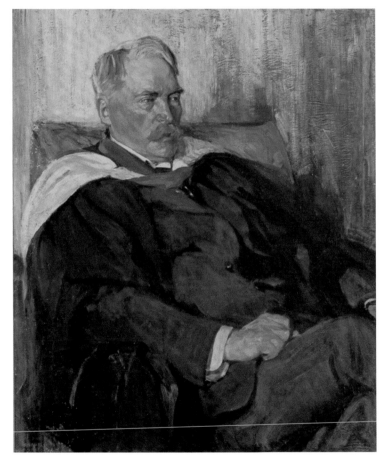

Fig. 9
Dean Cappon, 1919
Agnes Etherington Art Centre
Queen's University, Kingston

before that resistant face and that firm posture. In appearance, manner, and speech he had that about him which all call Personality and most bow to as Authority."[49] Varley was so pleased with his portrait of Professor Cappon that, as early as 1920, he entered it in the OSA show. Barker Fairley was also very happy with the result and later used a reproduction of the portrait as a sample of Varley's work to solicit other commissions.[50]

By the late fall of 1920, Varley was approached for another university commission, a portrait of Dr. Irving Heward Cameron, c. 1922 (fig. 10). From the number of portraits he was working on in 1920 and 1921, we can easily determine that it was a busy time for the artist. After completing the Chester Massey commission in November 1920, he finished the portrait of his friend Barker Fairley just in time for him to leave for another commission. By mid-December 1920, he was working in Sarnia on the portrait of William Kenny's eight-year-old daughter, Mary. The Kenny commission was finished sometime in January 1921, but Varley could not take a break. Other commission work awaited, and by early spring he had painted the portraits of Margaret Fairley and Minnie Ely. Between June and September 1921, he was most certainly working on the portrait of Sir George Parkin.

It was not until the fall of 1921 that the artist would find time to work on the portrait of Professor Cameron. Since the retirement date of Dr. Cameron (1855–1933) from the Faculty of Medicine at the University of Toronto was October 1920, it seems that the commission had been delayed for at least a year. There is no direct evidence to explain how Varley acquired the Cameron commission, but in view of his many engagements at the time, one can assume that his reputation as a portrait artist was growing in academic circles. At the University of Toronto, he had the support of faculty members such as Barker Fairley, Dr. James MacCallum, and Huntley Gordon.

Submissions to major exhibitions can be used as a more or less reliable source of information for a *terminus post quem* in dating Varley's portraits. Dr. Cameron's portrait, for example, was first shown in March 1922 at the OSA annual exhibition, which points to a date of creation of around the end of 1921 or early 1922. The

Fig. 10
Dr. Irving Heward Cameron, c. 1922
University of Toronto

portraits that predate the commission in Sarnia appeared in exhibitions in 1921.[51]

After the opening of the 1922 OSA annual exhibition, Fairley, ever the keen observer, voiced the opinion that "the Cameron portrait was at once the most traditional and the most original work in the exhibition." Fairley admired Varley's craftsmanship and saw in this portrait a successful integration of figure and background. He commented on the artist's mastery of colour in the depiction of both figure and clothing, which he compared to the rather plain and conventional treatment of the background. He also noticed Varley's preoccupation with unusual lighting.[52] Indeed, the use of a simple, dark background is somewhat unusual for Varley, considering the preference for a brighter, shimmering surface in some of his post-war portraits. Not even the formal portrait of Dean Cappon was painted in such dark tones. In this respect, the only work that shows a certain kinship, *W. Theophilus Stuart*, dates back to about 1912–15.

Dr. Cameron's portrait was a stylistic departure for the artist, and one that he saw as significant to his current development. Evidence of this viewpoint can be found in a letter to Eric Brown, dated December 7, 1935. In it, Varley asked that his portrait of Dr. Cameron be included in the Group of Seven retrospective planned for 1936 at the National Gallery. To justify its inclusion, he relates the Cameron painting to his portrait of Vincent Massey and declares it "an excellent contrast and important to me."[53]

Varley's portrait of Professor Cameron has often been compared to E. Wyly Grier's portrait of the Rev. Dr. T.C.S. Macklem, shown at the OSA annual exhibition of 1923.[54] The subject's pose is one shared feature that is readily apparent; the use of a brilliant red for the academic robes is another. (It would also be interesting to examine E. Wyly Grier's portrait of Dr. Cameron, painted in 1931, a decade after Varley's, for the Toronto General Hospital.)

In 1922, Varley was chosen by the University of Alberta in Edmonton to paint the portrait of its founding president, Dr. Henry Marshall Tory (1864–1947; fig. 11), to mark his fifteenth year in office.[55] It was decided that the artist would be paid a fee of $1,000 out of voluntary contributions by staff and alumni. The portrait would be presented on the occasion of Dr. Tory's anniversary celebration, planned for the spring convocation of 1923, and would then be gifted to the university. Dr. John MacEachran, a professor of philosophy at the University of Alberta, seems to have been responsible for organizing the commission and collecting the donations. There was a long-standing tie between MacEachran and Fairley, dating back to the days when Fairley taught in Edmonton, and it was only natural for MacEachran to consult his old friend on the choice of artist. An unsigned letter from 1922 at the University Archives confirms that the artist selected for the commission was considered to be "Canada's foremost portrait painter." It further states that Varley's "search for character and his power of exhibiting forceful personality" made him the best candidate.[56]

Rather than have Varley travel to Edmonton, Dr. Tory came to Toronto for a short visit in early April 1923. Four sittings in Varley's studio proved to be insufficient for the completion of the portrait. After the sitter's departure, Varley turned to Tory's brother James to model the hands so he could finish painting them. Whether due to the urgency of the commission or the need to use a different model, the hands appeared disproportionately large and needed to be repainted at a later time. This minor problem did nothing to mar the painting's positive reception.

The pose Varley selected for Dr. Tory was new. He was portrayed in a standing position, facing the viewer directly, in contrast to Varley's earlier academic portraits in which the subjects were all seated and turned in a three-quarter view. The stance was so natural for Dr. Tory that at the presentation ceremony, one university art instructor remarked on the fact that when Tory rose to accept the gift, he actually assumed the same pose.[57] The portrait was also larger in size than previous works, since

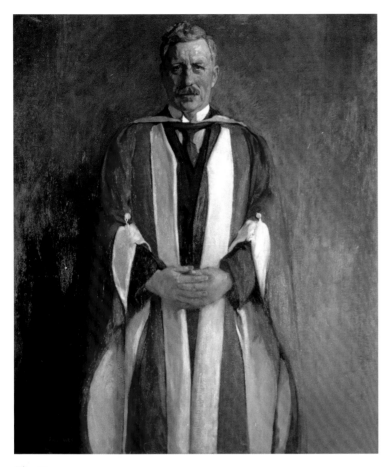

Fig. 11
Dr. Henry Marshall Tory, 1923–24
University of Alberta Art Collection

the subject was painted in three-quarter length. The academic robes, defined by long vertical lines, reinforced the outlines of the figure by giving it more volume and a stronger presence.[58] Pleased with the results, Varley would repeat the pose in his 1927 portrait of Dr. Francis Lovett Carter Cotton, former chancellor of the University of British Columbia.

In 1924, the artist's first trip to Western Canada led to other commissions, for example the one for a portrait of the superintendent of the Winnipeg School Board, Dr. Daniel McIntyre (1852–1946), who was three years away from retirement.[59] Organized through a subscription of teachers and staff, the commission was first offered to W.J. Phillips, who had known

Dr. McIntyre since 1913 when he was hired to teach art at a Winnipeg high school.[60] Phillips was the obvious candidate for the commission, and he initially accepted it, despite his lack of experience as a portrait artist. However, in 1923 he visited Toronto and met Varley, who had just lost his house for non-payment of the mortgage. Seeing Varley's plight, Phillips decided to help out by passing on the commission.[61]

Varley arrived in Winnipeg around the middle of January 1924 and settled at the Marlborough Hotel. His hotel room was quickly turned into an art studio, as Dr. McIntyre showed up for his sittings almost immediately. The educator made a powerful first impression on the artist, who wrote to his wife: "I've met Dr. McIntyre. By Jove he's splendid — I'm going to revel in painting him. I shall begin on Thursday morning."[62] After four sittings over the course of a week, a buoyant Varley wrote to Maud: "There is nothing in it to say it is going well — it just looks ready for something to happen to it — but the man is splendid — the arrangement, colour, and light and shade is like an old Rembrandt and if I don't make a success of it — I — well, I cannot conceive failure — I have every opportunity and must succeed."[63]

As on many occasions during his long career, Varley's enthusiasm for the portrait came from his personal response to the sitter. Dr. McIntyre captivated Varley, who exclaimed to Maud:

> You know dear what it means to paint a character. Simply being absorbed by the sitter & by Jove, this dear old gentleman has made me a slave. We commenced finding each other in conversation and at first my vigour and general outlook floored him and he felt I knew so much more. He spoke of his work as worthwhile and gradually the see-saw began to move. He told me things these last few days and said he'd never spoken so much before. He spoke of losing his wife, his son during the war, two little children age 7 and 9 who were stricken with diphtheria & were taken in 24 hours.[64]

This sharing of their life stories formed a bond between the two men. After the sittings, they would go out into the prairie to watch the sunset and further enjoy each other's company. "I nearly blubbed my heart away," Varley admitted, "and I knew that his whole heart was somewhere back of the sunset and his knowledge was mature and golden and I was struggling to find what age can only bring — what a kid, a helpless kid I felt, and of course I told him what he'd done to me, but he just quietly laughed and said it wasn't him, but the sunset was a glory to behold."[65]

Varley's brief sojourn in Winnipeg was coming to an end, for other commitments were calling him to Edmonton. Although the time had not proved sufficient to complete the portrait of Dr. McIntyre, the result so far was admirable. The subject was seated at ease in a chair and was portrayed frontally, in three-quarter-length size. The folds of his academic robes were rendered in a playful way, showing Varley's mastery of light and shadow. McIntyre's hands were folded in his lap, relaxed and assured. His facial expression conveyed strength and directness, but also the gentle and caring side of his character. The artist planned to return in the spring to finish the portrait.

The commission for which Varley had to leave Winnipeg was the portrait of the University of Alberta's new chancellor, Charles Allan Stuart (1864–1926; pl. 20). This picture of Dr. Stuart was conceived as a companion piece to that of his predecessor, Dr. Tory, and would hang in the senate chamber as well. Once again, the person responsible for the commission and for collecting donations was Dr. John MacEachran.[66] The sittings were arranged for late February or early March 1924. The painting was completed by April 2 and presented to Chancellor Stuart by Dr. Tory at the spring convocation in May 1924.[67]

A lawyer by profession, Stuart served as an Alberta Supreme Court judge. In an interview, Dr. MacEachran recalled that during the sittings, Chancellor Stuart talked a great deal about his experiences on the bench and commented on current trials, especially murder cases. MacEachran felt that the nature of these conversations affected Varley's response to the subject, causing him to portray this otherwise very warm individual with the air of a judge presiding over his court.[68] Interestingly, the sessions with Stuart were conducted in a similar manner to those with Dr. McIntyre, but the messages in the finished portraits are quite the opposite. Varley was very proud of both works and deemed them his best accomplishments, though the two were markedly different.[69] Reactions to the portrait of Chancellor Stuart also differed: James Adam found it highly unconventional,[70] while Augustus Bridle proclaimed it the best portrait done by Varley before 1926.[71]

For the Stuart portrait, Varley deliberately chose a cool colour scheme, in contrast to the bright red robes of Dr. Tory. Chancellor Stuart is wearing an indigo academic gown with yellow fittings.[72] Andrea Kirkpatrick observes that Varley introduced two stylistic features here that appear experimental: Stuart's seated figure is contained within a geometric composition and assumes a pyramidal shape; and light and shadow repeat and extend beyond that pyramidal form only to be reduced into fragments of light that follow a geometric pattern. Traces of the pattern are especially evident in the lower-right corner. Kirkpatrick notes a similar treatment of light patterns in the work of the German Cubist Lyonel Feininger (1871–1956), particularly after 1910.[73] We would point out that some art historians have interpreted Feininger's use of geometric patterns to distinguish light from shadow as a means of diminishing the difference between the presentation of material and immaterial objects.

Foreground and background merge into one in Varley's portrait of Chancellor Stuart. Form, treated with the same importance as light and shadow, is drawn forward into a single picture plane. This has the effect of flattening the image and decreasing the distinction between body and void. Varley would become so fond of this technique that he would use it in the majority of his portraits of the 1930s and 1940s. Some of his best-known images of Vera Weatherbie, his Vancouver student and companion, carry this experimentation a step further.

Back in Winnipeg to resume work on the McIntyre portrait, Varley wrote to a friend, "I am anxious to get into a working stride." He went on to recount that he drew colour inspiration from the view through the window of his hotel room/studio: "This morning I was painting the white facings of the Doctor's gown & the light & shade & pearly colours were just the same as snow

drifts on the mountain sides."[74] Now well versed in applying colour to maximum advantage, Varley turned his attention to the surface of the painting, wanting to create a sense of the texture of the fabric. It took only a week to complete the portrait, which was unveiled on May 30 to mark the naming of a local school after the esteemed superintendent and which was given to the Public School Board in trust for the residents of Winnipeg.[75]

In art historical literature and in the press, much has been made of Varley's negative view of arranged portrait commissions. As he wrote on the train from Winnipeg in April 1924, "From now on I want to paint mountains — It's easier to sell mountains than to barter for portraits — I hate others doing it for me."[76] This particular comment was most likely provoked by an experience he had just had in Winnipeg. In a recently discovered correspondence with his new-found love in Edmonton, Kathleen Calhoun, Varley refers to Mrs. Stuart's efforts to obtain a portrait commission from a lady in her social circle. Eager for the income, he agreed at the start, but the process of soliciting it wore him down: "Mrs. Stuart took me to the Golf Club on Monday & we met Col. McGilvray who has pots of money & has wanted for a long time a portrait of his wife. Mrs. Stuart says she will do her best to persuade the Lady because the Lady in question is like others in Edmonton & feels a little embarrassed about it or perhaps feels she may disillusion the husband by complying."[77] As this incident illustrates, when an intermediary set out to secure a commission for Varley, too often it ended in disappointment and hurt pride. As much as he enjoyed portrait work, he simply did not like the social dealings involved, the feeling of being at someone else's mercy.

The Gypsy Tradition

Although in the period after the First World War the artist's growing skill as a portrait painter did a lot to build his reputation and "put bread on the table," portrait work did not become an exclusive activity. From time to time, other genres and themes would capture his imagination, and he would follow where they led. In late 1919 or early 1920, Varley focused his attention on the depiction of gypsies as a symbol of the free human spirit. His renewed fascination with these unbridled wanderers was a result of several external factors. In boyhood, Varley had manifested a curiosity about the physical appearance of gypsies and their way of living. While taking regular sketching trips with his father in the Derbyshire Park District and the moors surrounding Sheffield, the two sometimes encountered gypsy caravans. The campfires and the mystical gatherings of large families stirred the budding artist's imagination. Varley's first depiction of gypsies dates back to 1912: a small watercolour, *The Hillside* (fig. 12), showing two girls wandering in the English countryside.

Fig. 12
The Hillside, c. 1912
Varley Art Gallery of Markham

During his war service in London, in 1918–19, Varley had had occasion to view paintings of gypsies by his close contemporary Augustus John (1878–1961) at the Tate Gallery, including his *Smiling Woman*, 1909.[78] John was the foremost practitioner of a trend in British art that began in the late nineteenth century: to romanticize the beauty and freedom from social constraint of the gypsy people.[79] He had been charmed by the gypsies in his native Wales, learned the Romany language, and lived with the travellers in a caravan of his own.[80] It is easy to comprehend their appeal, and the counterpoint to staid Victorian society that they symbolized. In the current context, we use the phrase "the gypsy tradition" to represent Varley's fascination with the notion of costuming models in brightly coloured dresses and accessories and painting them as gypsies.[81]

In Toronto, around 1920, Varley painted at least three portrait-size oil canvases and one large decorative panel using the same model dressed as a gypsy woman. Recent research has laid to rest earlier suppositions that Varley's model was an ethnic gypsy. In this instance, his model was Mrs. Goldthorpe, a working-class woman from Yorkshire (fig. 13) who had immigrated to Canada around the same time as Varley. As far as Mrs. Goldthorpe's relatives can testify, she had no gypsy heritage, but the hue of her skin and her weathered face suited the artist's purpose.[82] The model's then twelve-year-old daughter also recalled being dressed by Varley to appear in the large decorative panel *The Immigrants*, which will be discussed in more detail below.

The gypsy theme may have resonated especially with Varley because of its connection with the migrant's life. An immigrant himself, he was sympathetic to these people's economic struggles, their encounters with a new reality, and their efforts to recreate an Old World setting in their adopted home. He felt a similar underlying tension in his own life between the need to cherish his past while immersing himself in the new society of Toronto. In those years, the definition of an ideal immigrant to Canada was restricted to an independent farmer or labourer of British or American stock. An immigrant not from the British Isles was referred to as "foreigner." The predominantly English-speaking society of the day was against cosmopolitanism and

Fig. 13
Mrs. Goldthorpe (back row, second from left) and her family
Photo: Varley Art Gallery of Markham Archives

viewed ethnicity as a temporary pathological state, which is quite a contrast to the multiculturalism of our era.[83]

Among the various groups of newcomers to Canada in the early 1900s, the gypsies were the least welcome. In the public mind they were associated with petty crime. Along with this reputation for dishonesty, their migrant lifestyle and stubbornly alien ways made them archetypes of the unassimilable, or "bad foreigners." Despite all the impediments to their resettlement, groups of gypsy families managed to reach Toronto and other major Canadian cities.[84] Moving about in their tribal formations in their wagons or old cars, these dark-skinned outsiders were viewed with a mixture of fascination and fear.

Western culture had long been imbued with prejudice against gypsies. What child had not heard stories of the gypsies stealing children? Yet at the time that Varley took up the old romantic tradition of portraying gypsies, he was already considered a modernist. We might wonder if other modern artists were part of the same trend. Entries in the catalogue of the 1922 CNE exhibition reveal the submission of gypsy portraits by at least two other Toronto artists: J.W. Beatty's *Gypsy* and Dorothy Stevens's *La Gitana*.[85]

Varley's *Gypsy Blood*, 1919 (fig. 14), symbolizes his attempt to find an archetype of an earthy and sensual female beauty. In this particular image, the greatest similarity between Varley's work and Augustus John's gypsy portraits of his second wife, Dorothy McNeill (whom he called "Dorelia"), is evident. Here, the model's torso and head are turned slightly to the right, following the direction of her glance. An enigmatic, playful smile invites the viewer to ponder the object of her interest. This charming smile lightens her expression and softens the serious and introspective look in her eyes. Her hair is tucked tidily under a scarf, in contrast to the lively curls in Varley's other canvas of the same time, *Gypsy Head*, 1919 (pl. 5). There is no clear evidence to indicate which of the two character studies was painted first.

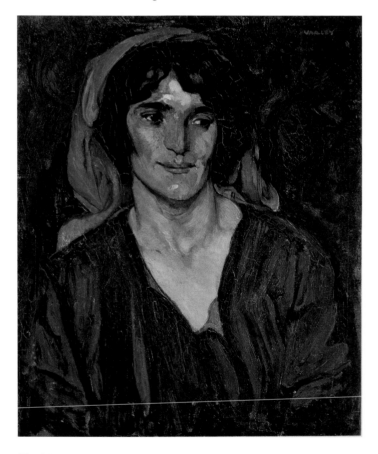

Fig. 14
Gypsy Blood, 1919
Private Collection

The model is wearing the same red dress in both images. The background is changed from a deep green, which created a strong contrast with the figure in *Gypsy Blood*, to a shimmering red in *Gypsy Head*. As well, Varley tried to give more volume, rather than the usual flatness, to the woman's unruly hair, by painting it in motion, as if windblown. His choice of colour for her dress and the background is striking. The painter used the warmth and heat of bright red to powerful effect, increasing the symbolic meaning of the work. In her analysis of Varley's painterly style, Joyce Zemans calls this "a complex, systematic correlation of colour and character."[86]

The work was shown as early as 1922, at the third Group of Seven exhibition at the Art Gallery of Toronto. It appeared again in their 1925 show at the same venue, but under a different title, *Character Study*. The new title gave rise to the widespread assumption among curators and art historians that *Gypsy Head* is not really a portrait but rather a character study. The debate is still open about Varley's intentions for this image, with the separate viewpoints tending to be represented by the following questions: Was the image an experimental step in his quest to find the archetype of feminine beauty? Or was it an attempt to capture the individuality of a woman, albeit one with exotic and mysterious features — a femme fatale? Toronto art critic Hector Charlesworth appeared to join the latter camp in his *Saturday Night* review of the Group's 1925 exhibition, in which he made reference to the portrait of a gypsy as "done in the tradition of femme fatale."[87]

Towards the end of the nineteenth century, particular attributes of women's portraits were consistently identified with the femme fatale type: "A woman seen frontally; her upright and frequently taut posture is combined with a thrown back head and lowered eyelids."[88] Other elements, including a spiral motif in the background or on clothing, or perhaps in the curls of the woman's hair, were frequently used to reinforce the image's degree of erotic content. Whereas an upright posture signified control over self and others, the loosed hair, tilted head, or raised arms symbolized both abandon and acquiescence.

The femme fatale tradition cannot easily be traced in Varley's work. For one thing, his portraits rarely offer a narrative, which

is a characteristic of this type. In the case of *Gypsy Head*, the woman depicted is not sensual and erotic with soft features; instead, she is strong, earthy, and stout, with features worn out by the harsh realities of life. There are certain parallels with the portraits of nineteenth-century painter Dante Gabriel Rossetti, whose female subjects are presented in a similar close-up view and display the same powerful, columnar neck, yet remain delicately sensuous.[89]

The great attention given to *Gypsy Head* is justified, for the portrait holds an eternal value. It has all the characteristics of a work that becomes a milestone in an artist's career. Moreover, the study of this portrait is important to anyone who wants to understand the further development of Varley's personal style. With *Gypsy Head* he embarks on a celebration of womanhood in his art, one that would continue into the late 1950s. The iconic images that Varley produced over the years, in addition to their sensual and monumental qualities, immortalize some outstandingly charming women. Through his portraits — *Vera*, 1930; *Norma*, 1935; *Erica*, 1942; *Natalie*, c. 1943; *Jess*, 1950; and *Laughing Kathy*, c. 1952–53 — Varley paid homage to the "eternal feminine."

Varley also used the same "gypsy" model for a less known but very unusual work, the large decorative panel titled *The Immigrants*, c. 1921 (pl. 15). This study for a mural was first entered in the Group of Seven's 1921 exhibition with the unpretentious title *Decorative Panel*. A large canvas of this type was often referred to as "decorative," although its decorative qualities may be of less importance than its subject matter. In works like this, the foreground needs sufficient strength to support the weight of the composition, an issue that Varley resolved by introducing his previously painted gypsy model as the central figure.

Personifying the common immigrant in this image, his model stands in a crowd and looks directly out at the viewer. She is visibly centred in the composition, wearing a pink dress and a red scarf and holding a bundle in one hand, perhaps all her possessions for life in the new world. The mixed throng of immigrants, disembarking, look weary from the long sea voyage. Varley would have had no trouble conjuring up the feelings of hope and uncertainty that accompanied his own passage in 1912. He might have been trying to work from memory, while using models for some of the personages. A possible prototype for this complex panel could have been *The Brass Shop*, painted by Frank Brangwyn in 1906.[90]

Varley used his gypsy model for yet another work, *Character Study*, 1919–20 (fig. 15), since disappeared, where she is shown leaning against a mantelpiece. The painting was first presented at the CNE show of 1921, then again in 1922, when it was reproduced in the catalogue (no. 317). It made another appearance later on in 1922, in the Group of Seven exhibition at the Art Gallery of Toronto. Its inclusion in these shows indicates that it was probably painted around the same time as the other gypsy images. Some affinities with the textural background of *Gypsy Head* also point to this presumed date. Certain weaknesses in the execution of *Character Study*, however, suggest that it was not painted from direct observation but from memory. The model's left arm, for example, is too long and unnatural in appearance; her right arm

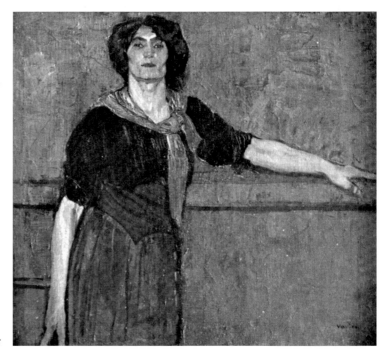

Fig. 15
Character Study, 1919–20
Location unknown

46

also does not seem to fit with the outline of the shoulder and sleeve. The hands were left rather roughly executed. On close observation, the lines of the folds of the skirt are very sketchy, which is not typical of Varley's otherwise meticulous manner.

It is interesting to note that the composition used in *Character Study* was published two years later as the front cover illustration for the *Complete Poems of Tom MacInnes* (1923). In the published version, the model's arms are rendered in perfect proportion to the body. The left arm is bent at the elbow, as she leans towards a tree trunk or an unidentifiable architectural element. The woman's facial features have been softened, giving the image an air of elegance and sensuality. Credit for this new tone may be given to the basic nature of graphic design, but it owes more to the fact that in this instance the gypsy has been transformed into a poet's muse.

When discussing Varley's gypsy portraits, one cannot ignore the context. At the time he was working on these romantic images related to the nineteenth-century British tradition, the other members of the Group of Seven were preparing for their first exhibition, to open on May 7, 1920. Their manifesto on this occasion would declare the Canadian landscape as their primary subject matter. In light of this, Varley's — and Harris's — decision to include portraits in their group's debut was to say the least surprising, and according to Charles C. Hill "shows the complexity of their intent."[91] In recent years, Fred Varley's somewhat tentative relationship with the Group has been a topic of discussion among art historians. Generally, Varley is treated on his own artistic merits, standing apart from the Group of Seven. He is seen as a wandering soul, often called "the Gypsy" of the Group.

The validity of this viewpoint is affirmed in Peter Varley's description of his father's character: "He was, above all 'his own man,' enigmatic and contradictory. He had a strong feeling for family, in large part sentimental, that was with him through life; yet his impassioned gypsy side, his psychic and mystic nature, his romanticism and an absolute need for freedom of action struck out at anything that tried to restrict him."[92]

Another aspect of the appeal of gypsies that cannot be overlooked is Varley's love of beautiful women. As a man and as a portraitist, he had a profound understanding of the subtle secrets of women's inner natures. Over the next two decades, Varley developed the gypsy theme further, even finding a way to use it to "modernist" ends. In the 1940s, he emphasized characteristic aspects of that gypsy spirit in friends and acquaintances who were lovely, young, free, and wild girls. To Miriam Kennedy, whom he called Manya, and Natalie Kessab, who shared certain qualities with his idealized gypsy image, Varley ascribed something of the sort of fierce independence that he so envied.

CHAPTER 3

PUBLIC FACES: SOCIETY PORTRAITS

The artist's job is to unlock fetters and release spirit.
— Fred Varley

In the early months of 1920, Varley received his first important portrait commission from the University of Toronto. The occasion was the completion of a new student union building, planned as "a unifying force on a fragmented campus." A gift to the university from the Massey Foundation by its president, Chester Massey, the building was intended as a memorial to his father, Hart Massey. In his history of Hart House, Ian Montagnes states that the creation of a student union building was a unique idea at the time, and Hart House became one of the earliest examples in the world.[93] Credit for the idea belongs to Chester's son, Vincent Massey (1887–1967), who also oversaw its planning and construction, despite the interruptions caused by the First World War.

Vincent Massey

Friends and members of the Hart House committee, headed by Barker Fairley, decided to commission Vincent's portrait as a gesture of gratitude. But it was Vincent himself who had the final say in choosing the artist. As a member of the Massey family, where portraits were a tradition, Vincent would have had direct experience in commissioning paintings. Notable examples of portraits of family members include those of W.E.H. Massey and Hart Massey, painted by J.W.L. Forster, which were then part of the collection at Victoria College, University of Toronto. Thus, Forster would have been a likely choice for Vincent's portrait.[94] By the mid 1910s, back in Toronto from his studies in England, Vincent took a strong interest in the arts and was well acquainted with Toronto's art scene. Through the Massey company partnership with the Harris family, he also knew Lawren Harris and had acquired works by contemporary Canadian artists, including some sketches by Tom Thomson.

Barker Fairley related that Massey and Varley had been introduced to each other before the war, at the Arts and Letters Club. Both men were members, Vincent from 1911 and Varley from shortly after his arrival in Toronto in 1912.[95] It is a measure of the success Varley's war paintings had enjoyed in London, the favourable notice these and other works had earned in the press, and the reputation he had acquired in Toronto that the artist Vincent Massey chose to paint his portrait was Fred

Varley. Once the commission was confirmed, sittings were arranged at Tom Thomson's shack, which Varley was renting as a studio.[96]

Varley depicted Vincent Massey (pl. 9) seated comfortably in an armchair, in a three-quarter pose similar to that of Dean Cappon. Every detail of his appearance exudes self-confidence. He looks authoritative, self-assured, and polished. Varley's response to the personality of his subject may well have influenced his artistic approach to the portrait. By choosing not to paint the image as close to the picture surface as he had done in Cappon's portrait, he avoids having the viewer feel overwhelmed by the man's presence. As a result, Massey remains rather distant and self-absorbed. The cool yet luminous background adds to the feeling of isolation in space.

Members of the Massey family were known to be very private and socially reserved, and Vincent Massey was no exception. The public, however, was curious about the private lives of the Masseys and given to describing their individual character traits. Thus, some stories concerning the portrait commission were born and began to circulate in Toronto. Repeated often and embellished over the years by various storytellers, these anecdotes have acquired a certain claim to veracity.[97] A favourite tale has Vincent Massey arriving an hour late for his sitting. Varley, we are told, was upset about the long wait and decided to teach his client a lesson. In one version, he apparently announced that the session was over, packed up, and left. In another version, he excused himself and walked out of the studio, leaving Massey to wait for him for an entire hour.

Peter Varley relates that just before the last session with Massey, the painter appeared to be so disappointed with the results that he scraped off Vincent's head and repainted it at the final sitting.[98] An outside source of light illuminates the body, helping to outline the silhouette against the shimmering, prismatic pattern of the background. The light around the head seems to mould its shape gently and bring forth the facial features, adding some depth. The body, however, remains rather flattened and heavy, absorbing the light rather than reflecting it. The finished portrait embodies the artist's dual goals of achieving a good likeness and capturing the individuality of his subject. A comparison between this portrait of Massey and one of the same subject by Augustus John, *Vincent Massey*, 1939 (NGC), makes Varley's accomplishment clear.

The portrait was completed and presented to Vincent Massey during a special unveiling ceremony on April 17, 1920, in the Music Room of Hart House. It was received very favourably by all, and Massey was so content that he asked that it remain in the Hart House art collection. "A masterful delineation and a remarkable example of intense emotionalism," is how Augustus Bridle described the portrait in his review.[99] Varley himself must have considered it a success, for over the next few years he entered it in numerous exhibitions, including the first Group of Seven show in May 1920 and later that year at the CNE. In 1924, Varley's *Vincent Massey* was presented at the British Empire Exhibition at Wembley.

Admiration for the work was not unqualified, however. The dichotomy between a more voluminous, three-dimensional head and a rather flattened body did not escape some reviewers. Critics writing about the British Empire Exhibition engaged in a discussion of Varley's attitude to the third dimension. One of them, Rupert Lee, interpreted Varley's response to perspective as more intellectual than physical and traced its origins to Oriental art. According to Lee, "This was a positive element, manifested in the Massey portrait by the primacy of line," which he regarded as "valuable for the shape it encloses, not the bulk it suggests."[100]

CHESTER MASSEY

Another Massey portrait commission soon followed. This time the subject was Vincent's father, Chester Massey (1859–1926), a prominent benefactor of the University of Toronto and Victoria College, and a respected member of Toronto's elite and of the Methodist Church. Approaching seventy, he was to be presented with an honorary Doctor of Laws degree from the University of Toronto on June 3, 1920. The commissioning of the portrait

was not an initiative undertaken by the university's Board of Governors, on which he served. It must have come from Vincent Massey, most likely after the completion of his own portrait, and having been intended as an additional gift to mark the occasion.

Varley first mentions the Chester Massey commission in a letter to Eric Brown, dated June 1, 1920.[101] The convocation was only two days away at the time, which might indicate that plans for a portrait had been underway earlier. For health reasons, Chester Massey was unable to attend the spring convocation, and so the conferring of the degree was delayed until the fall. On June 11, Varley wrote to Brown again, expressing his eagerness to get started on Chester Massey's portrait.[102] The sittings must have taken place between the second part of June and the end of October. The portrait was completed just in time for the official ceremony on November 3, 1920. The painting was unveiled in the Music Room of Hart House and gifted to the collection. Soon after the unveiling, Chester Massey's portrait (fig. 16) appeared in an RCA exhibition in Montreal.

Fig. 16
Chester Massey, 1920
Hart House, University of Toronto

The two Massey portraits — father and son — may have been conceived as a pair, judging from the similarities in size and horizontal composition, the formal, seated poses, and the overall treatment of the figures within the space. The family resemblance even extends to their bearing. Varley painted both men in three-quarter-length and positioned slightly off-centre, allowing for an open visual space on one side. We would call attention to a compositional kinship between Varley's *Chester Massey* and Lawren Harris's portrait *Mrs. Oscar Taylor*, related to the setting, horizontal arrangement, pose, and placement of the figure within a framework. In all probability, portrait work did not interest Harris as much as it did Varley. Rather, it seemed to fit in with his nationalist program, taking the form of a search for individual expressions of the Canadian spirit.

As had been the case with Vincent's portrait, several anecdotes attached themselves to the Chester Massey commission, making their way through Toronto circles for some years. They centred on the unfriendly relationship between the artist and the sitter. The story about an argument over the price of the commission, however, should not be taken seriously: Chester Massey was neither the client nor the ultimate recipient of the portrait.

SIR GEORGE PARKIN

Varley's success with the first two Massey family portraits brought another commission his way, this time for a painting of Vincent Massey's father-in-law, Sir George Parkin. Vincent and Sir George's daughter, Alice, had married in 1915. A prominent member of Toronto society and well-respected educator, Sir George served as principal of Upper Canada College from 1895 to 1902, when he accepted the post of Secretary of the Rhodes Scholarship Trust and moved to England.

It was Sir George's announcement, in 1920, of his decision to retire from the Trust that prompted a group of Rhodes scholars to form a committee to find ways of recognizing his many years of service.[103] They agreed on the commissioning of a portrait, intending to present it to Lady Parkin. On learning that Sir George was

planning a trip to Canada, they decided it would be most suitable to offer the job to a Canadian artist. Despite the lengthy correspondence on the subject, it is not clear exactly how the committee came to select Frederick Varley. However, Raleigh Parkin, Sir George's son, asserts that Vincent Massey played an important role in influencing the committee's decision.[104]

Sir George arrived in Canada in the spring of 1921, and by May the idea of the portrait was presented to him.[105] Varley was at work on the canvas in June 1921 and wrote enthusiastically of it to Eric Brown, expressing the view that this would be his best portrait so far. He also reported that arrangements had been made for the Parkin commission to be paid in three instalments, but that he still had not received a payment; he asked Brown to intercede on his behalf.[106] From correspondence, it is obvious that by mid-August, Varley was still waiting for payment.[107] Still, he did agree to allow the portrait to be shown privately in the fall of 1921, at the Rhodes Trust offices in New York. When the picture appeared in the RCA annual in November 1921, a glowing review in the *Toronto Globe* deemed it a work "marked by excellent modelling and character study, though all carried out in a low key."[108]

Sadly, Sir George died less than a month before the official ceremony. Nonetheless, the painting was shipped to London and presented to Lady Parkin, whose reaction to it is not on record. What conclusion can we draw from the fact that Lady Parkin preferred to supply an actual photograph of her husband when a likeness was requested for his biography? Why did she not offer a photo of Varley's portrait instead? Could this be an indication that she did not approve of it? Or did she perhaps associate its creation with Sir George's sudden death? We can only speculate.

The essence of Sir George Parkin that Varley so successfully transferred to canvas is his air of quiet dignity. This work lends itself readily to a comparison with the portraits of Vincent and Chester Massey, as far as composition, pose, size, and manner of execution are concerned. The similarities may have been deliberate. The choice of colours, however, with a deeper tonal integration between image and background, as well as the modelling

of the body, foretell stylistic elements that would soon emerge in Varley's portrait work and which are more evident in his *Mrs. E.*, c. 1921 (pl. 11).

ALICE MASSEY

The next portrait that Varley undertook for the Massey family — that of Vincent's wife, Alice Stuart Massey (c. 1879–1950) — proved to be one of the most challenging commissions of his career. Hers was a private commission and one of the few images of society women that Varley painted during this period. We do not know whether Alice herself initiated the commission. Perhaps the arrangements were made entirely by her husband, and she merely complied with his wishes. If this was the case, it might shed light on the tensions that arose between the sitter and the artist. Certainly, each one entered the arrangement with specific expectations. We are also told that Alice had strong views about colour and design, which she applied with great enthusiasm in the decoration and furnishing of Hart House, as well as in her homes in Toronto and Port Hope.[109]

Inevitably, the encounters between Alice Massey and Fred Varley generated anecdotes that were avidly consumed by the public. According to one account, Mrs. Massey speculated out loud about how Augustus John would approach her portrait, which offended Varley to such a degree that he threatened to abandon the commission. On another occasion, she is said to have asked him to change the expression on her face. Reportedly, the artist was so infuriated by her interference that he slashed the canvas to shreds with his palette knife. We will never know the truth about these stories. We do know that the media delighted in repeating them, and considered them evidence of Varley's rebellious character and tumultuous lifestyle.

Alice Parkin and Vincent Massey had first met in England while he was at Oxford, but it was only when Alice arrived at the University of Toronto in 1914, as head of Queen's Hall, the women's residence, that their relationship began. Alice played an active role in society and was known to cultivate the arts. The

two married a year later in Kingston, where Alice's sister Maude and her husband, William Grant, a professor at Queen's, had their home. Soon Alice Massey was involved in a number of her husband's projects at the University of Toronto, including Hart House, where she served as a member of the Theatre Board. Her avid interest in the role of women in society led her to write a book, *Occupations for Trained Women in Canada*, which was published in 1921.

The uncertainty that surrounds the arrangements for the commission, such as when Varley began work on it, also affects the date of execution. In general, 1925 has been accepted as a *terminus post quem*, since the portrait appeared at the OSA annual exhibition in March 1925.[110] However, new evidence from Varley's correspondence with Kathleen Calhoun, from the late spring of 1924, allows us to move the date of the sittings to a year earlier. More than a month after his return from Edmonton, on June 14, 1924, Varley wrote of his frustration with the commission: "My Mrs. Massey portrait will never be finished. It is the rottenest piece of painting I've ever done & I flamed up & damned the thing to eternity."[111] Varley also mentioned that he was looking forward to assuming his teaching duties at the Ontario College of Art, beginning July 2, 1924, and was eager to complete the Massey commission before that date.

As old photographs attest, Alice was a strikingly handsome woman with fine, classical features. Her romantic appeal was so irresistible that her sister Maude was rumoured to keep a card index in which she recorded all of Alice's early beaus and suitors. The difference in age between Mrs. Massey and her husband was of some concern. Alice, or Lal, as Vincent usually called her, was eight or nine years his senior, but she compensated for it with great vivacity and vigour.[112]

At the time Varley began this commission, he would occasionally produce a character study in oil before turning to the actual portrait. The head-and-shoulder version of *Alice Massey*, c. 1924–25 (pl. 23), unknown until recently, was perhaps his first informal study of the sitter. In this close-up view, she was painted without any outward signs of wealth or status, which one might have expected to see in her clothing or surroundings. She is wearing a plain dark dress and a dark headband. The artist's choice of a darker background adds an air of dignity to her classical profile. This canvas may well predate the portrait *Alice Massey*, c. 1924 (pl. 24), also known as *The Green Shawl*.

Equally unusual for a society portrait, yet typical of Varley, is the absence of flattery in his treatment of the subject. In the larger three-quarter-length portrait, Alice Massey, wrapped in a green shawl, appears rather heavy, seated not on a comfortable armchair but possibly on a stool. There is no other furniture in the scene. She wears the same black dress and no jewellery. The shawl has a very modest decoration of flowers and, as one researcher points out, has the appearance of homespun cloth.[113] Varley used a shawl in at least two other society portraits, *Mrs. E.*, c. 1921 (pl. 11), and *Janet P. Gordon*, c. 1925–26 (pl. 28), and in both cases its arrangement had a lot to do with tonal contrast.

The noticeable stiffness of Alice Massey's facial expression in both portraits is emphasized by her rather long neck. One wonders if this was Varley's reaction to her stubbornness or snobbishness. To some extent, the treatment of this aspect was the painter's favourite way of revealing a disagreeable side of character, as is visible in his depiction of Janet P. Gordon, for example. On examination, the two portraits of Alice Massey have a number of characteristics found in Varley's work prior to 1924. They are classical in style and conventional in pose and treatment of surface and light. Their compositions are devised in two planes. In both, the figure is prominently placed in the foreground of the picture plane and silhouetted against an ambiguous background.

In its dramatic simplicity, Alice Massey's portrait with a green shawl has been compared to Lawren Harris's *Dr. Salem Bland*, 1925 (fig. 17). The newly suggested date of 1924 for Varley's canvas closes the door to any possible influence of Harris's work on Varley, while allowing for the likelihood of influence in the opposite direction. *Alice Massey* and *Dr. Bland* are painted in a similar palette, and each subject is represented in a state of withdrawn intensity.[114]

In late 1924, Varley continued to employ strong contrast in tonal values to outline the figure and to differentiate it from the background, despite his experiment with chromatic shifts in

Fig. 17
Lawren Harris
Dr. Salem Bland, 1920
Art Gallery of Ontario, Toronto

"The Green Vera," and later in his *Woman in Green*, c. 1939–40 (private collection).[115]

At its first public appearance at the OSA annual exhibition in March 1925, the portrait of Alice Massey wearing a green shawl drew mixed and ambivalent reviews. One critic saw the intensity of colour as unconventional and daring, and full of "some sort of symbolism" that detracted from the work's success.[116] In Hector Charlesworth's opinion, the painting had a certain poster-like quality, but it was a fine achievement in countenance.[117] Herbert Stansfield, on the other hand, was effusive about the image, praising the "glory of colour that Hokusai only would have dared."[118]

In preparation for the upcoming *Retrospective Exhibition of Painting by Members of the Group of Seven, 1919–1933* (February 20 to April 15, 1926), at the National Gallery, Varley wrote to the director, Eric Brown, on December 19, 1925, to inform him of a title change from *Mrs. Alice Vincent Massey* to *The Green Shawl*.[119] *The Green Shawl* remained in the Massey family until 1968, when it entered the National Gallery's permanent collection as part of the Vincent Massey Bequest. The painting was apparently well liked by the Masseys and prominently displayed in the study at Batterwood, their residence near Port Hope, Ontario.[120]

Portrait of Charles Allan Stuart. This is especially prominent in *Alice Massey*, where Varley used the tonal contrast of the shawl to enhance the presence of the form with sharp outlines. The modulation of colour in the background, from pale green to rich marine blue, has been a point of discussion among art historians. The effect is reminiscent of a clear sky or suggestive of an outdoor setting, without referring to a realistic landscape. In this sense, it is rather an imaginary open space. Certainly, the viewer's eye is drawn to the vibrant green and blue, which dominate the visual field. A similar transition from green to blue as a means of transcending mass and creating background was used by Varley in his portrait of Vera from 1930 (pl. 33), often referred to as

Dr. Harold Tovell

Varley was also known to have done a portrait drawing of Dr. Harold Murchison Tovell (1887–1947), whose wife, Ruth Tovell (1889–1961), was the eldest daughter of Walter and Susan Denton Massey and a first cousin to Vincent Massey. Dr. Harold Tovell was Toronto's first radiologist and a member of the Faculty of Medicine at the University of Toronto. He was knowledgeable about art and participated in various Hart House activities, such as organizing an exhibition of reproductions of old manuscripts in 1926.[121] Membership records show that he was also an active member of the Arts and Letters Club in the 1920s.[122] Ruth Tovell had a special interest in the arts and became a well-known art historian, author (e.g., *Flemish Artists of the Valois Court*, 1950), and collector of modern European art. She is even credited with having helped to

cultivate a taste for the arts in her cousin Vincent, in their youth.[123] Family members recall Varley attending parties at the Tovell estate at Dentonia Park, northeast of Toronto, where he drew a portrait of Dr. Tovell. Even though that drawing is lost, a small sketch that Varley did of fellow artist A.Y. Jackson, entitled *Alexander at Work*, 1925 (private collection), was allegedly drawn on one such social occasion at the Tovells.

JANET P. GORDON

In addition to the various Massey family pictures, in the 1920s, Varley painted several portraits of society women, all of which were private commissions. *Janet P. Gordon*, c. 1925–26 (pl. 28), is among Varley's most powerful images of the period. The date of circa 1925–26 was assigned to the portrait based on its first public appearance at the OSA annual in 1926. In our view, however, the painting is comparable stylistically to Varley's other portraits from 1920–21, and cannot not be readily grouped with the paintings of Maud, Viola Pratt, or Ellen Dworkin from 1925–26, which will be discussed later.

Janet P. Gordon (1855–c. 1934) was the daughter of John Kay, owner of one of the major local retail stores, the Murray-Kay Company. She was not known to have a particular interest in the arts and the idea for the commission did not originate with her, nor did she feel very enthusiastic about it. In fact, we are told that she never quite liked the finished portrait, despite the positive reaction from her family. Her son, Huntley Gordon, was a close friend of Barker Fairley and a member of the Arts and Letters Club. Huntley had also had his portrait painted by Varley, in 1921, and likely it was he who convinced his mother to commission the painting in order to help Varley financially. Even though Fred frequently rebuffed such attempts at charity, the $1,000 fee must have been a strong incentive.

Because of his sensitivity and psychological insights into his sitters, Varley often used a hidden message or allegory that was not easily decoded by his clients. In this portrait, Janet Gordon's obvious reluctance to be painted is indicated by her stiff posture and

skeptical look. Although comfortably seated, she appears alert and ready to walk away at any moment. Nonetheless, there is an innately regal quality about her expression and bearing. Her face is exquisitely modelled, down to the smallest detail of her hairstyle and the shadow of her glasses. Although her body appears quite sharply silhouetted against the neutral background, it is evident that Varley attempted to find a solution for a better integration of figure and background by lending more volume to the body mass. In some respects, *Janet P. Gordon* may be compared with *Vincent Massey*, *Mrs. E.*, and *Sir George Parkin*, namely in its treatment of figure, background, and light, as well as in the use of pastel hues.[124]

In later years, Barker Fairley remembered Mrs. Gordon as a "very upright" old lady, who was "very severe" and "austere" looking. Fairley was unceasing in his regard for this picture, counting it among Varley's best works.[125] When this portrait was first exhibited in 1926, one reviewer proclaimed: "[It is] the best thing [Varley] has done for some time: it is full of character and a sensitive feeling for beauty."[126]

MRS. MINNIE ELY

Varley's ongoing attempt to fully integrate the foreground with the background culminates in his portrait *Mrs. E.*, c. 1921 (pl. 11). He achieves his goal by placing the sitter against a lighter, variegated background and creating an aura of dignity and monumentality. One way of understanding this achievement is to see it as a further development of the style of portraiture manifested in *Captain O'Kelly* (pl. 2). In *Mrs. E.*, Varley added more depth of field and a pronounced play of light and shadow, which facilitates the integration of the picture planes. The subject's fine features and the gentle shadow over her face, the richness of her clothing, with the deeper folds of her skirt, all speak of a mastery of volume and technique unseen before in his portraits.

From what we know of Minnie Ethel Ely's background and social position, we must conclude that she was not posing in her usual attire. Ernest Frederick Ely was the owner of Ely Ltd., a men's clothing store in Toronto. His wife was known as a patron

of the arts, who commissioned portraits from such names as Marion Long, Florence Wyle, Ivor Lewis, and Frances Loring.[127] It is likely that Varley ventured to suggest a costume for her, as he had done with his gypsy model. An unfinished inscription on the back, on the stretcher, reads: "Portrait of a ... lady masquerading as an aboriginee by Horse-man Varley April 192(3)." The use of the word *masquerading* suggests that Minnie Ely readily went along with the artist's idea. No doubt the subject's defined features and high cheekbones, along with her earthiness and sense of individualism, appealed to Varley.

Mrs. R.A. Daly and Sons

The picture of Katherine Daly and her sons is Varley's most complex portrait thus far and his only group portrait, apart from the decorative panel *The Immigrants*. It was commissioned by Katherine's husband, Richard Arthur Daly, a wealthy businessman and president of the R.A. Daly & Co. securities firm in Toronto. According to previous research, Daly and Varley did not meet prior to the commission, even though they had mutual acquaintances.[128] Two of those friends, Arts and Letters Club members Gilbert E. Jackson and Peter Sandiford, had commissioned portraits from Varley in the past. They knew Daly through their association with the *Canadian Forum*, as his company had been advertising in the magazine since 1921. Moreover, Richard Daly contributed articles to Gilbert Jackson's "Trade and Industry" column.[129] Obviously a keen supporter of the arts, Daly had many links with Toronto's arts community; his sister was artist Kathleen Daly Pepper. In 1927, Daly would join the Council of the Art Gallery of Toronto.[130]

Portrait Group (Mrs. R.A. Daly and Her Sons, Dick and Tom), 1924–25 (pl. 22), includes Katherine Daly (née Cullen) and her two sons, ten-year-old Richard Arthur Jr. (Dick) and seven-year-old Thomas (Tom). Richard Jr. recalls that his parents had great faith in Varley's skill as an artist and made no special demands on him regarding the portrait.[131] In the composition and arrangement of the figures, the Daly family commission does not offer a new approach to group portraiture. Mrs. Daly and her younger son, who is snuggled up to her, make a pyramidal form in the foreground, while the older boy is seated on the right, at some distance from the other two figures.

Mrs. Daly's pose has given rise to much controversy. Her figure is central to the composition, but does not appear very stable. Instead, she leans to her right in a manner that looks uncomfortable. This awkward pose adds a certain visual tension to the overall composition. Can we assume it was intentional on the artist's part? Peter Varley suggests that the portrait should be interpreted as a "penetrating look into the boys' relation to their mother."[132] Varley probably felt that the younger boy's physical closeness implied a deeper dependency, while the older son's distance denoted more maturity and a drive towards independence. Whether the portrait offers a deeper reading of the domineering character of the mother or her preference for one of her children is hard to determine.[133]

When planning the composition, Varley chose to include a glimpse of his studio, with a side view of a canvas leaning towards the figure of the younger child. In order to enclose the group, Varley painted the edge of the frame of another canvas on the right, beside the couch, near the window. This inclusion of a reference to his identity as an artist brought something unconventional and unexpected to the composition. Perhaps Varley decided to take a factual approach to the physical surroundings in this instance, because the studio where the sittings took place was a part of the family home. Usually, he rented a studio at another location, but in 1925 the Varleys occupied a bright and spacious house on Yonge Street, with enough room for a studio. The details of the interior reveal not only a portion of the studio and some of the furnishings, but also a French door leading to the family room, in which Varley used to hold evening art classes.[134]

This intriguing reference to his studio has led some art historians to look for a possible prototype for the composition. When preparing for this commission, Varley may well have looked at examples of group portraits, but the issue of which prototype was most influential must be given careful consideration. Certainly he was aware of numerous precedents in art history of artists alluding to their métier, or including the tools of their trade, in their

images. Indeed, the Daly portrait was not the first such instance in Varley's own work. The *Self-Portrait* of 1919 (pl. 7) contains in the background similar references to his role as an artist. In 1924, he painted *Young Artist at Work*, an oil study of his son John trying his hand in the studio (pl. 21). The artist's easel is on the left and several canvases are scattered around the room. A preliminary drawing for that work, *In the Studio* (fig. 18), shows how Varley played with the idea.

It is Chris Varley's contention that the closest examples derive from the High Baroque era, more specifically the royal group portrait *Las Meninas*, 1656 (The Prado, Madrid), by Diego Velázquez (1599–1660). In his portrayal of the Spanish royal court, Velázquez chose to insert an image of himself, holding his palette and brushes while looking intently at his painting. The other figures are all assembled behind him, in still poses.[135] Another school of thought links the pyramidal outline of mother and son, as well as the planar recession of space, to High Renaissance prototypes. Toronto art critic Herbert Stanfield, for example, found similarities between Varley's *Portrait Group* and the work of the Italian old masters. He singled out *Virgin and Child with Saints* by Fra Filippo Lippi (c. 1406–1469) as a possible source of inspiration.[136] In his review of the 1925 OSA exhibition where the painting was first shown, Stanfield wrote, "Mr. Varley's portrait group No. 229, is unconventional, and, until by quiet contemplation one becomes absorbed by its beauties, a little uncomfortable. In reply to a query as to what the mother in the group was leaning on, a lady standing near the picture was heard to remark sarcastically: 'oh, on a line of composition, of course.'"[137]

When discussing precedents, it is worth noting that Renaissance and Baroque artists had differing views on composition. Carefully balanced compositions were more characteristic of Renaissance paintings, in which figures were often placed symmetrically around a central personage or focal point. It was not until the High Renaissance (c. 1490s–1520s) that the grouping of the principal figures was modelled in an apparently three-dimensional shape, suggestive of a cone or pyramid. By contrast, the Baroque age (1600–1750) favoured strong diagonals and curves in their

Fig. 18
In the Studio, 1924
McMichael Canadian Art Collection
Kleinburg

compositions, with figures standing alone or grouped together, yet an integral part of the whole. The individual figures were often connected by a look or a gesture, while overall they were linked by sweeping diagonals or unified by the brilliant colours of sashes and banners. In a Baroque composition, the arrangement of figures is more parallel to the picture plane, as in *Las Meninas*.

For his only known group portrait Varley devised a complex, unified colour scheme, where primary blue and red predominate, with green-blue and orange-red among the complementary hues. The artist uses these same colours across the canvas, employing

various patterns and lines, such as the decorative elements on Tom's clothing, which are repeated in the linear pattern of the cushion on the far right.

The older Daly boy is slim and delicate. His elongated facial features contribute to an air of self-absorption. It has been noted that Varley paid more attention to his bone structure than to the flesh, giving him an almost sickly appearance.[138] His younger brother is more robust, with a plump face and rosy cheeks. In the Northern European tradition of portrait painting, the sitter would often hold an object that had some reference to his status, interests, or profession. While Varley painted Tom holding an open book and Dick clutching a ball, all trace of boyish playfulness is absent. Their eyes meet the viewer's with the reserved dignity appropriate to their social status.

In his Daly family portrait, moreover, Varley showed an affinity to a technique typical of seventeenth-century Dutch artists, who were preoccupied with light and its effect on objects of different textures. Here, the glass in the French doors catches the rays of light and reflects them back into the room. In addition, the woollen texture of the boys' clothing and of their mother's dress seems to absorb the light, whereas her red blouse and little Tom's red tie glow softly. The beads of Mrs. Daly's necklace and the green satin material of the couch, on the other hand, are sparkling.

Regardless of the many historical precedents, Varley's *Portrait Group* has a modern aspect and thus deserves to be compared with some contemporary examples. Two artists who were active at the time come to mind: John Singer Sargent (1856–1925) and William Orpen (1878–1931). Sargent's *The Boit Children*, 1882 (Museum of Fine Arts, Boston), offers a fresh compositional solution to the difficult task of depicting the four daughters of Edward Boit. He gives equal importance to each, despite their differences in age, in a geometric perspective similar to *Las Meninas*. Orpen's *The Berridge Family*, c. 1910 (R.L. Berridge collection), portrays a mother with her two young children. She is seated on the left with one child in her lap, and their outline forms a triangle. For compositional balance, the other child is painted at the right, playing on the floor, and is also given a triangular shape. Orpen was known for organizing his space in a line, which owed much to

Velasquez; but the short foreground and lack of recession in *The Berridge Family* is derived from Whistler. Peter Varley suggests a link to Degas for some of Varley's portraits.[139]

The portrait of the Daly family made its first public appearance at the OSA exhibition that opened on March 7, 1925, which puts its date of execution between late 1924 and early 1925. Despite the winter season, Varley chose to depict a summer landscape through the window at the right. This switching of seasons had occurred before, in *The Sunflower Girl*, 1920/21 (pl. 12), and *Mary Kenny*, 1920/21, and might point to his use of landscape to create a particular atmosphere or mood in a painting, rather than as a realistic detail. The outdoor scenery is reminiscent of sixteenth-century Venetian portraits or even their Flemish successors, and its effect is almost panoramic. The horizon is painted blue to indicate distance, and the small hillside with trees is rendered in warm tones. The portrait was a treasured family possession, according to Richard and Thomas Daly.

Other Social Portrait Commissions

The 1923 financial crisis that forced the Varleys to leave their mortgaged house prompted a number of friends and acquaintances to offer help. One of the more noble ways of helping was to commission portraits. At least two portrait drawings of women likely came about in this way, and it is no coincidence that the two sitters were related by marriage. The initiative came from Helen Fraser, whose husband, Professor W.H. Fraser, taught French at University College, which no doubt meant a connection with Barker Fairley. On learning of the Varleys' financial woes, Helen Fraser kindly determined to commission a portrait of herself, then persuaded her close friend and in-law, Jean McPhedran, to do likewise. Thus, both drawings were arranged, with the price fixed at fifty dollars each.[140]

The drawing of Helen Fraser, 1924, is textured and contains many tonal nuances that are lacking in the portrait of Jean McPhedran. Varley probably liked Mrs. Fraser's disposition and found it easier to relate to her personality. That may be why he

chose a frontal pose. Her intense glance towards the viewer is challenging, yet warm and compassionate. Technically, the portrait is closer in tonal nuances to that of Mary Kenny from 1921, but it is executed with even greater precision. The facial features are drawn prominently, without flattery or any attempt to mask the sitter's age.

Jean Adam McPhedran was the wife of Dr. Alexander McPhedran, a physician and a member of the Faculty of Medicine at the University of Toronto.[141] Varley decided on a profile pose for the portrait of Mrs. McPhedran, which distanced his subject from the viewer. At the time that Varley drew her portrait, Jean McPhedran was suffering from diabetes, and his artistic solutions may have made allowance for the toll her illness was taking on her. Then too, he might have sensed her introverted personality, although before she fell ill, she was known among Toronto's elite as a philanthropist and active participant in the social gatherings of faculty wives. She was a well-educated and cultured woman, interested in music and the arts.[142]

Varley drew her facial features with great delicacy, introducing a buff wash to the surface of the paper. This technique allowed for a softer and finer image with enhanced outlines and restrained shading. The artist must have been happy with the finished drawing, as he entered it in the Group of Seven's 1925 exhibition. In his review of the show, Barker Fairley had high praise for the portrait: "Of course, when it comes to resourceful drawing in the full sense, Varley stands alone in Canada. His study of Mrs. McPhedran is faultless."[143] Fairley's admiration for Varley prevented him from comprehending the occasional viewer's indifference: "Why his drawings are not snapped up like hot cakes is a mystery to me. But that is an old story."[144] In *Saturday Night*, Hector Charlesworth also referred to Varley's drawing of an elderly woman, which he found to be "beautiful in sentiment and perfect in execution."[145]

Chronologically, the two drawings — of Mrs. McPhedran and Mrs. Fraser — are closely related, but as noted above, stylistically, Varley made them very distinct. By now, we are aware of just how essential a role personal dynamics played in his art, and here he was responding to two very different women.

In each case, his interpretation was sympathetic and open; however, he took an individual approach to each subject, making different artistic decisions and using a different technique. These two portrait drawings should stand as a warning to scholars to be on guard when attempting to date Varley's work based on stylistic development. As a draughtsman, his range was extremely wide; he was never confined to certain periods or predilections.

The subject for *Portrait of a Male*, 1925 (fig. 19), is unknown, but its depiction leaves the impression of a powerful concentration of will. In its volumetric treatment of form and refined handling of the medium, this work comes closer than any other to Varley's painterly concepts of drawing.

Fig. 19
Portrait of a Male, 1925
Varley Art Gallery of Markham
(cat. 34)

CHAPTER 4

PRIVATE FACES: CHILDREN, FAMILY, FRIENDS

I cannot hold to home life being the incentive to creative
work — the quiet home lover is not an artist.
— Fred Varley

There is a somewhat wistful quality to the act of characterizing oneself through painting. Traditionally, self-portraits were staged as an attempt to address that most personal and universal question: Who am I? In their varied responses, some artists chose to paint their realistic selves in reverse, as they looked at themselves in a mirror or mirrors. Others approached the depiction of their image purely as a psychological or spiritual exercise: they drew from a self-analysis in their own minds' eyes. What intrigued them all was the ever-elusive, yet unifying, element that Walt Whitman called "that shadow my likeness."

As a portraitist, Varley added his own exploration to the long tradition of artists' self-portrayals when, shortly after his return from the First World War, he painted *Self-Portrait*, 1919 (pl. 7). Peter Varley gives us a most detailed, intimate, and loving physical description of his father:

> Dad had a fine expressive face — an "ugly mug" he used to call it — very Yorkshire, with broad forehead rising to a shock of luxuriant copper-red hair, brushed back over a skull poised alertly on slender neck and shoulders. His nose was slight, but fitted the humour of his nature. Eyes and mouth worked as partners, each taking signals from the other. Bushy browed, his eyes were clear blue-green flecked with hazel and had the ability to turn you inside-out at will. The mouth was rarely still, like a sea creature testing and tasting the passing tide: sensitive, expressive, ready to smile in a crazy closed mouth way or open wide in laughter till tears filled his eyes.[146]

Fred Varley was extremely self-conscious about his appearance. A small man with a rugged face, he was far from unattractive, but he knew he was not handsome. Nonetheless, at the age of thirty-eight, Fred was a striking man, still youthful, with an erect posture, piercing blue eyes and reddish gold hair, which, according to Arthur Lismer, "burned like a smouldering torch on the top of a head that seemed to have been hacked out with a blunt hatchet."[147] He was also prone to soul-searching, and all the more so after his experience of war. In

his letters to family and friends he always offered an honest depiction of his emotional state, and liked to talk about his loneliness and his longings.

The artist devised his self-portrait in such a way as to give himself a formidable presence in the picture plane, standing in the middle of what looks like his studio. The necessity for self-observation would have obliged him to place a mirror to the right of his easel, which would be more convenient for a three-quarter view. Instead, he corrected the angle, for unknown reasons, which forced him to paint a frontal pose that brings him closer to the foreground, almost ready to step out of the frame. The intensity of the image is augmented by his concentrated look, as if intending to interrogate the viewer with his typical determination and curiosity. He is trying to provoke or challenge the audience, or even outface them. The image illustrates Philip Surrey's remark about Varley: "One felt at once the electric dynamism of the man."[148]

In his first study of himself, Varley applied the paint vigorously, using the green and muddy brown of his war canvas *Lieutenant G.B. McKean, V.C.* (pl. 3). Another echo is found in the rendering of the barely distinguishable background with a textured surface that creates geometric forms that run parallel to the figure, contributing to a sense of monumentality, even glamour. A similar background treatment is evident in the portrait of his first-born child, *John*, c. 1920–21 (pl. 10).

Over the years, the artist would make two more attempts to document his human condition and emotional state. *Mirror of Thought*, 1937 (pl. 43), was painted, as the title suggests, as a reflection of his face in the mirror. Defined by art historian Robert Stacey as a "ruminative" self-portrait, *Mirror of Thought* shows Varley in a very pensive moment, or, as Stacey describes it, "in intense communion with the secret recesses of his psyche."[149] His third essay came almost a decade later, *Self-Portrait — Days of 1943*, 1945 (pl. 51), when he was sixty-four. In this poignantly honest depiction, we ascertain a clearly disappointed man, exhausted by the constant pressures of making ends meet as an artist. An attempt to study the conundrum of his self-image and identity, this self-portrait is closer in composition and style to other portraits from that period, characterized by a split face, half illuminated in light and half in shadow, like *Erica*, 1942 (pl. 48).

CHILDREN'S PORTRAITS

That Varley enjoyed children is clear from the many paintings and drawings he did of them throughout his career. He entered the life of a professional artist at a time when children's portraits where commonly commissioned in England. At the end of the nineteenth century, society's perception of children changed fundamentally. The pursuit of affluence, a hallmark of this era in both North America and Europe, transformed family life, and children became the new centre of attention.[150] Up until then, portraits of young children rarely had been taken seriously by art critics, an attitude that raises the question: Was this because they did not accord with the ideals of high art?

One of the best-known portrait artists of the day, John Singer Sargent, worked on numerous commissions for paintings of children. He treated his young subjects with as much artistic ingenuity as he would any other subject, and had a major influence on his contemporaries in his approach to children as individuals. When Sargent's portrait *Essie, Rubie, and Ferdinand, Children of Asher Wertheimer*, 1902 (The Tate), was exhibited in London in 1902, the press called it a triumph. According to Barbara Dayer Gallati, "Large and lusciously painted, the triple portrait vividly demonstrated that the subject of childhood had been assumed into the highest levels of contemporary artistic production."[151]

Varley would have been familiar with these developments in the depiction of children in art, but we have no way of knowing how he felt about this shift in attitude, since the majority of his child subjects belonged to families who could afford to commission paintings, or were friends' children. However, he seemed to assess children's natures with an intuitive understanding. What is more, he was fascinated with their vulnerability and unfathomable innocence, and intrigued by these little beings whose character was still being formed.

MARY KENNY

In November 1920, shortly after completing Chester Massey's portrait for Hart House, Varley was approached about another portrait commission, this time of a young girl. The chain of events was started when his loyal ally Barker Fairley was invited by the Women's Conservation Committee in Sarnia, Ontario, to give a lecture on Canadian art.[152] During his presentation, he discussed Varley's portrait work, then showed reproductions of *Dean Cappon* and *Vincent Massey* and inquired whether anyone might wish to commission a portrait from the artist.

Fairley's contact in Sarnia was Norman Gurd, a lawyer and art collector as well as an active participant in the Sarnia Art Movement.[153] Gurd thought of William Kenny, a friend and business associate, who was related to him by marriage. By 1920, Kenny had established himself as one of Sarnia's most prominent and wealthy citizens. As head of the family business, wholesale grocers T. Kenny & Co., he was very involved in the life of the community. He, too, was a member of the Sarnia Art Movement and an art collector. As it happened, William Kenny had made an earlier attempt to commission a portrait of his seven-year-old daughter, Mary, as a gift to his father. He had even contacted E. Wyly Grier, who had built a reputation for portraits of children, but the matter was not yet settled.

Gurd threw his weight behind Varley's candidacy, seeking out reproductions of some of his portraits as well as letters of recommendation from men who were more familiar with the painter's ability and whose opinion would count in the final decision. Sir Edmund Walker, Chairman of the Board of the National Gallery, Professor Fairley, and Dr. MacCallum were three of the people he contacted. In his correspondence with Fairley, Gurd makes reference to the commission: "Mr. Kenny does not desire a large portrait, but thought perhaps head and shoulders, and he does not desire to spend more than $500 on the portrait."[154] Fairley and MacCallum responded in favour of the commission, but Walker was more hesitant. He thought highly of Varley's skills as a painter, but pointed out that so far his portraits did "not indicate a capacity for painting children."[155]

The Kenny family, however, appeared to have been sufficiently convinced; they offered the commission to Varley and invited him to their home.[156] He arrived on December 20, 1920, and stayed with the Kennys until mid-January 1921. A bout of the measles put the family under quarantine for some weeks and forced the artist to remain in Sarnia longer than anticipated. Although he usually preferred to paint directly onto the canvas, in this instance he produced two preliminary sketches and an oil portrait of Mary Kenny while in Sarnia. Unfortunately, the finished portrait, *The Sunflower Girl*, 1920–21 (pl. 12), did not meet the family's expectations. Varley then returned to Toronto and worked on a second version, *Mary Kenny*, 1921, which was more favourably received.

The Sunflower Girl reflects the pose of the first preliminary sketch of Mary (fig. 20), in the McMichael Canadian Art Collection. Drawing and painting are almost identical in composition. However, in the act of transferring the drawing to another medium, Varley introduced some uncertainty in the figure's disposition. Perhaps the young age of his sitter prevented him from holding long modelling sessions, and so he was obliged to work more from the drawing. In addition, the child's illness may well have restricted the painter's access to her. In both the sketch and the oil portrait, Mary is depicted frontally, looking steadily at the viewer. In the drawing, her eyes mirror trust and serenity. In the canvas, Varley introduced a play of light and shadow over the girl's face. Her unruly curls give the impression that she has just come from playing outside. However, her eyes are slightly averted and her head is somehow lost behind the large sunflower standing in the garden, painted on the same plane as the figure.

The second drawing of the little girl, *Mary Kenny*, 1920–21 (private collection), is quite different. It conveys the sense of a child, being caught in the moment of mischief. Peering over her right shoulder, Mary is turned three-quarters to her left. She is holding an open book, but is not looking at it. Instead, she turns away her gaze, as if in contemplation. Her swirling curls and the twist of her head create an impression of movement, although her eyes are dreamy and lost in a child's inner world. The composi-

Fig. 20
Mary Kenny, 1920–21
McMichael Canadian Art
Collection, Kleinburg (cat. 13)

winter, the time of year when the canvas was actually painted. As one researcher suggests, the small waves in the lake in the distance may indicate the lively breezes of springtime, while the warmth of the sunshine and the heavy shadow along the full bloom of the sunflowers point towards the height of summer.[158]

Varley's interest in painting portraits in outdoor settings was not new. This desire to combine portrait painting with his love of the countryside can be traced to his early days as an artist, and is reflected in the soft watercolour studies of figures within a landscape he did in England. With his move to Canada, the excitement he felt about his new surroundings fuelled this desire. In a letter to his sister Ethel, Varley wrote, "[I] am going to paint some outdoor pictures — portraits — this is an outdoor country."[159] Certainly, *Indian Summer*, 1914–15, and *Rocky Shore*, 1922, were among his first serious attempts to realize this intention. Both pictures portray his wife in a Canadian wilderness setting. When it came to selecting an appropriate backdrop for his portraits of Janet Aitken and Mary Kenny, interestingly, he eschewed rugged nature in favour of a domestic garden landscape — the perfect setting for childhood play.

The theme of children surrounded by flowers was not a novel idea in art at the time. It developed in European and, in particular, British portraiture during the 1890s and reached its apogee in the children portraits of John Singer Sargent, full of lyricism and elegance. In his *Helen Sears*, 1895 (Museum of Fine Arts, Boston), Sargent painted a little girl, standing indoors, surrounded by vases of large flowers. The same tradition was popular in Scotland, especially among members of the Glasgow School. Artists such as George Henry, David Gauld, and J. Stuart Park specialized in this type of children's portrait.

Varley's choice of background for *The Sunflower Girl* raises some questions. Was he influenced by the late-nineteenth-century European romantic portrayal of children? Was he seeking a symbolic meaning in his garden of sunflowers, linking the freshness and simplicity of childhood to that of nature? Or was he using the modern decorative approach? When he painted *The Sunflower Girl*, he must have been familiar with some famous precedents, such as Van Gogh's *Four Sunflowers*

tion of this drawing is based on diagonals and there is some indication of construction lines behind the figure. A label on the back of the original frame, indicating its entry into the 1922 OSA annual exhibition, lets us conclude that this was one of the three *Child Studies* Varley submitted that year.[157] In many ways, the second sketch is closer to his drawing of Primrose Sandiford (pl. 16).

In both oil portraits of Mary, Varley used an outdoor setting for the background, something he had already experimented with in his portrait of Lord Beaverbrook's daughter, *Janet*, 1919 (pl. 6). The season is hard to determine, although it is definitely not

of 1887 (Rijksmuseum Kröller-Muller, Otterlo), or Gustav Klimt's *Garden with Sunflowers*, c. 1905–06 (Österreichische Galerie, Vienna), with a pronounced decorative element. Could they have been an inspiration for his portrait? Varley would revisit the sunflower theme in 1939, in a small still life in watercolour, *Sunflowers* (private collection).[160]

In Varley's portrait, however, the decorative treatment of the Art Nouveau examples is not in evidence. His brushwork is rather rough and rudimentary, lacking the elegant finish of Van Gogh or Klimt. Nor does Varley seem to explore the decorative potential of the background, thus remaining more faithful to the sunflowers' natural appearance. What I believe is occurring here is an attempt, at this early stage in his development, to find some visual harmony and a more successful integration of figure and background. *The Sunflower Girl* shows some compositional weaknesses that may have contributed to the family's displeasure with it, for example, the way the little girl is engulfed by the huge flowers that crowd the canvas, or the awkward way her head and body are tilted to the right. One clue comes from Norman Gurd, who recalled that the Kennys objected to the shadow Varley added over Mary's face.[161] We know that the second portrait of Mary Kenny was painted from memory, in Varley's Toronto studio, and in it he successfully resolved all the previous problems of composition.[162]

For his second oil portrait, *Mary Kenny*, 1921 (private collection), Varley again chose an outdoor setting, but changed the lush sunflower garden to a wooded landscape, perhaps a more fitting Canadian scene. In this simplified and better organized composition, he treats the landscape as a backdrop, using long vertical strokes that serve as a natural frame for the figure. The tall trees complement the child's upright stance. Mary, standing firmly in the foreground, is now the focus of the painting. This version is more engaging, and the subject looks more confident and composed. Even though, at first glance, Mary's expression betrays the old familiar sweetness of the romantic idealization of children, we cannot overlook Varley's attempt to present a serious study of her character, giving it an air of dignity and charm, as he had done in the portrait of his eldest son, John.

Upon completion, the second portrait of Mary Kenny created a stir among Varley's supporters. In a letter to Mary's father, Norman Gurd enthused: "Prof. Fairlie [*sic*] has seen the portrait of Mary and is delighted with it. He calls it amazingly fine and says that even Varley seems satisfied. He speaks of a portrait of Varley's son John which is on exhibition at the Ontario Society of Artists exhibit. It is highly praised in the Toronto papers, but comparing it with Mary he says it will be altogether surpassed by the picture of the little girl."[163] While those who saw *Mary Kenny* were optimistic about its potential for gaining the artist future commissions, the wider public never had a chance to view the work, for it remained within the family and was never exhibited.[164]

PRIMROSE SANDIFORD

Sometime in 1921, Varley was commissioned by Betti Sandiford to do a drawing of her daughter, Primrose, then about eight years old. She planned the portrait as a gift for Peter, her husband. A violinist and aspiring playwright, Betti Sandiford won the prize for best amateur writer in Toronto and York County in a competition organized by the Women's Canadian Club, for her play *Crows*, in 1921.[165] She had a keen interest in the arts and knew of Varley through her husband's connections with the University of Toronto and the Arts and Letters Club.

Executed in the summer of 1921 or 1922, the drawing of Primrose Sandiford (pl. 16) stands out as one of his most convincing and accomplished children's portraits. It is a visual statement of all the key elements of his style.[166] Young Primrose meets the viewer's eye with an inquisitive, appraising, almost sagacious air. Even though she is seated, her look suggests a suspended motion, as though she had been caught making a spontaneous movement or turn of the head. Her pose is reminiscent of *John*, c. 1920–21, as is the curtained backdrop suggested by the application of some blue conte. The use of white and pink conte around the collar adds a fanciful touch to her otherwise sombre dress. The degree of finish evident in the draped background and the details of the girl's face and clothing is not typical of Varley's drawings of that period.

Indeed, only two other drawings, both of mature males, are comparable in their finish. These are *Dr. A.D.A. Mason*, 1921 (MCAC), and *Vincent Massey*, c. 1922, for the Arts and Letters Club, which will be discussed later.

JOAN FAIRLEY

Varley painted a portrait of the Fairleys' teenage daughter, Joan (pl. 29), sometime before May 8, 1926, the opening date of the Group of Seven exhibition in which it was presented. Many aspects of Joan's portrait relate it to *Maud*, 1925: the composition and treatment of the figure and background; the palette of muted blues, mauves, and browns; and the treatment of light. We know that Varley was occupied from around Christmas 1925 into 1926 with the portrait of Ellen Dworkin, which is more stylized and closer to his first Vancouver portraits.[167] The ambiguity of the background of the portrait of Joan is intriguing. If indeed it was intended as a landscape, one might easily envision open water with barren islands or perhaps a clear blue sky with a few clouds. The Fairleys were very fond of this painting and enjoyed it for many years. However, circumstances forced it to be sold in 1960, just seven years before the death of Joan Fairley (1915–1967). Oddly, when Varley entered the portrait in the 1926 CNE exhibition, it bore a price tag of $300.

ELLEN DWORKIN

Another commission for a young girl's portrait is that of Ellen Dworkin, intended as a surprise for Ellen's mother, Dorothy Dworkin (née Goldstick; 1912–1991). In 1922, she was among the founders of the Mount Sinai Hospital and the first president of its Women's Auxiliary. Mrs. Dworkin had worked in the medical field since 1907, and was well known in the Jewish community of Toronto as the first nurse at the Jewish Dispensary.[168] Her husband, Henry Dworkin, was a philanthropist of prominent standing. Together with his brother, he

established a travel agency whose aim was to help reunite families separated by the war.[169]

Varley was recommended for the commission by his friend Ruby Easser. The fee for Ellen's portrait was raised by donations from members of the Women's Auxiliary, and Varley was asked to complete the work over Christmas 1925 into early 1926. In order to keep it a surprise, thirteen-year-old Ellen had to go surreptitiously to the sittings in the artist's studio, during the Christmas holidays.[170] On one of her visits, she had to wait such a long time for a streetcar that when she finally arrived her limbs were frozen and the artist had to seat her by the fireplace to warm her up.[171]

From the point of view of stylistic development, *Portrait of Ellen Dworkin*, 1925 (pl. 26), is significant in that it reveals Varley's initial attempt to stylize his subject. It is a harbinger of many of the traits that would characterize his Vancouver portraits of Vera Weatherbie. The pose remains frontal, with the same thick, columnar neck as in *Maud* and other portraits from the Toronto period. The eyes become slanted and there appears a novel, stylized, arabesque pattern in the hair. Back again is the encroaching, variegated background that Varley employed in his portrait of Margaret Fairley. For the colour scheme, he preferred a deep red and green, contrasted with light flesh tones and the white collar of Ellen's dress.

THE VARLEY CHILDREN

In art history, there are many celebrated examples of artists' portraits of members of their own families. Varley was no exception: his earliest effort dates to 1912, the drawing of his father he made in Sheffield. He drew and painted his wife, Maud, frequently over the years. When his children were old enough to endure a longer sitting, he painted their portraits as well. In the 1920s, this became a regular occurrence, presumably because family members were the most accessible and least expensive models.

Shortly after his return from the war, the artist expressed his deep affection for his first-born son in *John*, c. 1920–21 (pl. 10). This masterly portrait, painted when John was nine years old,

conforms to all the classical compositional rules, with the sitter positioned slightly off-centre and the mass of the figure in emphatic contrast with the background. John's body, perched on the edge of a chair, is nearly in profile, while his head is facing forward. His look is just as intense and inquisitive as in Varley's *Self-Portrait* of 1919.

John Varley (1912–1969) was a sensitive and talented individual. Like his father, he manifested an early interest in music, writing, and the arts. Varley believed that young John would follow in his footsteps and become an artist. In fact, students at the British Columbia College of Art remember John Varley as being an even better draughtsman than his father. Although colour blindness prevented him from pursuing an artistic career, he not only studied art, but also often joined his father and Jock Macdonald on their sketching trips in the British Columbia interior. He was also fascinated by science, in particular astronomy, a subject that has a long history in the Varley family, who trace their line back to astronomer and telescope maker Cornelius Varley (1791–1873).[172]

The colour scheme Varley used in *John* is reminiscent of the greens, muddy browns, and oranges of his war paintings. These colours were first repeated in the *Self-Portrait* of 1919, which also has touches of green painted in long vertical strokes, like the ones on John's shirt. The curtain-like backdrop, also a feature of the period, includes some pink, light orange, and blue, which serve to sharpen the outline of the boy's figure. Here, Varley also furthers the exploration of the dramatic effects of light that he began in 1919 with *Cyril Barraud*. In 1919–20, Varley often employed this dramatic silhouetting of the sitter, and he uses it to good effect here. Together with the multiple contrasts between cool background and dark body and the pinkish-reddish flesh tones, it adds to the vitality of the portrait. The resulting canvas has often been compared to Augustus John's portrait of his son, *Robin*, 1915 (private collection).[173]

When *John* was exhibited for the first time at the OSA annual of 1921, the critics immediately recognized its quality. One writer asserted that it "showed a rare ability to catch the real and not sentimental spirit of childhood."[174] As always, Varley was eager to learn how the painting would be received in England. When it was presented at the British Empire Exhibition in 1924, however, his technique was criticized for lacking subtlety and refinement, and the reviewer for the *Birmingham Gazette* concluded that, "while it looked charming at a distance, Varley's portrait did not look right at arm's length."[175]

In 1924, Varley made an ink drawing of John sitting on the floor of his father's studio in front of a mirror, presumably working on a self-portrait. That drawing, *In the Studio* (fig. 18), was later reworked in oil as *Young Artist at Work*, 1924 (pl. 21). The carefully planned composition of the drawing lets us peer into the interior of the artist's studio in the family home on Yonge Street. In the works hanging on the wall, we can see the gate of the house and part of the garden. In the crude sketch propped up on the easel to the left, we can discern the family tent at Bobcaygeon from the previous summer. These details were not included in the oil version. Another pencil sketch of John's head dates to the same period (fig. 21).

Varley also made several fine studies of his second son, James. In a 1915 sketch of him as a newborn (fig. 22), the firmness of the line and degree of finish let us determine that Varley worked on this drawing at his leisure. James Varley (1915–1988) grew into a quiet and studious young man, who could always be found with a book in hand. On one such occasion, Varley executed a profile study of James absorbed in his reading. In *Portrait of James*, c. 1926–27 (fig. 23), the overall contour of his bust is drawn lightly with a soft graphite pencil.

Documentation indicates that Varley made several paintings and drawings of his youngest child, Peter (1921–2000), and his daughter Dorothy (1910–1974), who was born in Sheffield.[177] Unfortunately, these works remain inaccessible and are known only through black-and-white photographs. In 1926, one of the two, presumably recent, oil portraits he painted of his daughter was entered into the Group of Seven exhibition as no. 115, *Dorothy*. In an interview conducted by her brother Peter during the making of the Varley Inventory, Dorothy Sewell recalls her father painting her when she was about fifteen years old. This picture is comparable in size and style to *Portrait of Ellen Dworkin*, 1925 (pl. 26). In it, the figure of Dorothy has a certain

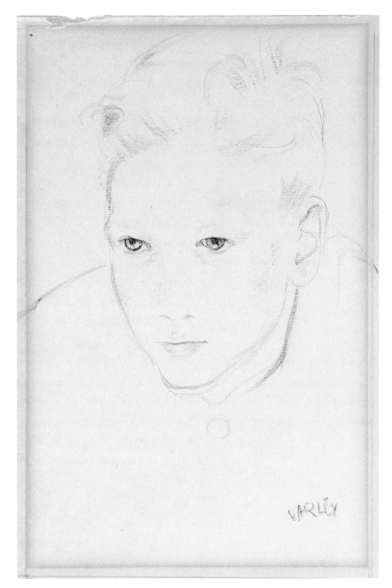

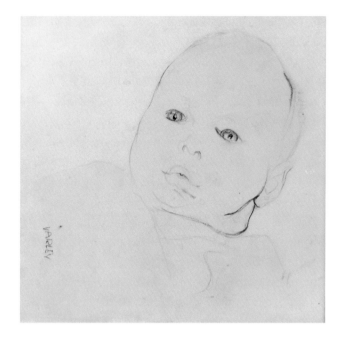

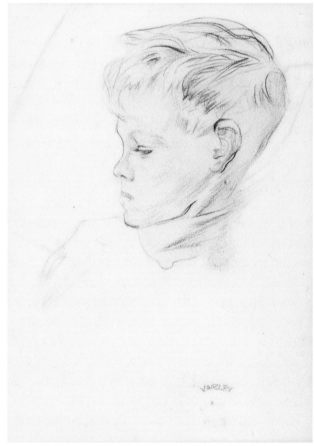

Above: Fig. 21
John, c. 1924
Private Collection (cat. 28)

Right (top): Fig. 22
Sketch of James, 1915
Varley Art Gallery of Markham
(cat. 3)

Right (bottom): Fig. 23
Portrait of James, c. 1926–27
Private Collection (cat. 39)

monumentality, which is augmented by her prominent neck and rather inflated body. The perfect frontal nature of her pose counters the direction of her gaze, which is away from the viewer. Her expression is somewhat sad and distant. The treatment of the background and the light across her face and neck relate to *Portrait of Maud* from 1925 (pl. 27). When viewed alongside the paintings of Viola Pratt and Ellen Dworkin, this image of Dorothy also signals Varley's gradual change towards more stylized facial features and patterns in the sitter's clothing.

MAUD VARLEY

Women were important figures in Fred Varley's emotional life. His mother Lucy doted on him, but it would appear that she was living in an unhappy marriage.[178] When, in 1910, Fred married Maud Pinder, art became his most sincere expression of his affection for her. Varley was seeking more than a passionate spiritual and physical relationship in his marriage: he needed a soulmate, someone who shared his passion for art and took a keen interest in his work. In his letters, he constantly encouraged his wife to take an active role in his process of creation, and shared his plans for future paintings. He valued her opinion enough to explain every mood and change in his work and to seek her reaction. But the hardship of building a life in a new country, the responsibility of raising their children, and the many financial burdens must have placed a strain on their marriage.

We have already been introduced to one of the earliest known oil studies of Maud, *Indian Summer* (pl. 1). Shortly after his return from the First World War, Varley drew a small, sensual, head-and-shoulder study of her in charcoal, *Maud*, c. 1919 (private collection), on the back of a war drawing.[179] His wife's head is turned, her gaze focused on something to her right; gentle shadows fall over her face. The rough-hewn outline of her hair gives a feeling of mass and weight, which is also evident in Varley's delineation of forms. In *Maud*, 1919, the artist did not idealize his subject; instead, he produced an accurate likeness of his wife and her hairstyle in those days, judging by some existent family photographs from around

1920. However, in a later depiction of Maud, dated August 30, 1922 (fig. 24), Varley set out to soften her features, especially the heavy jawline.[180] This drawing was published as a full-page reproduction in the September 1922 issue of the *Canadian Forum*, as *A Woman's Head*, and may have appeared with the same title in the 1923 OSA *Small Picture Exhibition* at the Art Gallery of Toronto.[181] Although Maud's pose resembles that of the drawing from 1919, her expression is now tinged with weariness and sorrow.

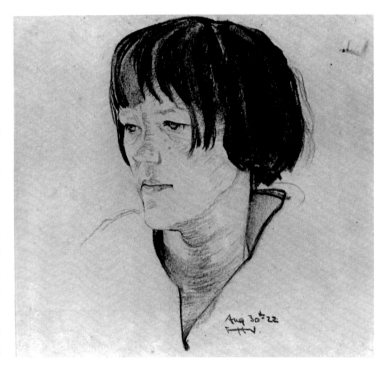

Fig. 24
Maud, August 30, 1922
Private Collection (cat. 20)

Another, very tender, image from the same period is a small, beautiful drawing, titled *Maud Asleep*, c. 1921–22 (private collection).[182] Drawn on brown paper in one subtly modulated line with assured draughtsmanship, this image offers a genuine glimpse into Maud Varley's daily life. Here, the artist has captured a very private moment; perhaps she is in the middle of an afternoon nap. His evocation of sleep is convincing, his touch deft and sincere. Despite the hardships the family was experi-

encing, Maud appears relaxed and content in her sleep, a time when people are most vulnerable.

A rather unusual portrayal of Maud from this era is *Rocky Shore*, 1922 (pl. 18), also known as *Maud on the Rocks* or *Lake Shore with Figure*. Painted in warm, summery colours, the artist's wife is shown seated on the rocks of an imaginary landscape. Here is what Augustus Bridle wrote about the work in the *Toronto Star*: "His *Rocky Shore* is uncommon enough, because it does not at first strike the beholder as being a shore at all, is only by outlines and colour a picture of rocks, and has for a main motif a trim, neatly dressed maid in pink who does not seem to belong to the picture, and was obviously put there to satisfy the painter's desire for a certain blend of colour."[183] Bridle is surely correct in his assumption that Varley painted the fresh pink dress to achieve the desired contrast; it is hardly the ideal outfit for an excursion in the wilds! Maud Varley was known as a nature lover who often went camping with her husband and friends. Family lore has it that the sale of *Rocky Shore* paid for some new clothes for Varley. He had fallen off a ladder while at work on the wall paintings at St. Anne's church in Toronto and damaged his trousers beyond repair. The palette of *Rocky Shore* is close to that of *Pink Wrapper*, 1921 (private collection), in which a standing Maud is seen in profile, looking down at the baby she is cradling in her arms (likely Peter Varley, who was born on May 29, 1921).[184]

The simply titled *Portrait of Maud*, 1925 (pl. 27), is the artist's only existing formal study of his wife. In her analysis of Varley's portrait painting from 1919 to 1926, Andrea Kirkpatrick states that Maud's pose, facial expression, and figure placement within the visual field are almost identical to his *Self-Portrait* of 1919 (pl. 7). She suggests that if it were not for the incompatible colour schemes, the two portraits could be seen as a pair.[185] This intensely lyrical portrait ranks with his best of that period. In it, Maud seems withdrawn; her facial expression is rather anxious and melancholy. The colour scheme of muted blues and pinks is in harmony with her mood. The background, hinting at a troubled sky before a storm, accentuates the atmosphere. The landscape setting has been compared to eighteenth-century British portraits by Gainsborough, Joshua Reynolds, and Romney. The

kinship with the British tradition may have been an intentional allusion to Maud's feelings for the land of her birth.

Maud's looming presence and overstated columnar neck are precursors to Varley's iconic and increasingly stylized portraits of Vera in the 1930s, Erica in the 1940s, or Jess Crosby in the 1950s. A proud woman, Maud kept her marital problems to herself, as befitted her Victorian upbringing. Peter Varley later wrote about his mother's difficult times: "We all loved our father deeply for his vitality, humour and belief in life as a gift to cherish and fulfil, but Mother had had many illusions shattered and seemed powerless to act against the fates."[186] Maud Varley's life was dedicated to raising her children. *Bobcaygeon*, 1923 (private collection), is a gentle study in charcoal and oil of Maud with her youngest son, Peter, asleep in her lap.[187] Painted the summer that the Varleys lived in a tent on E.J. Pratt's property at Bobcaygeon, Ontario, this drawing was sold in 1926, at an open house sale Maud organized to raise funds for the train fare to Vancouver for herself and the three children. The outlines of the family tent are visible in the upper-left corner of the composition. Varley painted a variation on the theme in *Evening in Camp*, 1923 (private collection).[188]

Barker and Margaret Fairley

There is no underestimating the value of Barker Fairley's friendship in Frederick Varley's life and career. Almost from their first meeting, Fairley was a most ardent admirer and advocate of Varley's talents, actively seeking portrait commissions for him and promoting him in academic and artistic circles. Sometime in the late winter or early spring of 1920, while he still had his studio at the Thomson shack, Varley painted *Portrait of Barker Fairley*, 1920 (pl. 8), a very revealing study of his dearest friend. The two men saw much of each other in those days, when the painter was still finishing his war paintings and hoping to get a mural commission. Fairley recalls: "He painted me in the shack. Painted me a whole winter through and then did a quick one in one sitting which is the one now in Ottawa of me, a very direct, strong head."[189]

Barker Fairley (1887–1986) was born in a little coal mining town in Yorkshire. After completing his elementary schooling, he won a scholarship to the University of Leeds to study modern languages, graduating with first-class honours in both French and German. He became an instructor at Jena University in Germany, where he earned his doctoral degree. Fairley came to Canada in 1910 to teach at the fledgling University of Alberta, then occupying humble premises at the Strathcona Collegiate Institute in Edmonton. Soon he met and married Margaret Keeling, a brilliant young literature student, who had been refused a degree at Oxford because she was a woman. Not only did the new university offer her a teaching post, but it also appointed her Dean of Women.

In 1915, Fairley accepted the post of Professor of German Literature at the University of Toronto. He remembers his first impressions: "When I first came to Toronto it was a dreary, unimaginative city, and yet my intellectual life really began here. It was in Toronto that I came to intellectual maturity."[190] His account of the cultural climate of the place where Varley would try to make a living as an artist was not glowing either: "There wasn't all this efflorescence of art galleries. There was very little world of art there, so that they were isolated. There was very little previous art history in the city. There were no collectors to speak of, just a few people that I knew bought a little."[191]

Among Fairley's earliest acquaintances in Toronto were the artists who would form the Group of Seven. He was introduced to Fred Varley at the Arts and Letters Club in 1918, shortly before the artist went overseas.[192] In the 1920s, Fairley watched his artist friends paint, he accompanied them on their trips, and he carried on endless discussions about making pictures with them. By this means, he became the first real champion — and critic — of the Group. In middle age, he too would take up painting, thanks to their encouragement.

As we have seen, Fairley's status in academic and artistic spheres enabled him to secure a number of portrait commissions for Varley. He became a faculty advisor to the student newspaper, *The Rebel*. It was his idea to take the paper beyond the confines of the university. He recalls his exact words at the time: "Let's go to the country with it!" The result was the birth of the *Canadian Forum* in 1920, a magazine that would have an impact on the critical fortunes of the Group of Seven, as well as on Fairley's own visual education. It was in the *Forum* that he published his first critical reviews. His writings on art and culture became a measured and intelligent counter-voice to the conservative press. According to Gary Michael Dault: "When Barker wrote about a painting he wrote a prose that attempted to match the sensuousness of the picture in front of him."[193] Although Fairley admired the work of all the members of the Group, he recognized Fred Varley as the one who made great formal achievements without the slightest abatement of reality and who kept strong emotion under perfect control.

There is no record to confirm a direct commission for the portraits of Barker Fairley's wife, Margaret, or of their daughter, Joan, but we do know that they were painted during a period when Barker was on a mission to help his friend financially. In an interview with Lawrence Sabbath, Varley mentioned that Fairley had paid him some minimal amount for his own portrait.[194] Margaret and Barker Fairley's sympathy and friendship extended to all of the Varley family. Their common Yorkshire heritage and a shared love of English literature strengthened the bonds between them.

Dynamic and resourceful, Margaret Fairley was engaged in her own journalistic endeavours. From 1925, she was on the publishing committee of the *Canadian Forum* and contributed articles, mainly on political themes. In her writings, she advocated societal change, expressing the view that every individual has the right to freedom of choice and freedom of action.[195] She supported left-wing social reform and later became a member of the Communist party. She found further intellectual stimulation in gatherings of the faculty wives, among them Viola Pratt, wife of Professor E.J. Pratt, also a subject of a Varley portrait. Margaret's energy is tangible in the image Varley made of her in the spring of 1921, even though he chose to portray her in an introspective mood. There is a readiness for action in her pose, seated almost on the edge of what appears to be a hard-backed chair. Indeed, when Margaret's husband was working on a portrait of her in 1937, he spoke of her restlessness when asked to maintain a pose for long periods. She would soon grow impatient and leave him

to work without a model. Barker saw this as a sign of her strength of character: "[I] appreciated her independence as indicating a better attitude to a husband than that of the adoring wife which I now and then saw other men suffering from."[196]

His portrait *Margaret Fairley*, 1921 (pl. 13), manifests a thoughtful, strained intensity. Varley carefully devised and applied a subtly illuminated colour scheme in this work. The background is divided diagonally into two areas, one a cool blue and green, and the other a warm orange and red. The tonal range is deliberately limited. In this portrait, Varley could be using colour for symbolic purposes, or perhaps it was the shade of Margaret's dress that inspired him to play with the visual effects of the background. The subject's figure is almost frontal, with her head slightly turned to the left. There is a remarkable psychological depth to this portrayal of Margaret Fairley. Did Varley set out to show through the tonal division the duality of her roles as both a proper English housewife and an intellectual? If so, the blue could signify the mannerly, dignified and subdued side, while the fiery orange and red tones evoke her free-thinking and independent spirit. Certainly, in this captivating portrait, Varley has seized some of the essence of Margaret's vibrant and engaging personality.

HUNTLEY K. GORDON

Huntley Gordon was a friend of the Fairleys and the brother of Robert K. Gordon, a professor of English at the University of Alberta. He was a student at University College when he met Barker Fairley, and through him became involved in the *The Rebel* and the *Canadian Forum*, to which he contributed numerous articles, editorial reviews, and poems. He was interested in the arts and liked to paint. Despite a crippling illness that he fought for most of his life, he was known to be quite an outdoorsman and a man of action. Fairley (who also made a portrait of his friend) claimed that Huntley taught him how to paddle a canoe with the Ojibway stroke, propelling and steering all in one movement.[197]

In the small and intimate *Portrait of Huntley K. Gordon*, 1921 (pl. 14), Varley creates an imposing presence by depicting the subject at close range. Gordon looks at the viewer with an air of emotional detachment. Painted in a combination of warm browns and reds, the image is well integrated with the slate blue of the background. In size and manner it is close to Varley's informal view of Cyril Barraud from 1919. Here, however, the dark backdrop and dramatic light effects have given way to a subtle integration. We note the artist's novel use of more vigorous brushstrokes in this portrait, which was a characteristic of his landscapes at the time.

THE ARTS AND LETTERS CLUB CONNECTION

Founded in 1908 as a social club for the arts community, the Arts and Letters Club flourished during Varley's Toronto years. It offered a creative milieu for interaction between artists, writers, musicians, and their patrons. Vincent Massey decided to become a member in 1911, after discovering how refreshing and intellectually stimulating its atmosphere was in comparison to other Toronto clubs.[198] From 1920 to 1922, he served as ALC president, and when his term ended, the club commissioned Varley to draw his portrait. While he was working on the Hart House project, Massey held meetings at the club with architects and fellow ALC members Henry Sproatt and Ernest Rolph. The Hart House Quartet and the Hart House Theatre also owe their genesis to ALC members.

Executed after Varley's 1920 oil portrait, the drawing of Vincent Massey, 1922 (fig. 25), does not vary much from the painting. It seems likely that instead of drawing from life, Varley used his previous work as a model, adding the left hand pressed against the cheek to suggest a pensive moment. In Andrea Kirkpatrick's view, there is also a technical proximity, "the refined handling of the medium, the volumetric treatment of forms, and the emphatic chiaroscuro" point to a closer link with Varley's portrait painting technique than with his drawing preferences.[199]

In late 1922 or early 1923, Varley made a similar portrait drawing of Dr. Arnold Denbow Mason (1878–1962), who had joined the ALC in February 1921.[200] In the fall of 1922, Dr. Mason was named Professor of Clinical Dentistry at the Royal College of

took to ship art supplies from England in those days. *Dr. A.D.A. Mason*, 1922–23 (fig. 26), is executed in a technique similar to the portrait drawing of Vincent Massey, using lines to accentuate the contours of light and dark. These lines emphasize the flat surface of the composition, without creating an illusion of depth. The opposite is true for the modelling of the face. There is an uneasy relationship between the more linear outlines of the

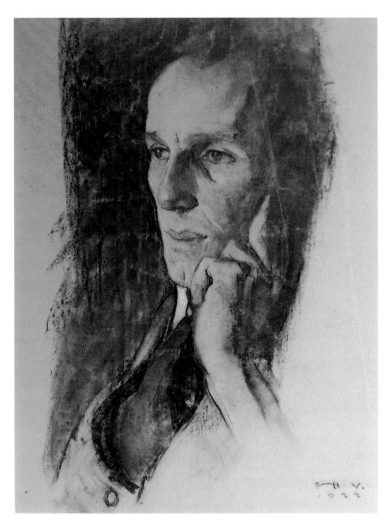

Fig. 25
Vincent Massey, 1922
Arts and Letters Club, Toronto

Dental Surgeons of Ontario. That appointment may have occasioned the commission.[201] Known as an art collector, he enjoyed both historical and modern works and held Varley's paintings in high esteem. It is no surprise that the two formed a friendship. When Dr. Mason was named Dean of the Faculty of Dentistry at the University of Toronto in 1945, it was again Varley he selected to paint his portrait in oil.[202]

The English watermark on the paper, dated 1922, offers the *terminus ante quem* for the drawing, bearing in mind the time it

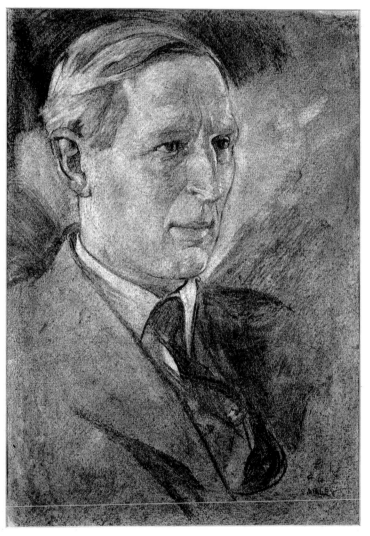

Fig. 26
Dr. A.D.A. Mason, 1922–23
McMichael Canadian Art
Collection, Kleinburg

clothing and the rather sculpted, three-dimensional presentation of the head.

Professor of Education and fellow Englishman Peter Sandiford (1882–1941) joined the ALC in 1915.[203] His meeting with Varley led indirectly to the Primrose Sandiford commission, discussed above. Through club members Barker Fairley, Gilbert Jackson, and Huntley Gordon, Sandiford became involved with the *Canadian Forum* from its inception. He was the journal's managing editor from 1920 until 1934 and also contributed articles, primarily on the Canadian education system and educational psychology.[204] Peter and Betti Sandiford joined the Madawaska Club at the University of Toronto in 1917, and leased a summer property near Split Rock, close to Dr. MacCallum's cottage at Go-Home Bay. It was there, in about 1922, that Varley painted an oil sketch of Peter Sandiford (pl. 17) reclining on the shore at Split Rock.[205] This small and colourful work has been often compared to Augustus John's *The Blue Pool*, 1911 (Aberdeen Art Gallery), in respect to composition, pose, and setting.

It would appear that the artist undertook *Portrait of Viola Pratt*, c. 1924–25 (pl. 25) on his own initiative, rather than as a commission, even though E.J. Pratt, the subject's husband, had been an ALC member since 1923.[206] The Pratts' daughter, Claire, believes it must have been painted around July 1924, when Viola Pratt was taking a summer course from Varley at the OCA.[207] Varley's portrait, a sympathetic interpretation of her warm and lively personality, stayed in the artist's possession and was never given to her. Later, the work was purchased by Harold Mortimer-Lamb; it remained in his collection until it was acquired by the Art Gallery of Greater Victoria in 1957.[208]

Viola Pratt (née Whitney, 1892–1984) was the wife of distinguished poet and English professor E.J. Pratt (1882–1964).[209] A graduate of the Arts program at Victoria College, Viola was a writer for the university publication *Acta* and took part in many social and intellectual activities. She belonged to a circle of professors' wives who met regularly.[210] It was in this context that she would have had occasion to meet Margaret Fairley, and perhaps even view Varley's portrait of her.[211] The house the Varleys bought on Colin Avenue in 1922 was near to the Pratts'

and the two families developed a close friendship. By 1923, when Fred and Maud lost their home, E.J. Pratt organized a commission for the artist to design the end papers for his upcoming book of poems, *Newfoundland Verse*.[212]

Stylistically, *Portrait of Viola Pratt* may be compared with Varley's *Portrait of Maud*, 1925, or even *Dorothy*, 1926; however, it is distinguished by its more fluid treatment of the surface. It appears to have been painted in haste and has an unfinished look, although it is signed by Varley.[213] Peter Varley suggests a later date, 1928, for the work, which would place the portrait in the artist's Vancouver period. It is known that Viola Pratt visited Vancouver in 1927, and that Varley was in Toronto in the summer of 1928, ostensibly providing two opportunities for him to paint her. However, the 1924–25 date accords with family recollections.[214]

KATHLEEN CALHOUN

When Varley travelled to western Canada in early 1924, he visited Edmonton, Calgary, and Winnipeg, and made a detour to Banff to see the Rockies for the first time. Everywhere he went, he was received as a celebrity. His reputation as a war artist had reached that part of Canada thanks to a Group of Seven travelling exhibition organized by the National Gallery in 1921. While in the West, he gave lectures and talks, made many new acquaintances, and was busily at work on several portrait commissions.[215] He stayed with the family of Dr. John MacEachran in Edmonton, and in that city he met Kathleen Calhoun, a beautiful and intelligent young woman from Ottawa who was finishing her studies at the University of Alberta.

Kathleen was all Varley had longed for: gentle and sensitive, responsive to his artistic ideas, sharing his likes and dislikes, fond of music and literature. We have no record of their first meeting, but the first extant letter from Varley to Kathleen was written during his return trip to Winnipeg to finish his portrait of Dr. McIntyre. By then he had a drawing of Kathleen with him and showed it to several people in Banff and Winnipeg who were considering portrait commissions.[216] Varley wrote Kathleen that

Dr. McIntyre was so taken with his drawing of her that he asked him over and over who the model was; not receiving an answer, McIntyre came to the conclusion that a drawing created with so much love must surely be of his wife.[217]

Varley was apparently unhappy with one charcoal drawing he had made of Kathleen and threw it in the garbage, from where it was rescued by Mrs. MacEachran. Today it is in the collection of the University of Alberta. In *Head of Kathleen Calhoun*, 1924 (fig. 27), Kathleen's pose is rather unflattering, but very evocative of Varley's early portraits celebrating feminine beauty. Her head is tilted back in a languid way, and the tinge of eroticism conveyed by her half-closed eyes recalls his gypsy paintings. This feature reemerges in the 1940s in his portraits of Manya and Erica. The drawing of Kathleen may have been a preparatory sketch, as it lacks the assured technique and crispness typical of his drawings from the 1920s.

Another drawing, *Kathleen Calhoun*, 1924 (pl. 19), which remained with the sitter until her death, is remarkably lively and fresh. Here, the artist has applied an even wash to the surface, which helped reduce the tonal contrast and made the image softer and mellower. He then employed charcoal to enhance the contours and coloured chalk to create a more dramatic framing and depth to the figure. A few deft strokes on the right accentuate her face, then turn into a playful decorative motif. This technique appears again in his portrait of Vera Weatherbie, *Head of a Girl*, 1936 (fig. 42).

There are two known drawings of Kathleen Calhoun recorded in the Varley Inventory of 1969. Since we know that one drawing of her stayed in Winnipeg and another remained with the sitter and was never publicly shown, we can safely assume that there must be at least one more portrait of her that Varley brought home with him. This conclusion is supported by a letter Varley wrote to Kathleen from Toronto on May 1, 1924. He describes a visit to the Fairleys soon after his return, who were eager to hear details of his trip out west. When he showed them photographs of the portrait of Dr. McIntyre and an original drawing of Kathleen Calhoun, Barker Fairley not only recognized the young woman, but remembered her well. The letter continues in Varley's typical

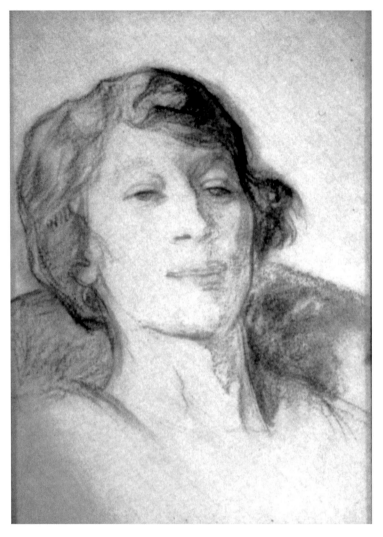

Fig. 27
Head of Kathleen Calhoun, 1924
University of Alberta Art Collection
University of Alberta Museums (cat. 24)

light narrative mode: "I let him see the drawing. He is a strange man — either stupidly dead or on fire. He mumbled away to himself when he first saw it & then 'My God, Fred, I could love' and he pulled himself up sharply & talked directly to me. 'But Fred, you must love her to make that drawing. I can't look at it for long.'"[218] It would seem that Fred Varley's feelings for Kathleen were transparent to all who saw the drawing.

GOOD FRIENDS AND FAREWELLS

In the mid 1920s, the Varleys saw a lot of family friends Nan and Trevor Garstang. Trevor was born in Lancashire, England, and he had a flourishing career in the theatre as a set designer, actor, and director prior to his immigration to Canada around 1920. He created sets in Paris for the Opéra and the Folies Bergère, in Milan for La Scala, in Vienna, and for various travelling ballet productions.[219] In Toronto, found work at Hart House Theatre, which was probably where he and Fred Varley met, rather than at the ALC, which Garstang only joined in May 1928. The two men bonded instantly. Varley drew a very spontaneous sketch of his friend, *Trevor Garstang*, 1923–25 (fig. 28), presumably from a distance, as Trevor seems unaware of being observed. According to Andrea Kirkpatrick, the odd diagonal cropping of the image on the left adds to the impression of a casual and unplanned act of drawing.[220] The rapt, absorbed expression on Trevor's face and the slouched right shoulder suggest that he was probably enjoying one of his pastimes, listening to the radio. His head was perhaps partly obscured to Varley, who left it undefined.

The image of Nan Garstang (fig. 29) — simple, yet bold and expressive — forms a striking contrast to that of her husband. The linear outline of her features and the light shading are similar to Varley's 1926 portrait of author Mazo de la Roche (1885–1961).[221] Nan's drawing was likely done the same year, because a photograph taken in the Garstang's living room shortly after the birth of their son, Peter, in 1926, shows the drawing prominently displayed above the mantel (fig. 30). However, in lieu of a fee for medical services, the Garstangs invited Dr. Minerva Reid, the physician who delivered their baby, to pick any artwork from their collection.[222] They hoped she would take one of Trevor's own paintings, but instead, she picked Varley's portrait of Nan. Thus, the much admired picture left the family.

The portrait artist in Varley was always at work, sketching friends and family at picnics, or drawing faces during formal or informal gatherings. He made a sketch of Trevor's brother

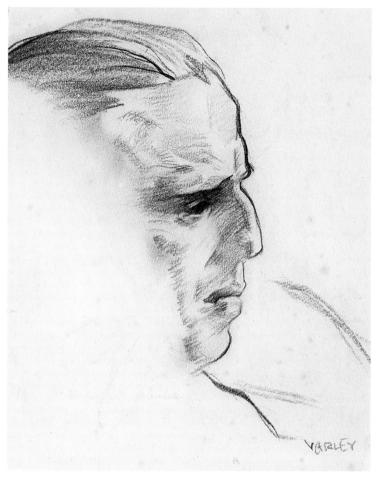

Fig. 28
Trevor Garstang, 1923–25
Private Collection (cat. 23)

and his friends, *Eddie Garstang* (fig. 31), during one of their regular summer outings to Toronto Island. When Varley went west in the autumn of 1926, to teach at the Vancouver School of Decorative and Applied Arts, it was Trevor Garstang who helped Maud to organize the sale in their Yonge Street house and pack the family belongings. Their friend Herbert Stansfield was left to look after the closing of the house and the payment of their rent.

One of Varley's last commissions in Toronto comprised four portrait drawings for the "My Religion" series in the *Star Weekly*. The records of the defunct newspaper no longer exist, but it is

Fig. 30
Nan, Trevor, and Peter Garstang photographed in their home, 1926
Private Collection

Fig. 29
Nan Garstang, 1925–26
Private Collection

Right (bottom): Fig. 31
Eddie Garstang, 1926
Private Collection (cat. 38)

reasonable to suspect that its financial editor, Fred Housser, directed the assignment to Varley. Beginning in November 1925, each week the series profiled a distinguished individual and his religious views. There were thirty-three articles in total, divided into three parts. Varley's pictures were required for the third part, featuring Canadians. His subjects were to be Edmund Scheuer, an educator and prominent member of the Jewish community; George A. Warburton, general secretary of the YMCA; and Ralph Connable, manager of the Canadian Branch of F.W. Woolworth Company, also known as the city's greatest philanthropist.[223] Since all three men lived in Toronto, Varley may well have drawn them from life instead of from photographs. The fourth image was to be an anonymous view of a Canadian soldier, as a survivor of the First World War; Varley produced a composite image of two soldiers. His drawing of Mazo de la Roche was also published in the same edition.[224]

CHAPTER 5

YEARS OF TEACHING AND TRAVELLING, 1926–1950

I'm teeming with things to paint, for I'm in magnificent surroundings.
— Fred Varley

The Vancouver appointment came at a strategic time for Varley, both personally and professionally. Along with steady employment, the West offered a new field of possibilities and a new audience. He felt that his work was not receiving enough recognition in Ontario, despite his regular contributions to the annual Group of Seven shows, the Canadian National Exhibition, the Ontario Society of Artists, and the National Gallery in Ottawa. He had every reason to be concerned: commission work was unreliable and art sales were low. In 1924, statistics show that of the total number of art sales in the country, works by Canadian artists amounted to only 2 percent. Those artists who managed to make a living exclusively from their art belonged to the older generation. With the exception of Lawren Harris, who was well off, the other members of the Group of Seven had to look for commercial or teaching jobs to support their families.[225]

In 1926, when Varley left Toronto, his skill in portraiture was at a high point. His portraits were winning prizes in serious competitions, pitted against the works of such names as Curtis Williamson and E. Wyly Grier, and were commanding competitive prices. Despite mixed reviews at various international shows, his paintings were much admired by the Toronto critics, with Augustus Bridle and Hector Charlesworth at the forefront. Fred Housser, in his essential study of the Group of Seven published in 1925, referred to Varley as "a painter with extraordinary talent and with great potential capacity for originality and feeling."[226]

Admittedly, there were also those who criticized Varley for not painting enough. A.Y. Jackson claimed that he and J.E.H. MacDonald were the "non-producers" of the Group of Seven.[227] Varley's instantly famous *Stormy Weather, Georgian Bay*, 1920 (National Gallery of Canada), was entered over and over again in major art shows touring in Canada and abroad. The truth is, in the Toronto years, he did not create many landscapes and his new work consisted primarily of portraits. This is not what Varley's friends and the Group's art patrons expected of him. The general public, too, clamoured for landscape paintings.[228]

Fellow Group member and longtime friend Arthur Lismer, when asked to contribute to the Varley retrospective at the Art Gallery of Toronto in 1954, wrote the following about Varley's post-war period:

His landscapes at this time were few. There is a large expansive one of Georgian Bay weather in the National Gallery. It is a very fine one, of about 1920; but he had no real love for the Canadian scene, at this point at any rate. Later, in British Columbia — but that belongs to another chapter. The wild and the untamed to which the Group had hitched their wagon as yet held no real attraction to him. He was too much of an individualist to be bound to do anything except to follow his own desires, to paint well those things that fired him to expression. He never succumbed to the clichés of others: he invented his own language of form.[229]

At the same time, there was competition from other artists — such as Edwin Holgate, Randolph S. Hewton, Prudence Heward, and Sarah Robertson — who were experimenting not only in classical portraiture but also in incorporating the human figure into the landscape. Especially for Holgate and Heward, affinities to the Group of Seven's style could be seen in their treatment of the landscape as a background to their portraits. In fact, Holgate was invited to contribute to the Group's 1924 show in Toronto, and his work was included in the Canadian submission to the 1924 British Empire Exhibition at Wembley, England — to which Varley objected! Before heading west, Varley added some old works to his CNE entry, including his decorative panel *The Immigrants*, c. 1920.

The move to British Columbia also represented an attempt to find a new freedom of expression. As Varley wrote to Eric Brown, "I have not experimented for years & I want badly to try out many adventures in paint that have been caged-in too long."[230] From Barker Fairley's perspective, however, the timing of the move was wrong. He thought that Varley was making a mistake in leaving Toronto just when the city was becoming more receptive to modern ideas in art; he would miss out on all that new stimulation.[231]

VANCOUVER, 1926–1936

In September 1926, Fred Varley and his fourteen-year-old son John took the train to British Columbia. As an instructor at the Vancouver School of Decorative and Applied Arts (VSDAA), he immediately began to make a deep impression on colleagues and students alike, and continued to do so for the ten years he spent in the province. Critics began to hail him as the most influential artist on the local cultural scene, which was bursting with new energy during the 1920s and early 1930s. While the local arts community was small compared to Toronto's, there was a sense of complete involvement, since artists and collectors frequently met at social functions.

The presentation of classical music concerts had recently begun at the Hotel Vancouver. Artists' societies flourished, among them the B.C. Art League (formed in 1920), the Vancouver Sketch Club, and the B.C. Society of Fine Art. The Pacific National Exhibition had included an art display since 1916, and the Vancouver Art Gallery opened in 1931. At the same time, private galleries proliferated. At the newly founded University of British Columbia, lectures and presentations were given on a variety of topics, including the visual arts. Moreover, many artists kept in close contact by taking sketching trips together or sharing studios.

The Sunflower Girl, 1920–21 (pl. 12) was the first of Varley's portraits to receive a review in the local press. It was written by Harold Mortimer-Lamb, a photographer who also wrote for a Victoria-based mining journal. Known as a liberal-minded, semi-professional art critic, Mortimer-Lamb was quick to see the artist's "spontaneity and vitality."[232] Actually, the enchanting image of young Mary Kenny had preceded its painter to Vancouver, for it was part of a Group of Seven travelling show held at the East Hastings Park exhibition grounds in 1922.

In Vancouver, Varley continued to make advances in his portrait work, but it was in the outdoors that he found the "adventures in paint" he had been craving. Jock Macdonald described Fred Varley as "mainly an outdoor artist during his ten years' residence on the Pacific coast. Almost every week-end he painted in the mountains and in the summers in Garibaldi Park, that unbe-

lievably beautiful country still unknown to tourists, where six-thousand-foot meadows are carpeted with wild flowers, the lakes are pure emerald, the glaciers are fractured with rose-madder, turquoise-blue and indigo crevasses, and the mountains are black, ochre and Egyptian red."[233] Macdonald continued, "When it was unseasonable to paint outdoors he worked on portraits in his mountain studio or made drawings of the 'characters' to be found in Vancouver's Chinatown or in the taverns."[234]

During the B.C. years, the subjects of Varley's portraits were drawn primarily from the immediate circle of colleagues and friends, as well as students and models from his drawing classes. Moreover, he was too busy with his teaching to look for commissions. In 1930, he painted a portrait of his colleague, *J.W.G. Jock Macdonald* (pl. 32). A graduate of the Edinburgh College of Art, with training in commercial design, Jock Macdonald (1897–1960) also joined the staff of the Vancouver School of Art and Design in 1926. He was sixteen years younger than Varley, but the two became fast friends and went on sketching trips together to Garibaldi National Park and Savary Island. On their

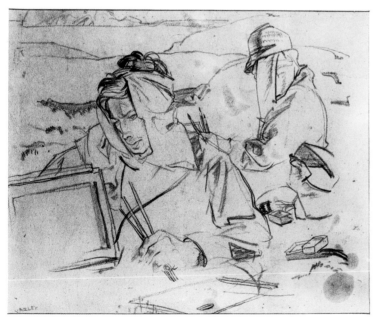

Fig. 32
Sketchers, c. 1927
McMichael Canadian Art Collection, Kleinburg (cat. 41)

first such trip, Varley drew Jock side by side with his son John in *Sketchers*, c. 1927 (fig. 32).[235] It was on these outings that Jock realized how inadequate his earlier pen-and-ink sketches and prints were to express his response to nature, so with his friend's encouragement, he switched to oils and began to experiment with colour.[236] Fred's instructions to Jock were explicit: "Stop drawing and start painting."[237]

AN INSPIRING INSTRUCTOR

Especially in his favourite subject, life drawing, Fred Varley put his whole being into teaching, generously devoting time and energy to his classes. The following tribute to his teaching was delivered in 1955 by one of his former students, Fred Amess, then principal of the same school: "We first imagined Varley to be a self-primed fount of knowledge, but we soon discovered that he was rather a spout through which flowed all the new excitements of the world, spiced rather than tamed by sound academic training. It was a violent stream that was hosed upon us, but those with roots were nourished, even if some were washed away; and it was a directed, steady stream."[238] Or, as another of his students, Jack Shadbolt, recalled, "Varley gave Vancouver the first genuine tingling sort of big excitement of art and we were all so proud that he was here and working among us."[239]

In his view, good observation skills were the key to successful drawing, and he would urge his students to concentrate on "getting the essence" of the subject rather than making a good painting.[240] In life-drawing classes, Varley often worked alongside his students and produced some superb drawings of faces and nudes such as *Nude with Apple* (private collection). Jack Shadbolt described him as someone who had a romantic concept of his work but held a severe notion of the technique required for its creation.[241] Former student Orville Fisher summed up the essence of Varley's approach to teaching: "There were the so-called rules, but if you can break them then you are becoming an artist."[242]

Varley personally picked the models for his classes, with each one intended to represent an essential thematic or art historical

point. For his classes on the Italian Renaissance, he found a "sinuous Italian girl" to serve as an example of Botticelli's art.[243] Students were encouraged to explore the ethnic diversity of Vancouver and sketch in the Japanese and Chinese areas of town. When class discussions focused on Oriental art traditions, he employed a Chinese girl to model, followed by a young Japanese-Canadian male model, Eugene, a favourite of all his students. Through his acquaintance with the director of the Victoria Memorial Museum, Marius Barbeau, Varley also introduced aboriginal art to his class and invited Emily Carr as a guest lecturer.[244]

Among Varley's preferred textbooks were Elie Faure's *History of Art: Modern Art*, Vernon Blake's *Art and Craft of Drawing*, Wilhelm Oswald's *Colour Primer*, and Albert Munsell's *A Colour Notation*. Fred Amess adds: "We were deluged by prints, trips to Chinatown … Chinese food … Chinese horses, Persian manuscripts, Matisse and Japanese prints. Puvis de Chavannes was dragged in to defend the Occidental title to the decorative arts with Whistler — Aubrey Beardsley … following up behind."[245]

Arthur Lismer, Canada's foremost art educator in his day, had this to say about Fred Varley, the instructor: "Teaching to him was only a means of conveying to others an enthusiasm for the exploration and interpretation of forms.… A man who takes a lot of trouble to teach and enjoys the experience sparks a lot of young people to draw and paint with a purpose. Varley's teaching was a notable contribution to art education in more than one city in Canada."[246]

Fig. 33
Catharina Vanderpant, c. 1930
Vanderpant Collection (cat. 48)

John Vanderpant

Of the new friends Varley made in Vancouver, John and Catharina Vanderpant were especially close. Peter Varley remembers the regular visits between the two families as a highlight of his boyhood: "These evenings enriched our lives profoundly, especially my father's, for he had a great hunger for music and missed having a piano at home. The Vanderpants' return visits on Saturday nights were the opposite of Thursday's sedate musicales. Dad and Vanderpant became exuberant and high spirited

in games of all kinds, testing each other's mettle."[247] The "sedate musicales" referred to were the soirées held on Thursdays at the Vanderpants' house, at which John played his newest records. On one such occasion, Varley painted *Portrait of John Vanderpant*, c. 1930 (pl. 36). He also made a drawing of John's wife, *Catharina Vanderpant*, c. 1930 (fig. 33).

John Vanderpant (1884–1939) was the most important photographer working in Vancouver in the early part of the twentieth century, according to Charles C. Hill.[248] Vanderpant came to

Fig. 34
John Vanderpant
Eve Every Time, 1918
Vanderpant Collection

Fig. 35
John Vanderpant's Photo Studio and Gallery on Robson Street, Vancouver, 1930s. Visible on the left is Varley's decorative panel *The Immigrants*, often used as a backdrop to Vanderpant's photographic portraits
Vanderpant Collection

Canada from the Netherlands in 1911, bringing with him a European belief in high culture.[249] He and Varley were similar in age and in outlook — at once old-world gentlemen and innovators. One writer observes that Vanderpant's life was marked by contrasts.[250] He worked as a portrait photographer to make a living, but found his creative release in art photography. The hallmarks of his style are precise composition and controlled modulation of light.[251] Among his best portraits was a photograph of his younger daughter, entitled *Eve Every Time*, 1918 (fig. 34), which was exhibited at the 1924 London Salon.

In the spring of 1926, John Vanderpant entered a joint venture with another successful photographer, Harold Mortimer-Lamb. They started Vanderpant Galleries, a studio and art gallery on Robson Street (fig. 35). Decorated with antiques, the salon-style gallery with a music room became the meeting place for Vancouver's intellectual set. Varley, Jock Macdonald, Harry Täuber, and Philip Surrey attended the poetry readings, exhibition openings, and lectures on advanced art and mysticism held there, as did any number of art students from the VSDAA. After a year, the partnership dissolved and John acquired sole ownership of the enterprise.

HAROLD MORTIMER-LAMB

Varley found he also had much in common with Harold Mortimer-Lamb (1872–1970), who was then in the vanguard of those who recognized and applauded the Group of Seven, and was credited as the first critic to draw attention to the work of Emily Carr.[252] Born

in Leatherhead, England, he came to Canada at the age of seventeen. In Montreal from 1905 to 1920, his early success as a writer and his growing reputation as an art collector and champion of contemporary artists won him work as art critic for the *Montreal Star* and Canadian correspondent for *The Studio*, the leading British art journal of the day.[253] Mortimer-Lamb made a name in art photography, and was a frequent contributor to international salons, including the Royal Photographic Salon in London, which led to a friendship with Alfred Stieglitz, whose New York studio was the centre of American avant-garde photography. Stieglitz reproduced some of Mortimer-Lamb's prints in his publications.[254]

Portrait of H. Mortimer-Lamb, c. 1930 (pl. 35), shows Varley at the top of his form as a portrait painter and offers a privileged glimpse into his sitter's inner world. The figure is positioned slightly off-centre, which gives the image the casual appearance of a snapshot. The artist's characteristic use of colour and skilful play with light and shadow draw our attention to the head. His application of paint is more delicate on the face and head than on the torso and richly textured background. According to his belief in the coloured aura that reflects an individual's psychological state, Varley applied some blue and purple colours as well as red, orange and light green — which suited Mortimer-Lamb's poetical nature.

Indeed, Mortimer-Lamb was a passionate and unconventional man. His striking personality was combined with deep sensibilities and refined interests in painting and photographic portraiture. Like Varley, he appreciated Asian art, and he had some excellent Chinese and Japanese pieces in his collection — jade carvings, paintings, and Ukiyo-e prints. The establishment of the Vancouver Art Gallery owes much to Mortimer-Lamb's vision and courage. When he was almost sixty-five years of age, he took up painting and held several successful exhibitions of his works in oil.[255]

Varley's move to British Columbia coincided with an increasing inquiry into colour theories, whether scientific or esoteric. His personal study of Oriental art, Buddhist philosophy and Hindu mysticism helped broaden his own intuitive theory of colour. A remarkable sensitivity to colour within an extremely close harmonic range manifested itself in both his landscape paintings and portraits. According to Maria Tippett, Varley greatly admired the work of the Vancouver-based painter Statira Frame. Born in Montreal, Frame received her training in San Francisco and worked in high-keyed colours, demonstrating an excellent colour sense. Varley apparently praised her oil canvases and her use of pink, violet, and milky green — shades he was fond of himself.[256]

VERA WEATHERBIE

Fred Amess recalls Varley's fascination with a plaster cast of an Oriental head that was used in one of his drawing classes. It bore a resemblance to the facial features of a certain female member of the class, in particular the oblique eyes, which had something of the mystic quality of the East about them.[257] That student was Vera Weatherbie, a young woman of unusual charm, with large almond-shaped eyes and delicate eyebrows and mouth. The artist's infatuation with her beauty is easily discernable in his minimalist drawing, *Vera*, 1926–29 (fig. 36). In the years to come, graceful and shy Vera would be Fred Varley's companion and confidante. Between 1930 and 1936, he would paint a series of portraits of her with an intensity unrivalled in Canadian art. Some examine her lovely features through the freshness and spontaneity of the watercolour medium, such as *Vera*, c. 1936 (pl. 42). Others are more frank than flattering images of their uneasy affair, for example, *Vera*, c. 1930 (pl. 34). Vera was his perfect model, the ideal he had long been seeking and a subject that constantly inspired and challenged him.

Vera Olivia Weatherbie (1909–1977) was a second-year student in the fall of 1926 when she took a drawing class with Varley and sometimes went along with other students to his Jericho Beach gatherings. In 1928, in her final year, she was given the lead in the school's Christmas play, *The Pageant of the Holy Grail*. John Vanderpant was in the audience, and he was so struck by Vera's performance as the Virgin Mary and her attractive appearance in her stage costume that he took some photographs of her (fig. 37). Instantly, Vera's image became a trademark for his photo studio and was used on his business card. That was when Varley decided to paint her. The location of that first image of Vera wearing a veil

is unknown, but the artist reprised the theme often over the years. *Head of a Girl*, c. 1933 (pl. 39), is one such depiction of Vera in the guise of the Madonna, her face radiant with holiness. Her facial features are portrayed with a tenderness that evokes comparisons with some eminent historical examples, especially Botticelli's *Birth of Venus*, 1482 (Uffizi) or Rubens' *Adoration of the Magi*, 1624–26 (Koninklijk Museum, Antwerp). In *Green and Gold, Portrait of Vera*, c. 1933–34 (pl. 40), another variation on the Madonna

theme, Varley employs some of his favourite stylistic devices: framing the image in an enclosed space and playing with the background, in an attempt to achieve compositional harmony.

By the summer of 1929, possibly after her graduation, the relationship between Vera and Varley intensified. By then, he and Jock Macdonald had moved to their new studios on Bute Street. The grand old building in downtown Vancouver, known as the Parakantas, belonged to the grandfather of a student at the art

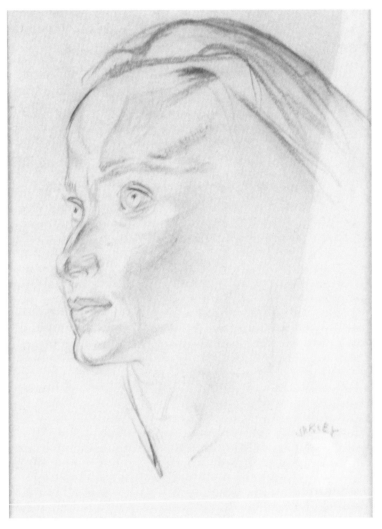

Fig. 36
Vera, 1926–29
Collection of Ed and Donna Andrew (cat. 40)

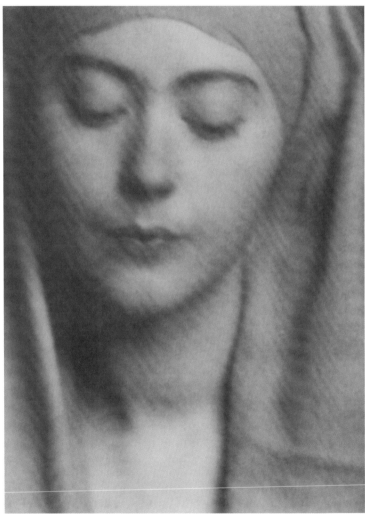

Fig. 37
John Vanderpant
Vera, 1930, silver bromide print
Vanderpant Collection

school. The interior was divided into several work spaces, which were given not only to the instructors but also to some students from the graduating class. Lilias Farley, Sybil Hill, and Margaret Williams shared a studio, while Vera Weatherbie was partnered with Irene Hoffar Reid.[258] It was there that Varley is said to have painted *Vera*, c. 1929 (pl. 31). She is seated in a frontal pose, wearing a striped jersey. Her expression is dreamy and distant, and her short hair, framing her face, is rather stylized. The artist has taken great care with the modelling of the head, but the body remains flat and stiff. Her arms hang in an awkward position and there is an obvious problem with the length of the right arm. In the background, he experiments with green and pink, trying to define Vera's personal aura. In the upper-left corner, he repeats the vertical lines of her jersey, suggesting a small window with protruding shafts of light.

Varley's numerous portraits of Vera — with her slanting eyes and stylized hair — are some of his most memorable works. In the most successful of them, *Vera*, 1930 (pl. 33), he brought her into the foreground in a frontal pose with her right shoulder slightly closer to the viewer. Her image, enveloped in shades of pale green and blue, was Varley's masterpiece.[259] His use of colour was idiosyncratic. His theory that each colour had either good or bad connotations in a personal or karmic way was derived from the five basic qualities of Tantric energy. Green had a spiritual value for him. Moreover, he believed every person is surrounded by a unique aura that could be expressed through a specific colour. He saw Vera as a "green person."[260] A portrait of another student from that time, Norma Parks, he painted in pink. In the 1950s, his companion Jess Crosby had a regal golden and orange aura, while Kathleen McKay was usually painted in bright red.

By choosing to depict his subject wearing an artist's smock in *Vera*, 1930, Varley was making a statement: Vera is an artist in her own right — his equal. In a 1959 interview with McKenzie Porter, Varley made a remark that sparked a long discussion about whether Vera had played a role in his new colour choices. He admitted that "without knowing it she made me see colour in new lights."[261] In a letter dated November 8, 1939, Fred wrote

to Vera: "I learnt more of Art, true Art in those years than at any other period — You taught me."[262] Peter Varley's research and interviews led him to the same conclusion, namely that Vera gave Varley his "colour sense."[263]

There was prescience, not condescension, in Varley's recognition of Vera Weatherbie's talent. After art school, she went on to post-graduate studies and rigorously developed her medium.[264] She often submitted works to annual shows in the local area, and competed in national and international exhibitions. When her work appeared in the *All-Canadian Artists' Pictures* exhibition in Vancouver in May 1932, she was referred to as "one of the most talented of the recent gradu-

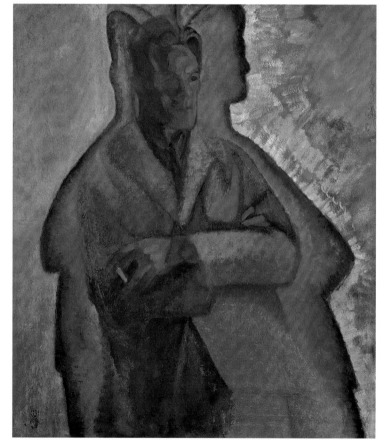

Fig. 38
Vera Olivia Weatherbie
Portrait of F.H. Varley, c. 1930
Vancouver Art Gallery

ates of the Art School."[265] Quietly, over a few decades, Vera produced a significant body of work that has not been seen or recognized. Circumstances in her life prevented the necessary evaluation of her work and obscured her presence.

Vera's three-quarter-length *Portrait of F.H. Varley*, c. 1930 (fig. 38), is remarkably close in style to his painting of her from that year. She uses the same green hue that gives a mystical quality to the image. One wonders, was she painting an actual portrait of Varley or trying to portray his spirit? When her picture was exhibited in May 1932, one critic's impression was that her subject appeared to have "a real head and two shadowy profiles, as though he had been spun around in a circle."[266] Emulating the manner of her esteemed teacher and companion, Vera also signed her work with a thumbprint.

The title of *Study for Dhârâna*, 1932 (AGO), and the subsequent canvas in oil, *Dhârâna*, 1932 (AGO), alludes to Varley's renewed interest in Buddhism. Here, he set out to produce a pictorial equivalent to the metaphysical state of being one with nature. His subject, Vera, in a kneeling pose, symbolizes a sacred communion with the environment, while the aura of blue and green that surrounds her creates an aesthetic and divine fusion.

New Directions

In its seventh academic year, the VSDAA suffered serious financial cuts. The local economy was in the throes of the Depression and the outlook for artists was not bright. So, when Varley and Jock Macdonald were notified of reduced teaching hours in 1933, they decided it was time to resign and found their own enterprise. That summer, a former car dealership and service garage was quickly remodelled to suit the needs of the new art school, which was to offer a broad spectrum of courses using the latest teaching methods. Thus, the British Columbia College of Art was born. Varley formulated its mission statement in these words:

> Realizing the vast opportunities which must inevitably grow from such an active centre as

Vancouver, powerfully influenced by the Occident and the Orient, we conceived the idea of the College of Art, which would have as its aim the awakening and development of art expression recognized not only in British Columbia but through the Dominion, and to make contact with the Orient through exchange of exhibitions of work. Also, if possible, when we are fully established, to procure the assistance of artists of the Orient to teach us new phases of expression.[267]

The excitement generated by the two very popular teachers was so infectious that many of their students from the VSDAA followed them to the new school. Fred Varley, Jock Macdonald, and Harry Täuber became art directors, and Beatrice Lennie, Vera Weatherbie, and Margaret Williams became their assistants. The college owed its opening to the generous support of private sponsors from Vancouver, but depended for its existence entirely on the revenue from student fees. At the beginning, there was a large enrolment for both day and night classes, as well as children's classes on Saturdays. But by the end of the first academic year, the financial problems had become insurmountable. The British Columbia College of Art closed after only two years.

Sometime during the school's brief existence (1933–35), Varley drew a quick sketch of his colleague and friend Harry Täuber (fig. 39). A painter with a strong interest in theatre, Täuber (1900–1975) had immigrated to Canada from Austria. He was a firm believer in the integration of the visual and the performing arts, and found in Fred Varley someone who shared his passion for music and theatre. Täuber was drawn to abstract art and particularly admired the work of the Russian-born painter Wassily Kandinsky (1866–1944). Varley and Jock Macdonald began to explore and discuss abstraction with Täuber, who viewed Kandinsky's work as a brand new way of seeing the basic value of art. Vera Weatherbie was now moving in this direction, fresh from her training in London, 1932–33, experimenting with fractured surfaces and painting shafts of diffused light in a muted colour scheme.

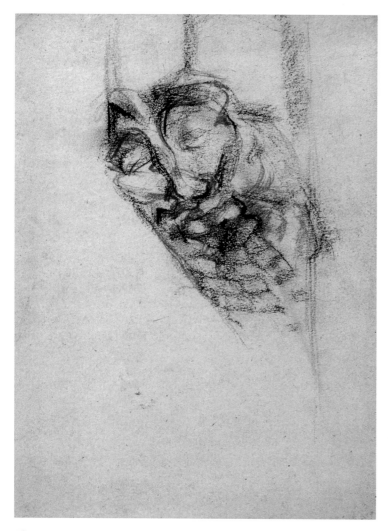

Fig. 39
Portrait of Täuber, c. 1930
Art Gallery of Greater Victoria (cat. 50)

among Vancouver artists in the 1930s. Varley also brought innovations to his portrait painting, including the way he would position a figure within a space, as seen in *Complementaries*, 1933 (pl. 38).[268] In this work he was trying to resolve problems with space and calling forms out of moving space.[269] Here, too, he was exploring "scientific vibrations in colour," under the influence of Wilhelm Ostwald's colour theory.[270]

Apparently, he worked on that canvas for nearly six months. "Well, I went into it first of all in a Munsell system of colour — it's five primary colours," Varley explains, "but that wasn't sufficient … it didn't mean anything, only there were colours — and then I'd say, now those colours in light — and so I worked out the Munsell system of scientific vibrations in colour, which don't come just in a circle. Some colours vibrate and come way out."[271] The two easily recognizable figures in *Complementaries* represent the earthly, material type and the non-material, aesthetic type of human being. The material type in the foreground was painted in shades of brown, while the aesthetic type in the middle ground was depicted in very light pink and ivory tones, symbolizing ephemeral, spiritual qualities. Here, Varley used a marked chromatic shift instead of a tonal contrast to decrease the distinction between body and void. The entire surface is broken into geometric, triangular or semicircular forms, which can also be interpreted as diffused shafts of light. The model for the two female figures is undoubtedly Vera Weatherbie, even though the only details of her fine features visible are the eyes, nose, and mouth.

In the late summer of 1934, Varley rented a house in the Lynn Valley, and the natural setting began to reassert itself in his portraits. One example is *Vera*, c. 1935 (private collection) (pl. 41), in which she is depicted standing tall against a panoramic view of the British Columbia landscape. The work is comparable to *Open Window*, 1932 (Hart House), where Varley balanced the same colour sphere with a quality of serenity and simplicity characteristic of Chinese landscape painting. Philip Surrey, who moved from Winnipeg to Vancouver in 1929 and attended only a few of Varley's evening classes, recalls the artist's new "framing" approach to composition, with the centres of interest at the edges of the canvas instead of near the middle.

Varley responded to these new ideas by eliminating many of the details in his landscape paintings. Works such as *Tree Tufts*, c. 1933 (NGC), are stripped down to the bare essentials of forms found in nature and rendered geometrically. In essence, Varley's purism was akin to the search for a universal language of art through elemental forms in nature that was being conducted by the French painter Amédée Ozenfant (1886–1966). His *Foundations of Modern Art* (1931), a treatise on art as an expression of sublime cosmic unity, was extremely popular

Among the numerous portraits of models and students at the VSDAA, Varley also drew *Marie*, 1934 (fig. 40), and after he moved to Ottawa he completed a head study of his former student and friend *Philip Surrey*, 1937 (fig. 41). Philip's mother, Mrs. Kate Alice Surrey, became a subject of at least two extant portraits in oil (pl. 44).

Another line of inquiry in this period involved the introduction of classical allusions or exotic scenes. The subject of

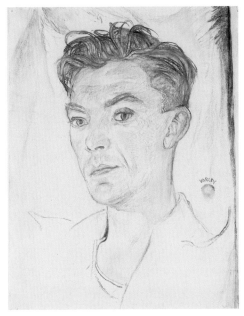

Fig. 41
Philip Surrey, 1937
Art Gallery of Ontario, Toronto (cat. 60)

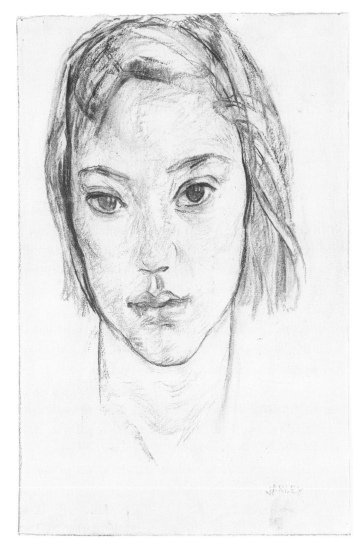

Fig. 40
Marie, 1934
Art Gallery of Ontario, Toronto (cat. 55)

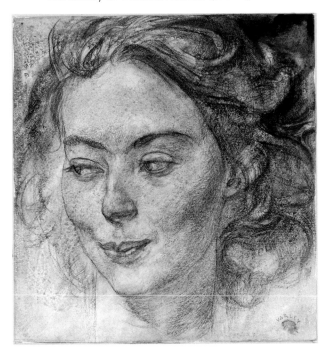

Fig. 42
Head of a Girl, c. 1936
National Gallery of Canada, Ottawa (cat. 57)

Head of a Girl, c. 1936 (fig. 42), has an enigmatic smile reminiscent of Leonardo's Mona Lisa. *Laughing Kathy*, 1952–53 (pl. 56), represents a later attempt to do a similar portrait of Kathleen McKay. Indeed, Varley acknowledged the Renaissance allusion by referring to his most accomplished drawing of Vera, *Head of a Girl*, as "The Florentine Head."[272] It has been justly observed that Vera Weatherbie was the personification of Varley's romantic ideal of woman, much as Dorelia McNeil was for Augustus John or Elizabeth Siddal for Gabriel Rossetti.

It is revealing to compare photographic images with portrait painting from the same period. In the 1930s, art photographs testified to a lingering romanticism through their exotic subjects or idyllic scenery. By the end of the decade, idealized images of women as allegorical figures or submissive temptresses in misty landscapes became very popular. Even such elite photographers as Mortimer-Lamb and Vanderpant were not able to abandon the nostalgic desire for exotica.

The quest for the ideal of feminine beauty had a very real psychological dimension for Varley. As a child, he had witnessed his parents' unhappy marriage. According to Varley's sister Ethel, she and her siblings "never saw a bit of love" between their parents. While the young Fred became keenly aware of the frustrations this caused for his mother, Ethel, who was closer to her father, sensed that it made him "low spirited."[273] In his adult life, Varley perfected a tender sensitivity towards women and an understanding of their needs and natures. He demonstrated this to women who needed emotional support and encouragement, such as Erica Leach, Reva Brooks, and Kathleen McKay. In his most intense personal relationships, Varley longed for the mutual surrender that was missing in his parents' marriage. According to Miriam Kennedy, he "wanted to engulf a person, to breathe that person in, to have that person become a part of himself."[274]

As a woman, Vera Weatherbie gave him her unconditional love and faith in his creative potential. As a model who was also an artist, she was capable of reflecting his emotions and artistic intentions. In their many long discussions about art, Vera did not hesitate to put forward her own opinions. Moreover, she and Varley were actively involved in each other's artistic processes.

There is a story about a time when Varley was working on *Dhârâna* and became stuck, not knowing how to proceed. Vera silently watched him struggle with it and one day decided to help him by scraping the surface. According to Vera's classmate, Bea Lennie, Varley was shocked when he saw what Vera had done to his canvas, but later found that this was "just what he needed."[275]

After Varley left Vancouver in 1936, he wrote to Vera, admitting, "I got into the way of your mind and mine criticising & suggesting until the canvas belonged to both of us."[276] In 1942, Vera married Harold Mortimer-Lamb. There was much gossip surrounding the pair, but they lived happily together until his death in 1970.[277] In his correspondence with Vera after he moved back east, and even after her marriage, Varley never failed to confide in her and to express his gratitude for her influence on his life and his art.[278]

OTTAWA AND MONTREAL, 1936 TO 1944

In April 1936 Varley travelled to Ottawa to attend the *Retrospective Exhibition of Paintings by Members of the Group of Seven, 1919–1933* at the National Gallery of Canada. In it, Varley was represented primarily by his work from the 1920s in Ontario, leaving aside his most recent achievements from British Columbia. The selection included eighteen portraits, no doubt a clear assertion of his status in the genre. Another incentive for the trip east was a commission to paint a portrait of the chairman of the National Gallery's board of trustees, Harry S. Southam (1875–1954), arranged by Eric Brown. From the start, Varley was unhappy with the many restrictions imposed on him, such as requiring the board's approval for the portrait; nor did his open dislike of Southam help the situation. He shared this opinion in his letters and described the problems he was having with the commission, but noted that he was pleasantly surprised to see the "higher range of colour vibrations" put to good use. Concerned with the relationship between colour and light, Varley painted Southam in a field of "prismatic colours."[279]

By June 1936, he was living in Ottawa and working in the studio that the National Gallery had provided for the Southam com-

mission. Now virtually penniless, Varley began his largest and most ambitious painting so far, the first version of *Liberation*, 1936 (AGO). Convinced that this was going to be the masterwork that would make his reputation in England, he wrote: "No one sees paint. They only see a six and a half foot figure coming out of strange colour lights, an evanescent something which in a moment more will be solid matter — molten metals and jewels — I can scarcely believe that I truly have something impossible for me to lose or wreck."[280] In *Liberation*, his experiment with integrating prismatic colours and shafts of light was successful. However, to his great disappointment, the jury of the Royal Academy rejected the work in 1937. Unable to pay the cost of shipping it back to Canada, Varley had it placed in storage in a London warehouse, where it remained until it was rediscovered in 1975.

Sometime between April and the end of June 1936, Varley painted a portrait of Margot McCurry, the nine-year-old daughter of Harry McCurry, assistant to Eric Brown. (McCurry would succeed Eric Brown as director of the National Gallery in 1939.) Strict regulations were in place at the National Gallery; for example, Varley was unable to work in his studio after the building closed at 5:00 p.m. The demand that he relinquish his smoking habit brought further irritation. Eventually, Eric Brown had no choice but to ask him to vacate the studio in July 1936. He returned to Vancouver, hoping to resume his happy existence in Lynn Valley and renew his relationship with Vera, but things did not go well between them. She left in September on a trip to the Far East, and Varley was back in Ottawa by early October.

The summer of 1937 saw him once again in Vancouver. By then his estranged wife, Maud, who had moved into the Lynn Valley house on his suggestion the previous fall, had a surprise for him. With a small inheritance from her mother's estate, Maud had bought the house, hoping to reconcile with Fred.[281] But this was not to be. John Vanderpant mounted a small exhibition of his own photographs and Varley's recent work at his gallery that summer, which brought an unexpected sale of forty pictures and resulted in a temporary upswing in the painter's finances. Apart from that positive note, Varley's plan to re-establish himself in Vancouver was not working out. His beloved Lynn Valley house was occupied

by Maud, his relationship with Vera was doomed, and he had no secure source of income. It was at this juncture that he painted a second self-portrait, *Mirror of Thought*, 1937 (pl. 43).

That last sojourn in British Columbia turned into a long and hard goodbye to places and people he had loved. Varley's future in eastern Canada was uncertain, but it did hold the prospect of more portrait commissions, a whole new environment to discover, and exhibitions that would continue to build his reputation. One such opportunity was on the horizon: three of his portraits would be included in *A Century of Canadian Painting* at London's Tate Gallery in 1938.

From his first view of the Arctic paintings of A.Y. Jackson and Lawren Harris in the Group of Seven exhibition at the Vancouver Art Gallery in 1931, Varley had dreamt of a journey to the Canadian North. On July 4, 1938, he received a letter from the deputy minister of Mines and Resources, Charles Camsell, giving him five days' notice to join the RMS *Nascopie* on its twelve-thousand-mile journey to the eastern Arctic. During his three months on the ship, Varley worked feverishly, producing numerous sketches and watercolour paintings of the barren landscape and

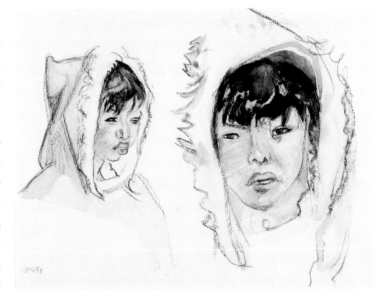

Fig. 43
Arctic Sketch, 1938
Private Collection

the Inuit settlements along the way. His *Arctic Sketch*, 1938 (fig. 43), shows his fascination with the unique features of the Inuit people he encountered. The Arctic left an indelible impression on him, and he would include elements of its scenery in his paintings for years to come. In his portrait of Miriam Kennedy, *Sea Music*, c. 1939–40 (private collection), for instance, the landscape in the background speaks of his fresh experiences in the Arctic as well as his nostalgic feelings for British Columbia.

In 1939, back in Ottawa, Varley was commissioned to do a portrait of the pioneer of Canadian broadcasting, Alan Butterworth Plaunt (1904–1941; pl. 45). Born and raised in the Ottawa Valley, he graduated from University College in Toronto in 1927 and received an honours BA in History from Christ Church College, Oxford, in 1929. Plaunt returned from England with a fresh vision of the future of his native land and a broader understanding of its greatness. His first initiative, in 1929, involved the organization, together with Graham Spry, of the Canadian Radio League. From 1932 to 1934, he and Spry owned and published the *Farmers' Sun*, a weekly newspaper in which they espoused an enlightened view in regard to problems affecting farm living and public life. In 1936, Plaunt became one of the original governors of the Canadian Broadcasting Corporation. The arts were another area of interest, especially writing and painting. In his portrait of Plaunt, Varley gives us not only a good physical likeness but also a sense of the man's dynamism and his gentle nature. According to the Honourable Brooke Claxton, Plaunt "had the enduring fibre and fabric of character as well as the warm heart of friendship."[282] In 1941, when he was just thirty-seven, Alan Plaunt's life was cut short by illness.

DRAWN TO WOMEN

In the summer of 1940, in the grips of a long bout of depression, Varley was a guest at the cottage of Wing Commander C.J. Duncan and his wife, Rae, near the air force base at Trenton, Ontario. Situated on the lovely Bay of Quinte, the Duncans' cottage was always a busy place, with friends staying over or just dropping by. One day, Ulric Mignon, Varley's old friend and former model in Vancouver, came to Trenton along with his wife, Erica, to take a course at the base. The couple stayed with the Duncans for a few days before moving on to rental accommodations. Erica's recollections of their arrival at the Duncan cottage and her first meeting with the artist are recorded in the section "Varley's Friends Speak" (see p. 105).

Erica Leach was born in Kelowna, British Columbia, in 1917. At the time she and Varley met, she was twenty-three and had been trapped in an unhappy marriage for five years. In her own words, she "felt frozen inside." This beautiful and vibrant young woman was in reality quiet and insecure. She does not remember speaking to Varley about her unhappiness, but perceived that he was able to see into her very soul. During one of their long talks, sitting at the dock for hours, he spoke to her about "a sense of wonder" that had tremendous power of awakening. Varley made two drawings of Erica on a relaxing afternoon they spent together while the others were away. His initial study in charcoal and chalk, *Erica*, 1940 (fig. 44), was a good physical likeness, but he was not pleased with it, knowing that it did not capture Erica's real self.

For the second drawing, *Head Study*, 1940 (fig. 45), Varley asked if he could borrow her lipstick to match the colour on her lips. This time he seized the essential Erica and the two sides of her nature. On the one hand, she is fresh and wanting, on the other, full of doubts and worries. This duality is symbolized by the light and dark sides of her face. Her right side and eye are sharper, more inquisitive; her left, obscure and reserved. The totality made for a haunting image. "I have always loved it because of the truth he drew," Erica says, "and that he was pleased by it. It seems that's the one which influenced him when he later did the oil portrait. It was all so natural and I didn't really think about it because I was so sad and lost inside myself."[283] Erica's husband purchased the drawings for her, and she has lived with them ever since.

The story surrounding the third portrait of Erica, painted in oil, *Erica*, 1942 (pl. 48), raises some questions about its date. In the late 1960s, when Peter Varley was working on the inventory of his father's works, he was able to identify the sitter as Erica and to interview her. He then dated the painting to 1942, based on the

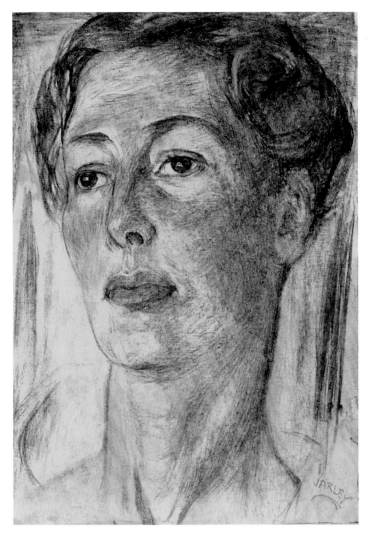

Fig. 44
Erica, 1940
Private Collection (cat. 63)

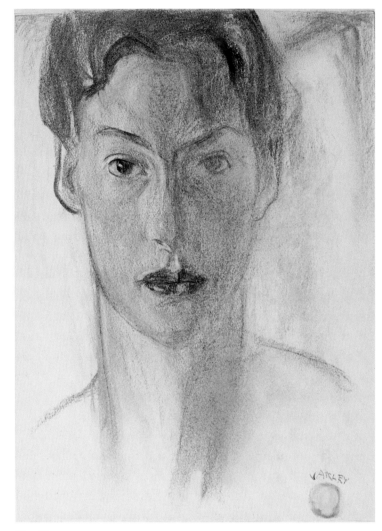

Fig. 45
Head Study, 1940
Private Collection (cat. 64)

information he received from her regarding a trip to Montreal in November 1942. There, she visited Varley several times at St. Luke's Hospital, where he was recovering from a skull fracture, resulting from a bad fall on an icy sidewalk. Erica recalls receiving a letter from Varley in the spring of 1943 describing her new portrait, which he painted in oil, with her face split by "a shaft of moonlight." Stylistically, this image of Erica is closer to his portraits of Manya dated around 1940 and to his *Woman in Green*, c. 1939–40. Here, he uses a wide range of colours in the background.

As in his second drawing of her, strong light falls on one side of Erica's face, while the other is in darkness, and pools of shadow collect around her eyes. In a manner evocative of seventeenth-century Dutch portraiture, Varley employs a chiaroscuro technique to create a pensive mood.

Back in Ottawa, Varley was introduced to the Naval Art Service office by his friend Tom Wood. The young artists and members of the Naval Service felt honoured to have Varley in their midst. They invited him to share their studio and art supplies, and

he worked on few portrait commissions there.[284] Leonard Brooks was one of those who gathered at the so-called Contempo studio, and Varley often visited him in his rooming house, where the two engaged in endless discussions about art. On one occasion, as his young friend played the violin, Varley soundlessly accompanied him using a table for a piano.[285] Eventually, Varley asked Leonard if he could stay a while in the guestroom of the Brooks' Toronto residence at 39 Boswell Avenue.

Leonard's wife, Reva Brooks (née Silverman; 1913–2004), received her guest hesitantly at first. Later, she and Varley would enjoy long conversations and at times he would play the piano. The daughter of Polish-Jewish immigrants, Reva was an attractive and sophisticated woman who loved music, art, and literature. According to Reva, Varley tried to convince her to awaken her artistic nature and devote more time to things that were important to her growth, instead of just being happy as a wife. She did not welcome his overtures: "It used to make me rather angry when he did that, because I had my own ideas."[286] Ironically, in 1947, at the age of thirty-four, while living in Mexico, Reva would pick up a camera for the first time and almost overnight win international recognition as a photographer.

During his several months' stay with the Brookses, Varley drew a sensitive charcoal sketch of Reva on brown paper, *Reva Brooks*, c. 1940 (private collection), using her lipstick to colour her cheeks and scarf. He depicted Reva in a moment of listening — perhaps while he recounted stories from his life. She is leaning forward, with her head propped on her hand, her eyes dark and expressive. The pose that Varley selected for her seems entirely natural, defining something of her essence.[287] He achieved a similar effect in his drawings *Nancy Cameron*, c. 1940 (pl. 46), and *Catherine*, 1943 (fig. 46).

The Second World War closed some doors to Varley (such as the periodic teaching he had been doing at the Ottawa Art Association) but opened others. In 1942, now sixty-one, he contacted Vincent Massey and Lord Beaverbrook about obtaining a war commission. The War Artists Committee did not offer him an official appointment; they did, however, commission three portraits of military personnel stationed at Kingston. Moreover,

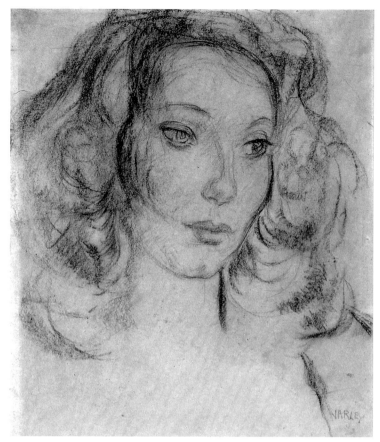

Fig. 46
Catherine, 1943
Art Gallery of Greater Victoria (cat. 69)

around then, at a party at the Duncans' cottage, Varley met an anonymous benefactor, thanks to whose unexpected support he was able to return to Montreal and enjoy six months of painting, free of worries about his daily needs. There he renewed his connection with Philip Surrey, who had recently moved to the city, and with fellow artists Fritz Brandtner, Louis Muhlstock, and Goodridge Roberts.

In Montreal, Varley made the acquaintance of a free-spirited young woman named Miriam Kennedy. She had been married to poet Leo Kennedy, but when she and Varley met, she was living alone. Their love of music was just one of the many things that drew them together. Miriam remembers that once when they were talking about music, Fred suddenly began to paint. The result of

his momentary inspiration was *Sea Music*, c. 1940.[288] Manya, or the Lady of Ethiopia as he lovingly called her, inspired some very sensual and erotic portraits. One of these, entitled *Manya, Portrait of Miriam Kennedy*, c. 1942 (pl. 49), was another spontaneous creation. Miriam recalls walking into his studio on a hot summer day, with her hair all mussed and sticky, and he asked her to stand still as he drew her head.[289] The resulting oil portrait is as powerful and evocative as Varley's work from the 1920s.

Despite his long-standing objection to commercial art, Varley was obliged to take on some assignments in order to keep afloat in Montreal. According to Miriam Kennedy, he "didn't have too much trouble getting work," at the time, but "he didn't have his heart in it."[290] In 1940–41, he worked on thirty-one illustrations for Stephen Leacock's book *Canada: The Foundations of Its Future*. The topic of immigration especially resonated with him, as is evident in the watercolour painting *The Immigrant Ship*, 1941 (pl. 47), which he produced for the volume.

Natalie Kessab, or Natasha as Varley nicknamed her, was probably the most mysterious woman ever to enter the painter's life. Said to be of Lebanese or Armenian descent, she had exotic, Oriental features. The owner of a successful lingerie shop on Sherbrooke Street West in Montreal, she was financially independent and recently divorced. Natalie was well disposed toward the painter and supportive of him. Research has failed to reveal much about her life. All that we know is that she eventually left Montreal and settled in New York, where she married a wealthy Greek merchant.[291] Only one of Varley's portraits of her has been located. *Natalie*, c. 1943 (pl. 50), reveals her sex appeal in the fashion of the femme fatale.

Toronto, 1945–1950

In the aftermath of the Second World War, the structures within which most portrait artists were accustomed to function and to exhibit their work were altered or ceased to exist. It was an era when government subsidy of the arts, through both the Canada Council and the National Museums Corporation, created new opportunities and new networks for artists, which were not always compatible with the old ways. Suddenly, the kind of representational work portrait painters were used to producing seemed out of date. Abstraction was beginning to gain ground. In the middle class, at least, the role of women in society was shifting from its wartime mode — which saw women entering the workforce in greater numbers to fill the spaces left vacant by men who had joined the armed forces — back to the peacetime ideal of women as housewives. One repercussion of the tendency to favour men in the public sector while encouraging women to return to their private domestic roles was that it inhibited the recognition of women artists. Indeed, it has only been in the last couple of decades that Canadian art history has begun to take stock of the contributions of some of the most accomplished female artists of the day.

Varley had decided to move back to Toronto in 1944. His first solo exhibition since returning to eastern Canada was being organized that year by Eaton's Fine Art Gallery. Some outstanding recent work would be included in the show, such as *Dr. T.*, 1944, an insightful portrait of Dr. D. Thompson, a psychiatrist. The attendance at his two-week show was very heartening and lent new impetus to his work. In addition, he was offered an exhibition at Hart House. Varley would be given another show at Eaton's gallery in the spring of 1950.

Self-Portrait, Days of 1943, 1945 (pl. 51), dates to this period. The timing of this third exercise in self-examination is significant. Varley's first self-portrait was created in 1919, as if to record his state of being after the First World War. Now that the second global conflict in his lifetime had ended, he once again paused to consider his current condition. He uses a similar colour scheme in the 1919 and 1945 self-images, the murky hues of his war canvases. The skull fracture he had suffered in Montreal in 1942 may explain why his right eye appears to be darker than the left. Charles S. Band visited Varley's studio in 1945 when he was working on the self-portrait. As a contemporary, who had lived through the same events, Band's memories are of particular relevance; they are given in "Varley's Friends Speak" (see p. 107). He would eventually amass a large collection of Varley's portraits in all media, including a

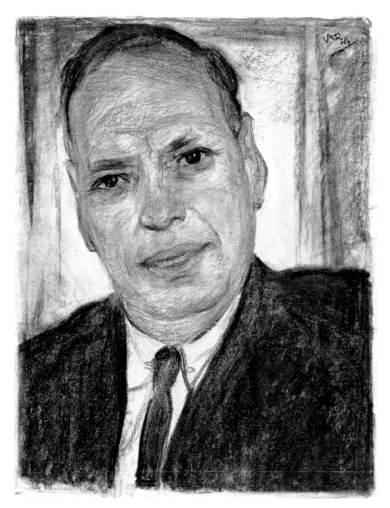

Fig. 47
Portrait of Samuel E. Weir, 1951
The Weir Foundation, Queenston, Ontario (cat. 77)

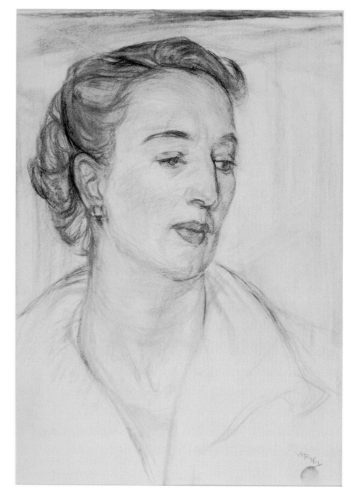

Fig. 48
Frances E. Barwick, 1952
Carleton University Art Gallery, Ottawa (cat. 78)

drawing of himself. In the early 1950s, Varley made several commissioned portrait drawings, including those of the art collectors Samuel Weir (fig. 47) and Frances E. Barwick (fig. 48).

JESS CROSBY

Varley's neighbour in his latest studio on Grenville Street, Jess Crosby, would become his companion and muse for several years, from 1946 to 1951. Jess was also from Yorkshire, and their relationship was built on a common love of the arts, music, books, and the outdoors. She was interested in sculpture and was also trying to paint. It has recently come to light that Jess had created a bust of Varley, which she later destroyed.[292] Of the four portraits of her in the present exhibition, we have the artist's own account of the creation of *Jess*, c. 1948 (fig. 49): "I keep looking at the drawing I made on Sunday — It is tantalising — intriguing is the word. I have never made a drawing like it before — and, when I think of you sitting there looking at me through your falling hair much more lovely than a small mouthed tight-

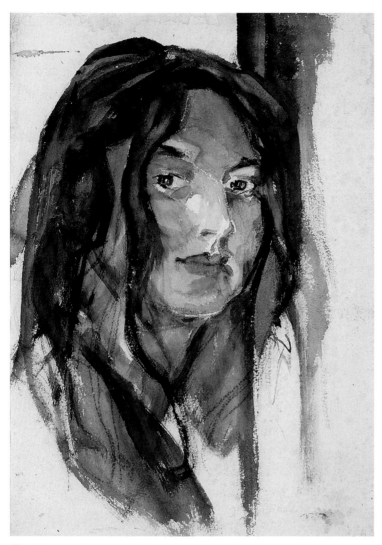

Fig. 49
Jess, c. 1948
Private Collection (cat. 73)

lipped Mona Lisa I am eager and awakened to actively make a hundred drawings and paintings."[293]

For two summers, Varley taught at the Doon School of Fine Arts, near Kitchener, Ontario. He regularly wrote to Jess from Doon, and on weekends the two often visited back and forth by train. *Jess*, c. 1947–52 (pl. 52), was painted on one such visit.

This delicate pencil and watercolour head study speaks volumes about Varley's warm regard for his companion. Purchased by Douglas Duncan, the portrait remained in the collection of his sister Frances Barwick and after her death was gifted to Queen's University. In old age, Jess still had a clear memory of the particular moment when she walked into Varley's studio with a hood over her head to protect her from the rain.[294] In this incisive character study, a slightly lateral light source projects enough shadows to make the volumes of her face and neck stand out.

Two oil portraits of Jess Crosby, each dated 1950, form an interesting study in contrasts. *Jess* (pl. 53) is a tender and enchanting portrayal of the subject, and undoubtedly one of Varley's best works of the period. This image, with its serene atmosphere, testifies to the elegance of the painter's style in the smooth, almost enamelled modelling of her face and clothing. *Jess* (pl. 54), however, has an impromptu quality about it. The artist has seized a fortuitous moment, capturing his subject seated in front of an open window, perhaps at her cottage in Belfountain.

The art scene in Toronto in the late 1940s and early 1950s has been recreated in the writings of Toronto artist John Gould, who knew Fred Varley and valued his work. For years Gould kept a journal, which was recently published by Moonstone Books. In it, the author reminds us that the Toronto of the 1950s was a far cry from the world-class city we know it as today. Rather, it was a mid-sized town with many quaint Victorian buildings. One of the landmarks of the day was Malloney's, a bar on Grenville Street, just a block away from Varley's studio. He put in regular appearances there, as did other artists and writers. Gould describes Malloney's as "a large complex of rooms, part art gallery, part reception and convention area, part bar."[295] Other favourite watering holes for the arts crowd were Angelo's Tavern, the Fifth Avenue, and the Pilot Tavern. In his second tenure in Toronto, the ever-sociable Varley appears to have found the camaraderie and exchange of ideas that formed a necessary part of his creative process.

CHAPTER 6

THE LATER YEARS, 1951–1969

I am only trying to get outside my own being, clarify my
own being so that I can go ahead a little more.
— Fred Varley

Around 1951 or 1952, Varley met the woman who was to exercise a major influence on the last decade of his life, Kathleen Gormley McKay (1900–1996) (fig. 50). At the time, she was fifty-two, married, and looking for a tangible way to express her passion for the arts. Kathleen was born and raised in Markham, on the outskirts of Toronto. Her mother, Sarah Milne, was from a wealthy farming family related to the Eckhards, one of the sixty-eight founding families of Markham, known as the "Berczy Settlers."[296] Kathleen was a graduate of the Royal Conservatory of Music in Toronto and later sang in the choir of Healey Willan. She married Donald McKay, a food chemist with Crosse and Blackwell, and moved with him to the United States. In his fifties, Donald McKay was diagnosed with multiple sclerosis and confined to a wheelchair. Forced to take early retirement, he moved his family back to Canada. They settled on Lowther Avenue in Toronto.

There are several quite distinct versions of Kathleen McKay's first meeting with Fred Varley. In one widely circulated story, having heard a lot about Varley's skill as a portrait painter, Kathleen decided to commission a picture of her husband.[297] Arriving at his studio to make arrangements, she found the door open and curiously peeked in, only to be stopped by Varley's commanding voice: "Hold it there!" He then grabbed a pencil and paper and rapidly drew a sketch of her in the doorway, *Studio Entrance*, c. 1952–53, which he later worked into the oil portrait *Studio Door*, c. 1952–53 (pl. 57).[298] Kathleen McKay's own version involves a chance encounter with Varley at Roberts Gallery, 759 Bloor Street.[299] We know, however, that Varley did not meet the owner of the gallery, Sidney Wildridge, until later, and only began giving works on consignment to the gallery around 1953–54. Jeannie Wildridge, Sidney's daughter-in-law, does not remember seeing Mrs. McKay there either, and gallery records do not show her as a client prior to 1954.[300] According to friends, in old age Kathleen became much more reticent about being interviewed. In yet another story, driven by her wish to do something practical for art, she was encouraged by a friend to write to Varley offering assistance.[301] The most convincing variation, supported by archival documents, is that Kathleen and Donald McKay already owned a work by Varley, and in January 1952 sought him out in order to purchase another painting. Their

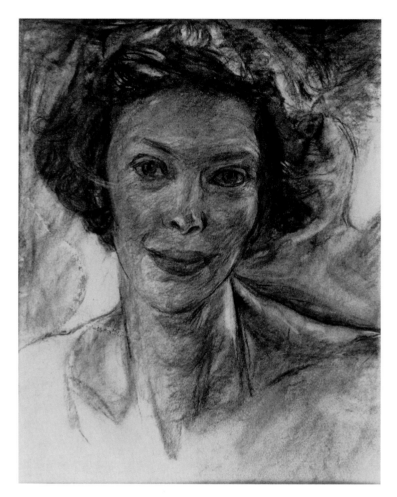

Fig. 50
Head of Kathy, c. 1952–53
Varley Art Gallery of Markham (cat. 79)

Fig. 51
Kathleen McKay at her home in Toronto in the 1980s
Varley Art Gallery of Markham Archives

intention was to assemble a small art collection and eventually donate it to the Art Gallery of Toronto.[302]

Regardless of the circumstances that brought them together, from the outset Kathleen McKay possessed tremendous faith in Varley and a desire to become his muse and helpmate. In a letter from December 1955, she writes, "Can I tell you how I believe in you and in the greatness of the paintings you create?"[303] During Varley's illness in the winter of 1952–53, the McKays invited him to stay at their house, providing him with a room and care until he recovered. It was during that time that Varley drew a gentle

image of Kathleen, which she kept at her home for the rest of her life (fig. 51). Varley's meeting with Kathleen and his subsequent move to the McKays' residence brought his relationship with Jess Crosby to an end.

Passion and enthusiasm were innate to Fred Varley's nature. Like many of his friends and lovers before, Kathleen McKay discovered that even listening to music or talking about art with him was a "wonderful experience."[304] It has been suggested that the artist based the graphite and chalk drawing, *Kathy*, c. 1954 (pl. 58), on Leonardo da Vinci's silverpoint drawing, *Profile of a Lady*, c.

1485–90 (Royal Collection, Windsor). He had purportedly spoken highly of a reproduction of it in the publication *Art and Scientific Thought*, by Martin Johnson (1949).[305]

Sidney L. Wildridge, a fellow Yorkshireman who had purchased the Roberts Gallery in 1948, entered Varley's life in the early 1950s. European art was Wildridge's specialty, but he agreed to represent the artist more on the basis of his British ancestry and training than on his fame as a member of the Group of Seven.[306] Up to this point, Varley had been showing his work at Douglas Duncan's Picture Loan Society, but no mutual understanding was ever forged between the two men, and Varley gladly parted with Duncan. The relationship between the artist and his new dealer, built on trust and loyalty, developed into an enduring friendship that later extended to Sidney's son, L.J. (Jack) Wildridge. In February 1957, Varley confided in George Hulme, financial administrator at the National Gallery: "I am very fortunate to have him as a friend who releases me from all matters of business."[307]

It was through the Roberts Gallery that Varley befriended Cooper Campbell, a manufacturer and art collector, who commissioned him to draw his daughters, Robin and Lexie. In May 1955, it was Campbell who drove Varley to Cape Breton, to the home of Dr. John Goldie, a physician in Whycocomagh (fig. 52). Varley had been slow in responding to Goldie's offer of hospitality, issued in 1954, but when he finally arrived in Cape Breton, he stayed on for the whole summer. He set about painting a commissioned portrait of Goldie in his usual "calm, unruffled, untroubled" manner.[308] It is true that the Cape Breton landscape did not have the same effect on him as his beloved British Columbia and that the work he produced there, painted in dull colours, was regarded as weak and unsure. However, the image he made of Dr. John Goldie demonstrates that Varley still had his astonishing ability to read character. In the words of Dr. Goldie, the picture saw "deeper than my perpetual bluff and depicted me as the fellow I thought was unknown to anybody except myself."[309]

Back in Toronto, Sidney Wildridge continued to look out for commission work for Varley. One of Sidney's clients agreed to commission a portrait of his son, Tupper Porter. In December 1955, Varley travelled to St. Andrew's East, Quebec, to carry out the work. Lawrence T. Porter (1899–1960) was an engineer and Princeton graduate with mining and shipping interests. He was one of those rare and modern art lovers who collected works by Canadian artists of the 1940s, including Lawren Harris, Emily Carr — and Fred Varley. The painter had a delightful time with Mr. Porter, marvelling at his collection and discussing art. He wrote regularly from there, keeping his dealer up to date on the progress of his work and requesting materials or financial assistance: "I am enjoying my sitter [Tupper Porter] and the painting of him, 28 years, older, 6' 3" high, weighs 195 lbs when working as geologist and prospector."[310]

In October 1954, a major retrospective exhibition of his work, *F.H. Varley, Paintings 1915–1954*, organized by the Art Gallery of Ontario, opened in Toronto, then toured to Montreal, Ottawa, and Vancouver. The catalogue included short essays by Arthur Lismer, Charles Band, Jock Macdonald, and Robert H. Hubbard. In January 1956, Fred Varley celebrated his seventy-fifth birthday, and his first solo show at the Roberts Gallery opened in February. Varley's reputation as an artist was secure, but he had no intention of hanging up his smock just yet. Painting was his lifeblood, and he found the human face as compelling a subject as ever. As

Fig. 52
Fred Varley in Whycocomagh, 1955
Photo: Dr. John Goldie

he grew older, his style lost the adventurous and experimental character of earlier days. Nonetheless, he still approached the act of portrait painting with energy and decisiveness.

His portrait *Florence Deacon*, 1955 (pl. 59), illustrates this point amply. Varley likely had glimpsed Mrs. Deacon running her daily errands in the village of Unionville, where he went from time to time in the company of Kathleen McKay (the McKays were now living in Markham) (fig. 53). He must have mentioned a desire to paint Mrs. Deacon, and Kathleen subsequently made the arrangements. The preliminary drawing was not to his satisfaction and he discarded it, although the sitter thought it very good. Next he determined to work in oil and asked Florence Deacon to wear the coral pink dress he had seen her in on a previous occasion.[311]

What began as a portrait drawing evolved into a serious painting in oil, which Varley was able to complete in five to six sittings. According to Mrs. Deacon, the painter worked quickly, and "time did not hang heavily" during the sessions. He worked quietly as well, going about his business without talking to her, which created a relaxed atmosphere. Florence Deacon remembers that he initially painted a forest landscape as a background, but then decided that

it was not suitable and without hesitation scraped the surface and repainted it in blue. She agreed with his colour choice, feeling that water, being her element, was closer to her spirit. When the portrait was done, Varley asked how she liked it. Instead of offering praise, she looked at it and asked timidly, "Are my shoulders too big, Mr. Varley?" To that he replied quite matter-of-factly, "That is the way I see them."[312] Kathleen McKay was to arrange at least one other sitting for the artist, for *Portrait of Nancy Robinson*, c. 1962 (pl. 60), and perhaps also for *Young Girl*, c. 1964 (fig. 54).

Fred Varley lived to the age of eighty-eight — long enough to enjoy the resounding success of his most recent solo show at the Roberts Gallery in February 1969. Nearly all the works in the exhibition were sold, including *Dr. John Goldie*, *Sketchers*, and many landscape paintings. The wish that Barker Fairley had

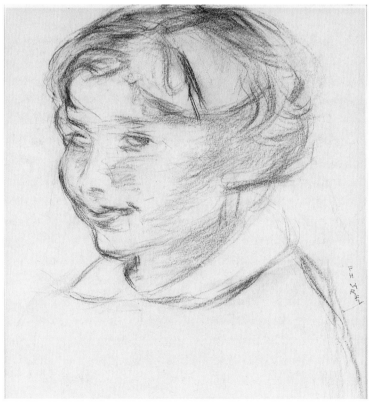

Fig. 54
Young Girl, c. 1964
Collection of Dan Driscoll and Paula Driscoll
(cat. 86)

Fig. 53
Kathleen McKay in front of her home at 197 Main Street, Unionville, late 1950s
Varley Art Gallery of Markham Archives

made on that distant day in 1925, that Varley's drawings be snapped up like hot cakes, had come true.

He died on September 8, 1969. Florence Deacon vividly recalls the memorial service for Varley held at St. Anne's Church, the same church he and his friends had helped to decorate in the 1920s. Barker Fairley delivered the eulogy, with a hand placed gently on the coffin, as if he were speaking to his old friend.

A MAN OF VISION

My research into the life and the art of F.H. Varley left me with many deep impressions, of which two predominate. First, that Varley found humanity exquisite in all its variations. One lifetime did not suffice to capture its endless possibilities in his portrait work. Second, that he was in essence a draughtsman and that his painting is most masterly when it most closely approximates drawing. His training as a draughtsman in Sheffield and Antwerp profoundly influenced his art, in which the traditional merges with the eclectic. His drawings are distinguished by the brilliance and audacity with which he applied established techniques and methods. Paradoxically, Varley rarely used preparatory sketches for his portraits, as he preferred to work directly on canvas. Consummate draughtsmanship underlies the strong contours and clearly defined forms of his best paintings. Composition — the relation of the parts to the whole — was of paramount importance to him.

Varley insisted on seeing the true nature of colour, searching out the exact value and hue instead of resorting to formulas. In that respect he had a less structured approach than the academic painters, who used to lay colours over carefully executed drawings. Once he had defined the largest areas of colour, he made sure that the colours worked together. He never viewed colours separately, because his goal was always a harmonious blend. By letting his colours pervade the surface of his portraits and by finding a balance between warm and cool hues with dark and light colour values, Varley gave his works a luminosity that is unsurpassed in Canadian portraiture.

He preferred to paint in his studio, where lighting and setting were most suitable (fig. 55). When he travelled for commissions, often under time pressure, he did as much as he could from life in three or four initial sessions. When he was with a sitter, Varley picked up much more than just the visual likeness: he "got the feel" of his subject. Often he decided on their clothing, choosing a colour that complemented their skin tone, then selected a complementary background colour. The impression of a draped curtain backdrop was sometimes used to achieve subtle colour transitions and the integration of image and background. As to lighting, he favoured light behind the dark side of the head and dark behind the light

Fig. 55
The artist in his Unionville studio, mid 1960s
Photo: Gabriel Desmarais (1926–1991), known as Gaby: Gaby Estate

Fig. 56
F.H. Varley in Unionville, mid 1960s
Photo: Catharina Vanderpant-Shelly

side, allowing both sides of the form to be read. Whenever he used shadows, he kept them flat, so that they acted as a foil to the halftones of the portrait — another technique learned from academic painting.

Many of the portraits Varley painted were commissions. Whenever such work came his way, he carried it out with seriousness and skill. While some faulted him for not securing more commission work on his own initiative, I wonder if it is fair to lay the blame wholly on the artist. The times also must be taken into account, and the place. Art in general, and the tradition of portrait painting in particular, had very shallow roots in the Canadian soil. Nor can Varley's independent nature be overlooked. In his own words, he could not "afford to be imprisoned or bound by the wills of others."[313]

From time to time, he would become discouraged with commissioned portraits and look for a change of subject. I feel this active seeking of a stimulating subject had its advantages, because it helped preserve the spontaneity of his response to the human face. One of its drawbacks, however, was that his gen-

uine reaction to the sitter depended on an intense emotion, which is, as every emotion, temperamental and fleeting.

It has often been said that the vision of painters tends to become more generalized with age. With Varley, we see this at the beginning of the 1950s, when even his drawing became broader and more painterly (fig. 56). Over the course of his career, he continued to explore new ideas, techniques, and methods, although it is true that he never embraced the latest art movements, such as abstraction. In my view, this is not a matter of limited ability or inadequacy, but simply that his style was so spontaneous and dynamic that it was not susceptible to the more geometric organization of abstract painting. By temperament, Varley belonged to the generation of British portrait painters that included Augustus John and William Orpen. Yet the circumstances in which he lived precluded the full realization of his innate and acquired talent for portraiture.

A man of grand vision and spirituality, Varley cared little for convention and the trappings of public acclaim, preferring to devote himself to the pursuit of beauty and the high artistic standards he set for himself. At the core of the exceptional body of work that he produced is his portraiture. It stands as an enduring testament to F.H. Varley's mastery of his craft and his deep respect for humanity.

VARLEY AND THE CRITICS

The critics were rarely silent about Fred Varley throughout his long career, although there were times when it was not entirely clear whether these critiques were being directed at the artist or the man. The real and purported facts of Varley's unconventional life ("scandalous" was the contemporary adjective) were often fodder for the press. One might wonder whether some of the statements written about his art were coloured by the authors' estimates of Varley's character. These critical voices uttered a broad range of viewpoints, from reservations and mild approbation to serious consideration and overwhelming acclaim. How Varley responded to what was said or written about him is not

well documented. We do know there were times when he did not get the hoped-for reception. There must also have been times when he felt that his achievements had been justly recognized. We would like to round out the sampling of reviews already quoted in our text with few more opinions.

Prior to Varley's solo exhibition at the Eaton's Fine Art Galleries in 1944, Ronald Hambleton declared that there were only two sorts of critical opinion about the artist: "One kind said that Varley was Canada's finest artist and the other said that Varley was all washed up." At the same time, Hambleton admitted that Varley was "Canada's most misunderstood famous painter."[314] After the 1944 solo show, Pearl McCarthy proclaimed that Varley was "bigger now" than in the days when he was associated with the Group of Seven.[315]

In 1949, Varley agreed to a National Film Board (NFB) proposal to make a documentary film on his life and artistic career. Producer Allan Wargon and director Tom Daly undertook the grand task of reconstructing the artist's Grenville Street studio inside the NFB building in Ottawa. When the film premiered in 1953, George Elliott offered this terse and insightful summary: "Here in twenty minutes is revealed the very moving tragedy of an artist-genius, now beaten down by the world's malaise and then raised to great heights of creative perfection by his own loving search for form."[316]

The short films the NFB produced on some members of the Group of Seven, along with the new books and silkscreen prints of their iconic works that were in circulation, fuelled popular interest in their art. The Art Gallery of Toronto mounted a series of retrospectives, featuring Lawren Harris in 1948, Arthur Lismer in 1950, A.Y. Jackson in 1953, and finally, in October 1954, Fred Varley. In his review of the exhibition *F.H. Varley, Paintings 1915–1954*, George Swinton predicted that Varley's "stature as keeper of an old and important tradition will grow as the years go by."[317]

In 1954–55, a retrospective exhibition of his work toured to Ottawa, Montreal, Winnipeg, and Vancouver. Everywhere, it was received with great acclaim. In the *Vancouver Sun*, Mildred Valley Thornton praised Varley as "the most able and versatile Canadian artist of his time."[318]

Full recognition was slow in coming for F.H. Varley, but it accumulated over the last years of his life. In 1961, he was awarded an honorary degree from the University of Manitoba. The following year, he received the Canada Council Medal for the Arts.

VARLEY'S FRIENDS SPEAK

Friendships, numerous and varied, sustained Fred Varley over his lifetime. Some were enduring, some were short-lived, but we can assume that all were intense, for that was the essence of the man. We thought it fitting to conclude our study by giving the last word to those who knew him.

Arthur Lismer, on Varley's beginnings (taken from Arthur Lismer, "Portrait of the Artist — An Artistic Reminiscence," *Montreal Gazette*, January 8, 1955):

> He was a student at the Sheffield School of Art, one of those worthy institutions founded in order to raise the standards of design in regional industries. We younger students knew him as a fine draughtsman. I can recall his life drawings on view in the class room: I can even remember my first impression of him. A man with a ruddy mop of hair — and it was red — which burned like a smouldering torch on top of a head that seemed to have been hacked out with a blunt hatchet. That colour was the symbol of a fire in his soul…. He was always rebellious, individual, anything but conventional — he was adventurous of spirit, vacillating in his human relations and always friendly with the kind of people who felt about life as he did.
>
> Looking back over fifty years, one may say that Varley as a personality and as an artist emerged at this period: his restlessness, sensitivity, and his search for something beyond the

materialism of the age, something beyond outward forms — all were there. The influence and events of early life had produced in him an individuality of outlook, a strength and a poetic vision. We have since seen them grow.

Erica Leach of Kelowna, on the summer of 1940 (interviewed by Karen Close, January 2006):

The Duncans had a beautiful cottage on the Bay of Quinte and Leo [a nickname for Varley] was staying with them. I remember when Ulric and I arrived it was dreadfully hot and they were playing archery on the lawn by the lake. It was decided we'd go for a swim so I quickly changed into bathing attire — a pink ruffled thing. When I came out of the water Leo said, "Oh Venus." This sounds ridiculous but I was very, very young and I was attractive. Leo's immediate attention was flattering, although I remained shy and withdrawn. Still he seemed to see me more clearly than I saw myself, and to sense my need to open. I spent about four or five days at the cottage. Leo and I had marvellous long walks in the fields. I loved the elms, the way they grew in shapes that I'd never seen before in the Okanagan. It was around the end of May or June. The hot weather had arrived and there were hay stacks and lots of colour. Seeing the surroundings through his eyes was a revelation.

I was aware that I gave affection, not at all because he was an artist but because he was another human being with whom I felt simpatico. I don't know how else to explain it. I guess it is when one feels totally at ease with another person. I think probably what I was reacting to was his generosity of giving. I feel very defensive of the reputation that is bandied about that he was a womanizer, a philanderer. A man who philanders is taking, grabbing. That was not Varley. He was eager to give from his talent. Perhaps that is hard for many to understand and so they interpret him according to their own way of being.

The artist in Toronto, 1950s (taken from John Gould, *Journals*, Moonstone Books, 1996):

Malloneys was afternoon home to the celebrated Fred Varley, whose studio was only a block away. Varley, doomed by Canadian critics to Group of Seven typecasting, was seen as a leading exemplar of landscape painting. But he was much more. He was an epic survivor of early Canadian burnout, a great portraitist, encompassing Augustus John, eastern mysticism and German expressionism, the embodiment of the Bohemian spirit, courtly of manner, dressed in ubiquitous corduroys, dark shirts, woven ties. Although physically slight, he was riveting to watch: the battered face of an ex–featherweight boxer, prominent cheekbones, thick white hair, not an extra pound on him — in his seventies by that time but moved like a kid.

What I learned from him during long sessions at Malloneys was commitment. He told me: "You must put your whole being into it." My respect for his portrait drawings was total. The touch was light and accurate. Sometimes it seemed that a light emanated from inside the model. His line was as sure as Holbein's.

I remember the sound of Varley on the word "form," which emerged as something like "foam." Both his British background and a slight impediment could lead to difficulties in interpretation. But when he spoke of form, he sang it out in capitals. Form was God.

Civil servants from nearby Queen's Park government offices often drank at Malloneys. The greatest art lecture I've ever heard was delivered by Fred Varley to a booth crowded with bureaucrats. The subject: the gradual revelation of form in nature. God knows how the improbable seminar took wing, but it did. Varley, by now well lubricated by Boilermakers, transformed a routine conversation into a solo performance. Suddenly, Malloneys' bar was hushed.

He described a mountaintop in British Columbia in the early morning. He had camped out overnight and now faced a fog-shrouded peak. He lay in the grass, watching the peak change as the sun rose, observing alterations of colour, nuances of revealed light. Little by little the mist cleared, allowing him to see the crag for what it really was. Form was creating itself in front of his eyes. In a calm, exact description he recreated a mountain, a description of such compelling authority that nobody dared reach for a drink while he spoke. It lasted no more than four or five minutes.

Charles S. Band, on the later years (C.S. Band, Toronto, excerpt from "The Later Years," *F.H. Varley, 1915–1954 Retrospective*, p. 8):

My first meeting with Fred Varley was on the day I called at his Bloor studio after his return from Ottawa and Montreal. It was in the summer of 1945, and he was doing a self-portrait. I was interested and watched him paint. We talked about his work and the events of those disturbing days at the end of the war.

I knew that life was not easy for him. He was completely dependent on his own work and still willing barely to exist rather than paint unless he had something to say. When the self-portrait was finished — and it is included in this retrospective exhibition — the turmoil and tension of those anxious days was impressively revealed.

Since that time certain qualities in Varley's character have made a lasting impression on me, and I have continued to see him and to respect his work and to feel fortunate to have in my collection several of his larger canvases and a number of drawings.

There is an integrity about him whenever he paints, and he never indulges in repetition. Varley is a great lover of nature, the changing moods of the day, of clouds, sunsets, and the magic of colour. His landscapes have a strong romantic flavour, often an intense spiritual quality. His portraits drawn or painted are always individual expressions. Very few Canadians can express themselves with such sincerity and power.

Varley reads extensively and is well informed on world events. He has a real appreciation and knowledge of music, and had he not chosen to be a painter, music might well have been his profession.

But there is another Fred Varley, the bohemian, the gaily attired, the carefree, one who has an understanding of his fellow man and likes to exchange his thoughts and ideas with those who accept his modest hospitality. Security for himself has never entered into his scheme of things.

In his mature years Varley still possesses an ardent spirit and great energy. His work still speaks for it.

CHRONOLOGY

FREDERICK HORSMAN VARLEY (1881–1969)

1881 Born January 2 in Sheffield, England.

1892–99 Attends Sheffield School of Art.

1900 Enters Académie Royale des Beaux-Arts in Antwerp, Belgium.

1902 Graduates with first-prize silver medals for both painting and drawing from the human figure. Returns to Sheffield. Age 21.

1903 Goes to London in the fall to look for work. Begins illustrating stories for *The Gentlewomen* and *The Sphere*.

1910 Marries Maud Pinder on April 10 and moves back to Sheffield; job as layout man on *Yorkshire Post*.

1912 Leaves for Canada in July. Works for Grip Ltd., Toronto, in August, then for Rous & Mann. Exhibits canvases at the Canadian National Exhibition. Joins Arts and Letters Club in November. Age 31.

1914 Beginnings of Group of Seven. Joins Tom Thomson, A.Y. Jackson, and Arthur Lismer with his family at Algonquin Park.

1916 Holds one-man show at Arts and Letters Club in February. Age 35.

1918 Commissioned for the Canadian War Records, February 7. Sails on RMS *Grampian* to Glasgow on March 26 with fellow war artists Cullen, Beatty, and Simpson. Assigned portrait work in Studio #5, The Mall, Parkhill Road, London. Goes to France September 1; back in the Mall in early November, preparing canvases for exhibition.

1919 Paints portraits of Lieutenant McKean, Captain O'Kelly, and others, including artist Cyril Barraud. Enters Canadian War Memorials exhibition at Burlington House, London. Sails for Canada August 1.

1920 Active as portraitist. Demobilized March 31. Exhibits twelve works in first Group of Seven show, May 7. Age 39.

1924 Work included in *British Empire Exhibition* in England. Through W.J. Philips, obtains portrait commission in Winnipeg, speaking engagement, and two commissions in Edmonton. Away from Toronto from mid-January to late April.

1926 Receives appointment to teach at Vancouver School of Decorative and Applied Arts. Leaves Toronto early September. Age 45.

1930 Holds one-man show in winter at Art Institute of Seattle; teaches there for six weeks in summer.

1933 Resigns from Vancouver School of Decorative and Applied Arts and, together with J.W. (Jock) Macdonald and Harry Täuber, founds British Columbia College of Arts.

1936 Exhibits in Group of Seven Show at the National Gallery of Canada. Commissioned to paint portrait of H.S. Southam, leaves B.C. and goes to Ottawa. Shares space with Alex Castonguay, a photographer, at 126A Sparks Street. Teaches at Ottawa Art Association. Age 55.

1938 Shows six canvases at the Tate Gallery, London, including *Vera*, 1930, and *Self-Portrait*, 1919. Receives official invitation to travel to Arctic on RMS *Nascopie*. Leaves Montreal July 9 and returns to Halifax September 30.

1944 Solo show at Eaton's Fine Art Galleries, Toronto.

1948 Meets Jess Crosby at Grenville Street studio. In June, starts teaching at Doon School of Fine Arts near Kitchener. Age 63.

1950 Eaton's show gets high praise but few sales. Reviewed in *Globe and Mail* and *Saturday Night*. Spends part of summer working around Belfountain, where Jess Crosby has cottage.

1952 Meets Kathleen McKay and paints *Studio Door*. His last letter from Grenville studio dated December 5. Age 71.

1953 Moves to Donald and Kathleen McKay's Toronto residence on Lowther Avenue during winter illness.

1954 Travels to Soviet Union in April with other Canadian artists, writers, and musicians. First retrospective exhibition at Art Gallery of Toronto opens on the night of Hurricane Hazel.

1956 One-man show at Roberts Gallery. Age 75.

1964 Retrospective exhibition at Willistead Art Gallery, Windsor, April 12 to May 17. Awarded Canada Council Medal for 1963. Age 83.

1969 Dies September 8. Age 88.

WORKS IN THE EXHIBITION

Not all the works will travel to each venue.
Each of the exhibitions cited took place during Varley's lifetime.

Cat. 1 (fig. 1)
Portrait of Samuel J. B. Varley (The Artist's Father), c. 1900
Charcoal on buff wove paper, 37.8 x 37 cm
National Gallery of Canada, Ottawa
Gift of Ethel Varley, Sheffield, England, 1969, in memory of the artist (15912)

Cat. 2 (pl. 1)
Indian Summer, 1914–15
Oil on canvas, 97.8 x 95.3 cm
Private Collection
Exhibitions: AGT 1954, no. 1, repr.

Cat. 3 (fig. 22)
Sketch of James, 1915
Graphite on paper, 20 x 19 cm
Varley Art Gallery, Town of Markham
Purchase, Varley-McKay Art Foundation (2006.4.1)

Cat. 4 (pl. 2)
Portrait of Captain C.P.J. O'Kelly, V.C., 1918
Oil on canvas, 102.5 x 76.5 cm
Beaverbrook Collection of War Art, Canadian War Museum (19710261-078)
Exhibitions: NGC 1923, no. 109; AGT 1926 (War Memorials), no. 233

Cat. 5 (pl. 3)
Portrait of Lieutenant G.B. McKean, V.C., 1918
Oil on canvas, 102.3 x 76.7 cm
Beaverbrook Collection of War Art, Canadian War Museum (19710261-0767)
Exhibitions: NGC, 1924, no. 112; AGT 1926 (War Memorials), no. 234; AGT 1954, no. 2

Cat. 6 (pl. 4)
Cyril H. Barraud, 1919
Oil on board, 38.1 x 33 cm
Art Gallery of Ontario, Toronto
Purchased with funds donated by AGO members, 1990 (90/41)

Cat. 7 (pl. 5)
Gypsy Head, 1919
Oil on canvas, 61.6 x 50.8 cm
National Gallery of Canada, Ottawa
Gift of Norman M. Paterson, Fort William, Ontario, 1947 (4836)
Exhibitions: AGT 1925, no. 56 (as *Character Study*); Paris 1927, no. 242; NGC 1936 (Group of Seven), no. 183, repr.; London 1938, no. 215, repr.; New Haven 1944, no number, repr.; Albany, 1946, no. 51; Boston 1949, no. 96; Richmond 1949, no. 75; Washington, D.C. 1950, no. 84; AGT 1954, no. 7, repr.

Cat. 8 (pl. 6)
Janet, 1919
Oil on canvas, 60.9 x 50.8 cm
Gift of Mrs. Jean Stickney, the Beaverbrook Art Gallery, Fredericton,
N.B. (1959.267)
Exhibitions: Fredericton 1955, no. 38 (as *Janet Gladys Aitken*)

Cat. 9 (pl. 7)
Self-Portrait, 1919
Oil on canvas, 60.5 x 51 cm
National Gallery of Canada, Ottawa
Purchased 1936 (4272)
Exhibitions: CNE 1920, no. 136; RCA 1920, no. 249; AMT 1921, no. 52;
WGA 1921, no. 31, repr.; Worcester 1924, no. 23; NGC 1926, no. 167;
Philadelphia 1926, no. 1556; Buffalo 1928, no. 50; New York 1932, no. 48;
NGC 1933, no. 270; NGC 1936 (Group of Seven), no. 195; London 1938,
no. 216; AGT 1954, no. 6, repr.; Windsor 1964, no. 4, repr.; NGC 1967, no. 45

Cat. 10 (pl. 8)
Portrait of Barker Fairley, 1920
Oil on canvas, 61.1 x 51.2 cm
National Gallery of Canada, Ottawa
Gift of Barker Fairley, Toronto, 1950 (5031)
Exhibitions: AMT 1920, no. 105 (as *Character Sketch — Prof. Barker
Fairley*); AGT 1954, no. 8; Stratford 1967, no. 28

Cat. 11 (pl. 9)
Portrait of Vincent Massey, 1920
Oil on canvas, 120.6 x 141.0 cm
Collection of Hart House, University of Toronto (20.1)
Exhibitions: AMT 1920, no. 102; CNE 1920, no. 135, repr.; Wembley
1924, no. 251, repr.; NGC 1936 (Group of Seven), no. 182 (as *Hon.
Vincent Massey*); London 1938, no. 182 (as *Hon. Vincent Massey*);
NGC 1967 (Centenary), no. 209, repr.

Cat. 12 (pl. 10)
John, c. 1920–21
Oil on canvas, 61.7 x 51 cm
National Gallery of Canada, Ottawa
Purchased 1921 (1787)
Exhibitions: OSA 1921, no. 144; Wembley 1924, no. 253; Paris 1927,
no. 240, repr.; NGC 1936 (Group of Seven), no. 176; NGC 1936
(Contemporary), no. 99; New Haven 1944, no number; CNE 1950, no.
52; AGT 1954, no. 11; Windsor 1964, no. 5

Cat. 13 (fig. 20)
Mary Kenny, 1920–21
Charcoal with chalk pastel on paper, 37.5 x 29.9 cm
The McMichael Canadian Art Collection, Kleinburg
Gift of Mrs. E.J. Pratt (1969.1)

Cat. 14 (pl. 11)
Mrs. E., 1920–21
Oil on canvas, 103.2 x 86.4 cm
Art Gallery of Ontario, Toronto
Gift of Mrs. E.F. Ely, Toronto, 1946 (2852)
Exhibitions: AMT 1921, no. 49; CNE 1921, no. 256, repr.; WGA 1921, no.
34; NGC 1936 (Group of Seven), no. 180 (as *Mrs. Ely*); CNE 1939, no.
219 (as *Portrait of Mrs. Ernest Ely*); CNE 1952, no. 22; AGT 1954, no. 13

Cat. 15 (pl. 12)
The Sunflower Girl, 1920–21
Oil on canvas, 60.1 x 50.8 cm
Private Collection
Exhibitions: CNE 1921, no. 255 (as *Sun Flowers*); WGA 1921, no. 28;
Worcester 1924, no. 24; OSA 1924, no. 199; NGC 1936 (Group of
Seven), no. 184

Cat. 16 (pl. 13)
Margaret Fairley, 1921
Oil on canvas, 76.8 x 57.2 cm
Art Gallery of Ontario, Toronto
Gift of Mrs. Fairley, 1958 (57/17)
Exhibitions: AMT 1921, no. 50 (as *Portrait of Mrs. F.*); CNE 1921, no.
257 (as *Portrait of Mrs. F.*); Buffalo 1928, no. 48 (as *Portrait of Mrs.
Fairley*); Windsor 1964, no. 12; NGC 1967, no. 46, repr.

Cat. 17 (pl. 14)
Portrait of Huntley K. Gordon, 1921
Oil on canvas, 36.4 x 26.3 cm
Collection of Hart House, University of Toronto
Huntley Gordon, gift of the estate to Hart House in 1961

Cat. 18 (pl. 15)
The Immigrants, c. 1921
Oil on canvas, 152.4 x 182.9 cm
The Thomson Collection
Exhibitions: AMT 1921, no. 55 (as *Decorative Panel*); RCA 1923, no.
243; RCA 1924, no. 200 (as *Decorative Panel*); CNE 1926, no. 233 (as

Decoration, "Immigrants"); NGC 1936 (Group of Seven), no. 198 (as *Decorative Panel — Immigrants*)

Cat. 19 (pl. 16)
Portrait of Primrose Sandiford, c. 1921–22
Charcoal and chalk on paper, 40 x 33.2 cm
Private Collection

Cat. 20 (fig. 24)
Maud, August 30, 1922
Charcoal on paper, 22.9 x 25.4 cm
Private Collection
Exhibitions: OSA 1923, no. 202 (as *Woman's Head*)

Cat. 21 (pl. 17)
Peter Sandiford at Split Rock, Georgian Bay, 1922
Oil on panel, 21 x 26.7 cm
Art Gallery of Ontario, Toronto
Gift in Memory of Dr. Martin Baldwin by the Art Institute of Ontario, 1968 (6815)

Cat. 22 (pl. 18)
Rocky Shore, 1922
Oil on canvas, 100 x 69.9 cm
Private Collection
Exhibitions: Worcester 1924, no. 22 (as *Landscape and Figure*); AGT 1926 (Group of Seven), no. 117 (as *Lake Shore with Figure*); AGT 1926 (Canadian), no. 193 (as *Lake Shore with Figures*); Buffalo 1928, no. 53 (as *Landscape with Figure*)

Cat. 23 (fig. 28)
Trevor Garstang, 1923–25
Graphite on paper, 21 x 28.6 cm
Private Collection

Cat. 24 (fig. 27)
Head of Kathleen Calhoun, 1924
Charcoal on paper, 40 x 31.1 cm
University of Alberta Art Collection, University of Alberta Museums (1971.5.37)

Cat. 25 (pl. 19)
Kathleen Calhoun, 1924
Charcoal and coloured chalk over charcoal wash on paper, 34.2 x 24.9 cm
Private Collection

Cat. 26 (pl. 20)
Portrait of Chancellor Charles Allan Stuart, 1924
Oil on canvas, 144.5 x 124.4 cm
University of Alberta Art Collection
University of Alberta Museums (1965.30.02)
Exhibitions: AGT 1926 (Group of Seven), no. 110; AGT 1926 (Canadian), no. 196; NGC 1936 (Group of Seven), no. 187

Cat. 27 (pl. 21)
Young Artist at Work, 1924
Oil and pencil on paperboard, 36.2 x 30.4 cm
Vancouver Art Gallery Acquisition Fund (91.6)
Exhibitions: OSA 1924, no. 205; AGT 1926 (Group of Seven), no. 120 (as *The Young Artist*)

Cat. 28 (fig. 21)
John, c. 1924
Graphite on paper, 18.1 x 11.4 cm
Private Collection

Cat. 29 (pl. 22)
Portrait Group (Mrs. R.A. Daly and Her Sons, Dick and Tom), 1924–25
Oil on canvas, 86.5 x 101.7 cm
Art Gallery of Ontario, Toronto
Purchase, 1989 (89/94)
Exhibitions: OSA 1925, no. 229, repr.; RCA 1925, no. 217, repr.; NGC 1936 (Group of Seven), no. 178 (as *Mrs. Daly and Children*); AGT 1954, no. 15 (as *Family Group*)

Cat. 30 (pl. 23)
Portrait of Alice Massey, c. 1924
Oil on canvas, 61.5 x 41.0 cm
Varley Art Gallery, Town of Markham
Purchase, Varley-McKay Art Foundation (2003.3.1)

Cat. 31 (pl. 24)
Alice Massey, c. 1924–25
Oil on canvas, 82.0 x 61.7 cm
National Gallery of Canada, Ottawa
Vincent Massey Bequest, 1968 (15558)
Exhibitions: OSA 1925, no. 228 (as *Portrait, Mrs. Alice Vincent Massey*);
NGC 1926, no. 166 (as *The Green Shawl*)

Cat. 32 (pl. 25)
Portrait of Viola Pratt, c. 1924–25
Oil on canvas, 43.7 x 33.6 cm
From the Collection of the Art Gallery of Greater Victoria
Gift of Harold Mortimer-Lamb (57.11)
Exhibitions: AGT 1926 (Group of Seven), no. 111 (as *Sketch Portrait*)

Cat. 33 (pl. 26)
Portrait of Ellen Dworkin, 1925
Oil on canvas, 43 x 33 cm
Private Collection
Exhibitions: OSA 1926, no. 116 (as *Jewish Girl*)

Cat. 34 (fig. 19)
Portrait of a Male, 1925
Charcoal on paper, 43.75 x 25.63 cm
Varley Art Gallery, Town of Markham
Purchase, Varley-McKay Art Foundation (2005.4.1)

Cat. 35 (pl. 27)
Portrait of Maud, 1925
Oil on canvas, mounted on beaverboard, 60.7 x 50.5 cm
National Gallery of Canada, Ottawa
Purchased 1978 (23152)
Exhibitions: Los Angeles 1925, no. 238 (as *The Artist's Wife*); NGC
1927, no. 203 (as *Portrait of the Artist's Wife*); RCA 1928, no. 153 (as
Portrait of the Artist's Wife); NGC 1929, no. 164 (as *Portrait of the
Artist's Wife*)

Cat. 36 (pl. 28)
Janet P. Gordon, c. 1925–26
Oil on canvas, 81.3 x 61.0 cm
Art Gallery of Ontario, Toronto
Bequest of Huntley K. Gordon, Toronto, 1950, conveyed 1973 (73/9)
Exhibitions: OSA 1926, no. 115, repr. (as *Portrait of a Lady*); NGC 1936
(Group of Seven), no. 181 (as *Mrs. Gordon*)

Cat. 37 (pl. 29)
Study of Joan (Fairley), 1925–26
Oil on canvas, 43.2 x 33 cm
The Thomson Collection
Exhibitions: AGT 1926 (Group of Seven), no. 118 (as *Joan*); CNE 1926,
no. 232

Cat. 38 (fig. 31)
Eddie Garstang, 1926
Graphite on paper, 21 x 28.6 cm
Private Collection

Cat. 39 (fig. 23)
Portrait of James, c. 1926–27
Graphite on paper, 20.3 x 14.6 cm
Private Collection

Cat. 40 (fig. 36)
Vera, 1926–29
Graphite on paper, 40.5 x 30.5 cm
Collection of Ed and Donna Andrew
Exhibitions: NGC 1932, no. 290

Cat. 41 (fig. 32)
Sketchers, c. 1927
Graphite on paper, 35.4 x 39.8 cm
The McMichael Canadian Art Collection, Kleinburg
Purchase, 1969 (1981.33)
Exhibitions: RCA 1928, no. 238

Cat. 42 (pl. 30)
Head of Vera, c. 1928
Oil on canvas, 32.2 x 35.5 cm
The McMichael Canadian Art Collection, Kleinburg
Gift of Mr. J.D. Young (1974.19.2)

Cat. 43 (pl. 31)
Vera, c. 1929
Oil on canvas, 81.8 x 66.7 cm
National Gallery of Canada, Ottawa
Purchased 1930 (3712)
Exhibitions: NGC 1930, no. 156; NGC 1930 (Willingdon), no number;
EMA 1931, no. 20; AGGV 1967, no. 35

Cat. 44 (pl. 32)
J.W.G. Jock Macdonald, 1930
Oil on canvas, 50.7 x 45.9 cm
Collection of the Winnipeg Art Gallery
Acquired with funds from the Winnipeg Foundation and an
Anonymous Donor (#G-72-9)

Cat. 45 (pl. 33)
Vera, 1930
Oil on canvas, 61 x 50.6 cm
National Gallery of Canada, Ottawa
Vincent Massey Bequest, 1968 (15559)
Exhibitions: RCA 1930, no. 163; New York 1932, no. 49; London 1938,
no. 214; Washington, D.C. 1950, no. 85, repr.; NGC 1953 (Coronation),
no. 68; AGT 1954, no. 17, repr.; VAG 1954, no. 73, col. repr.; NGC 1967,
no. 237, repr.

Cat. 46 (pl. 34)
Vera, c. 1930
Oil on canvas, 30.5 x 30.5 cm
Private Collection
Exhibitions: AGT 1954, no. 212; Windsor 1964, no. 16

Cat. 47 (pl. 35)
Portrait of H. Mortimer-Lamb, c. 1930
Oil on board, 45.9 x 35.7 cm
Collection of the Vancouver Art Gallery
Gift of Mr. H. Mortimer-Lamb (41.2)

Cat. 48 (fig. 33)
Catharina Vanderpant, c. 1930
Charcoal, pastel, and gouache on paper, 33 x 27.9 cm
Vanderpant Collection

Cat. 49 (pl. 36)
Portrait of John Vanderpant, c. 1930
Oil on panel, 34.9 x 45.1 cm
Vanderpant Collection

Cat. 50 (fig. 39)
Portrait of Täuber, c. 1930
Chalk on paper, 28.4 x 21.5 cm
From the Collection of the Art Gallery of Greater Victoria
Harold and Vera Mortimer-Lamb Purchase Fund (85.9)

Cat. 51 (pl. 37)
Girl's Head, c. 1931
Oil on panel, 47.3 x 55.5 cm
Collection of the Vancouver Art Gallery
Gift of Ruth Van Dusen (98.64)

Cat. 52 (pl. 38)
Complementaries, 1933
Oil on canvas, 101 x 85 cm
Art Gallery of Ontario, Toronto
Bequest of Charles S. Band, 1970 (69/128)
Exhibitions: NGC 1933, no. 269; NGC 1936 (Group of Seven), no. 196;
Ottawa 1937, no number; London 1938, no. 196; AGT 1954, no. 20

Cat. 53 (pl. 39)
Head of a Girl, c. 1933
Oil on panel, 30.3 x 30.3 cm
The Montreal Museum of Fine Arts
Gift of F.N. Southam (1937.661)

Cat. 54 (pl. 40)
Green and Gold, Portrait of Vera, c. 1933–34
Oil on canvas, 61 x 50.9 cm
Collection of Neil J. Kernaghan
Exhibitions: NGC 1936 (Group of Seven), no. 197 (as *Portrait, Green
and Gold*); Ottawa 1937, no number

Cat. 55 (fig. 40)
Marie, 1934
Conte on paper, 32.9 x 21.6 cm
Art Gallery of Ontario, Toronto
Purchase, 1937 (2414)
Exhibitions: RCA 1934, no. 230; AGT 1954, no. 303

Cat. 56 (pl. 41)
Portrait of Vera, c. 1935
Oil on canvas, 92.7 x 77.5 cm
The Thomson Collection

Cat. 57 (fig. 42)
Head of a Girl, c. 1936
Black chalk, charcoal, and charcoal wash on wove paper, 23.9 x 23.1 cm
National Gallery of Canada, Ottawa
Purchased 1936 (4305)

Exhibitions: AGT 1954, no. 305, repr.; Dallas 1958, no number; Windsor 1964, no. 22, repr.; NGC 1967 (Centenary), no. 236, repr.

Cat. 58 (pl. 42)
Vera, c. 1936
Watercolour and charcoal on paper, 28.7 x 21.5 cm
From the Collection of the Art Gallery of Greater Victoria
Gift of Mrs. Mortimer-Lamb in memory of her husband (70.112)
Exhibitions: AGGV 1967, no. 36, repr.

Cat. 59 (pl. 43)
Mirror of Thought, 1937
Oil on canvas, 48.8 x 59.2 cm
From the Collection of the Art Gallery of Greater Victoria
Gift of Harold Mortimer-Lamb (78.104)

Cat. 60 (fig. 41)
Philip Surrey, 1937
Charcoal and stump on wove paper, 36.8 x 29 cm
Art Gallery of Ontario, Toronto
Gift of Philip Surrey, Montreal, 1988 (88/116)

Cat. 61 (pl. 44)
Portrait of Mrs. Kate Alice Surrey, 1937
Oil on plywood, 38.1 x 30.5 cm
Art Gallery of Alberta Collection
Gift of Mr. Philip Surrey, 1981 (81.53)

Cat. 62 (pl. 45)
Portrait of Alan Butterworth Plaunt, 1939
Oil on canvas, 60 x 40 cm
Private Collection

Cat. 63 (fig. 44)
Erica, 1940
Charcoal and chalk on paper, 30.6 x 21.5 cm
Private Collection

Cat. 64 (fig. 45)
Head Study, 1940
Charcoal, chalk and lipstick on paper, 30.4 x 22.5 cm
Private Collection

Cat. 65 (pl. 46)
Nancy Cameron, c. 1940
Coloured chalk on paper, 28.1 x 24.4 cm
Private Collection

Cat. 66 (pl. 47)
The Immigrant Ship, 1941
Chalk and watercolour on paper on board, 50.2 x 40.7 cm
The McCord Museum of Canadian History, Montreal (M2000.83.121)

Cat. 67 (pl. 48)
Erica, 1942
Oil on canvas, 28.2 x 37.1 cm
Collections of Trinity College, University of Toronto

Cat. 68 (pl. 49)
Manya, Portrait of Miriam Kennedy, c. 1942
Oil on panel, 30.5 x 38.1 cm
Michael and Sonja Koerner
Exhibitions: AGGV 1967, no. 38

Cat. 69 (fig. 46)
Catherine, 1943
Charcoal on paper, 27 x 22.6 cm
From the Collection of the Art Gallery of Greater Victoria
Harold and Vera Mortimer-Lamb Purchase Fund (57.9)

Cat. 70 (pl. 50)
Natalie, c. 1943
Oil on board, 38.0 x 29.8 cm
Varley Art Gallery, Town of Markham
Gift of Hugh A. Smyth (1998.2.1)

Cat. 71 (pl. 51)
Self-Portrait, Days of 1943, 1945
Oil on canvas on masonite, 49.5 x 40.7 cm
Collection of Hart House, University of Toronto
Exhibitions: OSA 1946, no. 145; CNE 1949, no. 19; AGT 1954, no. 31, cov. repr.; Windsor 1964, no. 57; NGC 1967, no. 45

Cat. 72 (pl. 52)
Jess, c. 1947–52
Black chalk and watercolour on paper, 27.5 x 26.5 cm
Agnes Etherington Art Centre, Queen's University, Kingston
Bequest of Mrs. J.P. Frances Barwick, 1985 (28-187)
Exhibitions: AGT 1954, no. 315; Windsor 1964, no. 66

Cat. 73 (fig. 49)
Jess, c. 1948
Ink wash on paper, 37.8 x 27.3 cm
Private Collection

Cat. 74 (pl. 53)
Jess, 1950
Oil on canvas, 55.9 x 40.7 cm
Private Collection
Exhibitions: AGT 1954, no. 37; Windsor 1964, no. 65

Cat. 75 (pl. 54)
Jess, 1950
Oil on board, 38.1 x 30.5 cm
Roberts Gallery

Cat. 76 (pl. 55)
Portrait of a Man, c. 1950
Oil on canvas, 69.3 x 45.5 cm
The McMichael Canadian Art Collection, Kleinburg
Gift of the Founders, Robert and Signe McMichael (1966.16.138)
Exhibitions: AGT 1954, no. 38 (as *Portrait Study*)

Cat. 77 (fig. 47)
Portrait of Samuel E. Weir, 1951
Charcoal on paper, 38 x 30.5 cm
Collection of the Weir Foundation, Queenston, Ontario

Cat. 78 (fig. 48)
Frances E. Barwick, 1952
Black chalk on paper, 48.3 x 33 cm
Carleton University Art Gallery, Ottawa
The Jack and Frances Barwick Collection, 1985

Cat. 79 (fig. 50)
Head of Kathy, c. 1952–53
Charcoal and pencil on paper, 38.0 x 32.0 cm

Varley Art Gallery, Town of Markham
The Estate of Kathleen Gormley McKay (1996.1.77)

Cat. 80 (pl. 56)
Laughing Kathy, c. 1952–53
Oil on board, 38.3 x 30.0 cm
Varley Art Gallery, Town of Markham
The Estate of Kathleen Gormley McKay (1996.1.78)
Exhibitions: AGT 1954, no. 223

Cat. 81
Studio Entrance, c. 1952–53
Pencil and chalk on paper, 34.2 x 24.5 cm
Varley Art Gallery, Town of Markham
The Estate of Kathleen Gormley McKay (1996.1.76)

Cat. 82 (pl. 57)
Studio Door, c. 1952–53
Oil on canvas, 101.6 x 76.5 cm
The Montreal Museum of Fine Arts
Purchase, Horsley and Annie Townsend Bequest (1959.1216)
Exhibitions: AGT 1952, no. 85; NGC 1953, no. 73 (as *Studio Entrance*);
CNE 1954, no. 6 (as *Studio Entrance*); Windsor 1964, no. 81

Cat. 83 (pl. 58)
Kathy, c. 1954
Graphite and coloured chalks on paper, 28.6 x 21.0 cm
Art Gallery of Ontario, Toronto
Gift from the Fund of the T. Eaton Co. Ltd. For Canadian Works of
Art, 1954 (53/21)

Cat. 84 (pl. 59)
Florence Deacon, 1955
Oil on canvas, 43.3 x 53.3 cm
Deacon family, Unionville, Ontario

Cat. 85 (pl. 60)
Portrait of Nancy Robinson, c. 1962
Mixed media, 24.8 x 19.7 cm
Roberts Gallery

Cat. 86 (fig. 54)
Young Girl, c. 1964
Charcoal on paper, 26.7 x 23.5 cm
Collection of Dan Driscoll and Paula Driscoll

SELECTED EXHIBITIONS

Each of the exhibitions cited took place during Varley's lifetime.

AMT 1920
Group of Seven, Art Museum of Toronto, May 7–27, 1920.

CNE 1920
Canadian National Exhibition: Paintings by Canadian Artists, Toronto, August 28–September 11, 1920.

RCA 1920
Royal Canadian Academy of Arts: Forty-second Annual Exhibition, Art Association of Montreal, from November 18, 1920.

AMT 1921
Exhibition of Paintings by the Group of 7, Art Museum of Toronto, May 7–29, 1921.

CNE 1921
Canadian National Exhibition: Paintings by British and Canadian Artists and International Graphic Art, Toronto, August 27–September 10, 1921.

OSA 1921
Ontario Society of Artists Forty-ninth Annual Exhibition, Art Gallery of Toronto, from October 8, 1921.

WGA 1921
Canadian Art Today, Winnipeg Gallery of Art, October 15–December 10, 1921.

NGC 1923
Exhibition of Canadian War Memorials, National Gallery of Canada, Ottawa, January 5–March 31, 1923.

OSA 1923
Small Picture Exhibition by Members of the Ontario Society of Artists, Art Gallery of Toronto, from October 20, 1923.

RCA 1923
Royal Canadian Academy of Arts: Forty-fifth Annual Exhibition, Art Gallery of Toronto, November 22, 1923–January 2, 1924.

NGC 1924
Second Exhibition of Canadian War Memorials, National Gallery of Canada, Ottawa, January 18–April 30, 1924.

Worcester 1924
Exhibition of Paintings by Canadian Artists, Worcester Art Museum, Worcester, Massachusetts, April 6–27, 1924. Part of a larger U.S. tour, starting at the Minneapolis Institute of Arts in 1923.

Wembley 1924
British Empire Exhibition, Canadian Section of Fine Arts, Wembley Park, London, England, April 23–October 31, 1924.

OSA 1924
Small Picture Exhibition by Members of the Ontario Society of Arts, The Robert Simpson Co., Art Galleries, Toronto, November 8–22, 1924.

RCA 1924
Royal Canadian Academy of Arts: Forty-sixth Annual Exhibition,
National Gallery of Canada, Ottawa, November 20–December 20, 1924.

OSA 1925
Ontario Society of Artists Fifty-third Annual Exhibition, Art Gallery of
Toronto, 1925.

AGT 1925
Group of Seven Exhibition of Paintings, Art Gallery of Toronto, January
9–February 2, 1925.

RCA 1925
Royal Canadian Academy of Arts: Forty-seventh Annual Exhibition, Art
Association of Montreal, November 19–December 20, 1925.

Los Angeles 1925
First Pan-American Exhibition of Oil Paintings, Los Angeles Museum,
November 27, 1925–February 28, 1926.

NGC 1926
Special Exhibition of Canadian Art, National Gallery of Canada,
Ottawa, January 21–February 28, 1926.

OSA 1926
Ontario Society of Artists Fifty-fourth Annual Exhibition, Art Gallery of
Toronto, March 6–April 5, 1926.

AGT 1926 (Group of Seven)
*Exhibitions of the Group of Seven and Painting, Sculpture and Art in
French Canada*, Art Gallery of Toronto, May 7–31, 1926.

AGT 1926 (Canadian)
Summer Exhibition of Canadian Paintings, Art Gallery of Toronto,
June–July 1926.

Philadelphia 1926
*Paintings, Sculpture and Prints in the Department of Fine Arts, Sesqui-
centennial International Exposition*, Philadelphia, from July 24, 1926.

CNE 1926
*Canadian National Exhibition: Paintings and Sculpture by British,
American, Italian and Canadian Artists; Graphic Art, Applied Art and
Salon of Photography*, Toronto, August 28–September 11, 1926.

AGT 1926 (War Memorials)
Canadian War Memorials, Art Gallery of Toronto, October 2–31, 1926.

NGC 1927
Annual Exhibition of Canadian Art, National Gallery of Canada,
Ottawa, January 11–February 28, 1927.

Paris 1927
Exposition d'art canadien, Musée du Jeu de Paume, Paris, April
10–May 11, 1927.

Buffalo 1928
Exhibition of Paintings by Canadian Artists, Buffalo Fine Arts
Academy, Albright Art Gallery, September 14–October 14, 1928 /
Paintings by Canadian Artists, Memorial Art Gallery, Rochester, New
York, November 14, 1928–January 6, 1929.

RCA 1928
Royal Canadian Academy of Arts: Fiftieth Annual Exhibition, Art
Gallery of Toronto, November 29, 1928–January 8, 1929.

NGC 1929
*Annual Exhibition of Canadian Art; Exhibition by Members of the
Society of Sculptors of Canada*, National Gallery of Canada, Ottawa,
January 28–February 28, 1929.

NGC 1930
Annual Exhibition of Canadian Art, National Gallery of Canada,
Ottawa, January 23–February 28, 1930.

NGC 1930 (Willingdon)
Willingdon Arts Competition, National Gallery of Canada, Ottawa,
May 1930.

RCA 1930
Royal Canadian Academy of Arts: Fifty-first Annual Exhibition, Art
Gallery of Toronto, November 1930.

EMA 1931
Edmonton Museum of Arts Loan Exhibition, October 19–25, 1931.

NGC 1932
Seventh Annual Exhibition of Canadian Art, National Gallery of
Canada, Ottawa, January 22–February 23, 1932.

New York 1932
Exhibition of Paintings by Contemporary Canadian Artists, International Art Center of Roerich Museum, New York City, March 5–April 5, 1932 / *Exhibition of Contemporary Canadian Paintings*, Museum of Fine Arts, Boston, April 8–27, 1932 / Kalamazoo Museum and Art Institute, Michigan, May 1932.

NGC 1933
Annual Exhibition of Canadian Art, National Gallery of Canada, Ottawa, February 7–March 6, 1933.

RCA 1934
Royal Canadian Academy of Arts: Fifty-fifth Annual Exhibition, Art Gallery of Toronto, November 2–December 3, 1934.

NGC 1936 (Group of Seven)
Retrospective Exhibition of Painting by Members of the Group of Seven, 1919–1933, National Gallery of Canada, Ottawa, February 20–April 15, 1936 / Art Association of Montreal, April 17–May 3, 1936 / Art Gallery of Toronto, May 1 –June 15, 1936.

NGC 1936 (Contemporary)
Exhibition of Contemporary Canadian Painting, National Gallery of Canada, Ottawa. Arranged on behalf of the Carnegie Corporation of New York for circulation in the southern dominions of the British Empire, September 15, 1936–April 16, 1939.

Ottawa 1937
Frederick Varley, James Wilson and Company, Ottawa, November 1937.

London 1938
A Century of Canadian Art, Tate Gallery, London, October 15–December 15, 1938.

CNE 1939
Canadian National Exhibition: Canadian Painting and Sculpture, Canadian Water Colours, Canadian Graphic Art, British and Canadian Applied Art, Canadian Photography, Toronto, August 25–September 9, 1939.

New Haven 1944
Canadian Art, 1760–1943, Yale University Art Gallery, New Haven, Connecticut, March 11–April 16, 1944.

Albany 1946
Painting in Canada: A Selective Historical Survey, Albany Institute of History and Art, Albany, New York, January 10–March 10, 1946.

OSA 1946
Ontario Society of Artists Seventy-fourth Annual Spring Exhibition, Art Gallery of Toronto, March 9–April 13, 1946.

Boston 1949
Forty Years of Canadian Painting from Tom Thomson and the Group of Seven to the Present Day, Museum of Fine Arts, Boston, July 14–September 25, 1949.

CNE 1949
Canadian National Exhibition, Toronto, August 26–September 10, 1949.

Richmond 1949
Canadian Painting 1668–1948, Virginia Museum of Fine Arts, Richmond, Virginia, February 16–March 20, 1949.

Washington, D.C. 1950
Canadian Painting, National Gallery of Art, Washington, D.C. Exhibition arranged by the National Gallery of Canada and circulated throughout the U.S., October 29, 1950–May 6, 1951 / Shown in Vancouver, May 15–June 11, 1951.

CNE 1950
Canadian National Exhibition, Toronto, August 25–September 9, 1950.

CNE 1952
Canadian National Exhibition, Toronto, August 22–September 6, 1952.

AGT 1952
Canadian Group of Painters, Art Gallery of Toronto, November 1952 / Montreal Museum of Fine Arts, January 1954.

NGC 1953
Annual Exhibition of Canadian Painting, National Gallery of Canada, Ottawa, March 11–April 7, 1953.

NGC 1953 (Coronation)
Exhibition of Canadian Painting to Celebrate the Coronation of Her Majesty Queen Elizabeth II, National Gallery of Canada, Ottawa, June 2–September 13, 1953.

AGT 1954
F.H. Varley: Paintings, 1915–1954, Art Gallery of Toronto, October–November 1954 / National Gallery of Canada, November–December 1954 / Montreal Museum of Fine Arts, January–February 1955 / Western Tour, February–May 1955.

VAG 1954
Group of Seven, Vancouver Art Gallery, 1954.

CNE 1954
Canadian National Exhibition, Toronto, August 27–September 11, 1954.

Fredericton 1955
Paintings by Old and Modern Masters at the Bonar Law-Bennett Library, University of New Brunswick, Fredericton, 1955.

Dallas 1958
A Canadian Portfolio, Dallas Museum for Contemporary Arts, September 4–November 2, 1958.

Windsor 1964
F.H. Varley Retrospective 1964, Willistead Art Gallery, Windsor, Ontario, April 12–May 17, 1964.

Stratford 1967
Ten Decades, 1867–1967: Ten Painters, Rothman's Art Gallery of Stratford and New Brunswick Museum, Saint John, 1967.

AGGV 1967
Ten Canadians — Ten Decades, Art Gallery of Greater Victoria, April 25–May 25, 1967.

NGC 1967 (Centenary)
Three Hundred Years of Canadian Art: An Exhibition Arranged in Celebration of the Centenary of Confederation, National Gallery of Canada, Ottawa, May 12–September 17, 1967.

NGC 1967
Canadian Painting 1850–1950, National Gallery of Canada, Ottawa, exhibition circulated throughout Canada, January 8, 1967–April 18, 1968.

ENDNOTES

1. Barker Fairley, "F.H. Varley," in *Our Living Tradition: Second and Third Series*, edited by Robert L. McDougall (published in association with Carleton University by University of Toronto Press, 1959), 151–69.

2. Maria Tippett, *Stormy Weather: F.H. Varley, A Biography* (Toronto: McClelland & Stewart, 1998), 11.

3. Maria Tippett claims that a photocopy of this drawing exists in Sheffield City Archives.

4. NGC Library and Archives, The Varley Collection, Peter Varley interview with Ethel Varley, 4–5 Feb. 1969.

5. Michael Tooby, *Our Home and Native Land: Sheffield's Canadian Artists* (Sheffield: Mappin Art Gallery, 1991), 2.

6. Ibid.

7. Ibid.

8. Ibid., 3.

9. Maria Tippett, *Stormy Weather*, 16–17.

10. Arthur Lismer, "Portrait of the Artist — An Artistic Reminiscence," *The Gazette* (Montreal), 8 Jan. 1955.

11. John Hayes, *The Portrait in British Art: Masterpieces Bought with the Help of the National Art Collections Fund* (London: National Portrait Gallery, 1992), 12–16.

12. AGO, Varley Papers, Ethel Varley to F.H. Varley, 18 Jan. 1967.

13. Ibid.

14. Peter Varley, *Frederick H. Varley*. Preface by Jean Sutherland Boggs, appreciation by Joyce Zemans (Toronto: Key Porter Books, 1983), 81.

15. Maria Tippett, *Stormy Weather*, 288, n. 44.

16. Christopher Varley, *F.H. Varley: A Centennial Exhibition* (Edmonton: EAG, 1981), 19.

17. John Hayes, *The Portrait in British Art*, 28.

18. Dianne Sachko Macleod, "Art Collecting and Victorian Middle-Class Taste," *Art History* 10:3 (Sept. 1987): 345.

19. Maria Tippett, *Stormy Weather*, 40–42.

20. Ibid., 41.

21. AEAC, Lawrence Sabbath interview with F.H. Varley, September 1960 [typescript].

22. Michael Tooby, *Our Home and Native Land*, 15.

23. Ibid., 11.

24. Peter Mullen, *The Group of Seven* (Toronto, Montreal: McClelland & Stewart, 1970), 18–19.

25. Maria Tippett, *Art at the Service of War: Canada, Art and the Great War* (University of Toronto Press, 1984), 24–27.

26. Ibid., 45.

27. Ibid., 67.

28. CWM Archives, Captain C.P.J. O'Kelly file.

29. Ibid.

30. CWM Archives, Lieutenant G.B. McKean file.

31. Peter Varley, *Frederick H. Varley*, 86.

32. A.Y. Jackson, "The War Records," *F.H. Varley: Paintings, 1915–1954* (Toronto: AGT, 1954), 5.

33. Andrea Kirkpatrick, "The Portraiture of Frederick H. Varley, 1919 to 1926." Thesis (M.A.), Queen's University, 1986. (Ottawa: National Library of Canada, 1988), 17.

34. Maria Tippett, *Art at the Service of War*, 81.

35. Sir Claude Philips, *Daily Telegraph*, Review section, 7 Jan. 1919.

36. Lord Beaverbrook, "Portrait of a Daughter" (letter to the editor), *Maclean's Magazine*, 13 Feb. 1960: 50.

37. Maria Tippett, *Art at the Service of War*, 94.

38. LAC, MG30, D 401, Varley Papers, F.H. Varley to Maud Varley, 13 Apr. 1924.

39. Augustus Bridle, "E. Wyly Grier, R.C.A.," in *Sons of Canada, Short Studies of Characteristic Canadians* (Toronto: J.M. Dent, 1916), 205.

40. Dennis Reid, *The MacCallum Bequest* (Ottawa: NGC, 1969), 31.

41. Dorothy M. Farr, *J.W. Beatty 1869–1941* (Kingston: AEAC, 1981), 33.

42. Claire Bice, "Conflicts in Canadian Art," *Canadian Art* 16:1 (Feb. 1959): 31.

43. Charles C. Hill, *The Group of Seven: Art for a Nation* (Ottawa: NGC, 1995), 92.

44. AEAC, Lawrence Sabbath interview with F.H. Varley, September 1960 [typescript].

45. A. Lismer, "The Twenties," in *F.H. Varley: Paintings, 1915–1954* (Toronto: AGT, 1954), 6.

46. AEAC, Lawrence Sabbath interview with F.H. Varley, September 1960 [typescript].

47. Peter Varley, *Frederick H. Varley*, 25.

48. In an interview conducted in 1954, Fred Varley recalled a trip to Kingston for the painting of this portrait. In his research for the 1981 retrospective exhibition, Chris Varley raises an argument that the portrait of Dean Cappon was painted at Tom Thomson's shack, which Varley was renting after his return from the First World War. Christopher Varley, *F.H. Varley: A Centennial Exhibition* (Edmonton: EAG, 1981), 58.

49. In W.E. McNeil, "James Cappon, Some Great Men of Queen's," edited by R.C. Wallace (Toronto: Ryerson, 1941), 83. In *Queen's Journal*, 16 Dec. 1920, 2, there is an advertisement for the sale of this reproduction.

50. "Many Pictures by Canadians on Exhibition," *Toronto Globe*, 6 May 1920, 10.

51. Varley approached the commission for Dr. Cameron's portrait with the same intention as the portrait of Dean Cappon, namely working according to established tastes of formal portraiture with the focus on the sitter and his character. Stylistically, the use of a dark background made the integration of the figure more voluminous. "M.L.F.," who reviewed the OSA exhibition for the *Toronto Star*, found its appearance "quite outstanding." "Some Surprises in the Art Exhibition," *Toronto Star*, 18 Mar. 1922, 3. Stansfield also points to a date in 1922, see Herbert H. Stansfield, "Portraits at the OSA," *Canadian Forum* 5:56 (May 1925), 239.

52. Barker Fairley, "Some Canadian Painters: F.H. Varley," *Canadian Forum* 2:19 (Apr. 1922): 594–96.

53. NGC Library and Archives, F.H. Varley documentation file, F.H. Varley to Eric Brown, 7 Dec. 1935.

54. Andrea Kirkpatrick, 203.

55. E.A. Corbett, *Henry Marshall Tory: Beloved Canadian* (Toronto: Ryerson, 1954), 123.

56. UAB Archives, unsigned letter, dated 1922, no. 74-24-52. The note about the $1,000 fee is in UAB Collections curatorial file.

57. James Adam, "The Portrait of Dr. Tory: A Criticism," *The Trail* 7 (July 1923): 6.

58. Another portrait artist painting in the Toronto area, Allan Barr, was working on a commission of an academic portrait of the Chancellor and President of Victoria University, Richard Pinch Bowles, c. 1922. In Barr's portrait, Chancellor Bowles is standing tall against a plain, neutral background. His figure exudes a sense of directness and authority similar to that of Dr. Tory in Varley's portrait. In 1919, Lawren Harris painted an academic portrait, similar in style, of Dr. D. Bruce MacDonald, University of Toronto, using the same conventional, frontal, standing pose.

59. Distinguished educator and former Registrar, Dr. Daniel McIntyre had received an honorary LL.D. from the University of Manitoba in 1912. He served on Government Commissions of education for both Manitoba and Saskatchewan, and played an important role in the founding of the Winnipeg Children's Aid Society, Children's Home, and Institute for the Blind. For more information, see "Pioneer Educationalist Dies" and "City Leaders in Education Pay Tribute," *Winnipeg Tribune*, 16 Dec. 1946, 1, 4.

60. Duncan Campbell Scott, *Walter J. Phillips* (Toronto: Ryerson, 1947), 14.

61. Although there is no evidence confirming that Varley and Phillips knew each other prior to 1923 we could safely assume that they had at least heard of each other through their mutual acquaintance, the war artist Cyril Barraud, whom Varley painted in France. Phillips and Barraud were friends in Winnipeg before the outbreak of the First World War. (Chris Varley interview with Roger Boulet).

62. F.H. Varley to Maud Varley, Tuesday, 15 Jan. 1924, Dr. Daniel McIntyre Collegiate Institute, Winnipeg. Dr. D. McIntyre file, typescript.

63. F.H. Varley to Maud Varley, 21 Jan. 1924, Dr. Daniel McIntyre Collegiate Institute, Winnipeg. Dr. D. McIntyre file, typescript.

64. F.H. Varley to Maud Varley, 2 Feb. 1924, Dr. Daniel McIntyre Collegiate Institute, Winnipeg. Dr. D. McIntyre file, typescript.

65. Ibid.

66. "To Paint Portrait of Chancellor Stuart, Council Favours Proposal," *Gateway* 14:17 (19 Feb. 1924): 1.

67. F.H. Varley to Maud Varley, 2 Apr. 1924.

68. UAB Collections, Curatorial file.

69. F.H. Varley to Maud Varley, 15 Apr. 1924, Dr. Daniel McIntyre Collegiate Institute, Winnipeg, Dr. D. McIntyre file, typescript.

70. James Adam, "The Chancellor's Portrait," *The Trail* 10 (July 1924): 18.

71. The portrait of Chancellor Allan Stuart was included in the 1926 Group of Seven exhibition at the AGT. For further information, see Augustus Bridle's review of the exhibition, "Group of Seven Betray No Sign of Repentance," *Toronto Star Weekly*, 8 May 1926, 5.

72. According to James Adam, during the ceremony Chancellor Stuart was wearing the academic robes of the University of Toronto, black with purple facings and golden borders. See James Adam, "The Chancellor's Portrait," 18.

73. Andrea Kirkpatrick, 223.

74. F.H. Varley to Kathleen Calhoun, dated 15 Apr. 1924, Marlborough Hotel, Winnipeg, private collection, Toronto. The author would like to express her sincere gratitude to the relatives of Kathleen Calhoun who helped so graciously with this research.

75. "Dr. Daniel McIntyre's Portrait Is Unveiled," *Manitoba Free Press*, 31 May 1924, 4.

76. F.H. Varley to Maud Varley, 13 Apr. 1924, Dr. Daniel McIntyre Collegiate Institute, Winnipeg, Dr. D. McIntyre file, typescript.

77. F.H. Varley to Kathleen Calhoun, dated 8 Apr. 1924, Banff, Alberta, private collection, Toronto.

78. *Gwen John and Augustus John*, edited by David Fraser Jenkins and Chris Stephens (London: The Tate Gallery, 2004), cat. no. 77.

79. According to Augustus John, gypsies seemed to possess that rare and most unattainable thing in the world, called freedom. John Rothenstein, *Augustus John* (London, Phaidon, 1945), 11.

80. Augustus John, *Chiaroscuro: Fragments of Autobiography, First Series* (London: Jonathan Cape, 1952), 14.

81. Brian Vesey Fitzgerald, *Gypsies of Britain: An Introduction to Their History* (London: Chapman & Hall, 1944), xvi.

82. In an interview with Mrs. Goldthorpe's grandchildren in 2005, I learned that she may have met Varley during her initial voyage to Canada in 1912 on board the *Corsican*, and that the two could have kept in touch in Toronto from the time of their arrival until the early 1920s. The author would like to express her sincere gratitude to the relatives of Mrs. Goldthorpe for their assistance with this research.

83. This policy of attracting the "ideal immigrant" and turning away those who were viewed as unsuitable should raise many eyebrows in today's society, with its new standards, but at the turn of the twentieth century the Canadian government was no more racist in their way of thinking than the culture of the time. However, difficulties in recruiting the desired number of settlers soon forced Canadian authorities to find candidates from other ethnic groups. Next on the list in descending order were Scandinavians, followed by Germans and Ukrainians. Even groups that were considered less apt to assimilate, like Jews, Italians, South Slavs, Greeks, Syrians, and Chinese, were later added to the list.

84. *Toronto Star Weekly* (3 Mar.–14 Apr. 1923) published a series of articles about the gypsy population in Toronto.

85. In a 1922 CNE Exhibition art catalogue, Varley's *Character Study*, repr. (no. 317) and J.W. Beatty, *Gipsy*, repr. (no. 194).

86. Joyce Zemans, Appreciation, in Peter Varley, *Frederick H. Varley* (Toronto: Key Porter Books, 1983), 58.

87. Hector Charlesworth, "The Group System of Art," *Saturday Night* (24 Jan. 1925): 3.

88. Martha Kingsbury, "The Femme Fatale and Her Sisters," *Woman as Sex Object: Art News Annual* 38, (1972): 182.

89. *The British Portrait 1660–1960*, intro. by Sir Roy Strong (London: The Antique Collectors' Club, 1991), 331–33.

90. Charles C. Hill points to the resemblance in the model painted by Frank Brangwyn in his canvas *The Brass Shop*, 1906. Cited in Andrea Kirkpatrick, 98. Brangwyn's painting was sold at Christie's, London, 7–8 Nov. 1985, lot 23, repr.

91. Ibid., 309.

92. Peter Varley, *Frederick H. Varley*, 15.

93. Ian Montagnes, *An Uncommon Fellowship, The Story of Hart House University of Toronto* (University of Toronto Press, 1969), 5.

94. J.W.L. Forster was considered the official portrait artist for the Toronto Methodist Church and for Victoria College, two institutions with strong ties to the Massey family.

95. ALC Membership Records.

96. NGC Library and Archives, The Varley Collection, Peter Varley interview with Barker Fairley, 23 Apr. 1969.

97. McKenzie Porter, "Varley," *Macleans Magazine*, 7 Nov. 1959: 33.

98. Peter Varley, *Frederick H. Varley*, 99.

99. *Canadian Courier*, 22 May 1920, 6, and "Seven Painters Show Some Excellent Work," *Toronto Daily Star*, 7 May 1920, 3.

100. Rupert Lee, *Canadian Forum* 4:47 (Aug. 1927): 339.

101. NGC Library and Archives, F.H. Varley documentation file, F.H. Varley to Eric Brown, 1 June 1920.

102. NGC Library and Archives, F.H. Varley documentation file, F.H. Varley to Eric Brown, 11 June 1920.

103. LAC, MG 30, D 44, vol. 54, p. 14663, David R. Porter to Sir George Parkin, 17 Aug. 1921, George R. Parkin Papers.

104. NGC Archives, Raleigh Parkin to J.R. Harper, Curator of Canadian Art, 10 Nov. 1960. Sir George Parkin's other son-in-law, William L. Grant, was appointed Canadian liaison officer for the Rhodes Scholars' committee. No doubt Grant would have also consulted his brother-in-law, Vincent Massey, about the choice of artist.

105. See LAC, MG 30, D 44, vol. 54, p. 14458, David R. Porter letter, 13 May 1921, George R. Parkin Papers.

106. NGC Library and Archives, F.H. Varley documentation file, F.H. Varley to Eric Brown, 27 June 1921.

107. LAC, MG 30, D 44, Vol. 54, p. 14663, George R. Parkin Papers, David Porter to Parkin, 17 Aug. 1921.

108. "Progress of Canadian Art Splendidly Demonstrated at Annual Academy Show," *Toronto Globe*, 18 Nov. 1921, 13.

109. Claude Bissell, *The Young Vincent Massey* (University of Toronto Press, 1981), 57.

110. The spring of 1925 has been accepted without much debate since 1954, see George Elliott, "F.H. Varley: Fifty Years of His Art," *Canadian Art* 12:1 (Autumn 1954): 7.

111. F.H. Varley to Kathleen Calhoun, 14 June 1924, private collection, Toronto. The return address Varley provided in his correspondence to Kathleen Calhoun between 1 May 1 and 14 June indicates that he maintained a studio away from his household, namely in the Lombard Building, at 90 Lombard Street. It is quite possible that the sittings with Mrs. Massey took place there.

112. Claude Bissell, *The Young Vincent Massey*, 57.

113. Andrea Kirkpatrick, 230.

114. Ibid.

115. Janet Tenody, "F.H. Varley, Landscapes of the Vancouver Years." Thesis (M.A.), Queen's University, 1983, 169, suggests that the modulation of colour from green to blue dominates in some of Varley's Vancouver landscapes from 1926 onwards and becomes the virtual subject of his paintings from his Vancouver period, 1926–36.

116. "In the Art Galleries," *Mail and Empire*, 14 Mar. 1925.

117. Hector Charlesworth, "Ontario Society of Artists," *Saturday Night* 40:17 (14 Mar. 1925): 3.

118. Herbert H. Stansfield 'Portraits at the OSA," 239; Katsushika Hokusai (1760–1849) is best known for his brilliant colour prints.

119. NGC Library and Archives, F.H. Varley documentation file, F.H. Varley to Eric Brown, 19 Dec. 1935.

120. Hugo McPherson, "The Resonance of Batterwood House," *Canadian Art* 21:2 (Mar./Apr. 1964): 100.

121. "Dr. Tovell Arranges Fine Exhibit of Manuscripts," *Varsity*, 26 Oct. 1926, University of Toronto Archives, Tovell file.

122. ALC Membership Records.

123. Andrea Kirkpatrick, 322.

124. By 1921, Varley was showing less interest in the dramatic silhouetting effects of light, so characteristic of recent portraits such as *C. Barraud*, 1919, *Self-Portrait*, 1919, and *John*, c. 1920–21.

125. NGC Library and Archives, The Varley Collection, Peter Varley interview with Barker Fairley, 23 Apr. 1969.

126. Percy J. Robinson, "The OSA Exhibition," *Canadian Forum* 6:67 (Apr. 1926): 223.

127. Charles C. Hill, *The Group of Seven: Art for a Nation*, 315.

128. Andrea Kirkpatrick, 241.

129. Ibid., 245, n. 3. Despite the fact that Daly only joined the Arts and Letters Club in 1935, family tradition maintains that he was directed to Varley through a Club member. Charles S. Band's name has also been put forward as the one who introduced Daly to Varley, yet Band did not join the Club until 1931.

130. "R.E. Eaton Re-elected Art Gallery President," *Toronto Telegram*, 3 May 1927, 22. Dr. Harold Tovell and Vincent Massey also served on the Council.

131. Letter from R.A. Daly Jr., 12 Aug. 1984, cited in Andrea Kirkpatrick, 242.

132. Peter Varley, *Frederick H. Varley*, 10.

133. Christopher Varley, *F.H. Varley: A Centennial Exhibition*, 68.

134. NGC Library and Archives, The Varley Collection, Peter Varley interview with Jim Varley and Dorothy Sewell, 10 July 1970. Varley's daughter Dorothy and his son James remembered Mrs. Daly driving up in her car for the sittings.

135. Christopher Varley, *F.H. Varley: A Centennial Exhibition*, 66.

136. Herbert H. Stansfield "Portraits at the OSA," 240.

137. Cited in Peter Varley, *Frederick. H. Varley*, 104.

138. One of the two predominant Venetian styles of portrait painting in the 15th and 16th centuries was essentially linear. Figures were rather angular and lines met at angles rather than curves. Flemish artists of the 15th century shared their Italian contemporaries' concern with the problems of painting in a realistic manner, but placed greater emphasis on detail.

139. NGC Library and Archives, The Varley Collection, Peter Varley interview with Barker Fairley, 23 Apr. 1969.

140. Andrea Kirkpatrick, 303, n. 1.

141. In 1919, the University of Toronto had commissioned a portrait of Dr. McPhedran by Curtis Williamson. See Dr. McPhedran Honoured as a Teacher," *University of Toronto Monthly* 21:1 (Oct. 1920): 72. The McPhedrans may have had their own association with the Varleys, through Dr. Irving Heward Cameron, whose

portrait Varley painted for the Faculty of Medicine in 1922, or else as members of the Madawaska Club and friends of Dr. James MacCallum. The Madawaska Club, Go-Home Bay, 1898–1948 (not published, 1923).

142. "Mrs. Alexander McPhedran Philanthropist Dies," *Toronto Daily Star*, 23 Mar. 1927, 11, and Andrea Kirkpatrick, 307–08.

143. Barker Fairley, "The Group of Seven," 147.

144. Ibid.

145. Hector Charlesworth, "The Group System in Art," 3.

146. Peter Varley, *Frederick H. Varley*, 24.

147. Arthur Lismer, quoted in Peter Mellen, *Group of Seven*, 21.

148. NGC Library and Archives, The Varley Collection, Peter Varley interview with Philip Surrey, 15 & 20 July 1969.

149. Robert Stacey, *Hand Holding the Brush: Self Portraits by Canadian Artists* (London Regional Art Gallery, 1983), 59.

150. Barbara Dayer Gallati, *Children of the Gilded Era: Portraits by Sargent, Renoir, Cassatt, and Their Contemporaries* (London: Merrell, 2005), 8.

151. Ibid., 10.

152. Formed during the First World War, the Women's Conservation Committee in Sarnia found a new purpose after the war by focusing on the promotion and support of contemporary Canadian art.

153. Norman Gurd was a friend of Dr. James MacCallum's from their student days at the University of Toronto. For the invitation and the involvement of Gurd and Dr. MacCallum, see Norman Gurd's thank you letter, dated 30 Nov. 1920, Lambton County Library.

154. Norman Gurd to Barker Fairley, 30 Nov. 1920, Lambton County Library, Gurd letters, no. 535.

155. Norman Gurd to Fairley, 7 Dec. 1920, Lambton County Library, Gurd letters, no. 538.

156. Norman Gurd to MacCallum, 16 Dec. 1920, Lambton County Library, Gurd letters, no. 543.

157. Andrea Kirkpatrick, 274.

158. Ibid.

159. Christopher Varley, *F.H. Varley: A Centennial Exhibition*, 26.

160. Fred Varley's sudden interest in painting still lifes was apparently kindled by Billie Pike, a friend of Varley's, whom he often visited in Ottawa. NGC Library and Archives, The Varley Collection, Peter Varley interview with Billie Pike, 10 & 18 May 1969. *The Sunflowers* repr., Peter Varley, *Frederick H. Varley*, 163.

161. Gurd's daughter's recollection recorded by Andrea Kirkpatrick, 182.

162. NGC Library and Archives, The Varley Collection, Peter Varley interview with Barker Fairley, 23 Apr. 1969.

163. Norman Gurd to W. Kenny, 19 Mar. 1921, no. 568.

164. In his correspondence, Norman Gurd refers to a portrait commission of his late friend and business associate, James Henry Kittermaster. He sent Varley a photograph of Kittermaster, and specific instructions about the size of the portrait. However, no record was found to support the carrying out of another commission in Sarnia or the surrounding region.

165. *Toronto Star*, 31 Mar. 1921, 12, announced the award. The play was also published in the *Canadian Magazine*, 58.

166. Christopher Varley implies that the portrait drawing of Primrose Sandiford was one of the three *Child Studies* (nos. 198, 199, 201) in the 1922 OSA exhibition. These were all priced at $50. Our awareness of the provenance of the drawing makes us question the idea that it was offered for sale so soon after being commissioned as a gift. Christopher Varley, *F.H. Varley: A Centennial Exhibition*, 66, fig. 53.

167. G. Blair Laing wrongly assigned a date of circa 1923 to this portrait. G. Blair Laing, *Memories of an Art Dealer* (Toronto: McClelland and Stewart, 1979), fig. 42.

168. Author's interview with Ellen Dworkin's son, Aug. 2006. The author would like to express her sincere gratitude to the relatives of Mrs. Dworkin for their assistance with this research.

169. For further information, see Stephen A. Speisman, *The Jews of Toronto: A History to 1937* (Toronto: McClelland and Stewart, 1979).

170. Author's interview with Ellen Dworkin's son, Aug. 2006.

171. Ibid.

172. Cornelius Varley was the brother of the famed British watercolour artist John Varley, a founding member of the Society of Painters in Watercolour in London in 1804, who also wrote a *Treatise on Zodiacal Physiognomy* in 1828.

173. Gwen John and Augustus John, pl. 53. For further reference on John's portrait of his family, see Mark Evans, *Portraits by Augustus John: Family, Friends and the Famous* (Cardiff: National Museum of Wales, 1988).

174. *Christian Science Monitor*, 28 Mar. 1921: 12.

175. Press Comments on the Canadian Section of Fine Arts, *British Empire Exhibition*, 1924–25 (Ottawa: National Gallery of Canada, 1926): 41–42.

176. NGC Library and Archives, The Varley Collection, Peter Varley interview with Barker Fairley, 23 Apr. 1969.

177. Dorothy Varley was born on 18 August 1910. In recent literature, her year of birth was identified as 1909, which would have placed

it prior to her parents' marriage in 1910. See chronologies in Peter Varley, *Frederick H. Varley*, 197, and Christopher Varley, *F.H. Varley: A Centennial Exhibition*, 190.

178. AGO, Varley Papers, Ethel Varley to F.H. Varley, 7 May 1964.

179. *Maud*, 1919, on the back of a war drawing, repr. Christopher Varley, *F.H. Varley: A Centennial Exhibition*, 54, cat. no. 40.

180. *Maud*, 30 Aug. 1922, repr. Christopher Varley, *F.H. Varley: A Centennial Exhibition*, 54, fig. 40 and 49.

181. *A Woman's Head* by F.H. Varley, *Canadian Forum* 2: 24 (Sept. 1924): 751.

182. *Maud Asleep*, c. 1921–22, repr. Christopher Varley, *F.H. Varley: A Centennial Exhibition*, 68, fig. 56.

183. Augustus Bridle, "Group of Seven Betray No Sign of Repentance," or Peter Varley, *Frederick H. Varley*, 95. In comparison, Hector Charlesworth also observed that "Varley's drawing is almost invariably effective, especially in portraiture, although he is less successful in handling accessories. This is particularly true of *Lake Shore with Figure*, 1914–15, in which the kneeling woman is a "first-rate bit of painting." In Hector Charlesworth, "Toronto and Montreal Painters," *Saturday Night* 41: 27 (22 May 1926): 5.

184. *Pink Wrapper*, 1921, private collection, repr. Peter Varley, *Frederick H. Varley*, 94.

185. Andrea Kirkpatrick, 251.

186. Peter Varley, *Frederick H. Varley*, 19.

187. *Bobcaygeon*, 1923, repr. Christopher Varley, *F.H. Varley: A Centennial Exhibition*, 70, fig. 61. When the Varleys lost their Toronto house in the spring of 1923, E.J. and Viola Pratt offered them their summer place rent-free at Bobcaygeon, Ontario. According to David Pitt, the arrangement helped the Varley family "in a very difficult situation. Not infrequently, too, the grocery bill to feed five extra mouths was paid out of Pratt's meagre pocket." In David G. Pitt, *E.J. Pratt: The Truant Years 1882–1927* (University of Toronto Press, 1984), 226.

188. *Evening in Camp*, 1923, was also conceived at Bobcaygeon, repr. Christopher Varley, *F.H. Varley: A Centennial Exhibition*, 71, fig. 64. According to David Pitt (op. cit.), a large army tent pitched on a wooden platform provided shelter from the elements, and the Pratt's cottage nearby offered the necessary domestic facilities.

189. NGC Library and Archives, The Varley Collection, Peter Varley interview with Barker Fairley, 23 Apr. 1969.

190. Gary Michael Dault, *Barker Fairley Portraits*, with a text by the artist; edited and intro. by Gary Michael Dault (Toronto: Methuen, 1981), xi.

191. NGC Library and Archives, The Varley Collection, Peter Varley interview with Barker Fairley, 23 Apr. 1969.

192. Ibid.

193. Gary Michael Dault, *Barker Fairley Portraits*, xii.

194. AEAC, Lawrence Sabbath interview with F.H. Varley, September 1960 [typescript].

195. Barry Lord, *The History of Painting in Canada: Toward a People's Art* (Toronto: NC Press, 1974), 178.

196. Gary Michael Dault, *Barker Fairley Portraits*, x.

197. Ibid.

198. Massey Diary, 12 Jan. 1911, quoted in Claude Bissell, *The Young Vincent Massey*, 78.

199. Andrea Kirkpatrick, 295.

200. ALC, membership records.

201. Dr. Mason was a member of the Royal College of Dental Surgeons of Ontario, which in 1925 founded the Faculty of Dentistry at the University of Toronto. "Appointed in Charge of Clinical Department R.C.D.S.," *Toronto Telegram*, 24 Sept. 1921 (Mason file, University of Toronto Archives).

202. Peter Varley, *Frederick H. Varley*, 96. Also in an unpublished biography of Dr. Mason in the Faculty of Dentistry Library, University of Toronto, is mentioned his membership at the AGT. During his term as dean, Dr. Mason was also painted by Curtis Williamson, and that portrait is part of the University of Toronto Art Collection.

203. According to Peter Sandiford's daughter, Primrose, the two gentlemen most probably met at a club event. See Andrea Kirkpatrick, 277, and ALC Membership Records.

204. During the academic year 1921/22, Peter Sandiford was a member of the Hart House Art Committee, along with Barker Fairley, and he took part in the decision-making for art purchases for the collection.

205. Barker Fairley recalls the occasion in an interview with the artist's son. NGC Library and Archives, The Varley Collection, Peter Varley interview with Barker Fairley, 23 Apr. 1969.

206. It was, again, Barker Fairley who introduced Fred to E.J. Pratt. NGC Library and Archives, The Varley Collection, Peter Varley interview with Barker Fairley, 23 Apr. 1969.

207. Varley writes from Toronto to Kathleen Calhoun about his teaching at the OCA, letter dated 8 June 1924, private collection, Toronto.

208. Andrea Kirkpatrick, 237 and 238, n. 10.

209. For more on the life of E.J. Pratt, see *E.J. Pratt: His Life and Poetry*, ed. Susan Gingell (University of Toronto Press, 1983), 150.

210. C.B. Sissons, *A History of Victoria University* (University of Toronto Press, 1952), 248.

211. David G. Pitt, *E.J. Pratt: The Truant Years, 1882–1927*, 122–23.

212. E.J. Pratt, *Newfoundland Verse* (Toronto: Ryerson, 1923).

213. In the Group of Seven exhibition at the AGT in 1926, entry no. 111, a "Sketch Portrait from the artist's collection," may well have been the *Portrait of Viola Pratt*.

214. The recollections of the Pratts' daughter that her father had seen the portrait, and Viola's own memory of seeing her portrait at the Varleys' in Vancouver in the summer of 1927, would confirm that it was painted prior to Varley's departure for Vancouver. Claire Pratt to Andrea Kirkpatrick, 7 Apr. 1985, cited in Andrea Kirkpatrick, 238, n. 5.

215. Varley could have met Kathleen Calhoun at an art lecture he gave in Edmonton in 1924. His talk was acknowledged in "Sees Vision of Golden Age of Expression on the Horizon," *Edmonton Journal*, 27 Mar. 1924, 7. Kathleen's brother and his wife, as is evident from his letter to her, knew W.J. Phillips and his wife, Varley's hosts in Winnipeg. In one of his letters from Winnipeg, Varley mentions seeing her brother again during his stay there.

216. Undated interview with Dr. John MacEachran, University of Alberta Collections, curatorial files. Dr. MacEachran recalls that Varley painted a portrait of Kathleen Calhoun and made many sketches of her. Andrea Kirkpatrick, 315.

217. F.H. Varley to Kathleen Calhoun, dated 1 May 1924, private collection, Toronto.

218. Ibid.

219. Herbert H. Stansfield, "Trevor Tremain-Garstang: Artist, Actor and Stage Director," *ETCETERA* (Nov. 1930): 10.

220. Andrea Kirkpatrick, 330–31.

221. The author Mazo de la Roche was living in Toronto. According to Peter Varley, the portrait she commissioned from Varley was her favourite work of art. Peter Varley, *Frederick H. Varley*, 13. Biographer Ronald Hambleton also confirms that information in Ronald Hambleton, *Mazo de la Roche of Jalna* (New York: Hawthorn Books, 1966).

222. The author would like to thank Trevor and Nan Garstang's son for his generosity and help with this research.

223. Edmund Scheuer's portrait was published in the *Toronto Star Weekly*, 10 July 1926, 19. The article on George A. Warburton appeared 17 July 1926, 21; and the one on Ralph Connable, 24 July 1926, 21. The two Canadian soldiers appeared 31 July 1926, 20.

224. Mazo de la Roche's drawing was published in the *Toronto Star Weekly*, 31 July 1926, 33.

225. Charles C. Hill, *The Group of Seven, Art for a Nation* (Ottawa: NGC, 1995), 224.

226. Frederick B. Housser, *A Canadian Art Movement, The Story of the Group of Seven* (Toronto: Macmillan, 1925), 214.

227. NGC Library and Archives, F.H. Varley documentation file, A.Y. Jackson Papers, A.Y. Jackson to Eric Brown, 30 Nov. 1920.

228. Charles Hill, *The Group of Seven, Art for a Nation*, 224.

229. Arthur Lismer, "The Twenties," in *F.H. Varley: Paintings, 1915–1954*, 6.

230. NGC Library and Archives, F.H. Varley documentation file, F.H. Varley to Eric Brown, 17 Aug. 1926.

231. Varley Collection, National Gallery of Canada Library and Archives, Barker Fairley interviewed by Peter Varley, 23 Apr. 1969.

232. Harold Mortimer-Lamb, "The Modern Art Movement in Canada," *The Daily Province* (Victoria), 15 Sept. 1922.

233. J.W.G. (Jock) Macdonald, "Vancouver," in *F.H. Varley: Paintings, 1915–1954*, 7.

234. Ibid.

235. Robert Stacey, "Heaven and Hell: Frederick Varley in Vancouver," in *The Group of Seven in Western Canada* (Calgary: The Glenbow Museum, 2002), 66.

236. Joyce Zemans, *Jock Macdonald: The Inner Landscape, A Retrospective Exhibition* (Toronto: AGO, 1981), 22.

237. Gerald Tyler interview with Ann Pollock, Jan. 1969, quoted in Joyce Zemans, op. cit., 31.

238. NGC Library and Archives, The Varley Collection, Fred Amess, transcript 1955.

239. Maria Tippett, *Stormy Weather*, 159.

240. NGC Library and Archives, The Varley Collection, Peter Varley interview with Fred Amess, 22 June 1970.

241. NGC Library and Archives, The Varley Collection, Peter Varley interview with Jack Shadbolt, 27 May 1970.

242. NGC Library and Archives, The Varley Collection, Peter Varley interview with Orville Fisher, 8 July 1970.

243. NGC Library and Archives, The Varley Collection, interview with Fred Amess [typescript], Apr. 1955.

244. Author's interview with Luciana Benzi, 2005, whose in-laws, Vito Cianci and Sybil Hill, were both students of Varley's at the VSDAA.

245. NGC Library and Archives, The Varley Collection, Peter Varley interview with Fred Amess, 22 June 1970.

246. Arthur Lismer, "The Twenties," 7.

247. Peter Varley, *Frederick H. Varley*, 17.

248. Charles Hill, *John Vanderpant Photographs* (Ottawa: NGC, 1976).

249. VAG, Lorna Farrell-Ward interview with Anna Ackroyd, transcript, n.d.

250. Sheryl Salloum, *Underlying Vibrations: The Photography and Life of John Vanderpant* (Victoria: Horsdal & Shubart, 1995), 1–4.

251. Lilly Koltun, ed. *Private Realms of Light: Amateur Photography in Canada 1839–1940* (Markham: Fitzhenry and Whiteside, 1984). See also Petra Rigby Watson, "John Vanderpant," *C Magazine* (Sept. 1990): 64.

252. Maria Tippett, "Who Discovered Emily Carr," *Journal of Canadian Art History* 1:2 (Fall 1974): 30–35.

253. While in Montreal, Mortimer-Lamb very likely studied art with Laura Muntz and Maurice Cullen.

254. *Arts Victoria* 4:1 (Mar. 1978): 12–14.

255. "Art Gallery Pioneer Photographer — Artist," *Vancouver Sun*, July 1952.

256. Maria Tippett, *Stormy Weather*, 171.

257. NGC Library and Archives, The Varley Collection, Fred Amess, "Varley" [typescript], Apr. 1955.

258. Eswyn Lyster, "Norma," *Westworld* (Jan./Feb. 1982): 82.

259. When John Vanderpant saw *Vera*, 1930, at the NGC in 1931, he wrote to Eric Brown: "Don't you think that Varley's portrait of Vera Weatherbie is one of the best things that West has produced yet?" NGC Library and Archives, F.H. Varley documentation file, Eric Brown Papers, John Vanderpant to Eric Brown, 6 Jan. 1931.

260. NGC Library and Archives, The Varley Collection, Peter Varley interview with Miriam Kennedy, 19 July 1969.

261. McKenzie Porter, "Varley," *Maclean's* 72:23 (7 Nov. 1959): 66. Varley's student Irene Hoffar Reid (1908–1994), in her 1987 interview with Letia Richardson, suggested that Vera shared ideas on art techniques with both Varley and Mortimer-Lamb. According to her, "Varley's change of colour while in Vancouver was a direct result of Weatherbie's influence." Quoted in Jill Pollack, "Portrait Captures Art Legend," *Vancouver Courier*, 25 Aug. 1991, 17.

262. F.H. Varley to Vera Weatherbie, 8 Nov. 1939, quoted in Christopher Varley, *F.H. Varley: A Centennial Exhibition*, 96.

263. NGC Library and Archives, The Varley Collection, Peter Varley interview with James Varley and Dorothy Sewell, 18 May 1970.

264. Letia Richardson, *First Class: Four Graduates from the Vancouver School of Decorative and Applied Arts, 1929: Lilias Farley, Irene Hoffar Reid, Beatrice Lennie, Vera Weatherbie* (Vancouver: Floating Curatorial Gallery, Women in Focus, 1987), 9.

265. "All-Canadian Artists' Pictures on Exhibition," *Vancouver Sun*, 11 May 1932.

266. Ibid.

267. *Vancouver: Art and Artists 1931–1983* (VAG, 1983), 59.

268. MCAC, Varley Papers, "Varley, Information re: Paintings, derived from meetings with Varley Apr. 2nd and 6th," 1954, 2.

269. AEAC, Lawrence Sabbath interview with F.H. Varley, Sept. 1960 [typescript], 11.

270. Ann Davis, *The Logic of Ecstasy: Canadian Mystical Painting 1920–1940* (Toronto, 1992), 84–86.

271. AEAC, Lawrence Sabbath interview with F.H. Varley, Sept. 1960 [typescript], 11.

272. Art Gallery of Alberta, F.H. Varley to Vera Weatherbie, May 1937.

273. NGC Library and Archives, The Varley Collection, Peter Varley interview with Ethel Varley, 4–5 Feb. 1969.

274. NGC Library and Archives, The Varley Collection, Peter Varley interview with Miriam Kennedy, 19 July 1969.

275. NGC Library and Archives, The Varley Collection, Peter Varley interview with Bea Lennie, 4 July 1970.

276. AEAC, F.H. Varley to Vera Weatherbie, n.d. 1936.

277. B.C. Provincial Archives, H. Mortimer-Lamb Papers, MS 2834.

278. McKenzie Porter, "Varley," 66.

279. MCAC, Chris Varley, F.H. Varley to John Varley [transcript], 14 May 1936.

280. Ibid.

281. Peter Varley, *Frederick H. Varley*, 29.

282. *Visions of Canada: The Alan B. Plaunt Memorial Lectures 1958–1992*, edited by Bernard Ostry and Janice Yalden (Montreal: McGill-Queen's University Press, 2004), 565–68.

283. Author's interview with Mrs. Erica Leach, Sept. 2005. Same story recorded by Karen Close, Kelowna, Jan. 2006.

284. NGC Library and Archives, The Varley Collection, Peter Varley interview with Leonard and Reva Brooks, 24 Apr. 1969. Tom Wood became a war artist in the Second World War.

285. John Virtue, *Leonard and Reva Brooks: Artists in Exile in San Miguel de Allende* (Montreal: McGill-Queen's University Press, 2001), 81.

286. Ibid., 84.

287. Karen Close, *Unfinished Women: Seeds from My Friendship with Reva Brooks* (Shanty Bay, Ont.: Yinward Bound, 2001).

288. NGC Library and Archives, The Varley Collection, Peter Varley interview with Miriam Kennedy, 19 July 1969.

289. That drawing is most likely *Manya*, 1941, private collection, repr. Christopher Varley, *F.H. Varley: A Centennial Exhibition*, 152, pl. 170.

290. NGC Library and Archives, The Varley Collection, Peter Varley interview with Miriam Kennedy, 19 July 1969.

291. NGC Library and Archives, The Varley Collection, Peter Varley interview with Louis Muhlstock, 12 July 1969.

292. Author's interview with Gloria Varley, Aug. 2006. The author would like to express her sincere gratitude to Gloria Varley for her assistance with this research.

293. LAC, MG 30, D 401, Varley Papers, F.H. Varley to Jess Crosby, 21 June 1949.

294. NGC Library and Archives, The Varley Collection, Peter Varley interview with Jess Crosby, 11 Dec. 1969.

295. *John Gould Journals* (Moonstone, Ont.: Moonstone Books, 1996).

296. *Berczy*, edited by Rosemarie Tovell (Ottawa: National Gallery of Canada, 1991), 92–97.

297. Peter Varley, *Frederick H. Varley*, 45.

298. The story about the portrait commission was repeated by Toronto artist Gus Weisman, in conversation with the author in the spring of 1999. Weisman had a studio in the same building and recalled seeing Varley's sketch and a subsequent work on canvas in his studio.

299. Maria Tippett interview with Kathleen McKay, 27 Sept. 1995, quoted in *Stormy Weather*, 252.

300. Author's interview with Mrs. Jeannie Wildridge, July 2006. The author would like to express her sincere gratitude to Mrs. Wildridge and her son, Paul Wildridge, the current director of the Roberts Gallery, for their generosity and kindness during the research for this publication.

301. McKenzie Porter, "Varley," 66.

302. AGO, Varley Papers, Kathleen McKay to F.H. Varley, 5 Jan. 1952.

303. AGO, Varley Papers, Kathleen McKay to F.H. Varley, 6 Dec. 1955.

304. Maria Tippett interview with Kathleen McKay, 27 Sept. 1995, quoted in *Stormy Weather*, 252.

305. Maria Tippett, *Stormy Weather*, 255.

306. Author's interview with Mrs. Jennie Wildridge, July 2006.

307. On 31 Jan. 1957, George Hulme wrote to Varley seeking his approval for the NGC to produce ten thousand prints of his famous painting *Stormy Weather*, which were to be manufactured in Montreal and widely distributed to all department stores. Varley replied on 15 Feb. 1957, referring him to S.L. Wildridge. Both letters at the Roberts Gallery Archives, Varley file.

308. AGO, Varley Papers, J.S. Goldie to Kathleen McKay, 17 Oct. [1955].

309. Vancouver Art Gallery, J.S. Goldie to Cooper Campbell, 31 Jan. 1956.

310. Roberts Gallery Archives, F.H. Varley to S.L. Wildridge, 14 Dec. 1955.

311. Author's interview with Mrs. Florence Deacon, July 2006. The author is most grateful to Mrs. Deacon and her sons for their help during the research for this publication.

312. Author's interview with Mrs. Florence Deacon, July 2006.

313. LAC, MG 30, D 373, John Vanderpant Papers, F.H. Varley to John Vanderpant, Easter Monday [1936]

314. Ronald Hambleton, "The Return of Varley," *Mayfair* 18:12 (Dec. 1944), 104.

315. Pearl McCarthy, "Varley of Today Mature in Power," *Globe and Mail*, 4 Nov. 1944.

316. "Varley — A Film Review by George Elliott," *Canadian Art* 10:3 (Spring 1953), 60.

317. George Swinton, "Our Lively Arts — Painting in Canada," *Queen's Quarterly* 62:4 (Winter 1955–56), 543.

318. Mildred Valley Thornton, "Varley Paintings on Display Here," *Vancouver Sun*, 13 Apr. 1955.

SELECTED BIBLIOGRAPHY

Art Gallery of Toronto. *F.H. Varley: Paintings, 1915–1954*. Toronto: AGT, 1954.

Cayzer, Elizabeth. *Changing Perceptions: Milestones in Twentieth-Century British Portraiture*. Brighton: Alpha Press, 1999.

Christensen, Lisa. *A Hiker's Guide to Art of the Canadian Rockies*. Calgary: Fifth House Publishers, 1999.

Christensen, Lisa. *A Hiker's Guide to the Rocky Mountain Art of Lawren Harris*. Calgary: Fifth House Publishers, 2000.

Christensen, Lisa. *The Lake O'Hara Art of J.E.H. MacDonald and Hiker's Guide*. Calgary: Fifth House, 2003.

Davis, Ann. *The Logic of Ecstasy: Canadian Mystical Painting, 1920–1940*. London, Ont.: London Regional Art and Historical Museums, 1990.

Duval, Paul. *A Vision of Canada: The McMichael Canadian Collection*. Toronto: Clarke, Irwin, 1973.

Duval, Paul. *A Heritage of Canadian Art: The McMichael Collection*. Toronto: Clark, Irwin, 1979.

Elliot, G.H. "F.H. Varley — Fifty Years of His Art." *Canadian Art* 12:1 (1954).

Hill, Charles C. *The Group of Seven: Art for a Nation*. Ottawa: National Gallery of Canada, 1995.

Housser, F.B. *A Canadian Art Movement: The Story of the Group of Seven*. 1926. Reprint, Toronto: MacMillan, 1974.

Hunkin, Harry. *A Story of the Group of Seven*. Toronto: McGraw-Hill Ryerson, 1976.

MacTavish, Newton. *The Fine Arts in Canada*. Introduction by Robert McMichael. Toronto: Coles Publishing, 1973.

Mastin, Catharine, and Glenbow Museum. *Group of Seven in Western Canada*. Toronto: Key Porter Books, 2002.

Mellen, Peter. *The Group of Seven*. Toronto: McClelland and Stewart, 1979.

Murray, Joan. *The Best of the Group of Seven*. Edmonton: Hurtig, 1984.

National Gallery of Canada. *Retrospective Exhibition of Painting by Members of the Group of Seven, 1919–1933*. Ottawa: NGC, 1936.

Newlands, Anne. *The Group of Seven and Tom Thomson: An Introduction*. Willowdale, Ont.: Firefly Books, 1995.

Reid, Dennis. *The MacCallum Bequest*. Ottawa: National Gallery of Canada, 1969.

Reid, Dennis. *The Group of Seven*. Ottawa: National Gallery of Canada, 1970.

Reid, Dennis. *The Group of Seven: Selected Watercolours, Drawings, and Prints from the Collection of the Art Gallery of Ontario*. Toronto: Art Gallery of Ontario, 1989.

Russell, John, of London. *British Portrait Painters*. London: W. Collins, 1944.

Silcox, David P. *The Group of Seven and Tom Thomson*. Toronto: Firefly Books, 2003.

Stacey, Robert and Sharon Gaum-Kuchar. *Varley: A Celebration*. Markham, Ont.: Varley Art Gallery of Markham, 1997.

Tippett, Maria. *Stormy Weather: F.H. Varley, A Biography*. Toronto: McClelland and Stewart, 1998.

Tooby, Michael. *Frederick Varley*. Kingston, Ont.: Quarry Press, 1995.

Vann, Philip. *Face to Face: British Self-Portraits in the Twentieth Century*. Bristol: Sansom & Company Ltd., 2004.

Varley, Christopher. *F.H. Varley*. Ottawa: National Gallery of Canada, 1979.

Varley, Christopher. *F.H. Varley: A Centennial Exhibition*. Edmonton: Edmonton Art Gallery, 1981.

Varley, Peter. *Frederick H. Varley*. Preface by Jean Sutherland Boggs, appreciation by Joyce Zemans. Toronto: Key Porter Books, 1983.

Wendorf, Richard. *The Elements of Life: Biography and Portrait-Painting in Stuart and Georgian England*. Oxford: Clarendon Press, 1990.

PLATES | PLANCHES

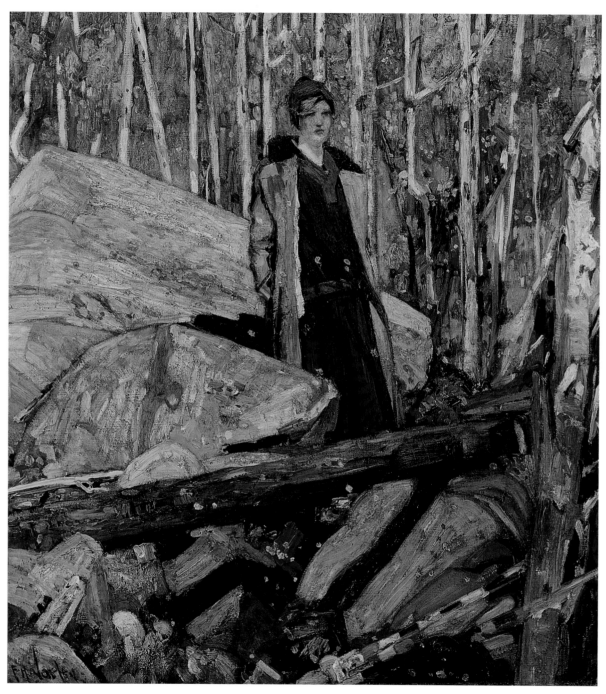

Pl. 1
Indian Summer, 1914–15
Private Collection (cat. 2)

Pl. 1
Été indien, 1914–1915
Collection particulière (cat. 2)

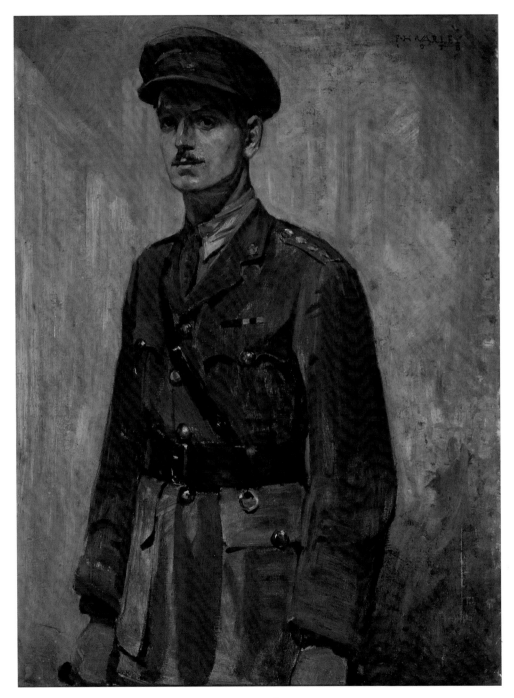

Pl. 2
Portrait of Captain C.P.J. O'Kelly, V.C., 1918
Canadian War Museum, Ottawa (cat. 4)

Pl. 2
Portrait du captaine C.P.J. O'Kelly, V.C., 1918
Musée canadien de la guerre, Ottawa (cat. 4)

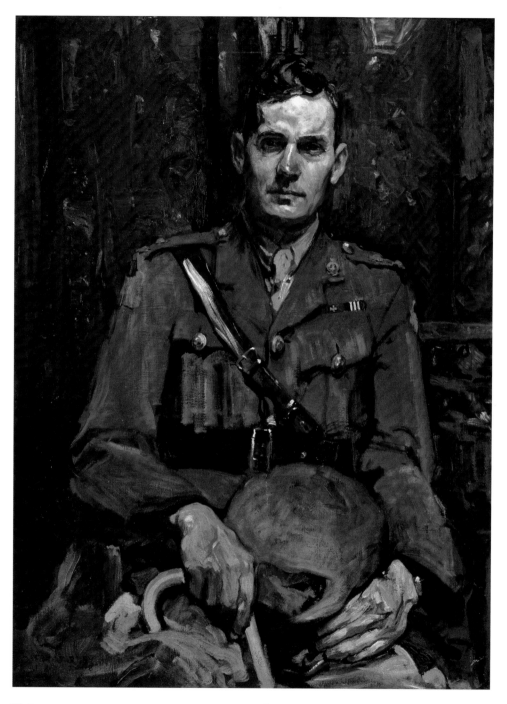

Pl. 3
Portrait of Lieutenant G.B. McKean, V.C., 1918
Canadian War Museum, Ottawa (cat. 5)

Pl. 3
Portrait du lieutenant G.B. McKean, V.C., 1918
Musée canadien de la guerre, Ottawa (cat. 5)

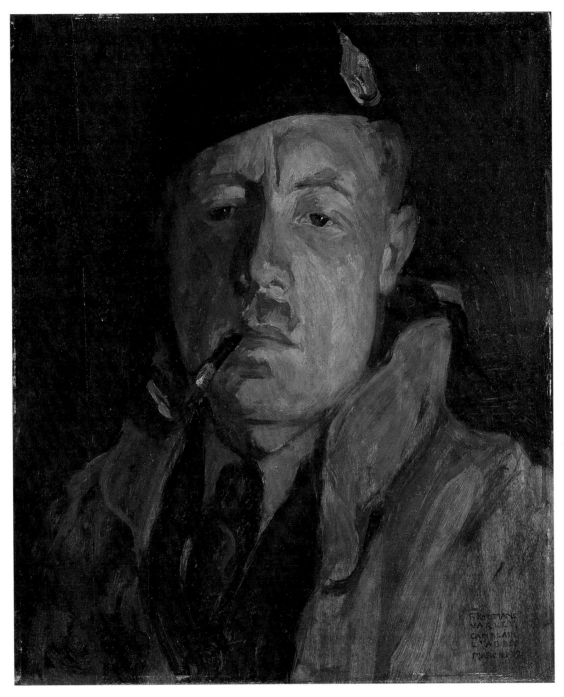

Pl. 4
Cyril H. Barraud, 1919
Art Gallery of Ontario, Toronto (cat. 6)

Pl. 4
Cyril H. Barraud, 1919
Musée des beaux-arts de l'Ontario, Toronto (cat. 6)

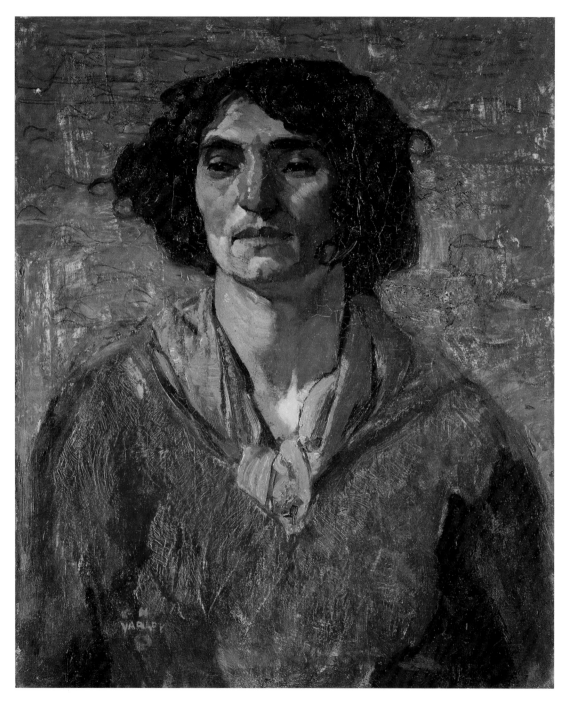

Pl. 5
Gypsy Head, 1919
National Gallery of Canada, Ottawa (cat. 7)

Pl. 5
Gitane, 1919
Musée des beaux-arts du Canada, Ottawa (cat. 7)

Pl. 6
Janet, 1919
Beaverbrook Art Gallery, Fredericton (cat. 8)

Pl. 6
Janet, 1919
Galerie d'art Beaverbrook, Fredericton (cat. 8)

Pl. 7
Self-Portrait, 1919
National Gallery of Canada, Ottawa (cat. 9)

Pl. 7
Autoportrait, 1919
Musée des beaux-arts du Canada, Ottawa (cat. 9)

Pl. 8
Portrait of Barker Fairley, 1920
National Gallery of Canada, Ottawa (cat. 10)

Pl. 8
Portrait de Barker Fairley, 1920
Musée des beaux-arts du Canada, Ottawa (cat. 10)

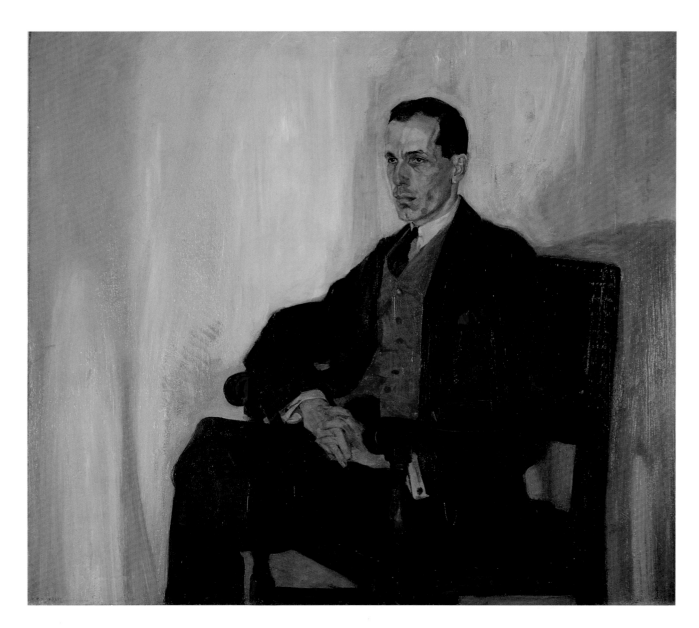

Pl. 9
Portrait of Vincent Massey, 1920
Collection of Hart House, University of Toronto (cat. 11)

Pl. 9
Portrait de Vincent Massey, 1920
Collection de la Hart House, Université de Toronto (cat. 11)

Pl. 10
John, c. 1920–21
National Gallery of Canada, Ottawa (cat. 12)

Pl. 10
John, v. 1920–1921
Musée des beaux-arts du Canada, Ottawa (cat. 12)

Pl. 11
Mrs. E., 1920–21
Art Gallery of Ontario, Toronto (cat. 14)

Pl. 11
Mme E., 1920–1921
Musée des beaux-arts de l'Ontario, Toronto (cat. 14)

Pl. 12
The Sunflower Girl, 1920–21
Private Collection (cat. 15)

Pl. 12
Fillette aux tournesols, 1920–1921
Collection particulière (cat. 15)

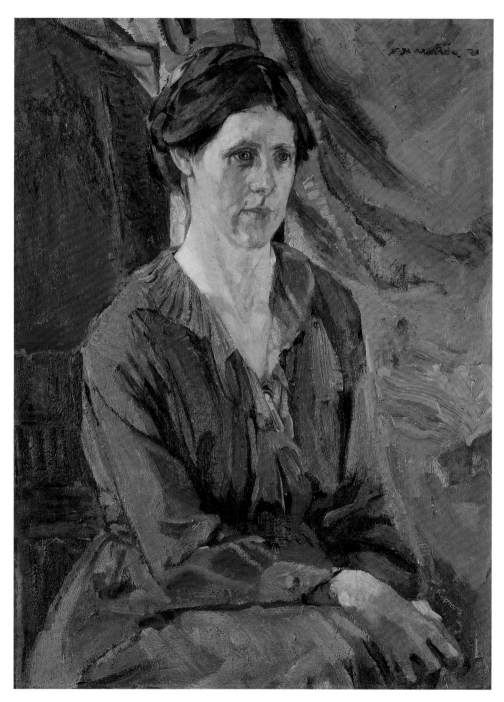

Pl. 13
Margaret Fairley, 1921
Art Gallery of Ontario, Toronto (cat. 16)

Pl. 13
Margaret Fairley, 1921
Musée des beaux-arts de l'Ontario, Toronto
(cat. 16)

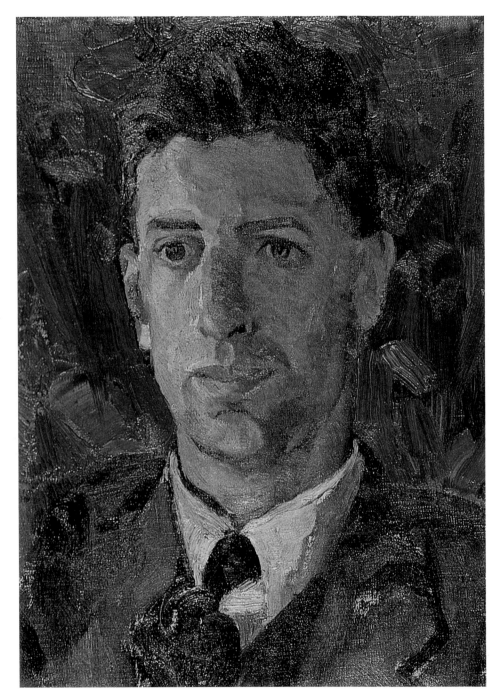

Pl. 14
Portrait of Huntley K. Gordon, 1921
Collection of Hart House
University of Toronto (cat. 17)

Pl. 14
Portrait de Huntley K. Gordon, 1921
Collection de la Hart House
Université de Toronto (cat. 17)

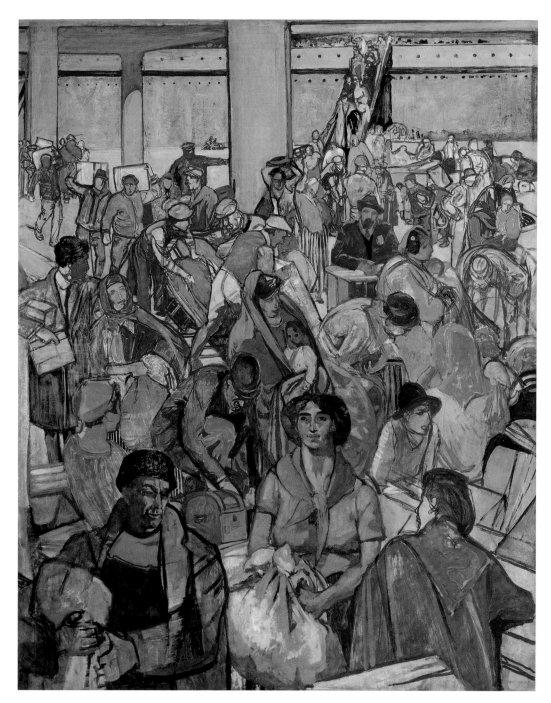

Pl. 15
The Immigrants, c. 1921
The Thomson Collection (cat. 18)

Pl. 15
Les Immigrants, v. 1921
La Collection Thomson (cat. 18)

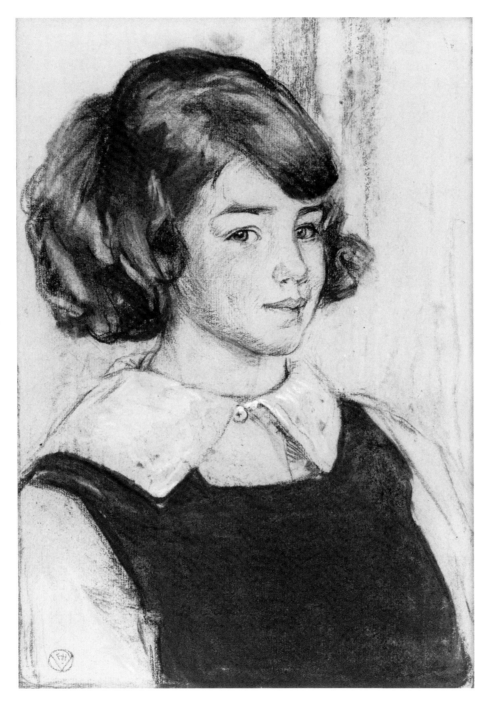

Pl. 16
Portrait of Primrose Sandiford, c. 1921–22
Private Collection (cat. 19)

Pl. 16
Portrait de Primrose Sandiford, v. 1921–1922
Collection particulière (cat. 19)

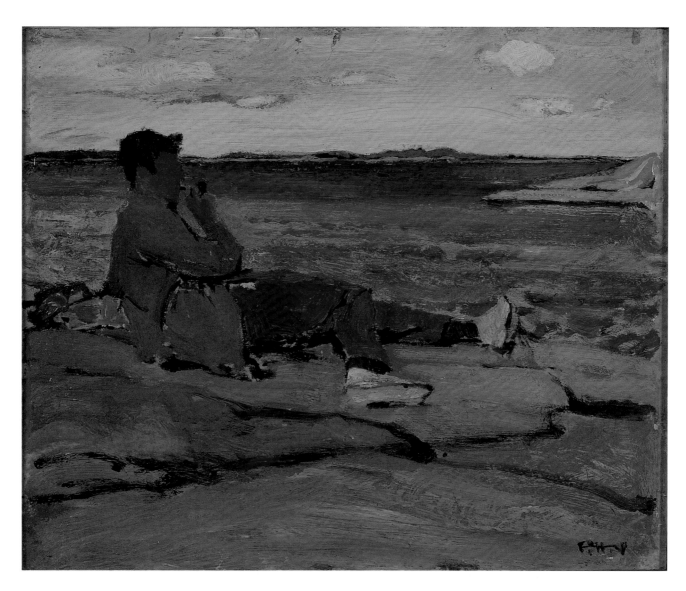

Pl. 17
Peter Sandiford at Split Rock, Georgian Bay, 1922
Art Gallery of Ontario, Toronto (cat. 21)

Pl. 17
Peter Sandiford à Split Rock, baie Georgienne, 1922
Musée des beaux-arts de l'Ontario, Toronto (cat. 21)

Pl. 18
Rocky Shore, 1922
Private Collection (cat. 22)

Pl. 18
Rivage rocheux, 1922
Collection particulière (cat. 22)

Pl. 19
Kathleen Calhoun, 1924
Private Collection (cat. 25)

Pl. 19
Kathleen Calhoun, 1924
Collection particulière (cat. 25)

Pl. 20
Portrait of Chancellor Charles Allan Stuart, 1924
University of Alberta Art Collection
University of Alberta Museums (cat. 26)

Pl. 20
Portrait du chancelier Charles Allan Stuart, 1924
Collection de l'Université de l'Alberta,
Musées de l'Université de l'Alberta (cat. 26)

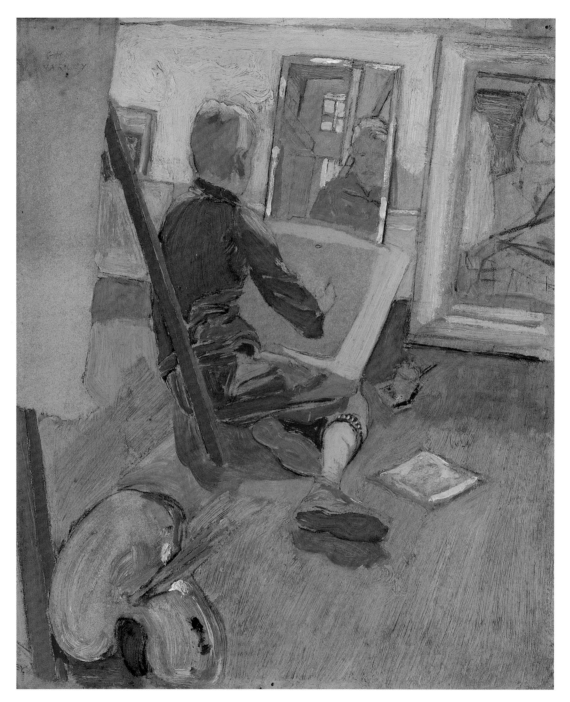

Pl. 21
Young Artist at Work, 1924
Collection of the Vancouver Art Gallery (cat. 27)
Photo: Teresa Healy

Pl. 21
Jeune artiste à l'œuvre, 1924
Collection de la Vancouver Art Gallery (cat. 27)
Photo : Teresa Healy

Pl. 22
Portrait Group (Mrs. R. A. Daly and Her Sons, Dick and Tom),
1924–25
Art Gallery of Ontario, Toronto (cat. 29)

Pl. 22
Portrait de groupe (Mme R. A. Daly et ses fils, Dick et Tom),
1924–1925
Musée des beaux-arts de l'Ontario, Toronto (cat. 29)

Pl. 23
Portrait of Alice Massey, c. 1924
Varley Art Gallery, Town of Markham
(cat. 30)

Pl. 23
Portrait d'Alice Massey, v. 1924
Galerie Varley, Ville de Markham
(cat. 30)

Pl. 24
Alice Massey, c. 1924–25
National Gallery of Canada, Ottawa (cat. 31)

Pl. 24
Alice Massey, v. 1924–1925
Musée des beaux-arts du Canada, Ottawa
(cat. 31)

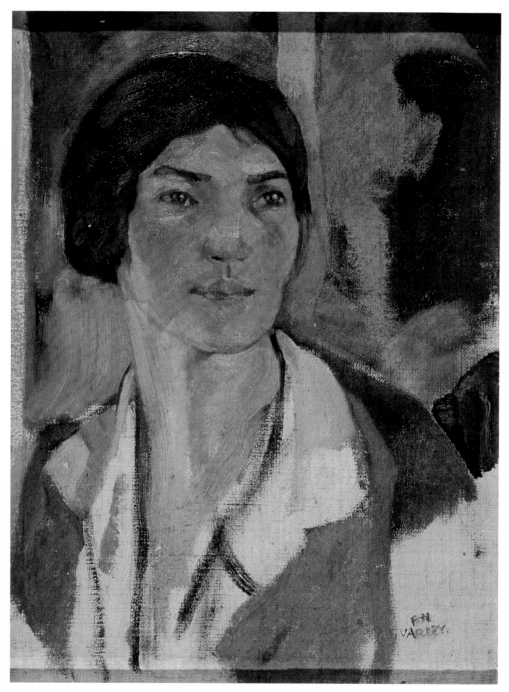

Pl. 25
Portrait of Viola Pratt, c. 1924–25
From the Collection of the Art Gallery of
Greater Victoria (cat. 32)

Pl. 25
Portrait de Viola Pratt, v. 1924–1925
Collection de l'Art Gallery of Greater Victoria
(cat. 32)

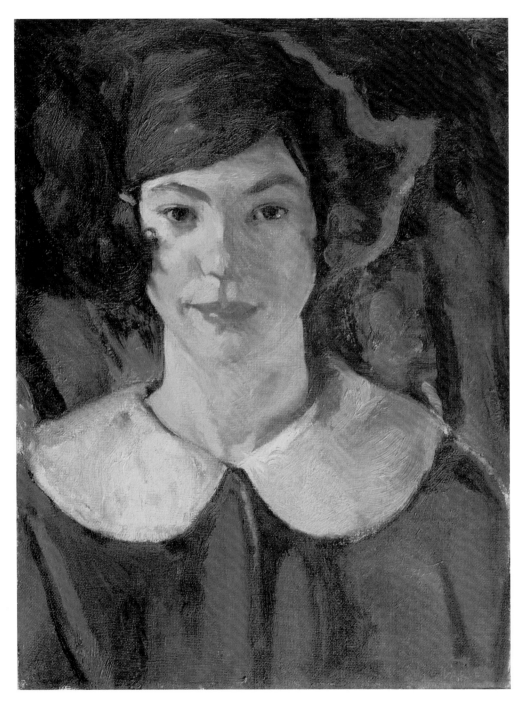

Pl. 26
Portrait of Ellen Dworkin, 1925
Private Collection (cat. 33)

Pl. 26
Portrait d'Ellen Dworkin, 1925
Collection particulière (cat. 33)

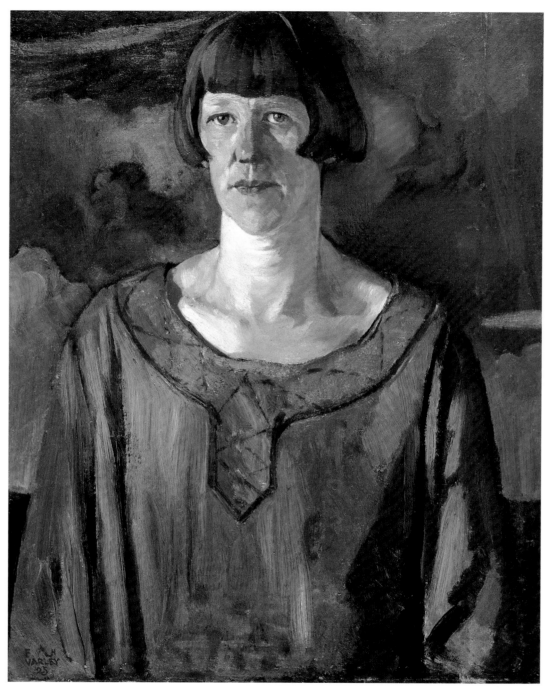

Pl. 27
Portrait of Maud, 1925
National Gallery of Canada, Ottawa (cat. 35)

Pl. 27
Portrait de Maud, 1925
Musée des beaux-arts du Canada, Ottawa (cat. 35)

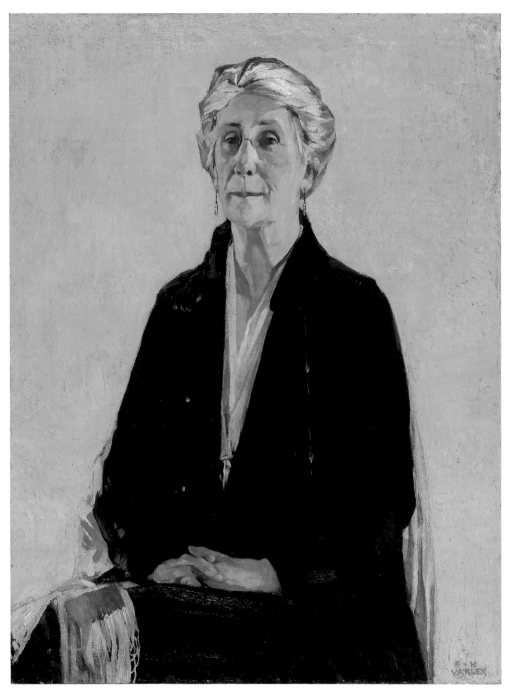

Pl. 28
Janet P. Gordon, c. 1925–26
Art Gallery of Ontario, Toronto (cat. 36)

Pl. 28
Janet P. Gordon, v. 1925–1926
Musée des beaux-arts de l'Ontario, Toronto
(cat. 36)

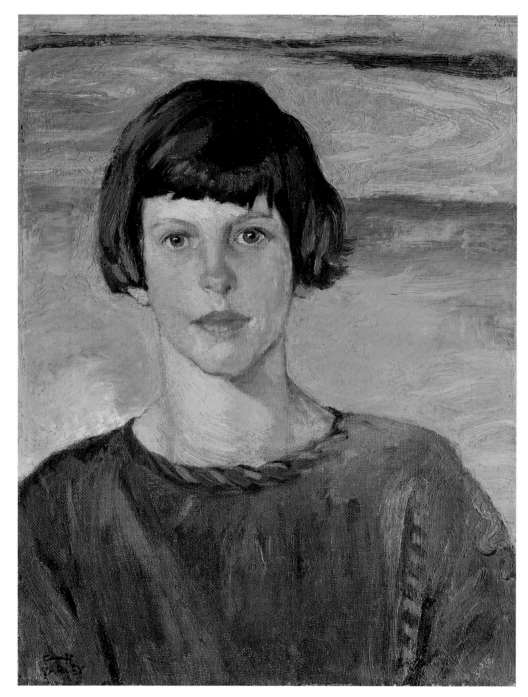

Pl. 29
Study of Joan (Fairley), 1925–26
The Thomson Collection (cat. 37)

Pl. 29
Étude de Joan (Fairley), 1925–1926
La Collection Thomson (cat. 37)

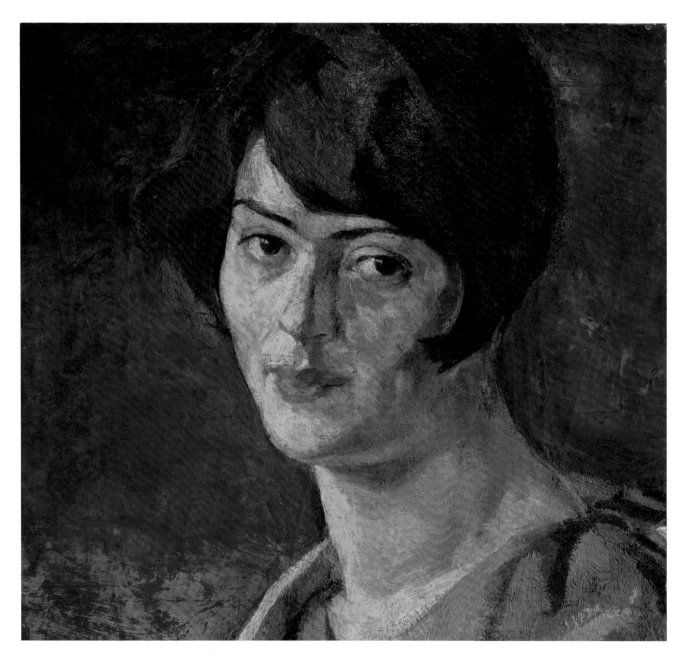

Pl. 30
Head of Vera, c. 1928
The McMichael Canadian Art Collection, Kleinburg (cat. 42)

Pl. 30
Tête de Vera, v. 1928
Collection McMichael d'art canadien, Kleinburg (cat. 42)

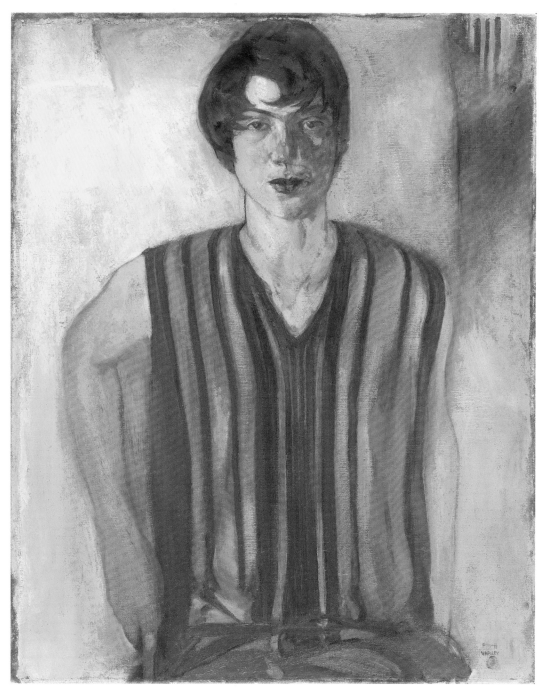

Pl. 31
Vera, c. 1929
National Gallery of Canada, Ottawa (cat. 43)

Pl. 31
Vera, v. 1929
Musée des beaux-arts du Canada, Ottawa (cat. 43)

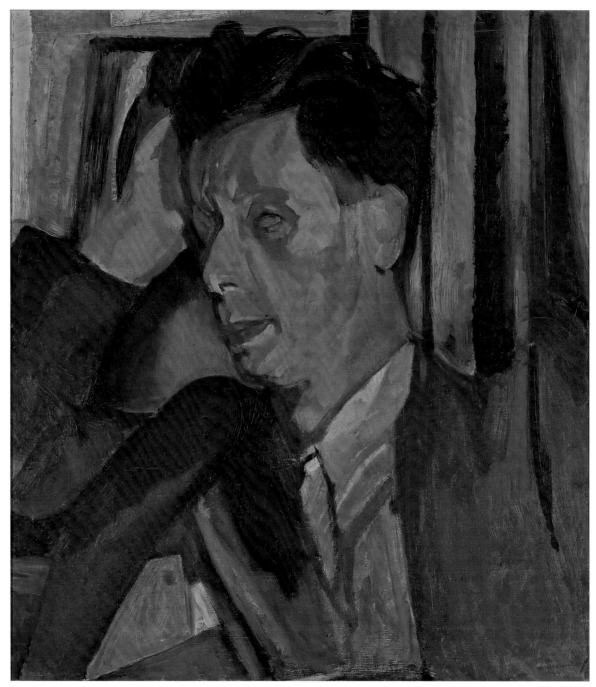

Pl. 32
J.W.G. Jock Macdonald, 1930
Collection of the Winnipeg Art Gallery (cat. 44)
Photo: Ernest Mayer

Pl. 32
J.W.G. Jock Macdonald, 1930
Collection de la Winnipeg Art Gallery (cat. 44)
Photo : Ernest Mayer

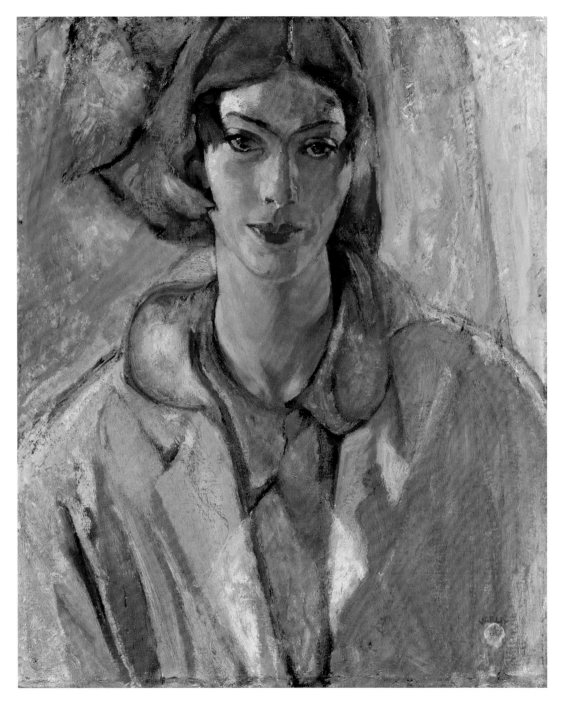

Pl. 33
Vera, 1930
National Gallery of Canada, Ottawa (cat. 45)

Pl. 33
Vera, 1930
Musée des beaux-arts du Canada, Ottawa (cat. 45)

Pl. 34
Vera, c. 1930
Private Collection (cat. 46)
Photo: John Dean

Pl. 34
Vera, v. 1930
Collection particulière (cat. 46)
Photo: John Dean

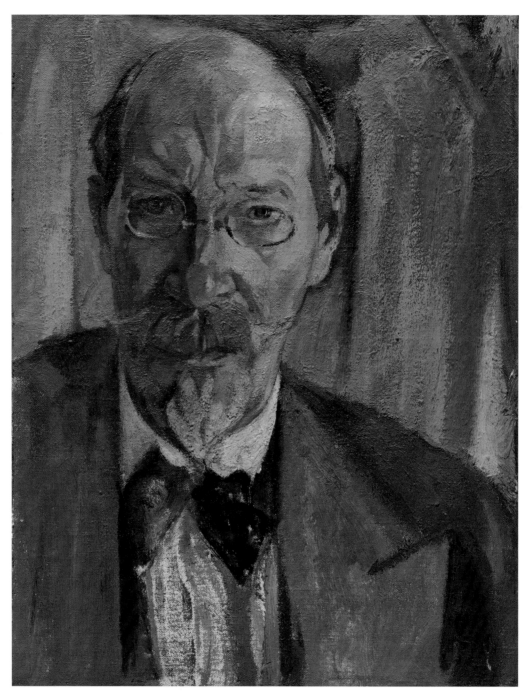

Pl. 35
Portrait of H. Mortimer-Lamb, c. 1930
Collection of the Vancouver Art Gallery (cat. 47)
Photo: Henri Robideau

Pl. 35
Portrait de H. Mortimer-Lamb, v. 1930
Collection de la Vancouver Art Gallery (cat. 47)
Photo : Henri Robideau

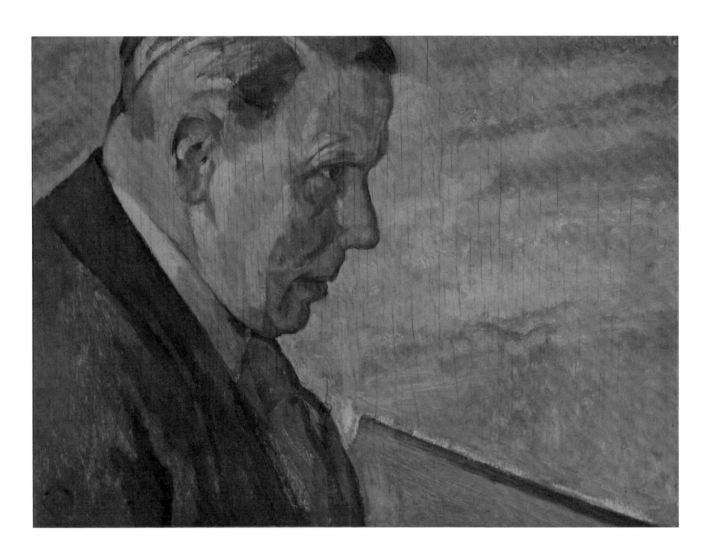

Pl. 36
Portrait of John Vanderpant, c. 1930
Vanderpant Collection (cat. 49)

Pl. 36
Portrait de John Vanderpant, v. 1930
Collection Vanderpant (cat. 49)

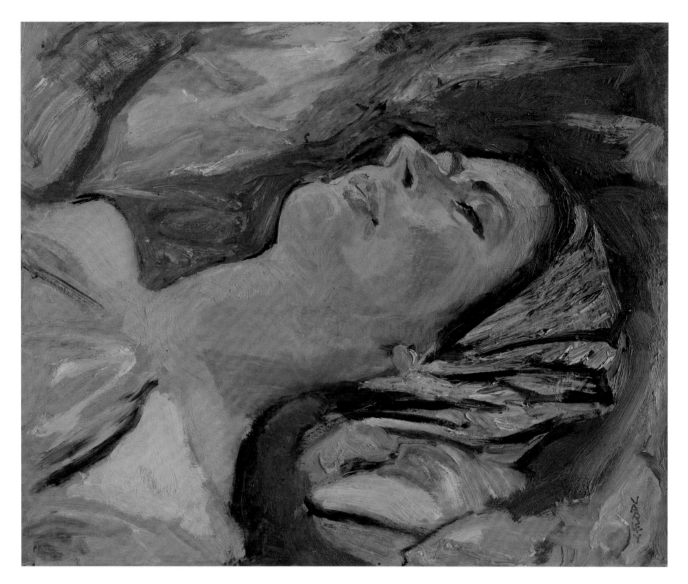

Pl. 37
Girl's Head, c. 1931
Collection of the Vancouver Art Gallery (cat. 51)
Photo: Henri Robideau

Pl. 37
Tête de jeune fille, v. 1931
Collection de la Vancouver Art Gallery (cat. 51)
Photo : Henri Robideau

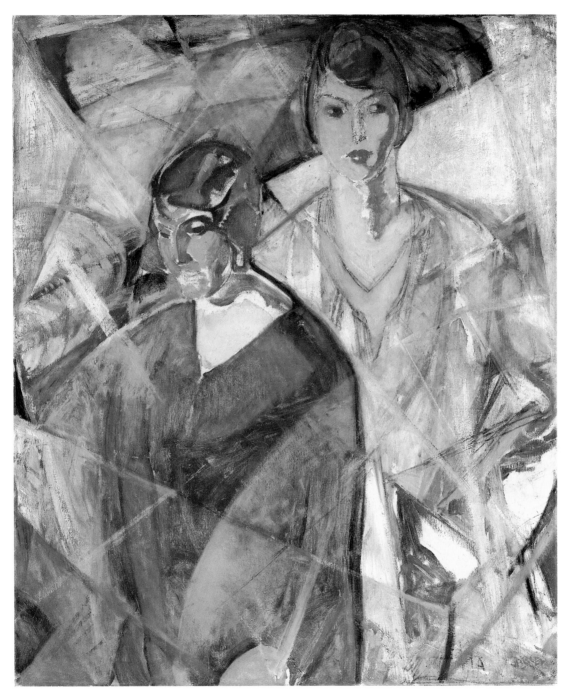

Pl. 38
Complementaries, 1933
Art Gallery of Ontario, Toronto (cat. 52)

Pl. 38
Complémentaires, 1933
Musée des beaux-arts de l'Ontario, Toronto (cat. 52)

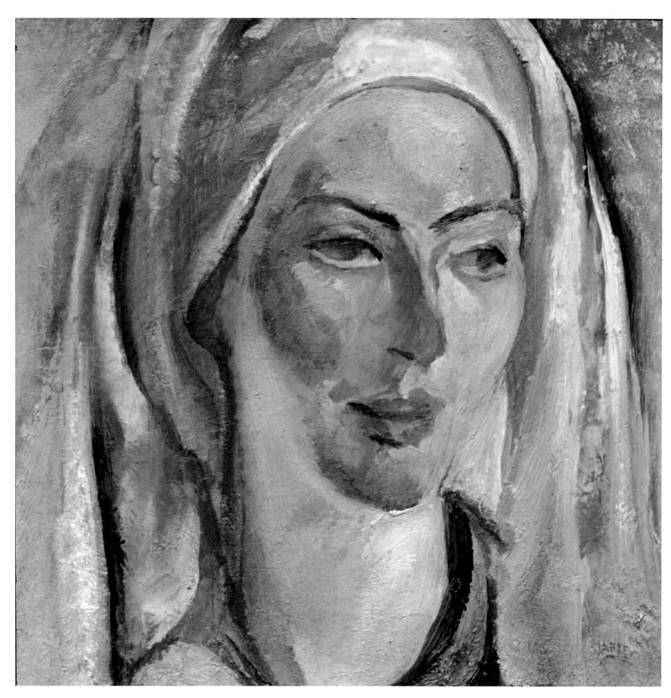

Pl. 39
Head of a Girl, c. 1933
The Montreal Museum of Fine Arts (cat. 53)

Pl. 39
Tête de jeune fille, v. 1933
Musée des beaux-arts de Montréal (cat. 53)

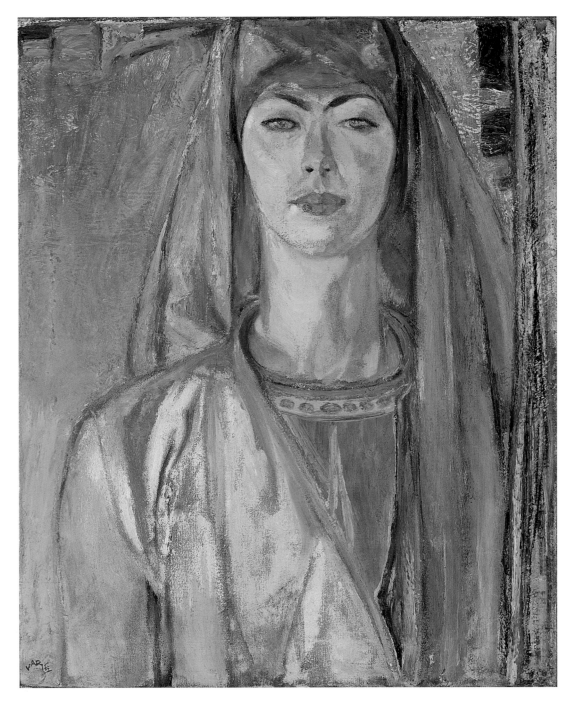

Pl. 40
Green and Gold, Portrait of Vera, c. 1933–34
Collection of Neil J. Kernaghan (cat. 54)

Pl. 40
Vert et or, Portrait de Vera, v. 1933–1934
Collection de Neil J. Kernaghan (cat. 54)

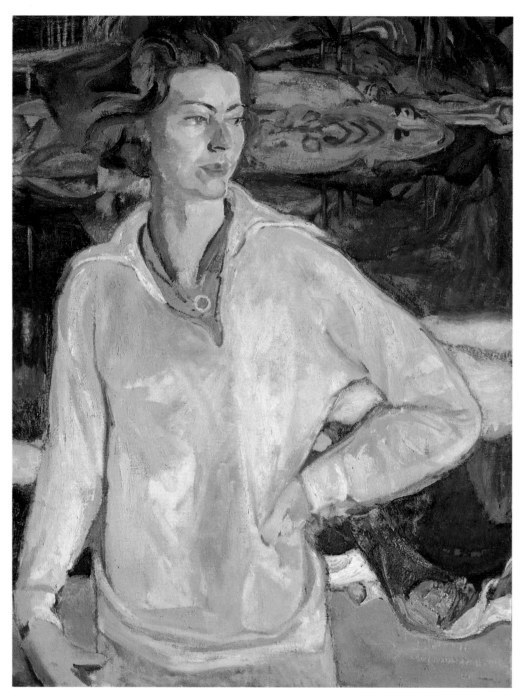

Pl. 41
Portrait of Vera, c. 1935
The Thomson Collection (cat. 56)

Pl. 41
Portrait de Vera, v. 1935
La Collection Thomson (cat. 56)

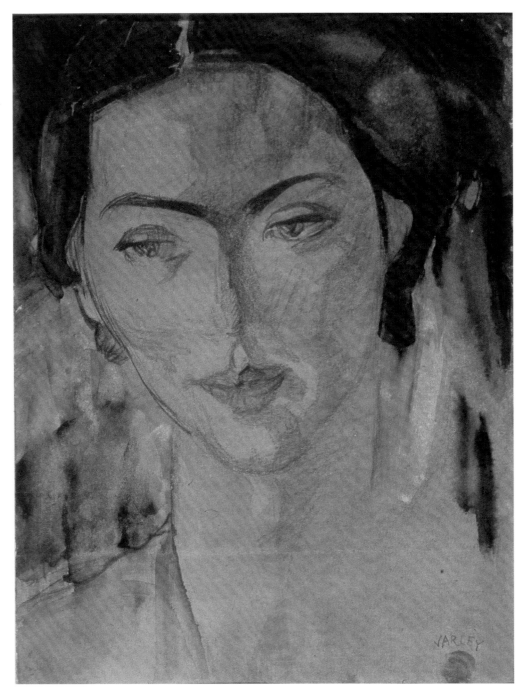

Pl. 42
Vera, c. 1936
From the Collection of the Art Gallery of
Greater Victoria (cat. 58)

Pl. 42
Vera, v. 1936
Collection de l'Art Gallery of Greater Victoria
(cat. 58)

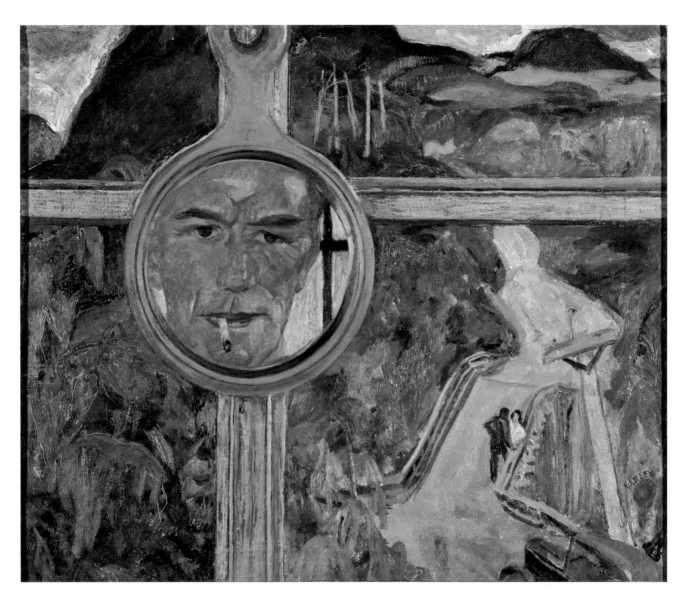

Pl. 43
Mirror of Thought, 1937
From the Collection of the Art Gallery of Greater Victoria
(cat. 59)

Pl. 43
Miroir de la pensée, 1937
Collection de l'Art Gallery of Greater Victoria (cat. 59)

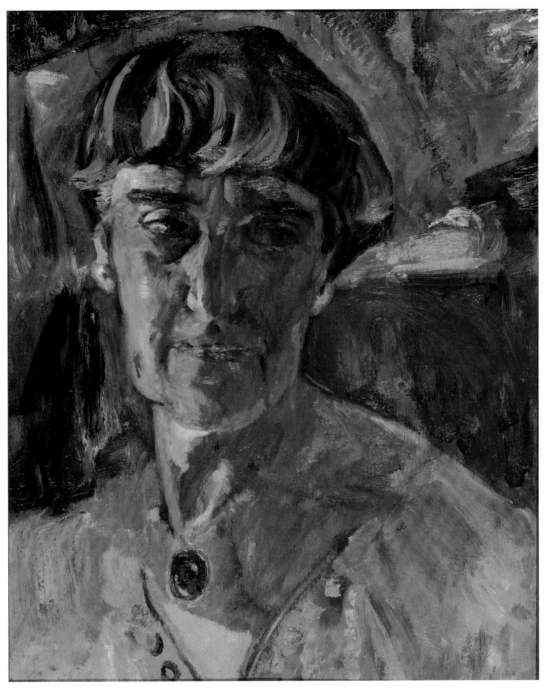

Pl. 44
Portrait of Mrs. Kate Alice Surrey, 1937
Art Gallery of Alberta Collection (cat. 61)

Pl. 44
Portrait de Mme Kate Alice Surrey, 1937
Collection de l'Art Gallery of Alberta (cat. 61)

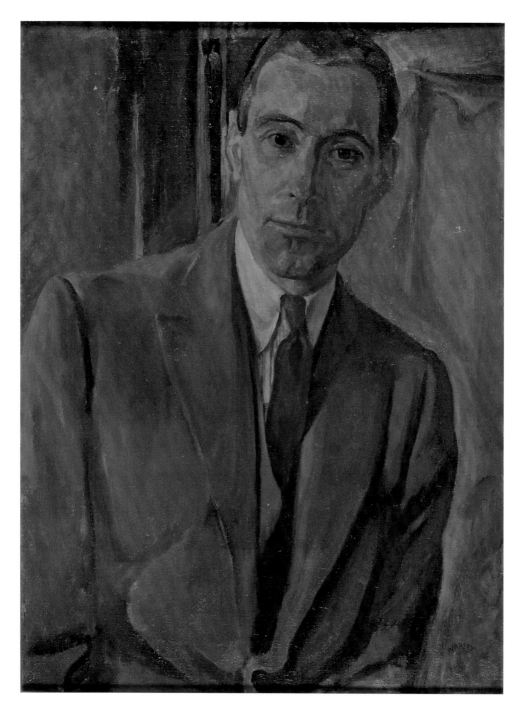

Pl. 45
Portrait of Alan Butterworth Plaunt, 1939
Private Collection (cat. 62)

Pl. 45
Portrait d'Alan Butterworth Plaunt, 1939
Collection particulière (cat. 62)

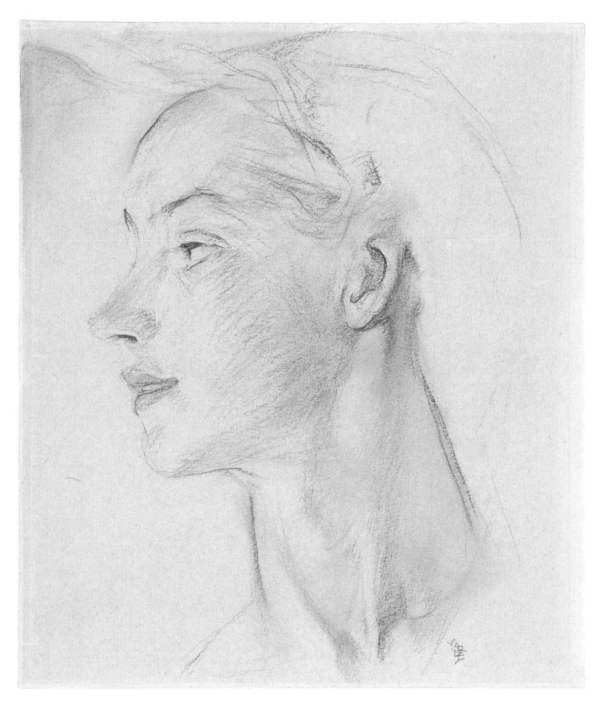

Pl. 46
Nancy Cameron, c. 1940
Private Collection (cat. 65)

Pl. 46
Nancy Cameron, v. 1940
Collection particulière (cat. 65)

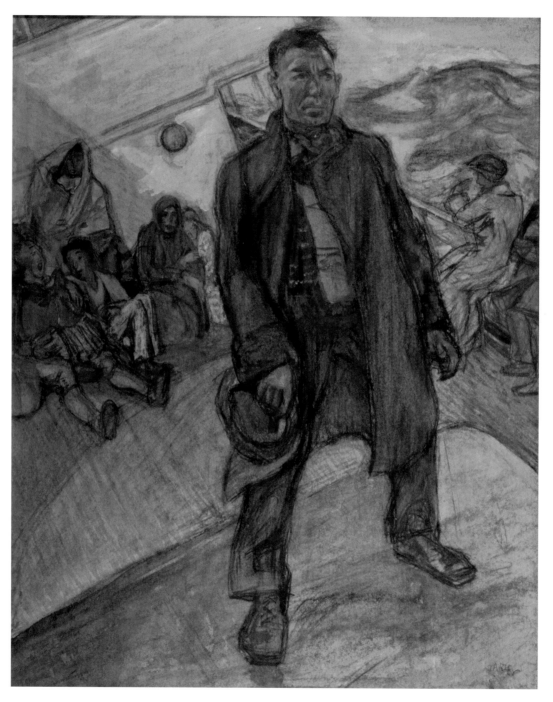

Pl. 47
The Immigrant Ship, 1941
The McCord Museum of Canadian History,
Montreal (cat. 66)

Pl. 47
Le bateau d'immigrants, 1941
Musée McCord d'histoire canadienne, Montréal
(cat. 66)

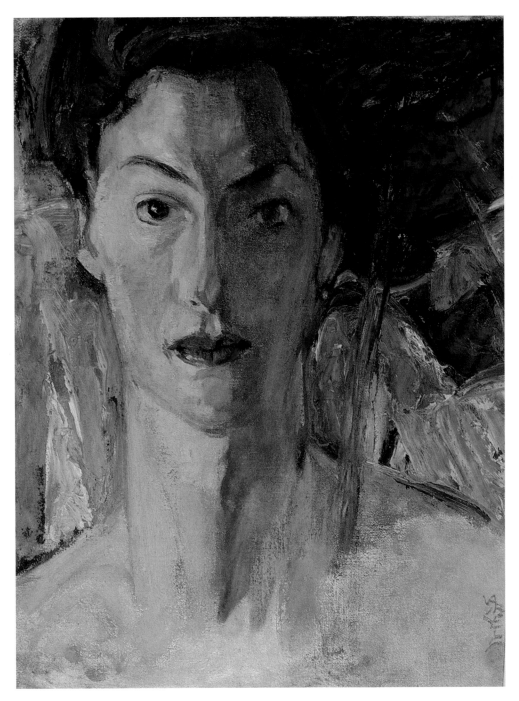

Pl. 48
Erica, 1942
Collections of Trinity College, University of
Toronto (cat. 67)

Pl. 48
Erica, 1942
Collections du Trinity College, Université de
Toronto (cat. 67)

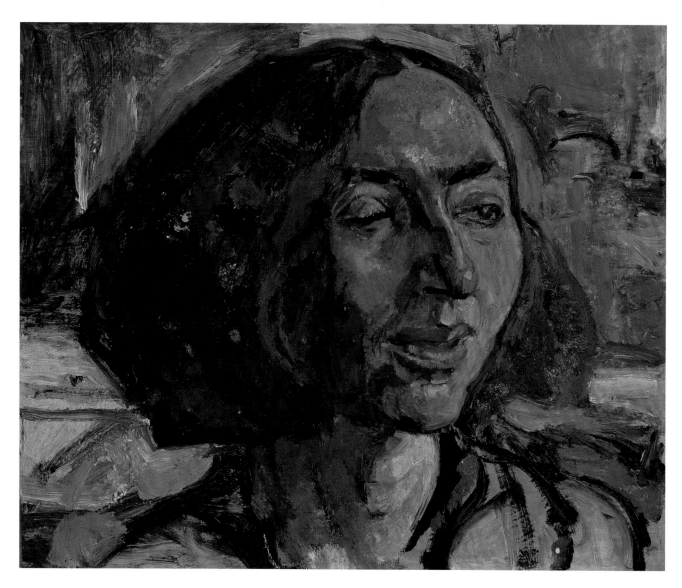

Pl. 49
Manya, Portrait of Miriam Kennedy, c. 1942
Michael and Sonja Koerner (cat. 68)

Pl. 49
Manya, portrait de Miriam Kennedy, v. 1942
Michael et Sonja Koerner (cat. 68)

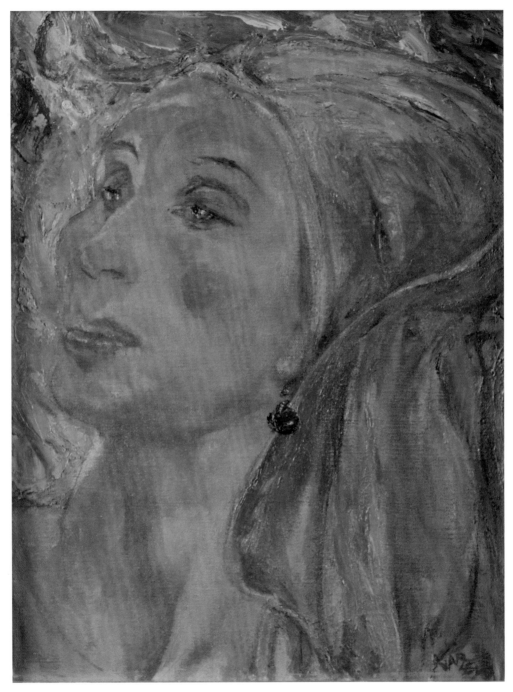

Pl. 50
Natalie, c. 1943
Varley Art Gallery, Town of Markham (cat. 70)

Pl. 50
Natalie, v. 1943
Galerie Varley, Ville de Markham (cat. 70)

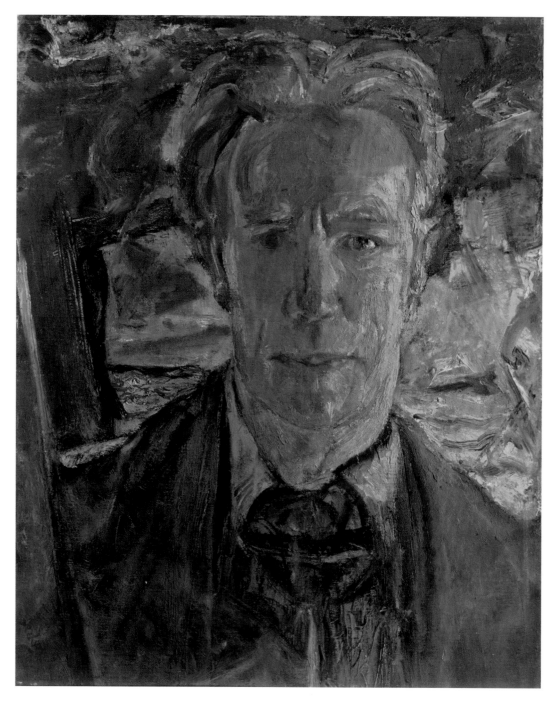

Pl. 51
Self-Portrait, Days of 1943, 1945
Collection of Hart House, University of Toronto
(cat. 71)

Pl. 51
Autoportrait, journées de 1943, 1945
Collection de la Hart House, Université de
Toronto (cat. 71)

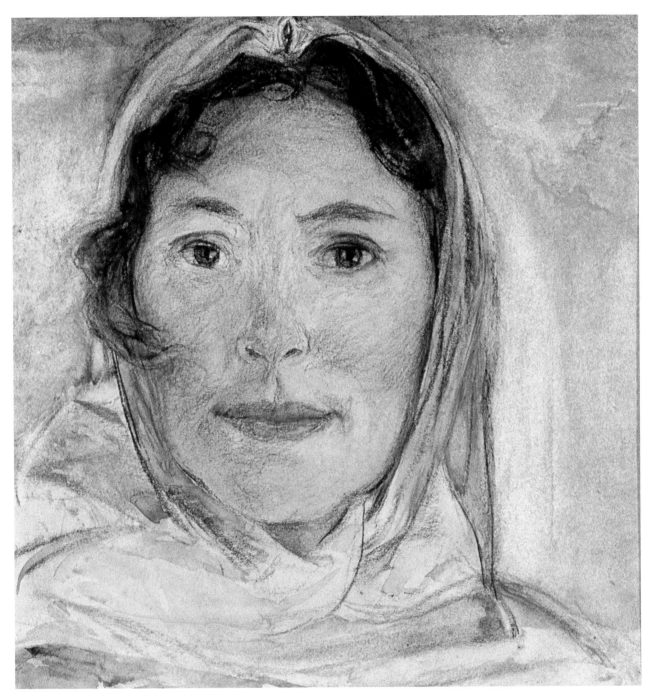

Pl. 52
Jess, c. 1947–52
Agnes Etherington Art Centre, Queen's University, Kingston
(cat. 72)

Pl. 52
Jess, v. 1947–1952
Agnes Etherington Art Centre, Université Queen's, Kingston
(cat. 72)

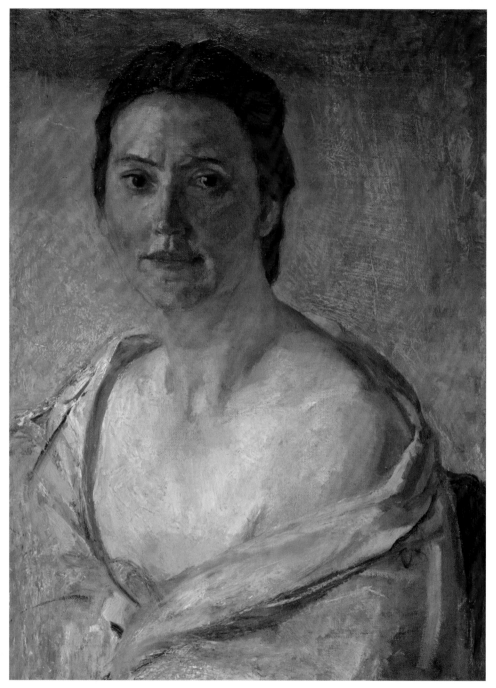

Pl. 53
Jess, 1950
Private Collection (cat. 74)
Photo: Nancy Rahija Photography, Toronto

Pl. 53
Jess, 1950
Collection particulière (cat. 74)
Photo : Nancy Rahija Photography, Toronto

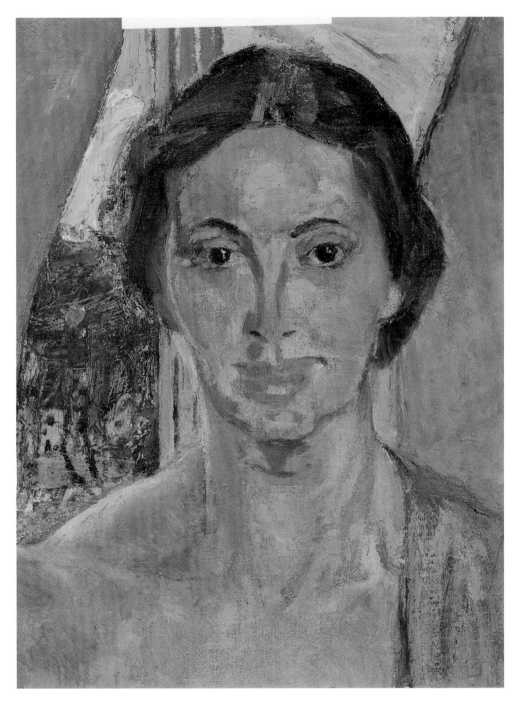

Pl. 54
Jess, 1950
Roberts Gallery (cat. 75)

Pl. 54
Jess, 1950
Roberts Gallery (cat. 75)

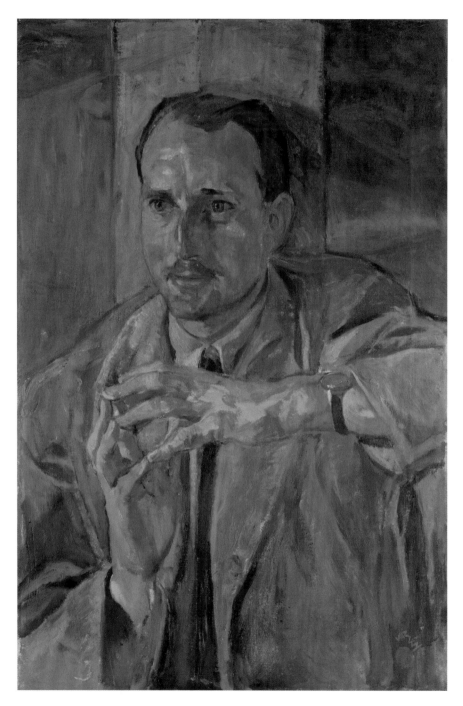

Pl. 55
Portrait of a Man, c. 1950
The McMichael Canadian Art
Collection, Kleinburg (cat. 76)

Pl. 55
Portrait d'un homme, v. 1950
Collection McMichael d'art canadien,
Kleinburg (cat. 76)

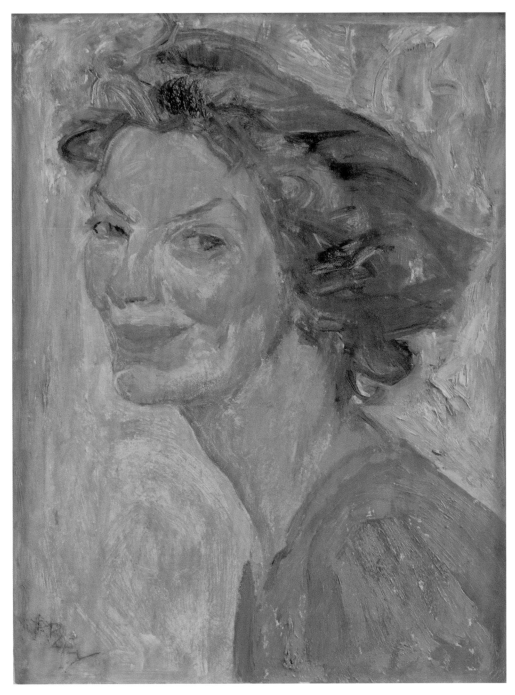

Pl. 56
Laughing Kathy, c. 1952–53
Varley Art Gallery, Town of Markham (cat. 80)

Pl. 56
Kathy riant, v. 1952–1953
Galerie Varley, Ville de Markham (cat. 80)

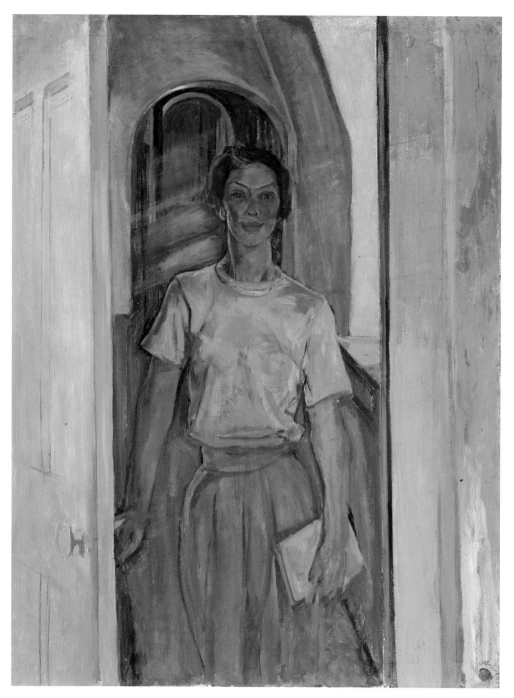

Pl. 57
Studio Door, c. 1952–53
The Montreal Museum of Fine Arts (cat. 82)
Photo: Marilyn Aitken

Pl. 57
Porte d'atelier, v. 1952–1953
Musée des beaux-arts de Montréal (cat. 82)
Photo : Marilyn Aitken

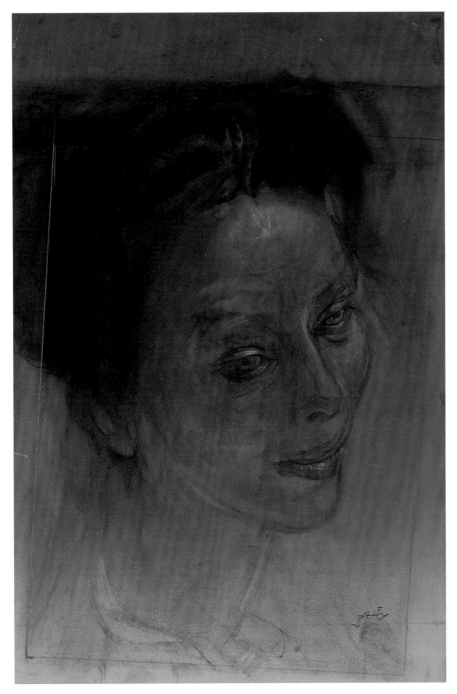

Pl. 58
Kathy, c. 1954
Art Gallery of Ontario, Toronto (cat. 83)

Pl. 58
Kathy, v. 1954
Musée des beaux-arts de l'Ontario,
Toronto (cat. 83)

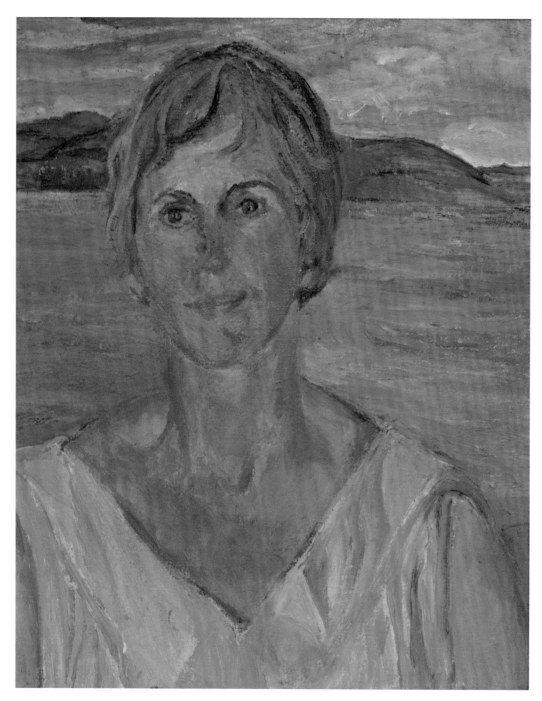

Pl. 59
Florence Deacon, 1955
Deacon family, Unionville, Ont. (cat. 84)

Pl. 59
Florence Deacon, 1955
Famille Deacon, Unionville, Ont. (cat. 84)

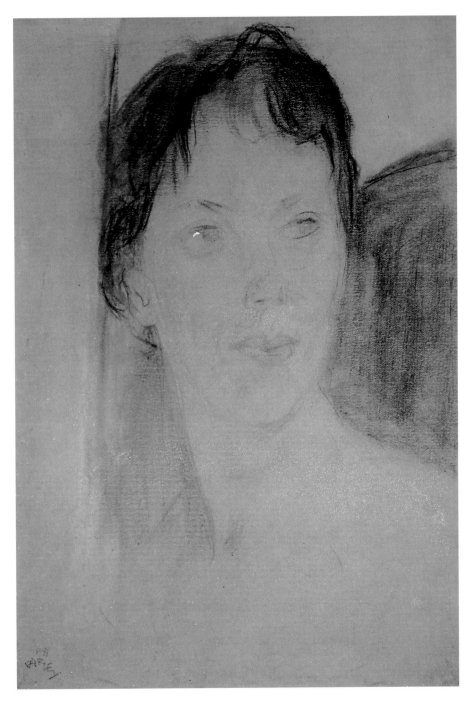

Pl. 60
Portrait of Nancy Robinson, c. 1962
Roberts Gallery (cat. 85)

Pl. 60
Portrait de Nancy Robinson, v. 1962
Roberts Gallery (cat. 85)

ABRÉVIATIONS

AEAC Agnes Etherington Art Centre, Kingston
AGGV Art Gallery of Greater Victoria
AGO Musée des beaux-arts de l'Ontario, Toronto
AGT Art Gallery of Toronto
ALC Arts and Letters Club, Toronto
AMT Art Museum of Toronto
BAC Bibliothèque et Archives Canada, Ottawa
CNE Canadian National Exhibition, Toronto
EAG Edmonton Art Gallery (actuelle Art Gallery of Alberta)
FSGC Fonds de souvenirs de guerre canadien

MBAC Musée des beaux-arts du Canada, Ottawa
MCAC Collection McMichael d'art canadien, Kleinburg
MCG Musée canadien de la guerre, Ottawa
OCA Ontario College of Art, Toronto
OSA Ontario Society of Artists, Toronto
RCA Académie royale des arts du Canada, Toronto
UAB Université de l'Alberta, Edmonton
VAG Vancouver Art Gallery
VAGM Galerie Varley de Markham
VSDAA Vancouver School of Decorative and Applied Arts
WAG Winnipeg Art Gallery

INTRODUCTION

Frederick Horsman Varley, un des plus grands portraitistes canadiens de la première moitié du vingtième siècle, est un curieux exemple d'un artiste qui, en dépit de sa renommée comme portraitiste, est surtout connu pour ses paysages. Cela tient largement à sa notoriété comme un des membres fondateurs du Groupe des Sept, qui prône le développement d'une identité nationale par la la représentation du paysage canadien. De nombreuses collections publiques canadiennes, dont celles du le Musée des beaux-arts du Canada (MBAC), du Musée des beaux-arts de l'Ontario (AGO) et de la Vancouver Art Gallery (VAG), comptent certains des portraits les plus célèbres de Varley. Or ces œuvres s'inscrivent difficilement dans l'histoire conventionnelle du Groupe des Sept. Aujourd'hui encore, près de quarante ans après la mort de l'artiste, ces portraits ne sont toujours pas pleinement reconnus dans leur contexte.

Les hommes de l'envergure de Varley sont rarement simples. Un examen approfondi révèle un homme qui se distingue des autres, un homme en proie à des émotions conflictuelles. Sa façon de vivre sa vie et son indépendance farouche ont incité certains de ses contemporains à le cataloguer comme « rebelle ». Du moins, est-ce l'image que certains commentateurs ont tenté de lui fabriquer, insistant sur le fait qu'il s'opposait aux normes établies et, surtout, à la culture traditionnelle. Cette perception du caractère de Varley me semble loin de la vérité. À mon avis, il réussissait à saisir la complexité de ses modèles parce qu'il était lui-même un être complexe et qu'il posait un regard extérieur.

Après la nature, c'est l'étude de la forme et de la nature humaines qui passionnait Varley. Son plus ardent défenseur, Barker Fairley, admirait la fascination de l'artiste pour l'humanité de ses modèles, comparant la réaction de Varley à ses modèles à sa préoccupation pour le thème de la guerre[1]. Si les chercheurs contemporains n'ont pas réussi à établir cette vérité, le moment est venu d'affirmer qu'aucun autre portraitiste canadien n'est parvenu à une telle compréhension du drame humain ou du rayonnement et du mystère de la beauté féminine. Ces portraits de femmes ne sont pas de simples hommages romantiques à la beauté, ce sont des expressions de ses convictions personnelles. Il est rare que l'esprit critique ou l'approbation personnelle fasse défaut à ces œuvres, Varley saisissait intuitivement l'équilibre entre les deux.

L'intérêt de Varley pour le potentiel expressif du portrait est palpable. Ses portraits se distinguent par leur simplicité et leur acuité psychologique. Intrigué par le caractère de ses modèles, il recourt à la pose et à la combinaison des couleurs pour exprimer leur spécificité. Varley préfère les portraits ressemblants aux portraits flatteurs. Nous avons l'impression de connaître suffisamment les modèles de ses portraits pour s'entretenir avec eux.

L'exposition *F.H. Varley : Mise en lumière des portraits* se distingue à trois niveaux. Elle met en valeur les portraits, elle les

replace dans leur contexte et elle accorde autant d'importance aux dessins qu'aux huiles et aux aquarelles. La majorité des portraits de Varley se trouvent dans des collections particulières. Et si ces portraits font la joie des descendants des modèles, ou de leurs nouveaux propriétaires, ils n'en demeurent pas moins inconnus du grand public. Accessibles à une poignée de conservateurs et de spécialsltes, ces portraits n'ont fait l'objet que d'une étude sommaire et aucun renseignement à leur sujet n'a été publié dans les actuels ouvrages d'histoire de l'art. Par conséquent, la plupart des portraits seront pour les spectateurs de véritables découvertes. Nous espérons que les peintures et dessins présentés dans l'exposition et dans ce catalogue apporteront beaucoup de plaisir au public, voire même inspireront une étude plus exhaustive de l'art du portrait canadien du vingtième siècle.

Dans le cadre des préparatifs en vue de cette exposition, j'en suis venue à accorder la même importance aux lettres de Varley qu'à ses peintures, en raison de la poésie et de l'éloquence de sa plume. Avec le temps, je me suis rendue compte que la signification des lettres ne tenait pas au texte. Ce n'est qu'en lisant entre les lignes que j'ai enfin compris ce qu'il cherchait à communiquer. Je me suis plongée dans l'époque de la personne qui recevait ses confidences – écrire des lettres était une démarche personnelle qui lui tenait à cœur.

Les lettres représentent l'élément insaisissable trop souvent négligé par les spécialistes dans leur analyse de Varley l'homme et l'artiste. Je faisais parfois l'erreur d'extraire un passage d'une lettre là où il convenait d'inclure le texte intégral. Dans certains cas, la ponctuation même – les points d'exclamation ou les fleurons et marques suggérant une pause – révèle l'état d'esprit de l'auteur. Nous n'avons pas jugé opportun de reproduire de longues citations dans cette publication. Je souhaite sincèrement qu'un projet consacré à la publication d'un volume des lettres de Varley sera réalisera dans un avenir prochain.

La présentation chronologique des portraits dessinés et peints de Varley est divisée en sous-thèmes, notamment les tableaux de guerre, les commandes universitaires, la tradition gitane, les portraits d'enfants, les portraits de famille et les portraits mondains. Cette présentation permet une étude approfondie de la polyvalence de l'artiste, de son évolution stylistique et de son exploration soutenue du portrait. Les commentaires accompagnant les portraits renseignent non seulement sur la composition, l'arrière-plan, la combinaison des couleurs et l'éclairage, mais sur la vie des modèles. Cette approche équilibrée vise à servir les intérêts d'un public élargi.

L'historique des expositions des œuvres permet d'affirmer que dans toutes les expositions du Groupe des Sept Varley a présenté un nombre égal de portraits et de paysages. Même la désormais célèbre exposition inaugurale du Groupe des Sept, tenue à l'Art Gallery of Toronto en 1920, réunissait certains de ses portraits de même que ceux de Lawren Harris. Ce qui démontre que les membres du Groupe n'entendaient pas s'en tenir exclusivement à la peinture de paysage.

Au cours de mes recherches, j'ai eu la chance d'interviewer des gens qui ont connu Varley ou qui ont posé pour lui. Ces entrevues sont devenues un amalgamme de réminiscences, d'appréciations et de références, à témoin certaines des transcriptions partielles dans la section consacrée aux « Témoignages des amis de Varley ». Ces commentaires s'ajoutent au volumineux matériel publié sur l'artiste dans le but de faire lumière sur Varley, le portraiste et l'humaniste. Nombreuses sont les personnes ayant connu Varley dont les témoignages n'apparaissent pas dans ces pages. Leurs souvenirs sont aussi précieux que ceux que nous partageons avec nos lecteurs et j'espère qu'elles saisiront l'occasion de les ajouter à notre étude.

Beaucoup de choses ont été dites et écrites à propos de Fred Varley, le peintre et l'homme. En définitive, ce sont les œuvres – les peintures figurant dans l'exposition et les œuvres reproduites dans ce catalogue – qui offrent le témoignage le plus éloquent de son talent artistique. Le but sous-jacent de l'exposition *F.H. Varley : Mise en lumière des portraits* et du présent catalogue aura été atteint s'il ouvre au spectateur et au lecteur de nouvelles perspectives sur le talent de portraitiste de Varley. Nous espérons que cette mise en lumière de ses portraits permettra à Frederick Varley d'occuper la place qui lui revient dans l'histoire du portrait du vingtième siècle au Canada.

CHAPITRE 1

LES DÉBUTS DANS L'ANGLETERRE VICTORIENNE, 1881–1912

J'ai imploré à genoux mon cher créateur de me purifier, de m'enrichir d'amour et de m'amener à voir la beauté de son œuvre extraordinaire dans l'humanité.

— Fred Varley

Frederick Horsman Varley est né le 2 janvier 1881 à Sheffield, en Angleterre. Il est le benjamin d'une famille de quatre enfants. Son père, Samuel Joseph Bloom Varley (1849–1934), est un lithographe connu. Né à Islington en 1849, Samuel reçoit une formation d'artiste commercial à Londres, avant d'être embauché par les graveurs-imprimeurs Henry Pawson et Joseph Brailsford à Sheffield. Fier descendant de John Varley (1778–1842), un aquarelliste célèbre de la fin de l'époque géorgienne, il s'identifie à ses réalisations artistiques. Samuel avait à son actif de remarquables esquisses à la plume et à l'encre du vieux Sheffield, un dessin de mains pour une publicité de Pears Soap et des illustrations couleurs d'oiseaux. Native de Sheffield, l'épouse de Samuel, Lucy Varley (née Barstow, 1851–1936), exploitait une entreprise modeste, mais rentable de couture et de chapellerie féminine. Après son mariage, Lucy renonce aux affaires pour se consacrer à sa famille.

Convaincu que Frederick perpétuerait la tradition familiale et deviendrait un grand artiste, Samuel lui offre le soutien moral et financier nécessaire à sa formation. Soucieux de favoriser le talent précoce de son fils, il l'amène souvent en excursion de dessin à l'extérieur de la ville. Voir son fils se distinguer en art et atteindre à la célébrité est source de plaisir par procuration pour Samuel, qui souhaite que ses propres ambitions et son énergie spontanée survivent dans son fils[2]. En effet, dès son jeune âge Frederick Varley procure un immense plaisir à son père en manifestant un intérêt marqué et un talent pour le dessin. Une légende familiale veut que Fred ait exécuté son premier autoportrait à l'âge de six ans. Œuvre que son père a conservé dans la famille[3].

Varley fréquente l'école publique de Springfield avant de suivre des cours particuliers avec le professeur de sciences William Ripper[4]. En 1892, à l'âge d'onze ans, il est admis à la Sheffield School of Art, qui comptait parmi les meilleures écoles d'art en Grande-Bretagne[5]. Étudiant, Varley découvre les théories victoriennes contemporaines sur l'art et sa création, et assiste aux conférences de certains des plus grands spécialistes anglais de l'art, dont James Orrock et John Ruskin pour ne nommer que ces derniers.

Outre Arthur Lismer, futur membre du Groupe des Sept, qui s'inscrit à la Sheffield School of Art un an après lui, Fred compte parmi ses camarades de classe Charles Sargent Jagger, un sculpteur, et Dudley Hardy, qui allait se distinguer comme illustrateur et

artiste de guerre. Dans son ouvrage, *Our Home and Native Land: Sheffield's Canadian Artists*, Michael Tooby se penche sur les artistes originaires de Sheffield qui ont fréquenté l'école en même temps que Varley et qui ont émigré au Canada, y compris Elizabeth Styring Nutt, Herbert H. Stansfield et Hubert Valentine Fanshaw. Selon Tooby, les étudiants travaillaient à l'obtention d'un certificat spécialisé dans une gamme de sujets basés sur le dessin et les procédés techniques[6].

À la Sheffield School of Art, Varley accroît sa capacité d'observation et de coordination main-œil essentielle au bon dessinateur. Principes de l'ornementation et du design, Dessin, Modelé et Modelage comptent parmi les huit sujets élémentaires et les vingt-huit sujets avancés offerts par l'école. Le programme avait été établi par le Département des sciences et de l'art du South Kensington Museum à Londres. Les illustrateurs et les peintres qui enseignent ces sujets, dont Henry Archer, se conforment aux directives, sans toutefois faire abstraction de leurs propres goûts. Les normes élevées tiennent aux récompenses décernées aux étudiants par le South Kensington Museum, qui compte parmi ses examinateurs des figures aussi célèbres que Walter Crane, George Clausen et Frederick Brown. Les œuvres primées sont exposées à la Mappin Art Gallery dans le cadre des manifestations de fin d'année dites « conversazione »[7]. Un an avant d'obtenir son diplôme, Varley reçoit une bourse de 9,3 £ pour acquitter ses frais de scolarité.

L'intérêt soutenu de Varley pour le portrait tient peut-être à sa formation en dessin d'après plâtre et modèle vivant, qui lui permet de maîtriser la ligne, le mouvement et le modelé. Varley s'exerce également à la copie des maîtres anciens dans le but d'enrichir son vocabulaire plastique. Le dessin de mémoire a peut-être joué un rôle catalyseur dans la carrière de portraitiste de Varley. Cet exercice lui apprend à observer le caractère de son modèle et lui permet de développer l'acuité psychologique pénétrante qui caractérise ses portraits. Selon certains, à tous les matins un de ses professeurs, J.T. Cook, ayant remarqué son talent pour le dessin, lui faisait palper les formes d'un torse moulé jusqu'à ce qu'il soit en mesure de les reproduire de mémoire[8].

De cette époque, nous ne connaissons que trois dessins à la plume et à l'encre exécutés vers 1897, dont *Nature morte, crâne et lanterne* (Collection McMichael d'art canadien, Kleinburg, Ontario). Il serait sans conteste intéressant de découvrir Varley à travers ses œuvres de jeunesse. Or comme l'a fait remarquer avec justesse sa biographe Maria Tippett : « Des artistes comme Fred Varley ont été formés tant par leur vécu que par leur formation académique[9] ». Repensant à l'époque où ils étaient étudiants à Sheffield, Lismer affirme « Fred Varley était un rebelle qui ne connaissait pas de limites[10] ».

Il vaut de noter que Varley reçoit sa formation à la fin de l'époque victorienne. Bien que les paysages de Turner et de Constable soient considérés comme l'apport majeur de l'Angleterre à la peinture européenne de l'époque, le portrait demeure au premier plan de l'art anglais du dix-neuvième siècle. Des études contemporaines de l'histoire du portrait anglais laissent entendre que le goût des Anglais pour cette forme d'art était inégalé dans toute autre nation européenne. Les premières commandes connues de portraits royaux sont celles des Tudor et des Stuart, et la tradition se maintient durant le règne de Victoria (1837–1901)[11]. La fin du dix-neuvième siècle voit l'émergence d'une forme d'art qui allait rivaliser le portrait : la photographie. Cela dit, le portrait a réussi à contrer la menace du portrait photographique.

En 1900, Fred Varley se rend à Anvers pour poursuivre ses études à l'Académie Royale des Beaux-Arts. Selon sa sœur aînée Ethel, il consacre de longues heures à ses études. La passion de Varley pour l'art tenait largement à son éducation, et plus particulièrement à l'influence de son père. Dans toutes ses initiatives, il aspire à plaire à son père, à ne pas le décevoir. Il n'est donc pas étonnant qu'il a tôt fait de s'imposer comme un des étudiants les plus doués de l'Académie, suscitant l'admiration de ses professeurs et de ses pairs. Malgré ce qui allait être dit au sujet de la démesure de son tempérament artistique, Varley s'astreignait à une discipline sévère. L'art était sa passion, et son assiduité était hors du commun. Tout au long de sa carrière, il appliquera cette assiduité à la réalisation des œuvres de commande. Déterminé à ne pas perdre de temps, il est toujours à l'heure, prompt à répondre à son courrier, et précis et courtois dans ses échanges.

Le portrait que Varley fit de son père vers 1902 (fig. 1) compte parmi ses œuvres de jeunesse les plus saisissantes. Témoignage

éloquent de sa formation académique, le portrait révèle son assurance en tant que dessinateur et sa sensiblité en tant que portraitiste. Samuel Varley était lui-même un dessinateur accompli. Même si son travail chez Pawson et Brailsford lui valait reconnaissance, il se limitait néanmoins aux besoins artistiques de l'entreprise. Homme gentil, à la voix douce, il passait une large part de ses loisirs à se promener et à dessiner dans les collines autour de Sheffield; il était souvent accompagné de ses enfants.

Selon Ethel Varley, un dimanche alors que la famille rentrait de l'église, son frère éprouva une forte envie de faire le portrait de leur père. À un âge avancé, elle écrit à Varley pour partager les bons souvenirs qu'elle gardait de lui. « Nous étions tous dans la salle à manger, portant encore nos chapeaux et manteaux, lorsque tu es entré en trombe en disant : "Papa, je veux te dessiner" [12] ». Cette détermination est caractéristique de l'approche de Varley. Ethel poursuit son histoire : « Tu as choisi la cuisine parce que personne ne t'y dérangerais. Papa s'est installé sur le coin de la table de cuisine et tu t'es mis à l'œuvre. C'est comme si un saint esprit se trouvait dans la maison. Aucun d'entre nous n'osait parler à voix haute, ne brisant le silence que lorsqu'un bruit s'est fait entendre dans la cuisine[13].

Le portrait de son père, très probablement exécuté à son retour d'Anvers au printemps 1902, est le premier portrait de Varley qui nous est connu. Il témoigne de son empressement à mettre en pratique le fruit de sa formation académique, de sa maîtrise des ombres et des lumières, et de l'attention qu'il porte au modèle. Malgré son jeune âge, il réussit un portrait à la fois ressemblant et pénétrant. Dans un ouvrage publié en 1983, Peter le cadet des fils de Fred Varley propose 1912 comme date d'exécution de ce portrait[14]. Maria Tippett a depuis établi que les parents de Fred ont déménagé à Bournemouth en 1907 ou 1908 lorsque Samuel a pris sa retraite. Bien qu'ils se soient rendus chez leurs enfants à quelques reprises, ils ne sont jamais retournés vivre à Sheffield[15]. Par conséquent, la date de 1902 avancée par le petit-fils de l'artiste, Christopher Varley, semble plus juste, à témoin la facture classique de l'œuvre[16].

Le séjour de Varley à Londres, de 1903 à 1908, marque son entrée officielle dans l'univers de l'artiste du vingtième siècle. Le dynamisme culturel de la capitale anglaise – foyer du mécénat et du style – lui permet d'apprendre des maîtres anciens, de mesurer ses connaissances aux développements en art contemporain et d'apprécier pleinement les galeries d'art. Inaugurée en 1897, la Tate Gallery présente des œuvres choisies de sa collection permanente, dont les portraits mondains de John Singer Sargent. L'école paysagiste anglaise est très bien représentée par Turner. En 1903, la Carfax Gallery présente les dessins et eaux-fortes d'Augustus John et de sa sœur Gwen John. Une rétrospective des œuvres des préraphaélites Edward Burne-Jones, Dante Gabriel Rossetti et John Millais est présentée dans plusieurs galeries de Londres, Birmingham, Manchester et Liverpool[17]. De plus, certaines expositions sont consacrées aux impressionnistes et d'autres aux maîtres anciens flamands.

Le mécénat est à la mode, et de nouvelles galeries publiques et privées ouvrent leurs portes à travers le pays. La mode est à la collection d'œuvres contemporaines et à la commande de portraits. À l'époque, les portraits représentent jusqu'à un tiers des objets d'une vente aux enchères de peintures anglaises. L'essor du marché de l'art est parallèle à celui des échanges commerciaux avec l'Europe et l'Amérique du Nord. Selon Dianne Macleod, au dix-neuvième siècle le mouvement esthétique et le nouveau rôle de l'artiste en tant que personnalité publique contribuent à élever le statut de l'art[18]. Ces développements étaient sans doute fort encourageants pour de jeunes artistes comme Varley.

Si l'importance du travail commercial accompli par Varley à Londres n'a pas été mesurée, on sait qu'il a réussi à obtenir plusieurs commandes d'illustrations. En 1903, il réalise une série d'aquarelles et de dessins à la plume et à l'encre pour le roman d'Eden Phillpotts, *The Farm of the Dagger*, publiée dans *The Gentlewoman* à l'automne de la même année. En 1904, il travaille à des ajouts décoratifs aux dessins d'architecture de Seppings Wright de la Westminister Cathedral accompagnant un article sur la cathédrale paru dans l'*Illustrated London News*. Les dessins de Varley illustrent la nouvelle, *The Letter-Box Charm*, écrite par Sidney Hesselrigge et publiée dans *The Idler* en mars 1905[19].

Selon Maria Tippett, les lavis et les aquarelles de Varley se distinguent par leur composition, leur exécution et leur virtuosité

technique. Cependant, le détail et le faible contraste des tons de ses dessins à la plume et à l'encre nuisaient à leur reproduction[20]. Cela s'explique peut-être par le fait que le processus de transfert exigeait que l'image soit réduite du tiers. Du point de vue stylistique, ses œuvres de la période londonienne sont très diverses, Varley tente de trouver une technique qui lui est propre tout en apprenant des plus grands illustrateurs du jour. Bien des années plus tard, il avouera que la vie d'illustrateur ne lui disait rien, un artiste commercial ne produisant jamais quelque chose digne d'être conservé précieusement[21].

Au cours d'un bref séjour à Sheffield en 1906, Varley fait la rencontre de sa future épouse, Maud Pinder (1886–1988). Native de Sheffield, Maud enseigne à Doncaster. Outre leurs origines communes et leur amour de la campagne du Yorkshire, ils se découvrent des affinités musicales et littéraires. À la fin de sa vie, Maud se souvient que Fred l'avait prise comme modèle dès le début de leur fréquentation. Elle affirme qu'il a réalisé de nombreux croquis et dessins la représentant, mais aucun n'a survécu. Les premiers portraits de Maud qui nous sont connus remontent à leurs premières années au Canada.

Malgré l'opposition de leurs familles, Fred et Maud se marient en avril 1910 à Doncaster. Ils s'installent à Sheffield où Fred trouve de l'emploi au journal local, le *Sheffield Daily Independent*, comme metteur en page. Il exécute à l'occasion des illustrations en noir et blanc. En 1911, il loue un atelier et entreprend un imposant tableau, prenant pour modèle l'épouse de son ancien camarade de classe David Jagger[22]. Le 29 février 1912, Varley est photographié devant son chevalet avec l'œuvre en arrière-plan. Intitulé *Éden*, le tableau représente un nu féminin grandeur nature, en plein air.

À l'époque, la scène artistique de Sheffield a peu de choses à offrir aux jeunes artistes. L'exode des gens qualifiés et talentueux, en quête d'une existence meilleure, est un sujet d'inquiétude. Deux anciens camarades de classe de Varley, William Broadhead et Arthur Lismer, étaient déjà installés au Canada[23]. En 1912, Lismer retourne brièvement en Angleterre pour épouser sa petite amie, Esther Mawson. Il revoit Varley et lui parle de son pays d'adoption et de son travail comme artiste commercial. Ses paroles interpellent l'esprit bohème de Varley. Le Canada était peut-être l'endroit qui lui permettrait de lancer sa carrière artistique et de subvenir aux besoins de sa femme et de ses deux enfants, Dorothy, née en 1910, et John, en 1912.

Le départ, 1912

À la fin de l'été 1912, Varley s'embarque pour le Canada. Peu de temps après son arrivée à Toronto, il trouve un emploi chez Grip Limited, un atelier d'impression et de gravure. Maud et les enfants ne le rejoignant que l'année suivante, il reprend le logement des Lismer au 119 avenue Summerhill, où il retrouve William Broadhead. D'autres jeunes artistes vivent au même endroit, dont Tom Thomson, qui travaille avec Varley chez Grip. Presque à tous les jours, Varley et ses nouveaux amis prennent leur repas du midi au Arts and Letters Club (ALC). Parmi eux se trouvent les futurs membres du Groupe des Sept, J.E.H. MacDonald, Franklin Carmichael et Frank Johnston. Aux dires de certains, ils s'assoient à la table des « artistes ». Lorsque Lawren Harris et A. Y. Jackson se joignent à eux il s'ensuit inévitablement une discussion animée sur les questions artistiques du jour[24]. L'adhésion au Club offre également aux jeunes artistes la possibilité de rencontrer des membres de l'élite culturelle de Toronto, notamment le Dr James MacCallum, Vincent Massey et sir Edmund Walker, qui allaient devenir leurs premiers mécènes.

Lorsque Maud et les enfants arrivent enfin au Canada, ils sont chaleureusement accueillis par les amis de Varley. En octobre 1914, la famille retrouve Jackson, Thomson, Lismer, Beatty et leurs familles dans le parc Algonquin. C'est le premier séjour de Varley dans la nature sauvage. À l'exception de Jackson et Thomson, le groupe s'installe au Mowatt Lodge, à proximité du lac Canoe que Thomson affectionnait particulièrement. Difficile à dire si c'est le coloris automnal ou le travail de Tom Thomson et des autres qui inspire Varley, mais son *Été indien* (1914–1915; pl. 1) se distingue par sa palette vive et colorée.

Le désir de Varley d'intégrer des personnes à ses paysages remonte à sa période anglaise. Cette notion s'inscrit dans le cadre de la tradition du paysage anglais et des écrits de John

Ruskin, qui déplore l'absence de présence humaine dans les scènes de plein air. Dans *Été indien*, Varley représente sa femme, Maud, dans un bosquet de bouleaux. Agissant comme éléments décoratifs, les arbres mettent en valeur le plan intermédiaire, alors que la figure apparaît plutôt indifférente.

Varley retourne en ville déterminé à retourner dans la nature pour y peindre la figure en plein air. Contrairement à l'année précédente, il n'obtient d'aide financière du Dr James MacCallum et doit abandonner son projet. En 1916, Varley est invité à se rendre à la baie Georgienne, et c'est à cette occasion qu'il découvre le paysage qui a inspiré son œuvre emblématique *Tempête, baie Georgienne* (1920). Ce tableau confirme que Varley est plus qu'un artiste commercial ou un peintre de personnages, il partage les idéaux des artistes avec qui il s'était lié à son arrivée au Canada et qui allaient devenir le Groupe des Sept.

La Première Guerre mondiale éclate alors que Varley se trouve au parc Algonquin. Les artistes se laissent gagner par l'esprit de l'époque et nombre d'entre-eux s'intéressent à la formation des troupes canadiennes et à l'éveil de la conscience patriotique. L'Académie royale des arts du Canada (RCA) organise une exposition au profit du Fonds patriotique canadien. Varley et ses amis y exposent et font don des revenus de la vente de leurs tableaux. Les expositions annuelles de l'Ontario Society of Artists (OSA) et de la RCA réunissent également des compositions s'articulant autour de la guerre. En 1916, Varley présente deux portraits à la Canadian National Exhibition, dont celui du captaine H.P. Langston.

L'idée d'établir le Bureau canadien des archives de guerre et d'embaucher des artistes pour documenter les activités des troupes canadiennes émane de lord Beaverbrook (Max Aitken), magnat des affaires du Nouveau-Brunswick qui avait élu domicile en Angleterre. Avec l'aide de lord Rothermere, Beaverbrook met sur pied un programme d'embauche des plus grands artistes britanniques « en vue de favoriser la production d'œuvres [...] honorant la mémoire des compatriotes [canadiens] qui se sont distingués pendant la guerre[25]. Paul Konody, le critique de l'*Observer*, est nommé au poste de conseiller artistique. Konody fait appel à des journalistes, photographes, cinéastes et artistes afin de promouvoir le rôle du Canada dans la guerre. Au bout d'un an, certains des artistes anglais participaient au programme, tandis que d'autres avaient été dispensés du service actif – Augustus John, sir William Nicholson, sir William Rothenstein, D.Y. Cameron, Charles Sims, Percy Wyndham Lewis, Paul Nash et C.R.W. Nevinson, pour ne nommer que ces derniers.

Alors que le bureau de lord Beaverbrook faisait de la promotion du Fonds de souvenirs de guerre canadiens en Angleterre, un nombre important d'artistes canadiens servaient déjà dans l'armée canadienne. A.Y. Jackson s'était enrôlé au printemps 1915. Un an plus tard, Lawren Harris s'enrôle à son tour. Randolph Newton, Ernest Fosbery, David Milne et William Broadhead, vieil ami de Varley de Sheffield, s'engagent eux aussi dans l'armée canadienne. Ils déplorent l'absence d'artistes canadiens dans le programme. Lord Beaverbrook réagit en invitant Eric Brown, le directeur du Musée des beaux-arts du Canada, et sir Edmund Walker, le président du Conseil, à présenter la candidature de quatre artistes canadiens. L'invitation est transmise à l'OSA et la RCA, qui soumettent les noms des artistes montréalais Maurice Cullen et Charles Simpson, et des artistes torontois William J. Beatty et C.W. Jefferys. Lorsque Jefferys refuse l'offre, il est remplacé par Fred Varley.

Durant les premières années de la guerre, Varley subsiste en travaillant comme artiste commercial chez Rous and Mann (il avait quitté Grip à la fin 1912) et en acceptant plusieurs contrats à la pige. Il réalise une série de portraits qui sont reproduits en page couverture du *Canadian Courier*; fait le portrait des chefs d'État Robert Borden, David Lloyd George et Woodrow Wilson; exécute une série d'illustrations pour leur manuel de recrutement de l'Imperial Royal Flying Corps; et illustre des nouvelles publiées dans *Canadian Magazine*.

Artiste de guerre, 1918–1919

Rien d'étonnant à ce que Varley soit choisi comme artiste de guerre au début 1918, étant donné qu'il était connu des lecteurs grâce à ses illustrations dans le *Canadian Courier*. Varley se voit

accorder le rang de capitaine et une solde annuelle, y compris un supplément pour l'achat de matériel pour artiste. Varley est ravi. Il se rend en Angleterre à la fin du mois de mars et sert comme artiste de guerre pendant près de dix-huit mois. L'expérience aura servi de catalyseur dans la carrière de Varley, lui révélant sa véritable vocation d'artiste. La commande de quatre portraits d'officiers décorés de la Croix de Victoria enrichit son expérience de portraitiste. A.Y. Jackson et lord Beaverbrook sont tous deux fort impressionnés par le travail de Varley.

Des quarante-cinq artistes employés par le Fonds de souvenirs de guerre canadiens en 1918, près de la moitié exécutent des portraits[26]. Leurs sujets comptent non seulement des généraux, des amiraux et des politiciens, mais également tous les soldats canadiens décorés de la Croix de Victoria. Si certains artistes sont d'avis que la guerre rend un soldat indifférenciable de l'autre, Varley distingue aisément l'homme qui se cache derrière l'uniforme.

Varley est pleinement conscient de l'opposition entre la violence au front et la liesse accompagnant la victoire. Il a l'impression que le simple soldat est une victime de forces indépendantes de sa volonté. Ses portraits du capitaine C.P.J. O'Kelly et du lieutenant George B. McKean, qui comptent parmi les portraits canadiens les plus accomplis de la Grande Guerre, révèlent l'expérience intime de l'individu aux prises avec le « jeu de la vie et de la mort[27] ».

Natif de Winnipeg, le capitaine O'Kelly (pl. 2) avait déjà reçu la Croix militaire lorsqu'il s'est mérité la Croix de Victoria pour s'être distingué lors de à la bataille de Passchendaele[28]. Sa citation, du 8 janvier 1918, se lit comme suit : « Pour un acte de bravoure remarquable où il mena sa compagnie avec une habileté et une détermination extraordinaires[29] ». Varley l'a représenté debout, très droit, sur un étrange fond aux couleurs pastel. La touche est puissante et nette, mais son application méticuleuse contribue à la stabilité de la composition.

Le portrait du lieutenant George B. McKean (pl. 3) est à de nombreux égards diamétralement opposé à celui du capitaine O'Kelly. McKean fréquente l'Université de l'Alberta à Edmonton lorsque la guerre éclate. Il s'enrôle en juin 1916 et part pour la France. Son « sens remarquable de la bravoure et du devoir[30] » lors d'une attaque près de Cagnicourt, le 1er septembre 1918, lui vaut la Croix de Victoria. Varley le représente assis, le corps très légèrement incliné (pour rappeler sa blessure), déséquilibrant du coup la composition. Les couches épaisses de pâte colorée, rehaussées de touches de couleur saturée, se distinguent nettement de la facture soignée du portrait du capitaine O'Kelly. Le sujet se détache contre ce que l'on devine être un décor d'atelier, ou peut-être même un rideau, contribuant à l'harmonie de l'organisation figure-fond. Le coloris intense est accentué par la touche nerveuse de l'artiste. L'expression de douleur contenue du lieutenant McKean ajoute à l'intensité psychologique de la composition. Dans son analyse du portrait de McKean, Peter Varley, le fils cadet de l'artiste, affirme que son père a su exprimer magistralement l'âme brisée et l'horreur muette de son sujet : « Il est rigide, son regard fixe, un œil montrant un mépris féroce, à la limite de la rage; l'autre prudent, cynique, abritant une tempête de haine[31] ».

Nous sommes en mesure d'affirmer que Varley a également réalisé un portrait du lieutenant McLead, récipiendaire de la Croix de Victoria, et celui d'un général dont le nom nous est inconnu. Ces deux œuvres ont depuis disparues. Cependant, A.Y. Jackson, lui aussi artiste de guerre, se souvient que Varley avait eu à composer avec certains problèmes : « [...] le portrait d'un général qui avait une vie facile à Londres et qui voulait que Varley le représente en véritable soldat; et un récipiendaire de la Croix de Victoria, peint par Varley, qui était si sollicité qu'il s'endormait sitôt arrivé à l'atelier[32]. Jackson a réalisé quelques portraits, dont celui de sergent-major de compagnie Robert Hanna (fig. 2), qui n'est pas sans rappeler celui du capitaine O'Kelly exécuté par Varley.

Varley s'est rendu sur le front français à deux reprises. La seconde fois, il rejoint les troupes canadiennes pour leur dernière offensive. Accompagné du lieutenant Douglas du Bureau canadien des archives de guerre canadienne et de l'artiste anglais Cyril H. Barraud, il rassemble le matériel qui lui permettra de réaliser ses tableaux de guerre les plus déchirants, *Pour quoi?* et *Un jour les gens reviendront* (1918; Musée canadien de la guerre). Dans une certaine mesure, la fortune critique de ces deux tableaux a éclipsé le succès de ses portraits de guerre. Cela dit, selon un chercheur, les

portraits de 1918 – ceux du capitaine O'Kelly et du lieutenant McKean – témoignent du talent de portraitiste de Varley et sont aux antipodes de sa production d'après-guerre [33].

Varley exécute un portrait intime de Barraud (pl. 4; Musée des beaux-arts de l'Ontario) alors qu'ils sont en garnison à Camblain-l'Abbé. Barraud était un ami du graveur canadien W.J. Phillips, à qui il avait rendu visite à Winnipeg avant la guerre. (Varley et Phillips allaient se rencontrer à une date ultérieure.) Le plan rapproché du visage rehausse les traits éclairés à la lumière d'une bougie ou d'un feu. La palette est délibérément sombre. Le portrait de Barraud a été conservé dans sa famille en Angleterre jusqu'à ce qu'il soit remis à W.J. Phillips.

En 1919, Varley présente certains de ses tableaux de guerre dans le cadre de l'exposition du Fonds de souvenirs de guerre canadiens tenue à la Burlington House à Piccadilly. Il est salué par la critique qui le considère comme « le plus accompli et le plus expressif des artistes canadiens officiels [34] ». Sir Claude Phillips aurait affirmé : « Nulle trace de sentimentalité ou de passion personnelle. [...] Mais plutôt une objectivité foudroyante, un sentiment de tragédie – de la volonté humaine terrassée par le Destin [35]. »

Au printemps 1919, lord Beaverbrook confie à Varley sa première commande privée : le portrait de sa fille aînée, Janet, âgée de onze ans. (Elle allait devenir juge de paix.) Le fait qu'il le choisisse parmi les nombreux artistes du programme atteste de la renommée grandissante de Varley comme portraitiste. Les séances de pose auront lieu à la résidence des Beaverbrook dans le Surrey au cours de l'été 1919.

À première vue, le portrait de trois quarts de Janet Beaverbrook (pl. 6) semble plutôt plat et décoratif, dénué de la sentimentalité caractéristique des portraits d'enfants. Varley met en scène son jeune sujet dans un extérieur ensoleillé. L'étendue de ciel bleu et le feuillage, qui nimbe la tête de la fillette, dans le coin supérieur gauche ajoutent à la fraîcheur de la composition. Varley fait preuve d'une grande assiduité dans l'exécution de son premier portrait mondain. Selon le témoignage de lord Beaverbrook, la famille était très satisfaite du portrait. Elle a versé 100 £ à Varley, somme supérieure à celle convenue [36].

Varley s'embarque pour le Canada le 1er août 1919. De retour au pays, il demeure à l'emploi du Corps expéditionnaire canadien et envisage de réaliser de nouvelles commandes d'œuvres de guerre. Paul Konody et le Fonds des souvenirs de guerre canadiens lui proposent de collaborer à l'exécution d'une murale de plus de 3 mètres destinée au futur musée de la guerre [37]. Or, des contraintes financières forcent le Fonds à abandonner le projet à la fin mars 1920.

CHAPITRE 2

L'ART DU PORTRAIT À TORONTO DANS LES ANNÉES 1920

Il faut s'y investir corps et âme.
— Fred Varley

Travailler comme portraitiste à Toronto au début des années 1920 pose un défi de taille, relevant davantage d'un sens aigu des affaires que du talent artistique. Malheureusement, l'absence de monographies sur la majorité des grands portraitistes torontois contemporains de Varley nous empêche de déterminer la part exacte de portraits dans leur production ou le nombre de portraits, peints ou dessinés, résultant de commandes. Certains font de la réclame dans les journaux, d'autres comptent sur leurs relations dans certains milieux. Il répugne à Varley d'avoir à offrir ses services. Il écrit à sa femme : « Si les gens viennent me voir, ça va, mais Seigneur! [...] ce colportage [38].»

Or l'époque voit l'émergence de nouveaux marchés, celui des universités et de la fonction publique, qui sont en plein essor, et du milieu des affaires, qui profite du boom industriel d'après-guerre. L'inauguration au début des années 1920 de l'Art Museum of Toronto, de l'Art Gallery of Toronto et de la Hart House Gallery offre de nouveaux débouchés aux artistes. Les goûts et les modes du jour prônent la reproduction exacte de la physionomie et du caractère du sujet. J.W.L. Forster, E. Wyly Grier, A.C. Williamson, Kenneth Forbes, Harry Britton, F.S. Challener, Stanley Gordon

Moyer et Owen B. Staples comptent parmi les portraitistes les plus recherchés. Ils n'hésitent pas à solliciter des commandes et participent régulièrement aux expositions annuelles de l'OSA et la RCA, deux importantes institutions.

John Wycliffe Lowes Forster (1850–1938) est le portraitiste le plus important de Toronto lorsque Varley arrive sur la scène artistique. Originaire de Norval, en Ontario, Foster étudie auprès de J.W. Bridgman à Toronto de 1869 à 1872, avant de se rendre en Europe pour parfaire ses connaissances. En 1879, il travaille sous la direction de C.S. Millard à la South Kensington Art School. De 1879 à 1883, il suit des cours avec William Bouguereau, Tony Robert-Fleury, G. Boulanger, Jules Lefebvre et Carolus Duran à l'Académie Julian à Paris. Vers 1879, il fait de la peinture avec William Blair Bruce dans la région de Barbizon. Il rentre à Toronto en 1883. Forster s'est surtout attaché à représenter des Canadiens bien en vue, mais on lui connaît également des tableaux historiques et religieux ainsi que des paysages. Peintre académique, il travaillait essentiellement à l'huile et au pastel.

E. Wyly Grier (1862–1957) avait vingt ans de plus que Varley. Né à Melbourne, en Australie, il arrive à Toronto en 1876. Il

étudie à Londres et à Rome avant de s'inscrire à l'Académie Julian, où il travaille sous la direction de Bouguereau et de Robert-Fleury. Adepte du traditionalisme, Grier est un habile détracteur du modernisme. Les portraits de Grier sont très expressifs, empreints d'humanisme et de chaleur[39]. En 1920, il réalise un excellent portrait du célèbre critique d'art Augustus Bridle (fig. 3), qui a été acheté par l'Arts and Letters Club de Toronto. Des artistes de l'envergure de Forster et de Grier démontrent l'existence d'un marché pour le portrait traditionnel dans la communauté torontoise.

A. Curtis Williamson (1867–1944) était un autre portraitiste qui avait travaillé sous Forster à Toronto avant de se rendre en Europe. Son approche résolument traditionnelle tenait à des convictions personnelles et son style empruntait largement aux maîtres hollandais. Il obtient de nombreuses commandes de l'Université de Toronto et des membres de l'élite torontoise, y compris de la famille Massey, comme il serait le cas pour Varley vingt ans plus tard. Williamson a réalisé un portrait de son grand ami le docteur James MacCallum, qui allait devenir un des plus grands défenseurs du Groupe des Sept[40]. Il a également peint Alexander McPhedran, dont l'épouse a été portraiturée par Varley dans les années 1920.

Kenneth Forbes (1892–1980) avait onze de moins que Varley. Après un apprentissage initial auprès de son père le portraitiste J. Colin Forbes, il se rend en Angleterre et y demeure pendant seize ans, étudiant et peignant dans divers endroits. À son retour à Toronto en 1924, il s'impose rapidement comme portraitiste. Ses œuvres se distinguent par la finesse d'exécution, la subtilité du modelé et un sens avisé de la couleur et de la finition. Forbes tient Varley en haute estime et le considère comme un artiste accompli. La carrière de Forbes démontre qu'il était possible pour de jeunes artistes de s'imposer comme portraitistes. Son portrait intitulé *Mme Clifford Sifton* (1926; localisation inconnue) présente une affinité stylistique avec ceux de l'artiste britannique William Orpen. Madame Sifton est représentée en plein air, sous un vaste ciel.

Il vaut de souligner la contribution de plusieurs artistes qui présentaient régulièrement des portraits dans le cadre des expositions annuelles du CNE et de l'OSA auxquelles Varley participait également. Natif de Londres Allan Robert Barr (1890–1959), travaille sous la direction de Frank Brangwyn, John M. Swan, George W. Lambert et William Nicholson à la London School of Art de 1907 à 1911. Il émigre au Canada en 1922 et s'installe à Toronto. Barr, qui travaillait principalement à l'huile, était connu pour l'excellence de sa technique et son traitement des ombres et des lumières. On lui connaît également des paysages, des natures mortes et des œuvres figuratives.

Frederick Sproston Challener (1869–1959) compte parmi les artistes qui se sont faits connaître comme portraitistes à Toronto. Né à Whetstone, en Angleterre, il déménage au Canada avec sa famille en 1870. En 1883, il se trouve un emploi dans une maison de courtage et dessine pendant ses moments de libre. Il suit des cours du soir à l'Ontario College of Art (OCA), où il étudie avec George A. Reid. Challener collabore avec C.W. Jefferys à la réalisation de plusieurs murales et exécute de nombreux tableaux historiques d'après des esquisses de Jefferys. En 1898–1899, il se rend en Europe et au Moyen-Orient. Il est artiste de guerre durant la Première Guerre mondiale. Il enseigne au Central Technical College de 1921 à 1924 et à l'OCA de 1927 à 1952. Challener participe aux expositions de l'ARC et de l'Art Association of Montreal. Dans le cadre de l'exposition de 1921 du CNE, il présente un petit portrait exécuté avec brio d'un modèle professionnel, *Le chapeau bleau*, 1922 (fig. 4); elle aurait également posé pour la *Jeune fille en rouge* de Varley (fig. 5).

Charles Fraser Comfort (1900–1994) compte parmi les artistes de la jeune génération. Né à Cramond, près d'Édimbourg, en Écosse, il déménage avec sa famille à Winnipeg en 1912. Il gagne son premier concours d'art à l'âge de huit ans, et à quatorze ans il remporte le premier prix d'un concours d'aquarelle au YMCA, jugé par F.H. Brigden. Cet exploit lui vaudra un poste dans l'imprimerie de Brigden à Winnipeg. Il fréquente la Winnipeg School of Art et, en 1922–1923, l'Art Students League à New York, où il travaille sous la direction d'E. Allen Tucker, Vincent Dumond et Robert Henri.

En 1925, Bridge transfert Comfort à Toronto. Déterminé à œuvrer sur la scène artistique durant le marasme économique

des années 1930, il s'associe à Will Ogilvie (1901–1989), qui avait quitté l'Afrique du Sud pour s'installer au Canada en 1925. Ensemble, ils réalisent des portraits, du matériel publicitaire, des dessins d'architecture et des illustrations pour des revues. Il a été artiste de guerre durant la Deuxième Guerre mondiale, président de l'ARC en 1957 et directeur du Musée des beaux-arts du Canada de 1960 à 1965. *Jeune Canadien* (1932; Hart House), représentant son ami et collègue Carl Schaefer (1903–1995), compte parmi ses portraits les plus accomplis.

L'artiste John William (Bill) Beatty (1869–1941) entretenait des liens étroits avec varley. Peintre et graveur, il avait travaillé sous la direction de J.W.L. Forster, George A. Reid et William Cruikshank. En 1900, il se rend à Paris où il fréquente l'Académie Julian. Ami de certains futurs membres du Groupe des Sept, il peint dans les Rocheuses canadiennes en compagnie d'A.Y. Jackson et C.W. Jefferys en 1914. Il occupe un atelier dans le Studio Building construit par le Dr MacCallum et Lawren Harris. Vers 1919–1920, Beatty enseigne à l'OCA, où il partage un atelier avec Varley. En 1922, Beatty fait appel à la jeune femme qui avait prêté ses traits aux « gitanes » de Varley pour exécuter deux portraits – *Joueuse de mandoline* (fig. 6) et *Diseuse de bonne aventure* (collection particulière) – présentés dans le cadre de l'exposition du CNE[41].

Le début du vingtième siècle voit l'émergence d'un nombre important de femmes artistes, dont la production est nettement plus dynamique et plus diversifiée que celle de leur homologues masculins. Elles sont nombreuses à être attirées vers le portrait, laissant aux hommes, qui étaient, peut-être, mieux à même de composer avec les exigences de la peinture en plein air, la glorification du paysage canadien. Marion Long (1882–1970), contemporaine de Varley, compte parmi les artistes les plus en vue. Elle fréquente l'OCA avant de se rendre à New York, où elle étudie avec William Chase et Robert Henri. Ses portraits des années 1920 se distinguent par leur réalisme et leur simplicité – héritage de l'enseignement et de la technique de Robert Henri[42]. Long réalise quelques portraits mondains et des portraits de professeurs de l'Université de Toronto. Son *Portrait de Luke Teskey* (1922; Université de Toronto), exécuté pour le Royal College of Dental Surgeons, rappelle la première commande universitaire connue de Varley, *W. Theophilus Stuart*, (v. 1912–1915; Université de Toronto), remarquable par le caractère classique et de la pose et du format.

Dorothy Stevens (1888–1966) était peintre, portraitiste, aquafortiste, graveur, illustrateur et professeur d'art. Elle a fréquenté la Slade School of Art à Londres, en 1903, et elle a également étudié à Paris. Aquafortiste de renom, elle est présidente de la Women's Art Association à Toronto. Dans les années 1920, elle s'intéresse à la représentation de gitanes, *Mademoiselle Juanita Cargill* (1922; fig. 7) compte parmi les portraits présentés dans le cadre de l'exposition de 1922 du CNE. Pegi Nicol MacLeod, Paraskeva Clark, Prudence Heward, Estelle Muriel Kerr et Kathleen Daly Pepper ont également pratiqué le portrait.

Lors de la première exposition du Groupe des Sept, tenue à l'Art Gallery of Toronto en mai 1920, Fred Varley et Lawren Harris présentent des portraits. Harris expose, entre autres, le *Portrait de Bess Housser* (1920; AGO) et *Mme Oscar Taylor* (1920; fig. 8). Varley présente *Portrait de Vincent Massey* (1920; pl. 9) et *Winifred Head* (1920; localisation inconnue) de même que des études de Barker Fairley (pl. 8) et de J.E.H. MacDonald (détruite)[43].

La démarche d'un portraitiste

Après la guerre, Varley se consacre surtout au portrait. Plus tard, il allait affirmer : « Le portrait vous enferme, impossible d'ouvrir toute grande la porte[44]. » L'aisance avec laquelle il exécute portrait après portrait au début des années 1920 est tout à fait remarquable. Ces portraits sont des témoignages d'humanité d'une grande simplicité. La majorité d'entre eux présentent une double conception de la forme juxtaposant une tête sculpturale à un corps sans relief. Dans certains portraits, une division géométrique de l'espace suscite un sentiment de calme et de stabilité. En générale, Varley recourt à un axe vertical prononcé et un contraste chromatique marqué. Chacun des sujets est peint avec une verve, une énergie et une perspicacité jusqu'alors sans précédent dans son œuvre.

Dans certains cas, le fond est lumineux, miroitant; dans d'autres, il consiste en un paysage ou une scène d'intérieur aux couleurs pastels. La touche est généreuse et ample. Elle apparaît parfois sinueuse en arrière-plan, comme dans *Gitane* (1919; pl. 5), ou encore elle sert à accentuer la structure de la composition, comme dans les portraits de Vincent Massey, Chester Massey, sir George Parkin et John, le fils de Varley. Les couleurs sont posées en couche épaisse, à la manière d'empâtements. Les carnations évoquent l'argile.

Arthur Lismer a déjà dit : « Varley a peint beaucoup de choses entre 1919 et 1926. Elles n'étaient pas toutes importantes. Certaines étaient mineures, mais elles étaient toutes essentielles à sa croissance : une tête de femme, un groupe d'enfants, une lueur dansant sur l'eau, un ciel rose, la terre chaude, la courbe d'un sein, un geste charmant, le reflet d'une humeur passagère[45]. » Même si la réussite semblait à portée de main, Varley se montre peu convaincu : « Je suis un garçon nerveux, beaucoup trop impressionnable pour vivre sainement dans cette existence commerciale[46] ».

Varley, le peintre et l'homme, était fasciné par certaines personnalités. « Mon père était fin psychologue, affirme Peter Varley, et certaines personnes piquaient son intérêt, peu importe leur rang social. Il décelait leur nature secrète, leur amour de la vie[47]. » Dans ses portraits d'après-guerre, Varley tente manifestement d'apprivoiser le genre. Par souci de clarté, nous avons groupé les portraits de cette période soit par thèmes, soit par types de commande : commandes universitaires, portraits de gitanes, commandes de la famille Massey, portraits mondains, portraits de famille et d'amis (y compris les membres de la famille de Barker Fairley), de membres et d'associés du Arts and Letters Club, et portraits choisis.

Commandes universitaires, 1920 à 1924

La commande de portraits par les universités était pratique courante durant le premier quart du vingtième siècle. Dans bien des cas, les fonds étaient réunis par souscription parmi les amis et les collègues de la personne à qui l'on rendait hommage. Les portraits étaient généralement offerts à l'occasion d'une retraite ou d'une occasion spéciale et, normalement, ils demeuraient dans la collection de l'université. Étant donné l'absence de documentation officielle, il est difficile d'obtenir des précisions sur le choix de l'artiste et les modalités du contrat.

La première commande canadienne que reçoit Varley est celle du portrait du professeur James Cappon, doyen des arts de l'Université Queen's (fig. 9), qui avait pris sa retraite en mai 1919. Varley y travaille à la fin de l'été et au début de l'automne 1919, à Toronto et à Kingston, où certaines séances de pose ont eu lieu[48]. Varley a probablement obtenu le contrat par l'intermédiaire de son vieil ami Barker Fairley, germaniste et spécialiste de Goethe à l'Université de Toronto. En 1917, Cappon avait prononcé une conférence à l'Université de Toronto; en 1919, Fairley et C.W. Jefferys avaient organisé une exposition de peintures canadiennes à l'Université Queen's. Les deux hommes comptaient parmi leurs amis communs le professeur John M. MacEachran d'Edmonton.

Varley représente le professeur Cappon assis dans un fauteuil. Malgré l'aspect formel de la pose, le sujet apparaît détendu, le corps et le regard légèrement de biais. Le portrait est ressemblant, et le modèle respire le calme et la confiance. Le fond se distingue de celui des portraits de guerre de Varley en ce que la lumière miroitante cerne les contours de la figure. En renonçant à tout effet de profondeur, l'artiste crée une présence envahissante, que vient accentuer le poing fermé du modèle – témoignage de la force de caractère et de la détermination du professeur. Fin psychologue, Varley a peut-être anticipé ce qu'avancerait W.E. McNeil dans sa biographie de James Cappon : « Plus d'un homme et plus d'un argument se sont effondrés devant cet air fermé et cette position rigide. Tant par l'apparence que la manière et le discours il avait ce que tous qualifient de Personnalité et la majorité d'Autorité[49]. » Ravi des résultats, Varley présente le portrait du professeur Cappon dans le cadre de l'exposition de 1920 de l'OSA. Barker Fairley, tout aussi satisfait, allait recourir à une reproduction du portrait pour solliciter d'autres commandes[50].

À la fin de l'automne 1920, Varley se voit proposer la commande du portrait du docteur Irving Heward Cameron (v.

1922; fig. 10). Le nombre de portraits entrepris par Varley en 1920 et 1921 permet d'affirmer qu'il traversait une période de grande activité. Après avoir terminé le portrait de Chester Massey en novembre 1920, il a à peine achever celui de son ami Barker Fairley qu'il entreprend déjà un autre projet. À la mi-décembre 1920, il s'installe à Sarnia pour peindre le portrait de Mary, la fillette de huit ans de William Kenny. Varley termine le portrait au cours du mois de janvier 1921, mais impossible pour lui de s'arrêter. D'autres commandes l'attendent. Au début du printemps, il compte à son actif les portraits de Margaret Fairley et de Minnie Ely. Entre les mois de juin et septembre 1921, il se consacre certainement au portrait de sir George Parkin.

Il lui faut attendre l'automne pour entreprendre le portrait du professeur Cameron (1855–1933). Le professeur avait pris sa retraite de la faculté de médecine de l'Université de Toronto en octobre 1920. L'exécution de la commande accusait donc un retard de plus d'un an. La documentation sur l'obtention de la commande étant lacunaire, on peut supposer que la réputation croissante de Varley dans les milieux universitaires y était pour quelque chose. À l'Université de Toronto, il bénéficiait de l'appui de Barker Fairley, James MacCallum et Huntley Gordon.

La présentation des portraits de Varley dans le cadre d'importantes expositions permet de leur attribuer une date de manière plus ou moins fiable. Le portrait du professeur Cameron, par exemple, a été présenté pour la première fois en mars 1922 lors de l'exposition annuelle de l'OSA, ce qui permet d'affirmer qu'il a été réalisé à la fin 1921 ou au début 1922. Les portraits antérieurs à celui exécuté à Sarnia figuraient dans des expositions de 1921[51].

À l'inauguration de l'exposition de 1922 de l'OSA, Barker Fairley affirme en observateur avisé que « le portrait de Cameron est à la fois l'œuvre la plus traditionnelle de l'exposition et la plus originale ». Il admire le talent de Varley et voit dans ce portrait une intégration harmonieuse figure-fond. Il insiste sur la maîtrise chromatique de l'artiste dans la représentation de la figure et des vêtements, la comparant au traitement plutôt banal du fond. Il souligne également l'éclairage insolite [52]. En effet, le fond sombre se distingue nettement de la surface miroitante de certains de ses portraits d'après-guerre. On ne retrouve pas cette palette sombre dans le portrait du doyen Cappon. Le seul tableau à avoir une certaine affinité avec ce portrait est celui de *W. Theophilus Stuart* et il date des années 1912–1915.

Le portrait de Cameron marque un important tournant stylistique dans la démarche de Varley. Le 7 décembre 1935, Varley écrit à Eric Brown lui demandant d'inclure le portrait du docteur Cameron dans la rétrospective du Groupe des Sept, qui doit avoir lieu au Musée des beaux-arts du Canada en 1936. Pour justifier sa demande, Varley établit un parallèle entre le portrait de Cameron et celui qu'il a réalisé de Vincent Massey, affirmant « c'est un excellent contraste et il me tient à cœur[53] ».

Le portrait du docteur Cameron a souvent été comparé à celui du révérend T.C.S. Macklem exécuté par E. Wyly Grier et présenté dans le cadre de l'exposition annuelle de l'OSA de 1923[54]. La pose du modèle est un élément commun; le rouge éclatant des toges universitaires en est un autre. (Il serait intéressant d'examiner le portrait du docteur Cameron exécuté sur commande par E. Wyly Grier en 1931 pour l'Hôpital Général de Toronto.)

En 1922, l'Université de l'Alberta commande à Varley le portrait de son président fondateur, Henry Marshall Tory (1864–1947; fig. 11), à l'occasion du quinzième anniversaire de son mandat [55]. Varley a reçu un cachet de 1 000 $ provenant de contributions volontaires du personnel et d'anciens élèves. Présenté au professeur Tory à l'occasion de son quinzième anniversaire lors de la collation des grades au printemps 1923, le portrait a été offert en don à l'université. John MacEachran, professeur de philosophie à l'Université de l'Alberta, s'est occupé de choisir l'artiste et de recueillir des dons. L'amitié entre MacEachran et Barker Fairley datait de l'époque où Fairley enseignait à l'Université de l'Alberta. Il est donc parfaitement normal que MacEachran consulte son vieil ami en matière du choix de l'artiste. Une lettre non signée de 1922 conservée dans les archives de l'université affirme que l'artiste choisi était considéré comme le « plus grand portraitiste du Canada » et que Varley était le candidat idéal parce qu'il s'attache à « exprimer le caractère et à rendre une personnalité énergique[56]».

Plutôt que de faire venir Varley à Edmonton, le professeur Tory effectue un bref séjour à Toronto au début avril 1923.

Quatre séances de pose ne suffisent pas pour achever le portrait et Varley doit faire appel au frère du professeur, James Tory, pour terminer les mains. Qu'il s'agisse des délais serrés qui lui sont imposés ou du besoin de recourir à un autre modèle, les mains apparaissent démesurées et Varley devra les repeindre à une date ultérieure. Détail qui ne diminue en rien l'accueil favorable réservé au portrait.

La pose du professeur Tory est inédite dans le vocabulaire de Varley. Contrairement aux portraits précédents où les sujets sont assis et vus de trois quarts, Tory est représenté debout, face au spectateur. Un professeur d'art de l'université a fait remarquer que le professeur Tory avait naturellement pris la même pose lors de la cérémonie de présentation du portrait[57]. Le format du portrait est également plus grand, le sujet étant représenté debout. La toge de cérémonie, avec ses longues verticales, ajoute au volume et à la présence de la figure[58]. Satisfait des résultats, Varley reprendrait la pose dans son portrait de 1927 de Francis Lovett Carter Cotton, ancien chancelier de l'Université de la Colombie-Britannique.

En 1924, le premier voyage Varley dans l'Ouest lui vaut d'autres commandes, dont celle du portrait de Daniel McIntyre (1852–1946), administrateur en chef de la Commission scolaire de Winnipeg, qui était à trois ans de la retraite[59]. Résultat d'une campagne de souscription auprès des enseignants et du personnel, la commande a d'abord été offerte à W.J. Phillips, qui avait rencontré McIntyre en 1913 au moment de son embauche comme professeur d'art dans une école secondaire de Winnipeg[60]. Phillips accepte la commande malgré son inexpérience du portrait. Cela dit, en 1923 il se rend à Toronto et rencontre Varley, qui vient de perdre sa maison pour non-paiement de l'hypothèque. Ressentant de la compassion pour Varley, Phillips décide de lui confier la commande[61].

Varley arrive à Winnipeg vers le milieu du mois de janvier 1924 et s'installe à l'hôtel Marlborough. Le professeur McIntyre débute ses séances de pose dès l'arrivée de Varley qui n'a vite d'autre choix que de transformer sa chambre en atelier. L'éducateur fait bonne impression à l'artiste, qui écrit à sa femme : « J'ai rencontré le professeur McIntyre. Sapristi ! il est formidable – je vais prendre grand plaisir à faire son portrait. Je vais commencer jeudi matin[62]. » Quatre séances de pose et une semaine plus tard, c'est un Varley optimiste qui écrit à Maude : « Rien dans le tableau ne permet d'affirmer que cela se passe bien – il a l'air d'attendre que quelque chose se produise – mais l'homme est formidable – l'agencement, la couleur, la lumière et l'ombre évoquent un vieux Rembrandt et si je ne réussis pas – je – eh! bien. Je n'imagine pas échouer – j'ai toutes les chances et je dois réussir[63]. »

Comme à de nombreuses occasions durant sa longue carrière, l'enthousiasme de Varley tenait à sa réaction personnelle au modèle. Fasciné par McIntyre, Varley écrit à Maud :

Tu n'es pas ma chère sans savoir ce que signifie peindre une personnalité, être absorbé par le modèle. Pardi! ce charmant gentleman a fait de moi un esclave. Nous avons appris à nous connaître en parlant et au début ma vigueur et ma façon de voir les choses l'ont réduit au silence et il avait l'impression que j'en savais beaucoup plus. Il parlait du mérite de son travail et petit à petit le mouvement de va-et-vient s'est enclenché. Il m'a raconté des tas de choses ces derniers jours et m'a avoué n'avoir jamais autant parlé. Il a parlé de la mort de sa femme, de celle de son fils durant la guerre, et de celle de deux enfants âgés de 7 et 9 ans emportés par la diphtérie en moins de 24 heures[64].

L'échange de confidences forge un lien entre les deux hommes. Après les séances de pose, ils se rendent dans la prairie pour regarder le soleil se coucher et passer un bon moment ensemble. « J'ai failli pleurer comme un veau, reconnaît Varley, et je savais qu'en quelque part son cœur irradiait du soleil et que son savoir était mûr et doré et que je me débattais pour trouver ce que seul l'âge peut apporter – quel enfant, quel enfant démuni je me sentais, et bien entendu je lui ai dit ce qu'il m'avait apporté, mais il s'est contenté de rire doucement et de me dire qu'il n'était pas responsable, mais que le coucher de soleil était une merveille[65]. »

Le bref séjour de Varley à Winnipeg tire à sa fin. Il doit se rendre à Edmonton où l'attendent d'autres projets. Bien que n'ayant pas achevé le portrait du professeur McIntyre, il s'en dit très satisfait. Le sujet est représenté de face, à mi-corps, confortablement assis dans un fauteuil. Les plis de sa toge sont brossés très librement, témoignant de la virtuosité de Varley en matière d'ombres et de lumières. Les mains sur les genoux, le professeur est à la fois serein et confiant. Varley a mis l'accent non seulement sur la force de son caractère, mais sur sa bienveillance. Il compte retourner à Winnipeg au printemps pour terminer le portrait.

Varley se rend à Edmonton pour exécuter le portrait du nouveau chancelier de l'Université de l'Alberta, Charles Allan Stuart (1864–1926; pl. 20). Le portrait du professeur Stuart ferait pendant à celui de son prédécesseur, Henry Marshall Tory, dans la salle du conseil de l'université. Une fois de plus, c'est à John MacEachran qu'il incombe de choisir l'artiste et de recueillir les dons [66]. Les séances de pose ont lieu à la fin février et au début mars 1924. Terminé le 2 avril, le tableau est présenté au chancelier Stuart par son prédécesseur lors de la collation des grades au mois de mai [67].

Avocat de profession, Stuart avait été nommé à la Cour suprême de l'Alberta. Le professeur MacEachran a affirmé que durant les séances de pose, le chancelier parlait beaucoup de ses expériences à la cour. Il lui arrivait de faire des commentaires sur certaines causes, de meurtres plus particulièrement. MacEachran avait l'impression que la nature des conversations avaient influencé Varley, l'amenant à représenter un individu autrement très chaleureux comme un juge présidant un tribunal [68]. Il vaut de noter que si les séances avec Stuart se sont déroulées sensiblement de la même façon que celles avec le professeur McIntyre, la lecture des deux portraits est diamétralement opposée. Varley était très fier des deux œuvres et les considérait comme ses meilleures réalisations, malgré la différence marquée entre les deux [69]. Le portrait du chancelier Stuart a suscité des réactions non moins partagées : James Adam fait valoir son caractère peu conventionnel [70], tandis qu'Augustus Bridle y voit le meilleur portrait de Varley exécuté avant 1926 [71].

Pour le portrait de Stuart, Varley choisit délibérément une gamme de couleurs froides, qui contraste fortement avec le rouge vif de la toge du professeur Tory. Le chancelier Stuart porte une toge bleu indigo garnie de passements jaunes [72]. Andrea Kirkpatrick fait remarquer que Varley expérimente deux éléments stylistiques : la figure assise de Stuart prend la forme d'une pyramide à l'intérieur d'une composition géométrique; les ombres et les lumières, répétées et prolongées au-delà de la forme pyramidale, deviennent des fragments de lumière aux allures d'un motif géométrique, notamment dans le coin inférieur droit. Kirkpatrick note une utilisation similaire des faisceaux de lumière dans le travail du peintre cubiste allemand Lyonel Feininger (1871–1956), plus particulièrement dans les œuvres postérieures à 1910 [73]. Il vaut de mentionner que certains historiens de l'art ont interprété l'utilisation des motifs géométriques pour distinguer entre la lumière et l'ombre chez Feininger comme un moyen d'atténuer la différence entre la présentation du matériel et de l'immatériel.

Dans le portrait du chancelier Stuart le premier plan et l'arrière-plan se fondent l'un dans l'autre. La forme, qui se voit accorder la même importance que la lumière et l'ombre, est rassemblée en un seul plan pictural, écrasant du coup l'image et brouillant la distinction entre le corps et le vide. Varley allait privilégier cette technique dans la majorité de ses portraits des années 1930 et 1940. Certains de ses portraits les plus connus de Vera Weatherbie, son étudiante et sa compagne de Vancouver, se veulent une manifestation extrême de cette technique.

De retour à Winnipeg pour retravailler le portrait de McIntyre, Varley écrit à un ami : « Il me tarde de trouver mon rythme de travail ». Il dit trouver son inspiration dans la vue de la fenêtre de sa chambre d'hôtel-atelier : « Ce matin je peignais les revers blancs de la toge du professeur et la lumière et les ombres et les couleurs nacrées étaient semblables à des traînées de neige sur les versants d'une montagne [74]. » Passé maître dans l'application des couleurs, Varley s'efforce de reproduire la texture même de la toge. Une semaine lui suffit pour terminer le portrait. Le tableau, qui est dévoilé le 30 mai à l'occasion du baptême d'une école qui portera le nom de McIntyre, est déposé en fiducie à la Commission des écoles publiques pour les résidents de Winnipeg [75].

Tant dans la littérature de l'histoire de l'art que dans la presse, on a attaché beaucoup d'importance au fait que Varley était défavorable aux commandes « arrangées ». Quittant Vancouver à bord d'un train en avril 1924, il écrit : « Dorénavant je vais peindre des montages – C'est plus facile de vendre des montagnes que de solliciter des portraits – Que les autres le fassent pour moi me fait horreur[76] ». Ce commentaire était sans doute provoqué par un événement qui venait de se produire à Winnipeg. Dans une lettre à Kathleen Calhoun, son nouvel amour qui habite Edmonton, Varley parle des efforts de madame Stuart pour lui obtenir la commande du portrait d'une de ses connaissances. Varley, qui est à court d'argent, accepte la commande, mais la démarche l'épuise. « Mme Stuart m'a emmené au club de golf lundi. Nous avons rencontré le colonel McGilvray qui roule sur l'or et qui souhaite depuis longtemps avoir un portrait de sa femme. Mme Stuart affirme qu'elle fera de son mieux pour persuader la Dame parce que la Dame en question est comme toutes les autres à Edmonton. Cela la gêne. Ou peut-être a-t-elle l'impression qu'elle va décevoir son mari en acceptant[77]. » Comme en témoigne l'incident, lorsqu'un intermédiaire entreprend de lui obtenir une commande, Varley est très souvent déçu et blessé dans son orgueil. Malgré le plaisir que lui procure ses portraits, les tractations et le sentiment d'être à la merci de quelqu'un lui sont insupportables.

La tradition gitane

Si durant la période d'après-guerre, le talent de portraitiste de Varley lui vaut une renommée croissante et lui permet de « gagner son pain », il ne s'y consacre pas exclusivement. Il arrive que d'autres genres et thèmes l'interpellent. À la fin 1919, début 1920 Varley s'intéresse de nouveau à la représentation du peuple gitan en tant que symbole de la liberté d'esprit. Adolescent, il était intrigué par l'apparence physique et le mode de vie des gitans qu'il croisait lors de ses excursions de dessin avec son père dans le parc national du Derbyshire et les landes autour de Sheffield. Les rassemblements mystiques autour des feux de camp nourrissent son imaginaire. Les gitanes apparaissent pour la première fois dans l'œuvre de Varley en 1912 dans une petite aquarelle intitulée *La colline* (fig. 12).

Durant son service de guerre à Londres, en 1918–1919, Varley a l'occasion de voir les tableaux de gitanes d'Augustus John (1878–1961), à la Tate Gallery, y compris sa *Femme souriant* (1908–1909)[78]. John était étroitement associé à un mouvement amorcé à la fin du dix-neuvième siècle prônant une représentation romancée de la beauté et de l'affranchissement de l'esprit gitan[79]. Charmé par les gitans de son pays de Galles natal, il apprend le romani et partage leur existence nomade[80]. Il est aisé de comprendre l'attrait des gitans qui s'opposent de façon frappante à la sclérose de la société victorienne. Dans le contexte actuel, l'expression « tradition gitane » se rapporte à prédilection de Varley pour l'idée de vêtir des modèles de costumes aux couleurs vives et d'accessoires et de les représenter en gitanes[81].

À Toronto, vers 1920, Varley représente le même modèle dans au moins trois portraits de chevalet et un imposant panneau décoratif dans la tradition gitane. Des recherches récentes infirment l'hypothèse selon laquelle le modèle était d'ethnie gitane. Il s'agit en fait d'une femme de la classe ouvrière du Yorkshire (fig. 13), madame Goldthorpe, qui avait émigrée au Canada à la même époque que Varley. La famille de madame Goldthorpe affirme qu'elle n'avait pas de sang gitan, mais que son visage hâlé servait les fins de l'artiste[82]. La fille du modèle, alors âgée de douze ans, avait également été habillée en gitane par Varley pour le panneau décoratif intitulé *Les Immigrants*, auquel nous reviendrons.

L'attrait du thème gitan pour Varley tient peut-être à son lien à la vie nomade. Lui-même immigrant, il s'associe à leur lutte quotidienne pour se nourrir, à leur découverte d'une réalité nouvelle et à leurs efforts pour recréer le vieux continent dans leur patrie d'adoption. Il éprouve la même tension sous-jacente dans sa propre vie entre le besoin de chérir son passé et de s'intégrer à la société torontoise. À cette époque, au Canada, la définition d'un immigrant idéal se limitait à un agriculteur ou à un travailleur d'origine britannique ou américaine. Un immigrant qui ne venait pas des îles britanniques était étiqueté

comme « étranger ». La société majoritairement anglophone était opposée au cosmopolitisme et considérait l'ethnicité comme un état pathologique temporaire[83].

Des nouveaux arrivants au Canada au début des années 1900, les gitans sont les moins désirables. Ils sont perçus comme de petits malfaiteurs. Leur réputation de malhonnêteté, leur nomadisme et leurs coutumes en font les archétypes de l'étranger inassimilable ou du « mauvais étranger ». Malgré les obstacles à leur relocalisation, les familles gitanes réussissent à se rendre à Toronto et dans d'autres grandes villes canadiennes[84]. Ces étrangers à la peau foncée, qui se déplacent en caravanes ou vieux tacots, provoquent un mélange de crainte et de fascination.

Les préjugés contre les gitans étaient enracinés dans la culture occidentale. Quel enfant ne connaissait pas les histoires d'enfants enlevés par des gitans? Or au moment où Varley s'adonne à la représentation romancée des gitanes, il est déjà considéré comme un moderniste. On peut se demander s'il s'agit d'une tendance. Deux autres artistes torontois présentent des portraits de gitanes dans le cadre de l'exposition de 1922 du CNE. J.W. Beatty expose *Gitane* et Dorothy Stevens *La Gitana*[85].

Sang gitan (1919; fig. 14) révèle désir de Varley d'atteindre à un archétype de la beauté sensuelle. Ce portrait atteste de l'affinité du travail de Varley avec les portraits gitans exécutés par Augustus John de sa seconde épouse, Dorothy McNeill (qu'il appelait « Dorelia »). Ici, le torse et la tête du modèle sont légèrement tournés vers la droite, suivant la direction de son regard. Un sourire énigmatique invite le spectateur à s'interroger sur l'objet de son intérêt. Il éclaire son visage et adoucit son regard méditatif. À la différence de l'autre portrait de l'époque intitulé *Gitane* (1919; pl. 5), ses cheveux sont retenus par un fichu. Rien ne permet d'affirmer laquelle de ces études a été peinte en premier.

Le modèle porte la même robe rouge dans les deux compositions. Dans *Sang gitan*, l'arrière-plan vert foncé agissait comme repoussoir. Dans *Gitane*, le sujet se détache sur un fond rouge vif. Varley donne du volume aux cheveux indisciplinés de la femme, en leur donnant l'air d'être défaits par le vent. Le choix de la couleur de la robe et du fond est saisissant. Varley utilise la chaleur du rouge vif pour obtenir un effet puissant, ajoutant à la

valeur symbolique de l'œuvre. Joyce Zemans décrit la technique picturale de Varley comme une « corrélation systématique et complexe de la couleur et du personnage[86] ».

L'œuvre est présentée en 1922 dans le cadre de la troisième exposition du Groupe du Sept à l'Art Gallery of Toronto. Elle y est de nouveau présentée en 9125, mais cette fois sous le titre d'*Étude de personnage*. Le nouveau titre laisse supposer à un grand nombre de conservateurs et d'historiens de l'art que *Gitane* est une étude plutôt qu'un portrait. D'ailleurs, on délibère toujours sur les intentions de Varley. Les différents points de vue se résuments aux questions suivantes : La compositon s'inscrit-elle dans le cadre de sa quête de l'archétype de la beauté féminine? Ou aspire-t-elle à rendre l'individualité d'une femme, d'une femme aux traits exotiques et mystérieux – d'une femme fatale? Pour sa part, le critique torontois Hector Charlesworth s'est rangé dans le deuxième camp. Dans son article sur l'exposition de 1925 paru dans *Saturday Night*, il fait référence au portrait d'une gitane « exécuté dans la tradition de la femme fatale[87] ».

À la fin du dix-neuvième siècle, certaines caractéristiques des portraits de femmes sont invariablement associées à la femme fatale : « Une femme vue de face, droite et généralement tendue, la tête rejetée en arrière et les paupières baissées[88] ». D'autres éléments – y compris les motifs en spirale en toile de fond ou sur les vêtements, voire même dans les boucles de cheveux – ajoutent à l'érotisme de la composition. Là où la position debout exprime la maîtrise de soi et des autres, la chevelure dénouée, la tête inclinée et les bras levés symbolisent à la fois l'abandon et le consentement.

La tradition de la *femme fatale* n'est pas évidente chez Varley. Ses portraits sont généralement dénués de la narration caractéristique de ce type de représentations. *Gitane* ne représente pas une femme sensuelle et érotique aux traits doux, mais une femme forte et corpulente aux traits usés par la vie. On peut établir certains parallèles avec les portraits de l'artiste du dix-neuvième siècle Dante Gabriel Rossetti, dont les sujets féminins sont représentés en gros plan, avec le même cou puissant, sans rien perdre de leur sensualité raffinée[89].

L'intérêt suscité par *Gitane* tient à intemporalité. Le tableau a toutes les caractéristiques d'une œuvre phare dans la carrière d'un

artiste. De plus, l'analyse de ce portrait est essentielle à la compréhension de l'évolution stylistique de Varley. *Gitane* amorce une célébration de la féminité qui allait se poursuivre jusqu'à la fin des années 1950. Au cours des années, Varley a exécuté des portraits emblématiques qui se distinguaient par leur sensualité et leur monumentalité, immortalisant des femmes au charme hors du commun. *Vera* (1931), *Norma* (1935), *Erica* (1940), *Nathalie* (v. 1943), *Jess* (1950) et *Kathy riant* (v. 1952–1953) sont autant d'hommages de Varley à l'« éternel féminin ».

Varley a également fait appel à cette « gitane » pour une œuvre inhabituelle, moins connue : un imposant panneau décoratif intitulé *Les Immigrants* (v. 1912; pl. 15). Cette étude pour une murale a été présentée pour la première fois dans le cadre de l'exposition de 1921 du Groupe des Sept sous le titre de *Panneau décoratif*. Les toiles grand format de ce type était souvent qualifiées de « décoratives », même si les qualités décoratives étaient supplantées par le sujet. Dans de telles œuvres, le premier plan se doit de supporter le poids de la composition. Varley a résolu le problème en articulant la composition autour de sa « gitane ».

Symbole de l'immigrante type, le modèle se tient au milieu de la foule, face au spectateur. Elle occupe le centre de la composition, vêtue d'une robe rose et d'un fichu rouge, avec dans son baluchon l'ensemble de ses effets pour sa nouvelle vie. Les immigrants semblent épuisés par la longue traversée. Varley n'aurait eu aucun mal à évoquer les sentiments d'espoir et d'incertitude ressentis durant son voyage de 1912. Il a peut-être tenté de travailler de mémoire, recourant à des modèles pour certains des personnages. Le tableau exécuté par Frank Brangwyn en 1906 et intitulé *L'atelier de cuivre* a peut-être servi de modèle à Varley[90].

Varley a également fait appel au même modèle pour une œuvre aujourd'hui disparue intitulée *Étude de personnage* (v. 1919–1920; fig. 15). Elle est représentée s'appuyant sur la chambranle d'une cheminée. Le tableau est présenté pour la première fois en 1921 dans le cadre de l'exposition du CNE, et de nouveau en 1922, figurant au catalogue (n° 317). Il figure également dans l'exposition de 1922 du Groupe des Sept tenue à l'Art Gallery of Toronto. Ce qui laisse supposer que ce tableau a été

exécuté à la même époque que les autres portraits de gitanes; certaines affinités avec le fond grenu de *Gitane* renforce cette hypothèse. Certaines faiblesses stylistiques laissent croire que le tableau a été exécuté de mémoire et non d'après le modèle. Par exemple, le bras gauche du modèle est trop long et manque de naturel; son bras droit ne suit pas le contour de l'épaule et de la manche. L'exécution des mains est plutôt grossière. En y regardant de près, les plis de la jupe sont sommairement esquissés, ce qui n'est pas conforme à la manière méticuleuse de Varley.

En 1923 il retravaille son *Étude de personnage* en vue de sa reproduction en page couverture du recueil *The Complete Poems of Tom MacInnes*. Dans cette version, les bras du modèle sont parfaitement proportionnés à son corps. Le coude gauche est appuyé sur un tronc d'arbre ou un élément d'architecture non identifiable. Les traits de la femme sont plus doux, ajoutant à l'élégance et à la sensualité de la composition. Cette réinterprétation tient peut-être à la nature même du graphisme, mais elle tient surtout au fait que la gitane a été transformée en égérie.

On ne saurait aborder les portraits gitans de Varley sans les inscrire dans leur contexte. À l'époque où il travaille à ces compositions empreintes du romantisme de la peinture anglaise du dix-neuvième siècle, les autres membres du Groupe des Sept préparent leur première exposition, qui sera inaugurée le 7 mai 1920. Ils annoncent leur intention de faire du paysage canadien le sujet de leur art. Que Varley et Harris aient décidé d'inclure des portraits dans l'exposition inaugurale du Groupe est pour le moins étonnant. Selon Charles C. Hill, cette initiative « démontre la complexité de leur dessein[91] ». Au cours des dernières années, les historiens de l'art se sont penchés sur les relations relativement timides de Fred Varley avec le Groupe. En général, Varley est traité selon ses mérites artistiques, indépendamment du Groupe de Sept. Il est considéré comme une âme errante, comme le « gitan » du Groupe.

Le bien-fondé de ce point de vue est confirmé par le portrait que brosse Peter Varley de son père : « Il était, avant tout, son propre maître, un être énigmatique et un homme de contradictions. Son sens de la famille, en grande partie sentimental,

ne le quitta jamais; pourtant son côté gitan, sa nature psychique et mystique, son romantisme et son absolu besoin de liberté d'agir se hérissaient contre quiconque tentait de le brimer[92].»

L'attrait des gitans et l'amour qu'avait Varley des belles femmes sont indissociables. En tant qu'homme et en tant que portraitiste, il avait une compréhension profonde des secrets intérieurs des femmes. Au cours des deux prochaines décennies, Varley allait approfondir le thème des gitanes, allant même jusqu'à l'utiliser à des fins « modernistes ». Dans les années 1940, l'esprit gitan habite les portraits qu'il réalise de ses amies et connaissances – des femmes jeunes, belles et résolument libres. À Miriam Kennedy, qu'il surnommait Manya, et Natalie Kessab, qui partageait certaines qualités avec sa gitane idéalisée, Varley a attribué une lueur de l'indépendance farouche à laquelle il aspirait.

CHAPITRE 3

LA SPHÈRE PUBLIQUE : PORTRAITS MONDAINS

Le devoir de l'artiste est de briser les chaînes et de
libérer l'esprit.
— Fred Varley

Dans les premiers mois de 1920, Varley reçoit sa première commande de l'Université de Toronto à l'occasion de l'inauguration des nouveaux locaux de l'association étudiante, qui se voulait « une force unificatrice à l'intérieur d'un campus fragmenté ». Un don de la Massey Foundation offert par son président, Chester Massey, l'édifice était conçu comme un monument à la mémoire de son père, Hart Massey, et il reçut le nom de ce dernier. Dans son histoire de la Hart House, Ian Montagnes affirme que la création de locaux pour l'association étudiante était une idée unique à l'époque, et la Hart House en est un des premiers exemples au monde[93]. C'est à Vincent Massey (1887–1967) que revient le mérite de l'idée. Il est responsable de la planification et de la construction de l'édifice, malgré les interruptions entraînées par la Première Guerre mondiale. Des amis et des membres du comité Hart House, dirigé par Barker Fairley, décident de commander un portrait de Vincent pour exprimer leur reconnaissance. Mais c'est à Vincent que revient le choix de l'artiste.

Vincent Massey

Chez les Massey, les portraits étaient une tradition familiale et Vincent avait sans doute déjà fait exécuter une œuvre sur commande. À l'époque les portraits de W.E.H. Massey et Hart Massey, peints par J.W.L. Forster, faisaient déjà partie de la collection du Victoria College de l'Université de Toronto. Forster aurait donc été un choix logique pour le portrait de Vincent[94]. Vincent Massey avait un intérêt marqué pour les arts et était au fait de la scène artistique de Toronto. Il connaissait Lawren Harris, dont la famille était partenaire dans l'entreprise des Massey, et s'était porté acquéreur d'œuvres d'artistes canadiens contemporains, dont des esquisses de Tom Thomson.

Barker Fairley raconte que Massey et Varley s'étaient rencontrés avant la guerre au Arts and Letters Club. Vincent était membre depuis 1911 et Varley y adhéra peu de temps après son arrivée à Toronto en 1912[95]. Le succès critique des tableaux de guerre de Varley à Londres, les comptes rendus favorables dans la

presse et sa renommée à Toronto sont autant d'éléments qui ont guidé le choix de Vincent Massey. Une fois l'entente conclue, les séances de pose ont lieu à la cabane de Tom Thomson, que Varley louait comme atelier[96].

Varley représente Vincent Massey (pl. 9) de trois quarts confortablement assis dans un fauteuil; la pose n'est pas sans rappeler celle du doyen Cappon. Massey apparaît comme un homme autoritaire, sûr de lui et raffiné. Tout porte à croire que la personnalité du sujet a influé sur l'approche de Varley. À la différence de Cappon, dont la présence est envahissante, Massey est représenté en retrait du spectateur. Varley nous donne l'impression d'un homme distant et renfermé. L'arrière-plan à la fois froid et lumineux ajoute au sentiment d'isolement.

Les membres de la famille Massey tenaient à leur vie privée, et Vincent ne faisait pas exception à la règle. Or, les Massey intriguaient le public qui était enclin à leur attribuer certains traits de caractère. Des histoires au sujet de la commande du portrait ne tardent pas à circuler dans Toronto. Enjolivées au fil des ans, ces anecdotes prétendent à la véracité[97]. Une histoire veut que Vincent Massey se soit présenté avec une heure de retard lors d'une séance de pose. Contrarié, Varley aurait décidé de lui servir une leçon. Selon une version, il aurait annoncé que la séance était terminée, rassemblé ses affaires et quitté les lieux. Selon une autre, il se serait excusé et quitté l'atelier, laissant Massey attendre pendant une heure.

Peter Varley raconte qu'à la veille de la dernière séance Varley, déçu de son travail, a supprimé la tête de Massey. Il l'a repeinte lors de la dernière séance[98]. Une source de lumière extérieure éclaire le sujet, découpant la silhouette contre l'arrière-plan prismatique. La lumière qui nimbe la tête en modèle la forme et souligne les traits du visage, ajoutant de la profondeur. Le corps, cependant, demeure relativement plat et lourd; il absorbe plutôt que reflète la lumière. Le portrait incarne le double objectif de Varley : traduire la ressemblance du sujet et exprimer sa personnalité. La comparaison de ce portrait de Vincent Massey à celui réalisé en 1939 par Augustus John (dans la collection du Musée des beaux-arts du Canada) permet d'affirmer que Varley a atteint son objectif.

Le portrait est présenté à Vincent Massey le 17 avril 1920 dans le cadre d'une cérémonie tenue dans le salon de musique de la Hart House. Il est très bien accueilli et Massey décide de le céder à la collection de la Hart House. Selon le critique Augustus Bridle, c'est « un portrait magistral et un exemple remarquable d'émotivité[99] ». Varley lui-même devait en être satisfait, au cours des prochaines années il le présentera dans le cadre de nombreuses expositions, y compris la première exposition du Groupe des Sept en mai 1920 et celle du CNE en août de la même année. En 1924, il le présente dans le cadre de la British Empire Exhibition à Wembley.

Le portrait ne fait cependant pas l'objet d'une admiration sans réserve. Certains critiques remarquent l'aspect volumineux, tridimensionnel de la tête et le manque de relief du corps. Lors de la British Empire Exhibition, les critiques débattent de l'approche de Varley à la perspective. Pour sa part, Rupert Lee y voit une réaction plus intellectuelle que physique ayant ses origines dans l'art oriental. « C'est un élément positif, exprimé dans le portrait de Massey par la primauté du trait [qui] est précieux pour la forme qu'il circonscrit et non le volume qu'il suggère[100]. »

Chester Massey

Varley obtient une autre commande de la famille Massey. Cette fois, il s'agit de Chester Massey (1859–1926), mécène reconnu de l'Université de Toronto et du Victoria College, membre important de l'Église méthodiste et de l'élite torontoise. Il allait être nommé docteur honoris causa le 3 juin 1920 à l'Université de Toronto. La commande n'était pas une initiative du conseil d'administration de l'université, auquel il siégeait. L'idée venait très probablement de Vincent Massey, dont Varley venait de faire le portrait, pour souligner la remise du titre honorifique.

Varley mentionne pour la première fois la commande du portrait de Chester Massey dans une lettre à Eric Brown, en date du 1er juin 1920[101]. Le fait que la cérémonie de la remise des diplômes doit avoir lieu le 3 juin suggère que les démarches en vue de la réalisation du portrait avaient déjà été entreprises. Des

raisons de santé empêchent Chester Massey d'assister à la collation des grades et la cérémonie est reportée à l'automne. Le 11 juin, Varley écrit de nouveau à Brown, lui faisant part de son empressement à entreprendre le tableau[102]. Les séances de pose ont sans doute eu lieu entre le milieu du mois de juin et la fin du mois d'octobre. Le portrait a été achevé peu de temps avant la cérémonie officielle du 3 novembre. Le tableau a été présenté dans le salon de musique de la Hart House et cédé à la collection. Le portrait de Chester Massey (fig. 16) a été présenté dans le cadre de l'exposition de la RCA inaugurée à Montréal le 18 novembre 1920.

Les deux portraits des Massey – père et fils – ont peut-être été conçus comme une paire. Ils sont similaires par la dimension et la composition horizontale, la pose formelle et le traitement spatial des figures. La ressemblance familiale se remarque même dans l'allure des sujets. Varley les représente tous deux de trois quarts et légèrement décentrés, avec un large plan latéral. Il vaut de souligner une certaine affinité entre le portrait de Chester Massey et celui que Lawren Harris a réalisé de madame Oscar Taylor au niveau de la mise en page. Selon toute probabilité, Harris n'accordait pas le même intérêt au portrait que Varley. Il s'inscrivait plutôt dans le cadre de son programme nationaliste comme autant d'expressions individuelles de l'esprit canadien.

Comme dans le cas du portrait de Vincent, plusieurs anecdotes ont circulé pendant plusieurs années. Elles insistaient sur les rapports inamicaux entre Varley et Chester Varley. Il ne faut tenir aucun compte de l'histoire associée au cachet de l'artiste : Chester Massey n'était ni le client ni le récipiendaire du tableau.

Sir George Parkin

Ces deux portraits valent à Varley une autre commande, celle du portrait de sir George Parkin, dont la fille Alice avait épousé Vincent Massey en 1915. Membre important de la communauté et éducateur tenu en haute estime, sir George est directeur du Upper Canada College de 1895 à 1902, lorsqu'il accepte le poste de secrétaire du Rhodes Scholarship Trust et s'installe en Angleterre.

En 1920, sir George annonce sa décision de prendre sa retraite. Un groupe de boursiers Rhodes décident de former un comité chargé de trouver un mode de reconnaissance pour ses nombreuses années de service[103]. Ils s'entendent sur la commande d'un portrait qui sera présenté à lady Parkin. En apprenant que sir George préparait un voyage au Canada, ils décident de proposer la commande à un artiste canadien. Malgré les nombreuses lettres échangées à ce sujet, les raisons qui ont motivé le comité à sélectionner Frederick Varley demeurent nébuleuses. Cela dit, Raleigh Parkin, le fils de sir George, affirme que Vincent Massey a joué un rôle déterminant dans la décision du comité[104].

Sir George arrive au Canada au printemps 1921 et le projet de portrait lui est proposé au mois de mai[105]. Varley y travaille dès juin et dans une lettre à Eric Brown affirme que ce sera le plus accompli de ses portraits. Il lui dit également qu'il sera payé en trois versements, mais qu'il n'a toujours rien reçu. Il demande à Brown d'intercéder en sa faveur[106]. Or à la mi-août, il est toujours en attente de paiement[107]. Il accepte néanmoins que le portrait soit présenté à l'automne 1921 dans les bureaux du Rhodes Trust à New York. Le tableau figure dans l'exposition annuelle de la RCA en novembre 1921. Une critique élogieuse dans le *Toronto Globe* affirme qu'il s'agit d'une « excellente étude au modelé hors du commun qui se distingue par son caractère discret[108] ».

Malheureusement, sir George meurt moins d'un mois avant la tenue de la cérémonie officielle. Le tableau est néanmoins envoyé à Londres où il est présenté à lady Parkin, sa réaction ne nous est pas connue. Quelle conclusion pouvons-nous tirer du fait que lady Parkin a préféré que la biographie de son mari soit illustrée d'une photographie plutôt que du portrait réalisé par Varley? Faut-il en déduire que le portrait ne lui plaisait pas? Ou encore est-ce qu'elle l'associait à la mort subite de sir George?

Varley a réussi à traduire l'essence de sir George Parkin – sa dignité. Le tableau se compare aisément aux portraits de Vincent et Chester Massey en ce qui a trait à la composition, la pose, la dimension et la facture. Les similarités sont peut-être délibérées. Le choix des couleurs, l'intégration figure-fond et le modelé du corps annoncent cependant l'intégration de nouveaux éléments

stylistiques dans la pratique de Varley, à témoin son portrait de *Mme E.* (v. 1921; pl. 11).

Alice Massey

Le portrait de l'épouse de Vincent, Alice Stuart Massey (v. 1879–1950), s'avère un des plus exigeants dans la carrière de Varley. Il s'agit d'une commande privée et un des rares portraits mondains qu'il a peints durant cette période. Rien ne permet d'affirmer que la commande lui a été proposée par Alice elle-même. Les dispositions ont peut-être été prises par son mari et elle s'est conformée à ces désirs. Ce qui expliquerait les tensions entre Alice et Varley. Il ne fait aucun doute qu'ils avaient tous deux des attentes bien précises. Alice, semble-t-il, avait des opinions bien arrêtées sur le choix des couleurs et l'aménagement des intérieurs. Opinions qu'elle s'empresse de faire valoir lors de l'aménagement de la Hart House et de ses demeures à Toronto et Port Hope[109].

Les rencontres entre Alice Massey et Fred Varley donnent inévitablement lieu à des anecdotes dont se régalent le public. Selon une version, madame Massey se serait interrogée à voix haute sur la façon dont Augustus John aurait abordé son portrait. Profondément offensé, Varley aurait menacé de renoncer à la commande. On raconte également qu'elle lui aurait demandé de changer l'expression qu'il lui avait donnée. Exaspéré par son commentaire, Varley aurait tailladé la toile avec son couteau à palette. Nous ne connaîtrons jamais la vérité au sujet de ces histoires. La presse prenait cependant plaisir à les répéter, y voyant des manifestations du caractère rebelle de Varley et de son mode de vie tumultueux.

Alice Parkin et Vincent Massey s'étaient connus en Angleterre alors que Vincent étudiait à Oxford, mais ce n'est qu'en 1914 lorsque Alice devient directrice de Queen's Hall, la résidence des femmes de l'Université de Toronto, qu'ils commencent à se fréquenter. Alice prend une part active à la vie sociale et culturelle. Ils se marient en 1915 à Kingston, où habitent Maude, la sœur d'Alice, et son mari, William Grant, un professeur à l'Université

Queen's. Alice Massey ne tarde pas à s'associer à plusieurs projets de son mari à l'Université de Toronto, dont la Hart House, où elle siège au comité de théâtre. Son intérêt marqué pour le rôle des femmes dans la société l'incite à écrire un livre, *Occupations for Trained Women in Canada*, qui est publié en 1921.

Le manque de renseignements sur les dispositions prises pour l'exécution de la commande influe également sur la date d'achèvement du tableau, généralement reconnu comme 1925. Le portrait a été présenté dans le cadre de l'exposition annuelle de l'OSA en mars 1925[110]. Cependant, la correspondance échangée entre Varley et Kathleen Calhoun à la fin du printemps 1924 permet d'avancer d'une année la date des séances. Plus d'un mois après son retour d'Edmonton, le 14 juin 1924, Varley exprime sa frustration : « Mon portrait de Mme Massey ne sera jamais terminé. Jamais je n'ai fait une peinture aussi moche. Je me suis emporté et je l'ai envoyé au diable[111] ». Varley affirme également qu'il a hâte de commencer à enseigner à l'Ontario College of Art, le 2 juillet 1924 et qu'il lui tarde de finir le portrait de madame Massey avant cette date.

Comme en témoigne des photographies de l'époque, Alice était une femme d'une beauté classique. Son charme irrésistible aurait incité Maude à conserver un fichier où était répertorié tous les anciens petits amis et prétendants de sa sœur. Alice, ou Lal comme Vincent avait l'habitude de l'appeler, était l'aînée de son mari de huit ou neuf ans, mais elle compensait cet écart par une vivacité hors du commun[112].

À l'époque où Varley accepte cette commande, il lui arrive d'exécuter une étude de caractère à l'huile avant d'entreprendre le portrait. Le portrait en buste d'Alice Massey (v.1924–1925; pl. 23), récemment découvert, est peut-être la première étude informelle du modèle exécutée par Varley. Elle est représentée sans les indices de richesse ou de classe sociale qu'on pourrait s'attendre à voir dans sa tenue vestimentaire ou ses accessoires. Elle porte une robe de couleur sombre et un bandeau. La sobriété de l'arrière-plan ajoute à la dignité de son profil classique. Il se peut fort bien que cette étude ait été exécutée avant le portrait d'*Alice Massey* (v. 1924; pl. 24), également appelé *Le châle vert*.

Tout aussi inhabituelle pour un portrait mondain, mais néanmoins typique de Varley, est l'absence de flatterie. Représentée à mi-corps, enveloppée dans un châle vert, Alice Massey apparaît plutôt lourde, assise non pas dans un fauteuil confortable mais sur un tabouret. La scène est dépourvue de mobilier. Elle porte la même robe de couleur sombre et aucun bijou. Le châle au motif floral discret semble avoir été filé à domicile[113]. Varley s'est servi d'un châle dans au moins deux autres portraits mondains, *Mme E.* (v. 1921; pl. 11) et *Janet P. Gordon* (v. 1925–1926; pl. 28), et dans les deux cas il sert à la mise en contraste des tonalités.

L'air guindé d'Alice Massey dans les deux portraits est accentué par son long cou. Faut-il y voir la réaction de Varley à son entêtement ou son snobisme? Dans une certaine mesure, c'est sa façon préférée de révéler le côté désagréable de la personnalité d'un sujet, manifeste dans sa représentation de Janet P. Gordon, par exemple. En y regardant de plus près, les deux portraits d'Alice Massey ont plusieurs caractéristiques en commun avec les œuvres de Varley exécutées avant 1924. La mise en page est classique et le traitement de la surface et de la lumière est traditionnel. Le sujet est représenté en premier plan, se découpant contre un fond ambigu.

Le caractère austère du portrait d'Alice Massey au châle vert se compare au portrait du révérend Salem Bland (fig. 17) exécuté en 1925 par Lawren Harris. La nouvelle date de 1924 avancée pour le tableau démentit les allégations selon lequel Varley se serait inspiré du travail de Harris, mais non l'inverse. Les portraits d'Alice Massey et du révérend Bland se ressemblent par leur palette et l'air impénétrable des sujets[114].

À la fin de 1924, malgré son expérimentation des changements chromatiques dans le *Portrait de Charles Allan Stuart*, Varley continue à jouer des valeurs tonales pour tracer le contour du sujet et le distinguer du fond. Dans le portrait d'Alice Massey, le châle agit comme repoussoir. La modulation chromatique de l'arrière-plan, du vert pâle au bleu nuit, est un sujet de discussion chez les historiens de l'art. L'arrière-plan évoque un ciel dégagé ou le plein air, sans référence aucune à un paysage donnant plutôt l'impression d'un grand espace imaginaire. Le regard du spectateur est sans conteste attiré par les verts et les bleus éclatants qui dominent le champ visuel. Varley utilise une transition semblable du vert au bleu à des effets de repoussoir dans son portrait de *Vera* (1930; pl. 33), souvent appelé « La Vera verte », et dans sa *Femme en vert* (v. 1939–1940; collection particulière)[115].

Présenté pour la première fois dans le cadre de l'exposition annuelle de l'OSA en mars 1925, le portrait d'Alice Massey au châle vert reçoit un accueil mitigé. Selon un critique, l'intensité des couleurs est originale et audacieuse, lourde d'un « symbolisme quelconque » qui diminue la qualité de l'œuvre[116]. Pour sa part, Hector Charlesworth souligne l'aspect décoratif du tableau en précisant cependant qu'il s'agit d'un portrait accompli[117]. Herbert Stansfield se montre enthousiaste, louant la « profusion de couleurs que seul Hokusai aurait osée[118] ».

Dans le cadre des préparatifs en vue de la rétrospective des œuvres du Groupe des Sept présentée au Musée des beaux-arts du Canada, Varley écrit au directeur, Eric Brown, pour l'aviser que dorénavant le tableau *Mme Alice Vincent Massey* s'intitulera *Le châle vert*[119]. Le tableau était très apprécié des Massey et occupait une place de choix dans le cabinet de travail à Batterwood, leur résidence près de Port Hope, Ontario[120]. Il est demeuré dans la famille Massey jusqu'en 1968, lorsqu'il a été légué au Musée des beaux-arts du Canada.

Le docteur Harold Tovell

Varley a également dessiné un portrait du docteur Harold Murchison Tovell (1887–1947), dont l'épouse Ruth Tovell (1889–1961), était la fille aînée de Walter et Susan Denton Massey et une cousine germaine de Vincent Massey. Le docteur Tovell était le premier radiologue de Toronto et membre de la Faculté de médecine de l'Université de Toronto. Il s'y connaissait en art et participait à diverses activités de la Hart House, dont l'organisation d'une exposition de reproductions de manuscrits anciens en 1926[121]. Il était également membre du Arts and Letters Club dans les années 1920[122]. Ruth Tovell, qui avait un intérêt particulier pour les arts, s'est fait connaître comme historienne de l'art, auteur (*Flemish Artists of the Valois Court*, 1950) et collectionneur d'art

européen moderne. Elle passe même pour avoir cultiver le goût de l'art chez son cousin Vincent[123]. Certains membres de la famille se souviennent que Varley assistait à des soirées au domaine des Tovell à Dentonia Park, au nord-est de Toronto. C'est au cours d'une de ces soirées qu'il aurait fait le portrait du docteur Tovell (aujourd'hui perdu). Une petite esquisse représentant son confrère A.Y. Jackson, intitulée *Alexander à l'œuvre* (1925; collection particulière), aurait été exécutée par Varley dans le cadre d'une de ces soirées.

Janet P. Gordon

Dans les années 20, Varley exécute plusieurs portraits mondains, tous issus de commandes privées. *Janet P. Gordon* (v. 1925–1926; pl. 28) compte parmi ses portraits les plus percutants de l'époque. La date de 1925–1926 lui a été attribuée en raison de la présentation du portrait dans le cadre de l'exposition de 1926 de l'OSA. À notre avis, cependant, du point de vue stylistique le tableau se compare aux portraits de Varley de 1920–1921. Il est difficile de l'associer aux portraits de Maud, Viola Pratt et Ellen Dworkin réalisés en 1925–1926.

Janet P. Gordon (1855–v. 1934) était la fille de John Kay, propriétaire d'un des plus importants magasins de détail de Toronto, la Murray-Kay Company. On ne lui connaît pas d'intérêt particulier pour l'art. L'idée de la commande n'était pas la sienne et ne l'emballait pas. En fait, il semble que le portrait ne lui ait jamais plus, malgré la réaction favorable de sa famille. Son fils, Huntley Gordon, était un ami proche de Barker Fairley et un membre du Arts and Letters Club. En 1921, Huntley s'était fait portraituré par Varley. Selon toute probabilité, c'est lui qui a convaincu sa mère de commander son portrait pour venir en aide à Varley. Et si Fred avait l'habitude de refuser qu'on lui fasse la charité, le cachet de 1 000 $ l'a sans doute motivé à accepter la commande.

Fin psychologue, Varley recourait souvent à des messages cachés ou des allégories pour exprimer la personnalité de ses clients, qui ne parvenaient pas toujours à les décoder. La réticence manifeste de Janet Gordon à se faire portraiturer se

traduit par sa raideur et son air sceptique. Confortablement assise, elle semble néanmoins sur le point de se lever et de mettre fin à l'exercice. Cela dit, elle est habitée d'une majesté innée. Le modelé de son visage est rendu dans les moindres détails, depuis sa coiffure jusqu'à l'ombre de ses lunettes. Et si son corps se découpe contre le fond neutre, il ne fait aucun doute que Varley aspirait à une plus grande harmonie figure-fond en ajoutant au volume du corps. Le portrait de Janet P. Gordon se compare à ceux de Vincent Massey, Mme E. et sir George Parkin par le traitement du sujet, de l'arrière-plan et de la lumière de même que par l'utilisation des nuances pastel[124].

Bien des années plus tard, Barker Fairley se rapellait madame Gordon comme une vieille femme « probe » à l'air « très sévère » et « austère ». Fairley a toujours considéré ce tableau comme un des plus accomplis de Varley[125]. Lorsque le portrait est présenté dans le cadre d'une exposition en 1926, un critique affirme : « C'est ce que Varley a fait de mieux depuis longtemps : il est empreint de caractère et d'une grande sensiblité à la beauté[126]. »

Madame Minnie Ely

La quête de Varley pour atteindre à l'harmonie figure-fond trouve son aboutissement dans le portrait de *Mme. E.* (v. 1921; pl. 11). Il réussit en représentant le sujet contre un arrière-plan moucheté de couleurs claires, créant une impression de dignité et de monumentalité. Cette réalisation s'inscrit dans l'évolution de l'approche du portrait du capitaine O'Kelly (pl. 2). *Mme E.* se distingue par sa profondeur de champ et son jeu de lumières et d'ombres qui contribuent à l'harmonisation des plans picturaux. Les traits délicats du sujet, l'ombre délicate projetée sur son visage, la richesse de ses vêtements et le drapé de sa jupe sont autant d'éléments qui attestent une virtuosité sans précédent dans les portraits de Varley.

D'après ce que nous connaissons du cadre de vie de Minnie Ethel Ely, il nous faut conclure que cette tenue vestimentaire ne lui était pas habituelle. Son mari Ernest Frederick Ely était propriétaire d'une boutique de vêtements pour hommes à Toronto. Mécène

bien connue des arts, Minnie Ely avait commandé des portraits de nombreux artistes, dont Marion Long, Ivor Lewis, Frances Loring et Florence Wyle[127]. Selon toute probabilité, l'idée du costume était de Varley et s'inscrivait dans le cadre de ses études de gitanes. On peut lire sur le châssis de la toile l'inscription suivante : « Portrait d'une dame costumée en aborigène par Horse-man Varley avril 192(3). » L'expression *costumée* laisse croire que Minnie Ely s'était prêtée de bonne grâce à la ruse de Varley. Varley a sans doute été séduit par les traits ciselés, les pommettes saillantes, la sensualité et l'individualité du modèle.

Madame R.A. Daly et ses fils

Le tableau représentant Katherine Daly et ses fils se distingue par la complexité de sa composition. Mis à part le panneau décoratif *Les Immigrants*, c'est le seul portrait de groupe de Varley. Le tableau a été commandé par le mari de Katherine, Richard Arthur Daly, homme d'affaires prospère et président de la société de placement R.A. Daly & Co. à Toronto. Selon des recherches antérieures, Daly et Varley ne s'étaient jamais rencontrés, mais avaient des amis communs[128]. Deux d'entre-eux, Gilbert E. Jackson et Peter Sandiford, qui étaient membres du Arts and Letters Club, avaient déjà confié des commandes à Varley. Ils connaissaient Daly en raison de leur association avec le *Canadian Forum*, celui-ci faisait de la publicité dans la revue depuis 1921. De plus, Richard Daly contribuait régulièrement des articles à la chronique « Trade and Industry » de Gilbert Jackson[129]. Grand défenseur des arts, Daly était bien connu dans la communauté artistique de Toronto. D'ailleurs sa sœur Kathleen Daly Pepper était une artiste bien connue. En 1927, Daly est nommé au conseil d'administration de l'Art Gallery of Toronto[130].

Portrait de groupe (Mme R.A. Daly et ses fils, Dick et Tom) (1924–1925; pl. 22) représente Katherine Daly (née Cullen) et ses deux fils, Richard Arthur fils (Dick) âgé de dix ans et Thomas (Tom) âgé de sept ans. Richard se souvient que ses parents se fiaient entièrement aux compétences de Varley et ne lui ont imposé aucune restriction[131]. Le portrait n'est pas novateur en

matière de la composition du tableau. Madame Daly et son fils le plus jeune, qui se blottit contre elle, forment une pyramide au premier plan, tandis que l'aîné est assis à droite, en retrait.

La pose de madame Daly a soulevé une controverse. Élément central de la composition, elle semble manquer de stabilité, s'appuyant gauchement contre son fils. Ce qui ajoute une certaine tension visuelle à la composition. Doit-on y voir une tactique délibérée de la part de l'artiste? Selon Peter Varley, le portrait se veut une « étude pénétrante du rapport entre les garçons et leur mère[132] ». Varley avait probablement l'impression que la proximité physique du cadet sous-entendait un lien de dépendance, alors que le retrait de l'aîné dénote une certaine maturité et un esprit d'indépendance. Il reste difficile à établir s'il s'agit de l'étude du caractère dominateur de la mère ou de sa préférence pour un de ses enfants[133].

Varley propose au spectateur un regard sur son atelier, appuyant le bord d'une toile contre le plus jeune des garçons. Varley peint également le bord d'une autre toile, à droite près de la fenêtre, de manière à circonscrire le groupe. Cette référence à son métier d'artiste ajoute quelque chose d'inédit à la composition. Cette approche tient peut-être au fait que les séances de pose avaient lieu chez lui. Varley avait l'habitude de louer des ateliers, mais en 1925 il occupait une vaste maison ensoleillée sur la rue Yonge avec suffisamment d'espace pour y travailler. Le tableau permet de voir une partie de l'atelier et du mobilier, ainsi que la porte-fenêtre s'ouvrant sur la salle de séjour où Varley donnait des cours de peinture[134].

Cette référence inusitée à l'atelier a incité certains historiens de l'art à y chercher des modèles. Il se peut fort bien que Varley ait fait des recherches sur les portraits de groupe, mais la source définitive de son inspiration mérite qu'on s'y attarde. Varley connaissait certainement les nombreux exemples d'artistes qui faisaient allusion, directement ou indirectement, à leur métier dans leurs tableaux. Effectivement, son autoportrait de 1919 (pl. 7) fait référence à son rôle d'artiste. En 1924, il exécute une étude à l'huile de son fils John dans l'atelier intitulée *Jeune artiste à l'œuvre* (pl. 21). Le chevalet de l'artiste apparaît dans le coin gauche et plusieurs toiles sont dispersées dans la pièce. Un dessin

préliminaire pour ce tableau, *Dans l'atelier* (1924; fig. 18), illustre la démarche de Varley.

Selon Christopher Varley, le tableau de la famille Daly puise aux sources des portraits du haut-baroque, plus précisément *Les Ménines* (1656; Musée du Prado, Madrid) de Diego Velázquez (1599–1660)[135]. Dans ce portrait de la cour d'Espagne, Velázquez a choisi de se représenter avec sa palette et ses pinceaux, scrutant son tableau. Une autre école de pensée associe la forme pyramidale de la mère et de son fils, ainsi que les lignes de fuite, aux portraits de la Haute Renaissance. Pour sa part, le critique d'art torontois Herbert Stanfield compare le portrait de Varley aux œuvres des maîtres italiens, citant en exemple la *Vierge à l'Enfant avec des saints* de Fra Filippo Lippi (1406–1469)[136]. Dans son compte rendu de l'exposition de 1925 de l'OSA où le tableau est présenté pour la première fois, Stanfield écrit : « Le portrait de groupe n° 229 de M. Varley est original et, jusqu'à ce qu'une contemplation méditative nous en révèle la beauté, et légèrement gênant. En réponse à une question sur la nature de l'objet contre lequel la mère s'appuyait, une dame se tenant à côté du tableau aurait affirmé d'un ton sarcastique « oh! sur une ligne de composition, bien entendu[137] ».

Il vaut de noter que les artistes du baroque et de la Renaissance avaient des vues divergentes sur la composition. Les tableaux de la Renaissance se caractérisent par une composition soigneusement équilibrée où les figures sont disposées avec symétrie autour d'un personnage principal ou d'un point de convergence. Ce n'est qu'à la Haute Renaissance (années 1490 aux années 1520) que les figures principales sont rassemblées dans une configuration tridimensionnelle à la manière d'un cône ou d'une pyramide. La période baroque (1600–1750) privilégie des compositions animées de diagonales et de courbes, où les figures isolées ou groupées font partie intégrante de la scène. Les figures étaient souvent reliées entre elles par un regard ou un geste. L'ensemble de la composition était unifiée par le dynamisme des diagonales ou des écharpes et des bannières aux couleurs éclatantes. Dans une composition baroque, les figures sont groupées parallèlement à la surface picturale, comme dans *Les Ménines*.

Le portrait de groupe de Varley repose sur l'utilisation du bleu et du rouge et des tons complémentaires, notamment le bleu-vert et le rouge-orange. La composition est animée de divers motifs, tels que ceux qui ornent le costume de Tom, qui sont repris dans le coussin à côté de Dick.

L'aîné apparaît mince et fragile. Ses traits allongés lui donnent un air renfermé. Il a été dit que Varley avait accordé une plus grande importance à l'ossature qu'à sa chair, lui prêtant un air maladif[138]. Son jeune frère est plus robuste; ses joues sont rebondies et roses. Dans la tradition nord-européenne du portrait, le modèle tient souvent un objet associé à son rang, son métier ou ses intérêts. Varley représente Tom avec un livre ouvert et Dick avec une balle. On ne dénote cependant aucune trace d'espièglerie. Ils affichent tous deux un air de dignité conforme à leur rang social.

La portrait de Varley a également des affinités avec le travail des artistes hollandais du dix-septième siècle, qui s'intéressaient aux effets de la lumière sur des objets de différentes textures. La porte-fenêtre réfléchit les reflets qu'elle reçoit du soleil couchant. L'étoffe de laine des costumes des garçons et de la robe la mère semble absorber la lumière, tandis que le rouge de sa parure et de la cravate de Tom dégage une douce lumière. Les perles de Katherine et le satin vert qui recouvre le fauteuil scintillent.

Indépendamment des antécédents historiques, le *Portrait de groupe* de Varley a un aspect résolument moderne et se doit d'être comparer à des œuvres contemporaines. Deux artistes s'imposent : John Singer Sargent (1856–1925) et William Orpen (1878–1931). Dans son tableau les *Filles d'Edward Darley Boit* (1882; Museum of Fine Arts, Boston), Sargent propose une solution inédite à la représentation non hiérarchique des quatre filles de M. Boit. Il réussit à leur accorder une place égale, malgré les différences d'âge, en recourant à une perspective géométrique qui évoque *Les Ménines*. Dans son portrait de *La Famille Berridge* (v. 1910; R.L. Berridge collection), Orpen représente une mère et ses deux jeunes enfants. Elle est assise dans le plan gauche du tableau avec un enfant sur les genoux, et leur silhouette forme un triangle. L'artiste a équilibré la composition en plaçant le second enfant à droite et lui donnant également une forme triangulaire. Orpen était connu pour son organisation spatiale linéaire, à la

manière de Velázquez. Par contre la technique du raccourci est celle de Whistler. Selon Peter Varley, certains portraits de Varley empruntent à Degas[139].

Le portrait de la famille Daly a été présentée pour la première fois dans le cadre de l'expostion de l'OSA inaugurée le 7 mars 1925; ce qui signifie que le tableau a été exécuté entre la fin 1924 et le début 1925. Malgré la saison hivernale, la fenêtre s'ouvre sur un paysage d'été. Varley avait également interverti les saisons dans *La fillette aux tournesols* (1920/21; pl. 12) et *Mary Kenny* (1920/21), ce qui laisse croire qu'il envisageait le paysage non pas comme un élément réaliste, mais plutôt comme un détail contribuant à l'ambiance du tableau. Le paysage évoque les vues panoramiques des portraits vénitiens du seizième siècle ou encore flamands. Le bleu de l'horizon, qui suggère le lointain, fait contraste aux tons chauds de la colline boisée. Selon Richard et Thomas Daly, la famille attachait une grande valeur au portrait.

Autres commandes de portraits mondains

En 1923, de graves problèmes financiers obligent Varley et sa famille à abandonner leur maison. Plusieurs amis et connaissances décident de leur venir en aide, une des façons les plus nobles de le faire étant la commande de portraits. Au moins deux commandes lui sont venues de cette façon, et ce n'est pas un hasard si les deux clientes étaient parentes par alliance. L'initiative est venue d'Helen Fraser. Son mari W.H. Fraser enseignait le français au University College et connaissait sans doute Barker Fairley. Mise au courant des problèmes financiers des Varley, Helen Fraser décide de se faire portraiturer et convainc sa belle-sœur, Jean McPhedran, d'en faire autant. Varley accepte de les dessiner et le prix unitaire des portraits est fixé à cinquante dollars[140].

Le portrait d'Helen Fraser, exécuté en 1924, présente une texture et des nuances tonales qui font défaut à celui de Jean McPhedran. Sans doute Varley avait-il plus d'affinités avec Helen Fraser. C'est peut-être la raison pour laquelle il a choisi de la représenter de face. Le regard intense qu'elle pose sur le spectateur est provocateur, mais néanmoins chaleureux et bienveillant. Techniquement, le portrait rappelle celui de Mary Kenny (1920–1921) par ses nuances tonales, mais il est plus accompli. Les traits sont bien définis, sans prétendre à avantager le modèle ou à cacher son âge.

Jean Adam McPhedran était l'épouse du docteur Alexander McPhedran, qui était membre de la Faculté de médecine de l'Université de Toronto[141]. Varley choisit de la représenter de profil, distançant le modèle du spectateur. À l'époque où Varley fit son portrait, Jean McPhedran était atteinte du diabète. Les choix de Varley lui sont peut-être dictés par les souffrances de sa cliente ou par ce qu'il perçoit comme son caractère fermé. Avant de tomber malade, Jean McPhedran était reconnue pour sa philanthropie et sa participation aux réunions entre femmes du corps professoral. C'était une femme cultivée qui s'intéressait à la musique et aux arts[142].

Varley fait preuve d'une grande délicatesse dans le modelé de ses traits. Il applique un lavis couleur chamois sur la surface du papier, rehaussant les contours et estompant les ombres. Varley était sans doute satisfait du résultat car il a présenté le dessin dans le cadre de l'exposition de 1925 du Groupe des Sept. Barker Fairley fait une critique très élogieuse du portrait : « Bien entendu, en matière d'ingéniosité graphique, Varley est sans égal au Canada. Son étude de Mme McPhedran est impeccable[143]. » Son admiration pour l'artiste l'empêchait de comprendre l'indifférence de certains spectateurs : « Je n'arrive pas à comprendre que ses dessins ne se vendent pas comme des petits pains. Mais c'est de l'histoire ancienne[144]. » Hector Charlesworth mentionne lui aussi le dessin de Varley d'une femme âgée, soulignant « la beauté du sentiment et la perfection de l'exécution[145] ».

Bien que réalisés à la même époque, les dessins de Mme Fraser et de Mme McPhedran se distinguent nettement sur le plan stylistique. Il ne fait aucun doute que la dynamique personnelle jouait un rôle de premier plan dans l'art de Varley. Ces deux portraits expriment sa réaction à deux femmes très différentes l'une de l'autre. Dans chacun des cas, son interprétation est sympathetique et ouverte. Il a cependant

abordé chacun des sujets de façon particulière, faisant des choix artistiques différents. Ces deux dessins devraient servir d'avertissement aux spécialistes qui tentent de dater les œuvres de Varley en fonction de son évolution stylistique. Il a toujours refusé de se cantonner dans un style particulier.

Bien que le sujet de *Portrait d'un homme* (1925; fig. 19) nous soit inconnu, l'œuvre réussit à traduire sa force de caractère. Par son exploration volumique de la forme et le traitement optimal du médium, cette œuvre exprime mieux que toute autre la notion picturale du dessin de Varley.

CHAPITRE 4

LA SPHÈRE PRIVÉE : ENFANTS, FAMILLE, AMIS

Il m'est impossible d'affirmer que la vie domestique incite à
la création – le casanier n'est pas un artiste.
— Fred Varley

Il y a une certaine nostalgie à se caractériser à travers la peinture. Traditionnellement, les autoportraits aspiraient à répondre à la question la plus intime et la plus universelle : Qui suis-je? Certains artistes ont choisi de se représenter à partir de leur image reflétée dans un ou plusieurs miroirs. D'autres ont fait de la représentation de leur image un exercice psychologique ou spirituel, leur portrait étant le résultat d'une auto-analyse. Ils étaient intrigués par cet élément à la fois insaisissable et unificateur que Walt Whitman appelait « cette ombre qui me ressemble ».

Varley a lui aussi enrichi la tradition en réalisant un autoportrait (pl. 17) peu de temps après être rentré de la guerre en 1919. Peter Varley brosse un tableau tour à tour détaillé, intime et affectueux de son père :

> Père avait un visage très expressif – une « salle gueule » comme il se plaisait à dire – très Yorkshire, avec un large front surmonté d'une épaisse tignasse cuivrée, lissée en arrière sur un crâne reposant sur un cou mince et des épaules étroites. Son nez était petit, mais parfaitement assorti à son humour. Yeux et bouche travaillaient en parfaite harmonie, se répondant l'un l'autre. Sous des sourcils broussailleux, des yeux pers qui ne demandaient qu'à vous émouvoir. La bouche était rarement immobile, comme une créature marine qui tâte et goûte la marée : sensible, expressive, esquissant un sourire ou riant à gorge déployée jusqu'à ce que les larmes lui viennent aux yeux[146].

Fred Varley était très conscient de son apparence. De petite taille et un visage taillé à coup de serpe, il n'était pas laid, mais il savait qu'il n'était pas séduisant. À trente-huit ans, il frappait néanmoins le regard avec son allure jeune, son port décidé, ses yeux bleus perçants et ses cheveux d'un blond-roux qui, selon Arthur Lismer, « brûlaient comme une torche ignée sur le dessus d'une tête qui semblait avoir été taillée avec un couteau émoussé[147] ». Varley était enclin à l'introspection, et davantage après avoir vécu la guerre. Les lettres à sa famille et ses amis étaient des témoignages

éloquents de son état émotionnel. Il aimait parler de sa solitude et de ses désirs.

Varley a conçu son autoportrait de manière à habiter la composition, debout au milieu de ce qui semble être son atelier. Une vue de trois quarts l'aurait contraint à installer un miroir à droite du chevalet. Il décide plutôt de corriger l'angle, pour des raisons inconnues, et de se représenter de face, donnant l'impression qu'il est sur le point de sortir du tableau. L'intensité de son regard laisse croire qu'il s'apprête à interroger le spectateur avec l'aplomb et la curiosité qu'on lui connaît. Il tente de provoquer ou de défier le spectateur, voire de lui faire perdre contenance. Le portrait illustre l'observation de Philip Surrey au sujet de Varley : « On percevait immédiatement la vitalité électrique de l'homme[148] ».

Varley a choisi de peindre son portrait d'une touche vigoureuse, reprenant le vert et le brun terne de son tableau de guerre représentant le lieutenant G.B. McKean (pl. 3). À l'arrière-plan, les empâtements créent des formes géométriques qui sont parallèles à la figure, lui prêtant une certaine monumentalité, un certain éclat. Varley recourt à cette technique dans le portrait de son premier-né *John* (v. 1920–1921; pl. 10).

Varley entreprendra à deux autres reprises de documenter sa condition humaine et son état émotinnel. Dans *Miroir de la pensée* (1937; pl. 43), il peint le reflet de l'homme qu'il voit dans le miroir. Qualifié d'autoportrait « méditatif » par l'historien de l'art Robert Stacey, *Miroir de la pensée* nous montre un Varley très songeur, ou, pour citer de nouveau Stacey « [Varley] communiant avec son âme[149] ». Il exécute *Autoportrait, jours de 1943* (1945; pl. 51) à l'âge de soixante-quatre ans. D'une honnêteté brutale, ce portrait est celui d'un homme déçu, épuisé par les efforts soutenus pour gagner sa vie en tant qu'artiste. Commentaire sur l'énigme de l'image de soi et l'identité, cet autoportrait se rapproche par la composition et le style à d'autres œuvres de cette période, dont *Erica* (1942; pl. 48), qui se distinguent par le traitement en clair-obscur du visage.

Les portraits d'enfants

L'amour que Varley portait aux enfants se traduit par le nombre de tableaux et de dessins qu'il leur a consacrés. Il entreprend sa carrière à une époque où la commande de portraits d'enfants était chose courante en Angleterre. À la fin du dix-neuvième siècle, la perception sociale des enfants change radicalement. La poursuite de la richesse, caractéristique de l'époque tant en Amérique du Nord qu'en Europe, transforme la vie de famille. Les enfants sont le nouveau centre d'attention[150]. Jusqu'alors les critiques d'art avaient accordé très peu d'importance aux portraits de jeunes enfants. Est-ce parce qu'ils ne répondaient aux critères de l'Art?

John Singer Sargent, un des plus grands portraitistes de l'époque, a exécuté de nombreuses commandes de portraits d'enfants en y donnant la pleine mesure de son talent. Son traitement des enfants comme sujets à part entière a largement influé sur ses contemporains. Exposé à Londres en 1902, son portrait intitulé *Essie, Rubie et Ferdinand, enfants de Asher Wertheimer* (1902; Tate) est qualifié de triomphe. Selon Barbara Dayer Gallati : « À la fois imposant et somptueux, le triple portrait démontre de façon frappante que le sujet de l'enfance avait acquis ses lettres de noblesse dans la production artistique contemporaine[151]. »

Varley était sans doute au courant de ce changement de position, mais sa réaction nous est inconnue. La majorité des enfants qu'ils peignaient venaient de familles aisées ou étaient les enfants de ses amis. Il avait une connaissance intuitive des enfants. Qui plus est, il était fasciné par leur vulnérabilité et leur innocence. Il était intrigué par ces petits êtres dont le caractère n'était pas encore formé.

Mary Kenny

Le 20 novembre 1920, alors qu'il vient tout juste de terminer le portrait de Chester Massey destiné à la Hart House, Varley se fait offrir une autre commande. Cette fois il s'agit du portrait d'une fillette. Tout commence lorsque le Women's Conservation

Committee de Sarnia, en Ontario, invite son fidèle allié Barker Fairley à prononcer une conférence sur l'art canadien[152]. Il leur parle de Varley et leur montre des reproductions des portraits du doyen Cappon et de Vincent Massey. Il conclut en leur demandant si quelqu'un souhaite passer une commande.

Norman Gurd, un avocat et un collectionneur d'art de même qu'un membre actif du Sarnia Art Movement, pense à William Kenny, son associé et un parent par alliance[153]. Kenny est un des citoyens les plus prospères de Sarnia. Directeur de l'entreprise familiale, les grossistes en alimentation T. Kenny & Co., il joue un rôle de premier plan dans la vie de la communauté. À l'exemple de Gurd, il est collectionneur et membre du Sarnia Art Movement. Il s'est trouvé que William Kenny avait déjà entrepris des démarches pour obtenir un portrait de Mary, sa fillette de sept ans, en vue de l'offrir à son père. Il avait communiqué avec E. Wyly Grier, qui était connu pour ses portraits d'enfants, mais aucune entente n'avait été conclue.

Gurd apporte personnellement tout son soutien à la canditature de Varley, recherchant des reproductions de certains de ses portraits et des lettres de recommandation d'hommes qui connaissaient le travail du peintre et dont l'opinion influerait sur la décision finale. Il s'adresse, entre autres, à sir Edmund Walker, président du conseil d'administration du Musée des beaux-arts du Canada, à Barker Fairley et au docteur MacCallum. Dans une lettre à Fairley, Gurd affirme : « M. Kenny ne désire pas un tableau grand format, mais plutôt un portrait en buste, et il n'a pas l'intention de dépenser plus de 500 $[154]. » Fairley et MacCallum se montrent en faveur d'octroyer la commande à Varley, mais Walker émet des réserves. Il tient Varley en haute estime, mais fait valoir qu'aucun de ses portraits « attestent sa capacité de peindre des enfants[155] ».

Convaincu d'avoir trouvé la personne qu'il lui faut, Kenny accorde la commande à Varley [156]. L'artiste arrive chez les Kenny le 20 décembre et y reste jusqu'à la mi-janvier. La rougeole force la famille à se mettre en quarantaine et prolonge son séjour. Contrairement à son habitude, Varley exécute deux esquisses préliminaires. Il exécute également un portrait à l'huile de Mary Kenny durant son séjour à Sarnia. Malheureusement, le produit final, *La fillette aux tournesols* (1920/21; pl. 12), ne répond pas aux attentes de la famille. Varley rentre à Toronto et produit un autre portrait, *Mary Kenny* (1921), qui reçoit un accueil favorable.

La fillette aux tournesols et l'esquisse préliminaire de Mary (fig. 20) sont presque identiques. Cependant en transposant le dessin dans un autre médium Varley introduit un élément d'incertitude. Il se peut que le jeune âge du modèle empêche des séances de pose trop longues et force Varley à travailler à partir du dessin. Et la maladie de l'enfant y est peut-être pour quelque chose. L'esquisse et le portrait représentent Mary de face, son regard soutenant celui du spectateur. Dans le dessin, son regard est confiant et serein. Dans le portrait à l'huile, le visage de la fillette est baigné d'ombres et de lumières. Sa chevelure ébouriffée donne l'impression qu'il y quelques moments à peine elle jouait à l'extérieur. Son regard est légèrement détourné et elle semble écrasée par les tournesols qui surgissent autour d'elle.

Le second dessin de la fillette, *Mary Kenny* (1920/21; collection particulière), se démarque nettement du premier. Il donne l'impression d'une enfant saisie en pleine espièglerie. Elle est représentée de trois quarts, tenant un livre ouvert sans le regarder. Ses boucles créent une impression de mouvement, mais son regard est rêveur. Elle est absorbée par ses pensées enfantines. La composition s'articule autour de lignes diagonales. Une étiquette collée derrière le cadre original nous permet d'affirmer qu'il s'agit d'une des trois études d'enfants présentées par Varley lors de l'exposition annuelle de l'OSA de 1922[157]. À de nombreux égards, la seconde esquisse ressemble davantage au *Portrait de Primrose Sandiford* (v. 1921–1922; pl. 16).

Dans les deux portraits à l'huile de Mary, Varley la représente en plein air, comme dans le cas du portrait de la fille de lord Beaverbrook, *Janet* (1919; pl. 6). La saison est difficile à déterminer. Cela dit, ce n'est pas l'hiver, époque de l'année durant laquelle il a peint le tableau. Comme le fait remarquer Andrea Kirkpatrick, les petites vagues à la surface du lac au loin évoquent les brises du printemps, tandis que la chaleur du soleil et les longues ombres évoquent le cœur de l'été[158].

Le désir de Varley de jumeler le portrait à la nature se manifeste très tôt dans sa carrière. Les études à l'aquarelle de figures en plein

air exécutées en Angleterre en sont des témoignages éloquents. Le paysage canadien attise son désir. En 1914, il écrit à sa sœur Ethel : « [je] vais peindre des extérieurs, des portraits – Car j'habite le pays du grand air[159]. » *Été indien* (1914–1915; pl. 1) et *Rivage rocheux* (1922; pl. 18), qui représentent son épouse Maud dans la nature, attestent sa volonté de donner suite à son projet. Dans les portraits de Janet Aitken et Mary Kenny, Varley abandonne la nature sauvage au profit du jardin – le cadre idéal pour les jeux d'enfants.

Le thème des enfants entourés de fleurs est apparu en Europe, et plus particulièrement en Grande-Bretagne, dans les années 1890. Il trouve son apogée dans les portraits d'enfants d'un lyrisme hors du commun de John Singer Sargent. Dans son portrait de Helen Sears (1895; Museum of Fine Arts, Boston), il représente la fillette, dans un intérieur, entourée de vases de larges fleurs. Le thème est également populaire en Écosse, notamment parmi les membres de l'école de Glasgow. George Henry, David Gauld et J. Stuart Park comptent parmi les artistes qui en avaient fait leur spécialité.

Le motif de l'arrière-plan de la *La fillette aux tournesols* soulève quelques questions. Varley est-il influencé par les portraits romantiques des artistes européens de la fin du dix-neuvième siècle? Cherche-t-il à symboliser les tournesols, associant la fraîcheur et la simplicité de l'enfance à celles de la nature? Ou encore s'oriente-t-il vers un art plus décoratif? Varley n'était pas sans connaître les *Quatre tournesols coupés* (1887; Rijksmuseum Kröller-Muller, Otterlo) de Van Gogh et le *Jardin aux tournesols* (v. 1905–1906; Österreichische Galerie, Vienne) de Gustav Klimt. Varley s'est-il inspiré de ces tableaux? Il reprendra le motif du tournesol en 1939 dans une nature morte à l'aquarelle intitulée *Tournesols* (collection particulière)[160].

La facture plutôt sommaire du portrait de Varley ne s'inscrit pas dans la tradition de l'Art nouveau. Son tableau est loin d'être aussi accompli que celui de Van Gogh ou de Klimt. Varley n'a pas exploré le potentiel décoratif de l'arrière-plan, privilégiant une représentation plus fidèle des tournesols. À mon avis, il aspire à une harmonie visuelle et une intégration figure-fond optimales. *La fillette aux tournesols* présente certaines lacunes au niveau de la composition qui ont peut-être contribué au mécontentement

de la famille : les fleurs géantes qui éclipsent la fillette ou encore l'étrange inclinaison de sa tête et de son corps. Selon Norman Gurd, l'ombre sur le visage de Mary déplaisait à la famille[161]. Nous savons que dans le second portrait de la fillette, peint de mémoire dans son atelier de Toronto, Varley a réussi à résoudre les problèmes liés à la composition[162].

Cette fois, Varley représente la fillette dans un paysage boisé, plus propice à une scène canadienne. Dans cette composition simplifée et mieux organisée, il aborde le paysage comme une toile de fond, les traits de pinceau allongés servent à encadrer la figure. La hauteur des arbres souligne la position de la fillette. Mary, qui occupe le premier plan, est le point de mire du tableau. Cette version est nettement plus attrayante, et la fillette apparaît plus confiante et plus posée. Même si au premier coup d'œil, l'expression de Mary trahit la douceur caractéristique de l'idéalisation romantique des enfants, force nous est de reconnaître que Varley aspire à une étude sérieuse de sa personnalité, lui prêtant dignité et charme, comme il avait su le faire dans le portrait de son fils aîné John (v. 1920–1921; pl. 10).

Le second portrait de Mary Kenny fait sensation parmi les défenseurs de Varley. Dans une lettre au père de la fillette, Norman Gurd affirme : « Le prof. Fairlie [*sic*] a vu le portrait de Mary et il est ravi. Il le dit excellent et affirme que même Varley en est satisfait. Il a mentionné un portrait de John, le fils de Varley, présenté dans le cadre de l'exposition de l'Ontario Society of Artists. Le portrait a été salué par la critique torontoise. Mais selon lui, il sera éclipsé par le portrait de Mary[163]. » Tous ceux qui ont vu le portrait de Mary Kenny s'entendaient pour dire qu'il vaudrait d'autres commandes à Varley. Le tableau, qui est demeuré dans la famille, n'a jamais été présenté au grand public[164].

Primrose Sandiford

En 1921, Betti Sandiford commande à Varley un dessin de sa fille, Primrose, âgée d'une huitaine d'années. Il s'agit d'un cadeau pour son mari Peter. Violoniste et dramaturge en herbe, Betti Sandiford se mérite le prix de meilleur écrivain amateur de Toronto et York

County dans un concours organisé par le Women's Canadian Club, pour sa pièce *Crows*[165]. Passionnée des arts, elle avait entendu parler de Varley par l'entremise de connaissances de son mari à l'Université de Toronto et au Arts and Letters Club.

Exécuté à l'été 1921 ou 1922, le dessin de Primrose Sandiford (pl. 16) s'impose comme un des portraits d'enfants les plus accomplis de Varley – le constat visuel des éléments caractéristiques de son style[166]. Le regard de Primrose rencontre celui du spectateur d'un air inquisiteur, voire sagace. Bien que représentée assise, son expression laisse croire qu'elle a été saisie au moment où elle esquissait un geste spontané ou tournait la tête. La pose du sujet et l'arrière-plan rehaussé au crayon conté bleu évoquent le portrait de John. Les rehauts de crayon conté blanc et rose sur la collerette ajoutent une touche de fantaisie à une tenue autrement sobre. La facture soignée de l'arrière-plan et le détail des traits et des vêtements de la fillette ne sont pas typiques des dessins de cette période. En effet, seuls deux autres dessins, représentant des hommes d'âge mûr, s'y comparent dans leur fini, ceux du Dr. A.D.A. Mason (1921; MCAC) et de Vincent Massey (v. 1922; Arts and Letters Club).

Joan Fairley

Varley a peint le portrait de Joan (pl. 29), la fille adolescente de Fairley, avant le 8 mai 1926, date de l'inauguration de l'exposition du Groupe des Sept dans lequel il figure. Il présente de nombreux affinités avec le portrait de Maud exécuté en 1925 : la composition et l'intégration figure-fond; la palette sourde de bleus, de mauves et de bruns; et le traitement de la lumière. Nous savons que la réalisation du portrait d'Ellen Dworkin (pl. 26), dont l'effet de stylisation le rapproche des premiers portraits de Vancouver, a occupé Varley de la fin décembre 1925 au début 1926[167]. L'arrière-plan du portrait de Joan se distingue par son ambiguïté. S'il s'agit effectivement d'un paysage, on pense à un plan d'eau avec des îles dénudées ou encore à un ciel bleu avec quelques nuages. Les Fairley aimaient beaucoup ce tableau et l'ont conservé pendant de nombreuses années. Un concours de circonstances contraint la famille à le vendre en 1960, sept ans avant le décès de Joan Fairley. Chose curieuse, lorsque Varley présente le portrait dans le cadre de l'exposition de 1926 du CNE, il porte une étiquette fixant son prix à 300 $.

Ellen Dworkin

Le portrait d'Ellen Dworkin avait été commandé dans le but de faire une surprise à sa mère Dorothy Dworkin (née Goldstick; 1912–1991). En 1922, elle compte parmi les membres fondateurs de la Women's Auxiliary de la Mount Sinai Hospital et en est la première présidente. Madame Dworkin œuvrait dans le domaine médical depuis 1907. Elle s'était fait connaître au sein de la communauté juive de Toronto comme la première infirmière du Jewish Dispensary[168]. Son mari, Henry Dworkin, était un philanthrope tenu en haute estime. M. Dworkin et son frère avaient ouvert une agence de voyages vouée à la réunion des familles séparées par la guerre[169].

Varley avait été recommandé par son amie Ruby Easser. Les membres de la Women's Auxiliary ont versé des dons pour couvrir le cachet de Varley, qui s'était engagé à réaliser le tableau durant la période de Noël 1925. Afin de ne pas gâcher la surprise, Ellen, qui est âgée de treize ans, doit se rendre à l'atelier en cachette[170]. Au cours d'une de ses visites, le tram s'étant fait attendre, elle arrive à l'atelier complètement transie et Varley doit l'installer près du foyer pour la réchauffer[171].

Le portrait d'Ellen Dworkin occupe une place importante dans la démarche de Varley en ce qu'il témoigne de la volonté de l'artiste de styliser le sujet. À de nombreux égards, il annonce les portraits de Vera Weatherbie que Varley allait exécuter à Vancouver. Ellen est représentée de face, son cou est épais à la manière des portraits de la période torontoise, notamment celui de Maud. Les yeux cependant sont bridés et la chevelure est stylisée. Varley reprend ici l'arrière-plan moucheté du portrait de Margaret Fairley. Il choisit une palette de rouges et de verts profonds qui fait contraste aux carnations claires et à la collerette blanche de la robe.

Les enfants de Varley

L'histoire de l'art compte de nombreux exemples d'artistes ayant pris des membres de leurs familles comme sujets. Et Varley est de ce nombre. Dès 1912, il dessine un portrait de son père à Sheffield. Il réalise de nombreux portraits dessinés et peints de son épouse, Maud, au cours des années. Lorsque ses enfants sont assez vieux pour se soumettre à des séances de pose prolongées, il fait également leurs portraits. C'était pratique courante dans les années 1920, sans doute parce que les membres de la famille constituaient les modèles les plus accessibles et les moins chers.

Peu de temps après son retour de la guerre, Varley exprime sa profonde affection pour son premier-né dans l'œuvre intitulée John (v. 1920–1921; pl. 10). Ce portrait magistral, peint alors que John est âgé de neuf ans, observe toutes les règles de la composition classique avec le modèle légèrement décentré et le saisissant contraste figure-fond. Varley représente John assis, de trois quarts, regardant directement le spectateur. Son regard est aussi intense et inquisiteur que celui de Varley dans son autoportrait de 1919 (pl. 7).

John Varley (1912–1969) était un être sensible et talentueux. À l'exemple de son père, il manifeste très tôt un intérêt pour la musique, l'écriture et les arts. Varley était convaincu que John marcherait sur ses traces et deviendrait artiste. En fait, les étudiants du British Columbia College of Art se rappellent que le talent de John Varley pour le dessin était supérieur à celui de son père. Bien que le daltonisme l'empêche de poursuivre une carrière artistique, il étudie néanmoins en art et accompagne souvent son père et Jock Macdonald dans leurs excursions de dessin dans l'intérieur de la Colombie-Britannique. Il était également fasciné par la science et plus particulièrement l'astronomie. Il vaut de noter que John comptait parmi ses ancêtres l'astronome et le fabricant de télescopes Cornelius Varley (1781–1873) [172].

La palette du portrait de John évoque les verts, bruns ternes et orangés des tableaux de guerre de Varley. Ces couleurs sont aussi celles de l'autoportrait de 1919 où l'on retrouve également les longs traits de vert identiques à ceux dans le chemise de John. Le drapé de l'arrière-plan – autre caractéristique des tableaux de cette période – aux rehauts de rose, d'orange clair et de bleu accentue la silhouette de l'enfant. Varley poursuit son exploration des effets de lumières amorcée en 1919 dans son portrait de Cyril Barraud (pl. 4). En 1919–1920, Varley privilégie une mise en silhouette théâtrale du sujet et le portrait de John en est un témoignage éloquent. Les nombreux contrastes de tons entre l'arrière-plan, la chemise et les carnations ajoutent à la vitalité de la composition. Le tableau a souvent été comparé au portrait que fit Augustus John de son fils Robin (1915; collection particulière) [173].

Présenté pour la première fois en 1921 dans le cadre de l'exposition annuelle de l'OSA, le portrait de John est salué par la critique. Selon un commentateur, le tableau évoque avec « un rare talent l'esprit réel et non sentimental de l'enfance [174] ». Comme toujours, Varley était impatient de voir comment le tableau serait reçu en Angleterre. Présenté dans le cadre de la British Empire Exhibition en 1924, les critiques lui reprochent son manque de subtilité et de fini. Selon le commentateur de la Birmingham Gazette, « charmant de loin, le portrait de Varley détonne vu de près [175] ».

En 1924, Varley exécute un dessin à l'encre, Dans l'atelier (fig. 18), représentant John assis par terre dans l'atelier devant un miroir travaillant à son autoportrait, qu'il transposera dans un portrait à l'huile intitulé Jeune artiste à l'œuvre (1924; pl. 21). Le dessin nous permet de jeter un regard dans l'atelier de Varley aménagé dans la maison familiale rue Yonge. On aperçoit au mur des dessins de l'entrée de la maison et d'une partie du jardin, et sur le chevalet une esquisse sommaire du séjour de la famille à Bobcaygeon l'été précédent [176]. Ces détails ont cependant été omis dans la version à l'huile. Une autre esquisse au crayon de John exécutée à la même époque nous présente un jeune homme à l'air résolu (fig. 21).

L'artiste a réalisé plusieurs très belles études de son second fils James. La fermeté du trait et le fini de l'esquisse de James nouveau-né (fig. 22) suggèrent que Varley a pris tout son temps pour l'exécuter. Calme et studieux, James Varley (1915–1988) avait toujours un livre à la main. Varley l'a représenté de profil, absorbé dans sa lecture. Le Portrait de James (v. 1926–1927; fig. 23) se distingue par le modelé des traits et de la tête.

Varley a également réalisé plusieurs dessins et peintures de son dernier-né Peter (1921–2000), et de sa fille Dorothy (1910–1974), née à Sheffield[177]. Malheureusement, ces œuvres ne nous sont connues que par des photographies noir et blanc. En 1926, un de deux portraits à l'huile, sans doute récents, de sa fille figure dans l'exposition du Groupe des Sept sous le titre *Dorothy* et porte le numéro 115. Au cours d'une entrevue avec son frère Peter lors de l'établissement du fonds Varley, Dorothy Sewell affirme que son père a fait son portrait alors qu'elle était âgée d'une quinzaine d'années. Ce tableau se compare par le format et le style à celui d'Ellen Dworkin. Varley a donné à Dorothy une présence quasi monumentale, soulignée par son cou épais et son corps plutôt gonflé. Représentée de face, l'adolescente détourne son regard de celui du spectateur. Elle a l'air plutôt triste et distante. Le traitement de l'arrière-plan et la lumière qui baigne son visage et son cou évoquent le *Portrait de Maud* (1925; pl. 27). Juxtaposé aux portraits de Viola Pratt et d'Ellen Dworkin, ce tableau de Dorothy marque le début d'une approche plus stylisée au niveau des traits du visage et des motifs des vêtements portés par le modèle.

Maud Varley

Les femmes jouaient un rôle de premier plan dans la vie de Fred Varley. Sa mère Lucy lui était dévouée, mais tout porte à croire qu'elle avait fait un mariage malheureux[178]. Lorsque Fred épouse Maud Pinder en 1910 il ne tarde pas à exprimer son affection pour elle à travers son art. Varley aspire à autre chose qu'à une relation physique et spirituelle profonde : il cherche l'âme sœur, quelqu'un qui partage sa passion pour l'art et qui s'intéresse vivement à son travail. Dans ses lettres, il encourage Maud à prendre une part active dans son processus de création et il lui parle de ses projets. Il attache beaucoup d'importance à son opinion et lui explique ce qu'il cherche à communiquer dans ses tableaux. Il lui demande son avis. Cependant, la difficulté de se refaire une vie dans un nouveau pays, les responsabilités familiales et les dettes ont mis leur mariage à rude épreuve.

Nous avons déjà examiné une des premières études à l'huile de Maud, *Été indien* (1914–1915; pl. 1). Vers 1919, Varley exécute un portrait en buste, intime et sensuel, de Maud au verso d'un dessin de guerre[179]. Sa tête est légèrement tournée et son regard fixe quelque chose à droite. Son visage est légèrement ombragé. L'ébauche de la chevelure ajoute à l'impression de volume, qui se manifeste également dans le contour des formes. Varley ne cherche pas à idéaliser le sujet. Il propose plutôt un portrait fidèle de sa femme, y compris de sa coiffure à en juger d'après des photographies prises vers 1920[180]. Cependant, dans un portrait exécuté le 30 août 1922 (fig. 24), Varley choisit d'adoucir ses traits, plus particulièrement le menton. Le dessin a été reproduit (pleine page) dans le *Canadian Forum*, sous le titre *Tête de femme*, et a peut-être également été présenté sous ce titre dans le cadre de l'exposition *Small Picture Exhibition by Members of the Ontario Society of Artists* tenue en 1923 à l'Art Gallery of Toronto[181]. Bien que la pose de Maud ressemble à celle du dessin de 1919, son expression en est une de lassitude et de tristesse.

Varley a également produit un très belle esquisse intitulée *Maud endormie* (v. 1921–1922)[182]. Dessinée avec brio, l'esquisse nous offre une tranche de la vie de Maud Varley. L'artiste l'a saisie dans un moment intime. Peut-être fait-elle la sieste. Sa représentation du sommeil est convaincante, sa touche habile et sincère. Malgré les moments difficiles que traverse la famille, Maud semble détendue et heureuse.

Varley nous offre un portrait plutôt inhabituelle de Maud dans *Rivage rocheux* (1922; pl. 18), également connu sous les titres *Maud sur les rochers* et *Rivage avec figure*. Maud est représentée assise sur les rochers d'un paysage imaginaire. Augustus Bridle en donne le compte rendu suivant dans le *Toronto Star* : « Son *Rivage rocheux* ne manque pas d'originalité, d'autant que, à première vue, on n'y discerne guère de rivage, sinon par certains contours et coloris. Le tableau présente une jeune fille bien mise, vêtue de rose, qui semble étrangère au tableau. Visiblement, elle sert de prétexte au rendu des couleurs[183]. » Bridle a sans aucun doute raison d'affirmer que Varley a peint la robe rose pour obtenir le contraste voulu, la tenue se prêtant guère à une excursion dans la nature. Amoureuse de la nature, Maud Varley faisait souvent du camping

avec son mari et ses amis. Selon une anecdote familiale, la vente de *Rivage rocheux* aurait permis à Varley de s'acheter des vêtements. Il avait déchiré son pantalon en tombant d'une échelle alors qu'il peignait une murale à l'Église St. Anne à Toronto. La palette de *Rivage rocheux* rappelle celle du *Peignoir rose* (1921; collection particulière), où Maud est représentée de profil, penchée sur le bébé qu'elle berce dans ses bras (selon toute probabilité son fils Peter né le 29 mai 1921)[184].

Le tableau intitulé *Portrait de Maud* (1925; pl. 27) est la seule étude formelle de la femme de l'artiste qui nous est connue. Dans son analyse des portraits peints par Varley entre 1919 et 1926, Andrea Kirkpatrick affirme que la pose de Maud, son expression et la place qu'elle occupe dans le champ visuel sont presque identiques à celles de l'artiste dans son autoportrait de 1919 (pl. 7). Elle fait valoir que seuls les coloris les empêchent d'être envisagés comme une paire[185]. D'une intensité lyrique hors du commun, ce portrait compte parmi les plus accomplis de cette période. Maud semble renfermée; elle a l'air anxieux et mélancolique. La palette sourde de bleus et de roses reflètent son état d'esprit. L'arrière-plan, aux allures de ciel orageux, contribue à l'atmosphère. Le paysage a été comparé à celui des portraits anglais du dix-huitième siècle, notamment ceux de Gainsborough, Joshua Reynolds et Romney. La manière anglaise du tableau se veut peut-être une allusion à l'affection de Maud pour sa terre natale.

La présence imposante de Maud et son cou disproportionné annoncent les portraits emblématiques et de plus en plus stylisés de Vera dans les années 30, d'Erica dans les années 40 et de Jess Crosby dans les années 50. Maud cachait ses problèmes conjugaux avec l'humilité qui convenait à son éducation victorienne. Adulte, Peter Varley a brossé le tableau suivant de la situation : « Nous aimions profondément notre père pour sa vitalité, son humour et sa façon d'envisager la vie comme un don à chérir, mais Mère avait vu toutes ses illusions dissipées et était impuissante face à l'adversité[186]. » Maud Varley a consacré sa vie à ses enfants. *Bobcaygeon* (1923; collection particulière) est une étude intime au fusain et à l'huile de Maud et de son jeune fils Peter qui dort dans ses bras[187]. Exécuté durant l'été que les Varley ont passé sous une tente sur la propriété d'E.J. Pratt à Bobcaygeon, ce dessin a été vendu en 1926 au cours

d'une vente organisée par Maud pour payer le prix des billets de train pour elle et les trois enfants pour rejoindre Varley à Vancouver. On aperçoit la tente dans le coin supérieur gauche de la composition. *Le soir au campement* (1923; collection particulière) est une variation sur le thème de Bobcaygeon[188].

Barker et Margaret Fairley

La valeur de l'amitié de Barker Fairley dans la vie et la carrière de Frederick Varley ne saurait être sous-estimée. Dès leurs premières rencontres, Fairley se révèle un ardent défenseur de Varley, ne ménageant aucun effort pour lui obtenir des commandes et vantant ses mérites dans les milieux académique et artistique. À la fin de l'hiver ou au début printemps 1920, alors qu'il avait toujours son atelier dans la cabane de Thomson, Varley peint *Portrait de Barker Fairley* (1920; pl. 8), une étude pénétrante de son ami le plus cher. Les deux hommes se voyaient régulièrement à l'époque où Varley achevait ses tableaux de guerre et espérait obtenir la commande d'une murale. Fairley se souvient : « Il m'a peint dans la cabane. Il m'a peint tout l'hiver et puis il a exécuté une étude, puissante et directe, en une séance. Celle qui se trouve aujourd'hui à Ottawa[189]. »

Barker Fairley (1887–1986) est né dans une petite communauté minière du Yorkshire. Il obtient une bourse de l'Université de Leeds pour étudier les langues modernes, il se distingue en français et en allemand. Il enseigne à l'Université de Jena en Allemagne, où il obtient son doctorat. Fairley s'installe au Canada en 1910 pour enseigner à la jeune Université de l'Alberta, qui logeait encore dans les locaux du Strathcona Collegiate Institute à Edmonton. Peu de temps après son arrivée il rencontre et épouse Margaret Keeling, une brillante étudiante en littérature, à qui Oxford avait refusé d'accorder un diplôme parce qu'elle était une femme. Non seulement l'Université de l'Alberta lui offre-t-elle un poste de professeur, mais la nomme doyenne des femmes.

En 1915, Fairley accepte le poste de professeur de littérature allemande à l'Université de Toronto. Il nous fait part de ses

premières impressions : « Lorsque je suis arrivé à Toronto, c'était une ville terne, sans originalité et pourtant c'est ici qu'a débuté ma vie intellectuelle. C'est à Toronto que j'ai atteint la maturité intellectuelle[190]. » Son compte rendu du climat culturel dans lequel Varley tenterait de gagner sa vie n'est guère plus élogieux : « Il n'y avait pas cette efflorescence de galeries d'art. Le monde de l'art n'existait pour ainsi dire pas. La ville n'avait pas de tradition artistique. Il n'y avait pour ainsi dire pas de collectionneurs, juste quelques personnes qui, à l'occasion, achetaient un tableau[191]. »

Les artistes qui allaient former le Groupe de Sept comptent parmi les premières connaissances de Fairley à Toronto. Il rencontre Fred Varley au Arts and Letters Club en 1918, peu de temps avant le départ de celui-ci pour l'Europe[192]. Dans les années 1920, Fairley observe ses amis artistes à l'œuvre, les accompagne dans leurs excursions et participe à d'interminables débats sur le processus de création. C'est ce qui lui permet de s'imposer comme le premier véritable défenseur – et critique – du Groupe des Sept. Il devient lui-même peintre dans la cinquantaine grâce à leur encouragement.

Comme nous l'avons vu, la position de Fairley dans les sphères académique et artistique a valu plusieurs commandes à Varley. Il est nommé directeur du journal étudiant, *The Rebel*, et c'est son idée de le distribuer à l'extérieur du campus. Il se rappelle exactement son cri de guerre : « Voyons grand! » En 1920, *Canadian Forum* voit le jour. Cette revue allait avoir des répercussions sur la fortune critique du Groupe des Sept, de même que sur l'éducation visuelle de Fairley. C'est dans le *Canadian Forum* qu'il publie ses premières critiques. Ses écrits sur l'art et la culture font contrepoids à la presse conservatrice. Selon Gary Michael Dault : « Lorsque Barker décrivait une peinture il faisait en sorte que sa plume soit d'une sensualité égale à celle du tableau qui se trouvait devant lui[193]. » Fervent admirateur de tous les membre du Groupe des Sept, Fairley voit cependant en Varley celui qui atteint à des réalisations formelles sans renoncer à la réalité et qui exerce une maîtrise parfaite de ses émotions.

Il n'existe aucun document officiel permettant d'affirmer que les portraits de la femme de Barker Fairley, Margaret, et de sa fille, Joan, sont des œuvres de commande, mais nous savons qu'ils ont été exécutés à un moment où Barker s'évertuait à venir en aide à son ami. Dans une entrevue avec Lawrence Sabbath, Varley mentionne que Fairley lui avait versé une modeste somme pour la réalisation de son portrait[194]. Margaret et Barker Fairley témoignaient de l'amitié non seulement à Varley, mais à toute sa famille. Leurs racines communes du Yorkshire et leur amour partagé de la littérature anglaise renforcent leurs liens d'amitié.

Dynamique et ingénieuse, Margaret Fairley poursuit ses propres initiatives journalistiques. À partir de 1925, elle siège au comité de rédaction du *Canadian Forum* et contribue des articles à teneur politique. Elle prône les changements sociaux, faisant valoir le droit à la liberté de choisir et d'agir pour tous[195]. Elle appuie la réforme sociale de gauche allant jusqu'à adhérer au parti communiste. Ses rencontres avec d'autres femmes de professeurs, dont Viola Pratt également portraiturée par Varley, sont également sources de stimulation intellectuelle. Varley réussit à rendre palpable l'énergie de Margaret dans le portrait qu'il fait d'elle au printemps 1921, même s'il choisit de la représenter repliée sur elle-même. Elle semble sur le point de se lever de la chaise droite sur laquelle elle est assise. Barker Fairley se rappelle qu'en 1937 lorsqu'il peignait Margaret, elle se montrait impatiente et quittait la pièce si les séances de pose se prolongeaient, le forçant à travailler sans modèle. Barker y voyait la preuve de la force de caractère de Margaret. « J'appréciais son indépendance qui lui prêtait une attitude autre que celle d'une femme en adoration devant son mari, attitude avec laquelle certains hommes avaient malheureusement à composer[196]. »

Le portrait de *Margaret Fairley* (1921; pl. 13) se distingue par son intensité réfléchie et son coloris lumineux. L'arrière-plan se divise en deux plans diagonaux : l'un aux tons froids de bleu et de vert, l'autre aux tons chauds d'orange et de rouge. La gamme de tons est délibérément restreinte. Le choix des couleurs a peut-être été dicté par des visées symboliques ou encore par la robe de Margaret. Le modèle est représenté presque de face, la tête légèrement tournée vers la gauche. C'est un portrait d'une profondeur psychologique hors du commun. Varley cherchait-il à illustrer la dualité des rôles de Margaret la ménagère anglaise et de Margaret l'intellectuelle? Si tel est le cas,

le bleu représente peut-être son côté digne et réservé, tandis que le rouge évoque son esprit libre et son autonomie. Varley a réussi à rendre avec brio l'essence de la personnalité et du dynamisme de Margaret Fairley.

Huntley K. Gordon

Huntley Gordon était un ami des Fairley et le frère de Robert K. Gordon, professeur d'anglais à l'Université de l'Alberta. Il fréquente le University College lorsqu'il fait la connaissance de Barker Fairley, qui l'encourage à collaborer au journal *The Rebel* et à la revue *Canadian Forum*. Ses contributions prennent la forme d'articles, d'éditoriaux et de poèmes. Il s'intéresse aux arts et fait de la peinture. Malgré une maladie invalidante contre laquelle il luttera presque toute sa vie, il aime le grand air et la nature. Il a la réputation d'un homme d'action. Fairley (qui a fait un portrait de son ami) se plaisait à dire que Huntley lui avait appris à ramer à la manière ojibway, propulsant et dirigeant l'embarcation en un seul coup[197].

Malgré le caractère intime du *Portrait de Huntley K. Gordon* (1921; pl. 14), Varley réussit à créer une présence imposante en représentant le sujet en gros plan. Le regard de Gordon est désintéressé. Peinte dans des tons chauds de brun et de rouge, la figure s'intègre bien au bleu ardoise de l'arrière-plan. Le format et la manière rappellent l'étude de Cyril Barraud exécutée en 1919. Ici, cependant, l'arrière-plan sombre et les effets de lumières font place à une subtile harmonisation. Il vaut de souligner la touche vigoureuse caractéristique des paysages de Varley de la même époque.

Les contacts du Arts and Letters Club

Fondé en 1908 comme un club social pour la communauté artistique, l'Arts and Letters Club (ALC) est en plein essor durant les années torontoises de Varley. C'est un milieu propice aux échanges entre artistes, écrivains, musiciens et mécènes. Vincent Massey décide d'y adhérer en 1911, s'étant rendu compte qu'aucun autre club offrait pareille stimulation intellectuelle à Toronto[198]. De 1920 à 1922, il exerce la fonction de président de l'ALC; à la fin de son mandat le Club commande un portrait dessiné de Massey à Varley. Alors qu'il travaille à la réalisation du projet de la Hart House, Massey a l'habitude de se rendre au Club pour y rencontrer les architectes Henry Sproatt et Ernest Rolph, qui sont également membres de l'ALC. Le quatuor de la Hart House et le théâtre de la Hart House ont vu le jour grâce aux membres de l'ALC.

Le dessin de Vincent Massey (1922; fig. 25) est très semblable au portrait à l'huile de 1920 d'après lequel il a été exécuté. Tout porte à croire que plutôt que de dessiner d'après modèle, il s'est inspiré du portrait à l'huile, ajoutant le détail de la joue appuyée sur la main pour donner au modèle un air songeur. Selon Andrea Kirkpatrick, « le traitement raffiné du médium, le volume des formes et le clair-obscur » suggèrent un lien plus étroit avec la technique picturale de Varley que sa technique graphique[199].

À la fin 1922 ou au début 1923, Varley dessine un portrait semblable du Dr Arnold Denbow Mason (1878–1962), membre de l'ALC depuis février 1921[200]. À l'automne 1922, il avait été nommé professeur de dentisterie clinique au Royal College of Dental Surgeons of Ontario. La nomination est peut-être à l'origine de la commande[201]. Collectionneur d'art connu, il apprécie tant les œuvres anciennes que modernes et tenait Varley en haute estime. Il n'est pas étonnant que l'artiste et le médecin se soient liés d'amitié. Lorsque Mason est nommé doyen de la Faculté de dentisterie à l'Université de Toronto en 1945, c'est Varley qui obtient la commande de son portrait[202].

Le filigrane anglais du papier, daté 1922, permet de fixer une date d'achèvement du dessin, compte tenu du temps requis pour l'expédition du matériel pour artiste à partir de l'Angleterre. *Le docteur A.D.A. Mason* (1922–1923; fig. 26) est exécuté à la manière de l'étude de Vincent Massey, les lignes servant à accentuer les plages d'ombres et de lumières. Elles soulignent la planéité de la composition, son absence de profondeur. Le contraire vaut pour le modelé du visage. Il y a une relation trouble entre la linéarité de la tenue vestimentaire et la tridimensionnalité de la tête.

Peter Sandiford (1882–1941), professeur de pédagogie et compatriote de Varley, devient membre de l'ALC en 1915[203]. Sa rencontre avec Varley mène indirectement à la commande du portrait de Primrose Sandiford. Par l'intermédiaire des membres Barker Fairley, Gilbert Jackson et Huntley Gordon, Sandiford collabore à la revue *Canadian Forum* dès ses débuts. Il exerce la fonction de directeur de rédaction de 1920 à 1934, et contribue régulièrement des articles, notamment sur le système éducatif canadien et la psychologie pédagogique[204]. Peter et Betti Sandiford adhèrent au Madawaska Club à l'Université de Toronto en 1917, et loue un chalet près de Split Rock, non loin du chalet du docteur MacCallum à Go-Home Bay. C'est à cet endroit que Varley exécute une esquisse à l'huile de Peter Sandiford (1922; pl. 17) allongé sur le rocher[205]. Ce petit tableau haut en couleur a souvent été comparé au *Bassin bleu* (1911; Aberdeen Art Gallery, Écosse) d'Augustus John au niveau de la mise en scène.

Il semble que le portrait de Viola Pratt soit le résultat d'une initiative entreprise par Varley et non d'une commande, même si le mari du modèle était membre de l'ALC depuis 1923[206]. Claire, la fille des Pratt, est d'avis que le portrait a probablement été exécuté en juillet 1924, lorsque Viola suivait un cours d'été à l'OCA donné par Varley[207]. Le portrait, qui traduit efficacement la chaleur et la vivacité du modèle, n'a jamais été offert à Viola Pratt. L'œuvre a été acquise par Harold Mortimer-Lamb et elle est demeurée dans sa collection jusqu'à ce qu'elle soit vendue à l'Art Gallery of Greater Victoria en 1957[208].

Viola Pratt (née Whitney, 1892–1984) est l'épouse d'E.J. Pratt (1882–1964), professeur d'anglais et poète tenu en haute estime[209]. Diplômée en art du Victoria College, Viola collabore à la publication universitaire *Acta* et prend une part active dans de nombreuses activités sociales et intellectuelles. Elle est membre d'un cercle d'épouses de professeurs[210]. C'est dans ce contexte qu'elle a pu rencontrer Margaret Fairley, et peut-être même voir le portrait que Varley en avait fait[211]. En 1922 les Varley achètent une maison avenue Colin à Toronto non loin de celle des Pratt. Les deux familles se lient d'amitié. En 1923, lorsque Fred et Maud perdent leur maison, E.J. Pratt confie à Varley la conception des papiers de garde de son receuil de poèmes, *Newfoundland Verse*[212].

D'un point de vue stylistique, le *Portrait de Viola Pratt* (v. 1924/25; pl. 25) se compare à ceux de Maud (pl. 27) et de Dorothy Varley, le facture est cependant plus fluide. L'aspect inachevé du tableau laisse croire qu'il a été exécuté rapidement. Il porte néanmoins la signature de Varley[213]. Peter Varley lui attribue la date de 1928, ce qui signifie que le tableau aurait été exécuté alors que l'artiste se trouvait à Vancouver. Nous savons que Viola Pratt s'est rendue à Vancouver en 1927 et que Varley a séjourné à Toronto à l'été 1928. Cela dit, la date de 1924–1925 est conforme aux souvenirs de la famille[214].

Kathleen Calhoun

En 1924 Varley entreprend un voyage dans l'Ouest canadien. Il visite Edmonton, Calgary et Winnipeg, et s'arrête à Banff pour voir les Rocheuses. Partout, il est reçu comme une célébrité, sa réputation d'artiste de guerre ayant été établie dans le cadre d'une exposition itinérante du Groupe des Sept organisée par le Musée des beaux-arts du Canada en 1921. Durant son séjour dans l'Ouest, il donne des conférences, élargit son cercle de connaissances et travaille à la réalisation de plusieurs commandes de portraits[215]. À Edmonton, Varley habite dans la famille du docteur John MacEachran. C'est à Edmonton qu'il fait la connaissance de Kathleen Calhoun, une jeune femme, belle et intelligente, originaire d'Ottawa qui termine ses études à l'Université de l'Alberta.

Kathleen répondait à toutes les attentes de Varley. Elle était douce et sensible, ouverte à ses vues artistiques, passionnée de musique et de littérature. Elle savait tout ce qu'il aimait et tout ce qu'il n'aimait pas. Aucun document ne permet de fixer la date de leur première rencontre, mais la première lettre, qui existe encore, de Varley à Kathleen a été écrite alors qu'il se rendait à Winnipeg pour terminer le portrait de Daniel McIntyre. Il avait déjà exécuté un dessin de Kathleen qu'il montrait aux clients potentiels à Banff et à Winnipeg[216]. Varley écrit à Kathleen que McIntyre, vivement impressionné par le dessin, lui demande à maintes reprises des précisions au sujet du modèle. Ne trouvant pas réponse à sa

question, McIntyre conclut qu'un portrait exécuté avec autant d'amour doit nécessairement être celui de sa femme[217].

Mécontent d'un dessin au fusain de Kathleen, Varley le jette à la poubelle. Récupéré par madame MacEachran, le dessin se trouve maintenant dans la collection de l'Université de l'Alberta. Peu flatteur, le portait *Tête de Kathleen Calhoun* (1924; fig. 27) est néanmoins évocateur des premiers tableaux de Varley célébrant la beauté féminine. La pose alanguie du modèle et ses paupières à demi fermées rappellent l'érotisme de ses portraits de gitanes. Il reprendra le motif dans les années 1940 dans ses portraits de Manya et d'Erica. Il n'est pas impossible qu'il s'agisse d'une esquisse préparatoire, la précision typique de ses dessins des années 1920 lui faisant défaut.

Kathleen Calhoun (1924; pl. 19), un dessin que le modèle a conservé toute sa vie, se distingue par sa vitalité et sa fraîcheur. Varley a appliqué un lavis uniforme qui contribue à réduire les contrastes et à adoucir l'image. Il recourt au fusain pour souligner les contours et à de la craie de couleur pour créer un effet de profondeur. À droite, quelques touches enlevées accentuent son visage et se fondent en un motif enjoué. Il reprendra cette technique dans son portrait de Vera Weatherbie, *Tête d'une jeune femme* (1936; fig. 42).

Le fonds Varley établi en 1969 fait état de deux dessins connus de of Kathleen Calhoun. Étant donné que nous savons qu'un dessin se trouve à Winnipeg et que l'autre a été conservé par le modèle et n'a jamais été présenté en public, nous pouvons dire sans trop nous avancer que Varley a sans doute gardé au moins un dessin de Kathleen. Cette hypothèse est étayée par une lettre de Varley à Kathleen, datée du 1er mai 1924, dans laquelle il décrit une visite qu'il a rendue aux Fairley pour leur raconter les détails de son voyage dans l'Ouest canadien. Il leur montre des photographies du portrait de Daniel McIntyre et un dessin original de Kathleen Calhoun. Barker Fairley non seulement reconnaît la jeune femme, mais en garde un vif souvenir. Varley poursuit avec sa légèreté habituelle : « Je lui ai montré le dessin. C'est un homme étrange – il est soit d'une passivité stupide, soit d'un enthousiasme débordant. Il a commencé par marmonner et puis s'est écrié 'Mon Dieu, Fred, je pourrais devenir amoureux.' Il s'est redressé brusquement et m'a dit : 'Mais Fred, tu dois être amoureux d'elle pour la dessiner de cette façon. Il me faut éviter de la regarder trop longtemps'[218]. » Il semble qu'il était évident pour quiconque voyait le dessin que Fred Varley était amoureux de Kathleen Calhoun.

Les bons amis et les adieux

Au milieu des années 1920, les Varley passaient beaucoup de temps en compagnie de leurs amis Nan et Trevor Garstang. Originaire du Lancashire, Trevor s'était fait connaître dans le milieu du théâtre anglais en tant que scénographe, acteur et metteur en scène avant d'immigrer au Canada vers 1920. Il avait créé des décors pour l'Opéra de Paris et les Folies Bergères, la Scala de Milan, des théâtres à Vienne et de nombreuses troupes de ballet[219]. À Toronto, il trouve du travail au théâtre de la Hart House, où il fait probablement la connaissance de Fred Varley. Garstang ne deviendra membre de l'ALC qu'en mai 1928. Les deux hommes se sont tout de suite liés d'amitié. *Trevor Garstang* (1923–1925; fig. 28) est le résultat d'une esquisse sur le vif. Trevor ne semble pas avoir conscience d'être observé. Il est possible que sa tête ait été partiellement cachée de la vue de Varley, qui a choisi de la laisser inachevée. Selon Andrea Kirkpatrick, le détourage en diagonale à gauche de la feuille ajoute à l'impression de spontanéité[220]. L'air captivé de Trevor et son maintien laisse croire qu'il écoute la radio, une des ses distractions préférées.

Le portrait de Nan Garstang (fig. 29) – simple, mais néanmoins audacieux et expressif – offre un contraste saisissant à celui de son mari. Le contour linéaire de ses traits et les ombres délicates rappellent le portrait de l'auteur Mazo de la Roche (1885–1961) exécuté par Varley en 1926[221]. Le portrait de Nan date probablement de la même année. Une photographie prise dans le salon des Garstang peu de temps après la naissance de leur fils, Peter, en 1926, permet de voir le dessin accroché au-dessus de la cheminée (fig. 30). Plutôt que de lui verser des honoraires, les Garstang invite le Dr Minerva Reid, qui a mis leur enfant au monde, à choisir une des œuvres de leur collection[222]. Ils

espéraient qu'elle choisisse une des œuvres de Trevor, mais elle a opté pour le portrait de Nan. La famille a donc dû renoncer au tableau de Varley.

Varley, le portraitiste, était toujours à l'œuvre, faisant des croquis de sa famille et de ses amis lors des pique-niques, ou dessinant des visages durant des réunions officielles ou entre amis. Il a fait un croquis d'Eddie (fig. 31), le frère de Trevor, durant une de leurs excursions à la Toronto Island. Lorsque Varley quitte Toronto à l'automne 1926 pour aller enseigner à la Vancouver School of Decorative and Applied Arts, c'est Trevor Garstang qui aide Maud à organiser la vente tenue à la maison rue Yonge et à emballer les effets de la famille. Leur ami Herbert Stansfield se charge de fermer la maison et de payer le loyer.

Une des dernières commandes de Varley à Toronto consiste en quatre portraits pour une série publiée dans le *Toronto Star Weekly*. Les archives de la défunte publication ont été perdues, mais on peut supposer que c'est le rédacteur financier, Fred Housser, qui a confié la commande à Varley. À compter de novembre 1925, le journal consacre un article de fond à une personnalité publique et à ses vues religieuses. Les trente-trois articles de la série sont divisés en trois parties. Les portraits de Varley serviraient à illustrer la troisième partie, consacrée aux personnalités canadiennes suivantes : Edmund Scheuer, éducateur et membre important de la communauté juive; George A. Warburton, secrétaire général de la YMCA; et Ralph Connable, directeur de la succursale canadienne de la F.W. Woolworth Company et philanthrope. Étant donné que les trois hommes vivent à Toronto, il se peut que Varley travaille d'après modèle plutôt qu'à partir de photographies. Le quatrième portrait était celui d'un soldat canadien anonyme, un survivant de la Première Grande guerre. Varley a réalisé un portrait composite de deux soldats [223]. Son dessin de Mazo de la Roche a également été publié dans le *Toronto Star Weekly*[224].

CHAPITRE 5

L'ENSEIGNEMENT ET LES VOYAGES, 1926–1950

Une multitude de sujets s'offrent à moi, je suis dans un endroit magnifique.

— Fred Varley

La nomination de Vancouver arrive à point nommé pour Varley, tant au niveau personnel que professionnel. Outre un emploi permanent, l'Ouest s'ouvre sur de nouvelles possibilités et un nouveau public. Varley estime que son travail est mal reconnu en Ontario, malgré sa participation soutenue aux expositions annuelles du Groupe des Sept ainsi que celles du CNE, de l'OSA et du Musée des beaux-arts du Canada à Ottawa. Il n'avait pas tort de s'inquiéter. Impossible de compter sur les commandes, et les ventes de tableaux sont faibles. En 1924, les statistiques démontrent que les œuvres d'artistes canadiens ne représentent que 2 pourcent de l'ensemble des ventes d'œuvres d'art au pays. Les artistes qui réussissent à vivre exclusivement de leur art sont ceux de la génération précédente. À l'exception de Lawren Harris, qui dispose d'une fortune personnelle, les membres du Groupe des Sept se tournent vers l'art commercial ou l'enseignement pour subvenir aux besoins de leurs familles[225].

En 1926, lorsque Varley quitte Toronto, il est au faîte de son talent de portraitiste. Ses tableaux sont primés dans le cadre d'importants concours, où sont représentés des artistes aussi connus que Curtis Williamson et Wyly Grier, et commandent des prix intéressants. En dépit des critiques mitigées sur la scène internationale, ses tableaux sont très prisés par les critiques de Toronto, notamment Augustus Bridle et Hector Charlesworth. Dans son étude exhaustive du Groupe des Sept, parue en 1925, Fred Housser affirme que Varley est « un peintre au talent hors du commun et au potentiel créatif et émotif remarquable[226]. »

Certains reprochent à Varley de peindre trop peu. A.Y. Jackson prétend que Varley et J.E.H. MacDonald sont les « improductifs » du Groupe des Sept[227]. La toile de Varley intitulée *Tempête, baie Georgienne* (1920; MBAC) connaît un succès immédiat. Elle figure à maintes reprises dans d'importantes expositions présentées au Canada et à l'étranger. La vérité c'est que durant la période de Toronto Varley produit peu de paysages, préférant se consacrer aux portraits. Il déçoit donc les attentes de ses amis et des mécènes du Groupe. Le grand public, lui aussi, réclame des paysages à cor et à cri[228].

Dans sa contribution au catalogue accompagnant la rétrospective des œuvres de Varley présentée à l'Art Gallery of Toronto en 1954, Arthur Lismer, membre du Groupe et ami de longue date de l'artiste, offre ce commentaire :

À cette époque [l'après-guerre] ses paysages étaient peu nombreux. Il y avait bien celui d'une tempête sur la baie Georgienne conservé au Musée des beaux-arts du Canada. Il est magnifique, il a été réalisé aux alentours des années 1920; mais il n'était pas passionné par le paysage canadien, du moins à cette époque. Plus tard, en Colombie-Britannique – mais c'est une toute autre histoire. Les territoires sauvages sur lesquels le Groupe avait jeté son dévolu ne l'intéressaient pas vraiment. Son individualisme farouche l'empêchait de poursuivre des objectifs autres que les siens. Il lui fallait peindre ce qui nourrissait sa passion. Il n'a jamais succombé aux lieux communs : il a inventé son propre vocabulaire de la forme[229].

Varley doit se mesurer à des artistes tels qu'Edwin Holgate, Randolph S. Hewton, Prudence Heward et Sarah Robertson qui s'essayent non seulement au portrait, mais à la mise en scène de la figure dans la nature. Holgate et Heward, notamment, se rapprochent du Groupe des Sept dans leur traitement du paysage comme toile de fond de leurs portraits. En fait, Holgate est invité à participer à l'exposition de 1924 du Groupe, et son travail fait partie du volet canadien de la *British Empire Exhibition* de Wembley. Varley proteste énergiquement! Avant de quitter Toronto, Varley ajoute certaines œuvres antérieures, dont *Les Immigrants* (v. 1921; pl. 15), à celles qu'il présente dans le cadre de l'exposition du CNE.

La Colombie-Britannique représente la quête d'une nouvelle liberté d'expression. Varley écrit à Eric Brown : « Ça fait des années que je n'ai pas d'expériences. J'ai grand besoin d'aventures en peinture qui sont depuis trop longtemps réprimées[230]. » Barker Fairley, quant à lui, estime que le moment est mal choisi. Il est convaincu que Varley fait une erreur en quittant Toronto au moment même où la ville s'ouvre à l'art moderne. Varley allait y perdre[231].

Vancouver, 1926 à 1936

En septembre 1926, l'artiste et son fils John, âgé de quatorze ans, se rendent en Colombie-Britannique en train. Dès son entrée en fonction à la Vancouver School of Decorative and Applied Arts (VSDAA), Varley fait une profonde impression sur ses collègues et ses étudiants, il continuera de le faire pendant les dix prochaines années. Les critiques le considèrent comme l'artiste ayant le plus d'influence sur la scène culturelle locale, qui durant les années 1920 et le début des années 1930 était balayée d'un vent de dynamisme. Bien que beaucoup plus petite que celle de Toronto, la communauté artistique se distingue par son engagement. Les artistes et les collectionneurs fréquentent les mêmes soirées.

L'Hotel Vancouver présente depuis peu des concerts de musique classique. Les sociétés d'artistes sont en plein essor, mentionnons, entre autres, la B.C. Art League (formée en 1920), le Vancouver Sketch Club et la B.C. Society of Fine Art. Le Pacific National Exhibition présentait des œuvres d'art depuis 1916, et la Vancouver Art Gallery ouvre ses portes en 1931. Les galeries d'art privées prolifèrent. La jeune Université de la Colombie-Britannique propose des conférences sur une variété de sujets, y compris les arts visuels. De nombreux artistes organisent des exercusions de dessin et partagent des ateliers.

La fillette aux tournesols (1920/21; pl. 12) est le premier portrait de Varley à faire l'objet d'une critique dans la presse locale. Elle est rédigée par Harold Mortimer-Lamb, un photographe qui collabore également à une revue de l'actualité minière produite à Victoria. Reconnu pour être un critique d'art semi-professionnel et large d'esprit, Mortimer-Lamb avait déjà souligner la « spontanéité et la vitalité » de Varley avant que ce dernier ne s'installe à Vancouver[232]. En effet, le ravissant portrait de la jeune Mary Kenny avait été présenté à Vancouver dans le cadre de l'exposition itinérante du Groupe des Sept tenue à East Hastings Park en 1922.

À Vancouver, Varley poursuit son travail de portraitiste, mais c'est dans la nature qu'il vit les « aventures en peinture qui sont depuis trop longtemps réprimées ». Jock Macdonald affirme que Varley fut « principalement un artiste de plein air durant ses dix

années sur la côte du Pacifique. Presque tous les week-ends il peignait dans les montagnes et l'été dans le parc Garibaldi, ce coin de pays d'une incroyable beauté encore inconnue des touristes, où des prairies de mille huit cent trente mètres sont tapissées de fleurs sauvages, les lacs sont d'un vert émeraude, les glaciers sont habités de crevasses rose de garance, bleu turquoise et indigo, et les montagnes sont noires, ocre et rouge d'Égypte[233]. » Macdonald ajoute également : « Lorsque le temps ne se prêtait pas à la peinture en plein air il retravaillait des portraits dans son atelier dans les montagnes ou dessinait les 'personnages' qui traînaient dans le quartier chinois de Vancouver ou dans les tavernes[234]. »

Varley choisit principalement les sujets de ses portraits parmi ses collègues et ses amis, et parmi les étudiants et les modèles de ses cours de dessin. De plus, sa charge d'enseignement occupe tout son temps. En 1930, il fait le portrait de son collègue J.W.G. Jock Macdonald (pl. 32). Diplômé du Edinburgh College of Art et formé en art commercial, Jock Macdonald (1897–1960) entre lui aussi en fonction à la Vancouver School of Decorative and Applied Arts en 1926. Malgré les seize ans qui les séparent, les deux hommes se sont tout de suite liés d'amitié et ils font souvent des excursions de dessin dans le Parc national Garibaldi et Savary Island. Lors de leur première excursion, Varley croque Jock et son fils John sur le vif, *Les Dessinateurs* (v. 1927; fig. 32)[235]. C'est au cours d'une de ces randonnées que Macdonald se rend compte de l'insuffisance de ses premières esquisses à la plume et à l'encre à exprimer sa réaction à la nature. Avec le soutien de Varley, il commence à travailler à l'huile et à faire des essais de couleurs[236]. Varley est explicite : « Arrête de dessiner et commence à peindre[237]. »

Un professeur inspirant

Fred Varley se consacre corps et âme à l'enseignement, plus particulièrement au dessin d'après nature. En 1955, Fred Amess, ancien étudiant de Varley et directeur de la VSDAA, déclare : « Au départ nous imaginions que Varley était une source de connaissances qui s'alimentait toute seule, mais nous nous rendions rapidement compte qu'il était plutôt une fontaine à

travers laquelle s'écoulait toutes les nouveautés fascinantes du monde, rehaussées plutôt qu'abâtardies par une formation académique solide. C'était un flot violent, dirigé et constant; et même si quelques-uns furent emportés par ce courant, ceux qui avaient de bonnes racines furent abreuvés[238]. » Un autre de ses étudiants, Jack Shadbolt, affirme : « Varley a communiqué à Vancouver la fièvre de l'art, et nous étions tous fiers qu'il était ici à travailler parmi nous[239]. »

Pour Varley, dessin et sens aigu de l'observation vont de pair. Il encourage ses étudiants à s'efforcer de « rendre l'essence » du sujet plutôt de faire un bon tableau[240]. Dans ses cours de dessin d'après nature, il travaille aux côtés des étudiants, produisant de remarquables portraits et nus, dont *Nu à la pomme* (collection particulière). Jack Shadbolt le décrit comme quelqu'un qui avait une notion romantique de son travail, mais qui était néanmoins très conscient de l'aspect technique de la création[241]. Orville Fisher, ancien étudiant de Varley, résume l'approche pédagogique de l'artiste comme suit : « Il y a les prétendues règles, mais si vous réussissez à les enfreindre vous êtes en voie de devenir un artiste[242]. »

Varley choisissait lui-même les modèles en fonction de l'illustration d'une thématique ou d'une convention artistique. Dans le cadre de son cours sur la Renaissance italienne, il choisit une « Italienne élancée » pour illustrer l'art de Botticelli[243]. Il encourage ses étudiants à explorer la diversité ethnique de Vancouver et à faire des croquis dans les quartiers japonais et chinois. Dans le cadre de son cours sur les canons de l'art oriental, il fait appel à une jeune Chinoise et à un jeune Canadien d'origine japonaise, Eugene, qu'il préfère à tous ses étudiants. Sous l'influence de Marius Barbeau, le directeur du Victoria Memorial Museum, Varley aborde l'art autochtone et invite Emily Carr à donner une conférence sur le sujet[244].

Parmi les ouvrages préférés de Varley, mentionnons *Histoire de l'art. L'art moderne* d'Elie Faure, *Art and Craft of Drawing* de Vernon Blake, *Colour Primer* de Wilhelm Oswald et *A Colour Notation* d'Albert Munsell. Fred Amess affirme : « Nous étions inondés de gravures, d'excursions dans le quartier chinois [...] de cuisine chinoise [...] de chevaux chinois, de manuscrits

persans, de gravures de Matisse et d'estampes japonaises. Le nom de Puvis de Chavannes est invoqué pour défendre la prétention de l'Occident aux arts décoratifs avec celui de Whistler – Aubrey Beardsley […] non loin derrière[245]. »

Arthur Lismer, le plus grand pédagogue canadien de son époque, disait de Varley le professeur : « L'enseignement était pour lui un moyen de communiquer son enthousiasme pour l'exploration et l'interprétation des formes […] Un homme qui se donne la peine d'enseigner et qui y prend plaisir incite bien des jeunes gens à dessiner et à peindre dans un but précis. Varley a largement contribué à l'enseignement de l'art dans plus d'une ville au Canada[246]. »

John Vanderpant

Des nouveaux amis que se fait Varley à Vancouver, John et Catharina Vanderpant sont les plus proches. Peter Varley se rappelle des visites que se rendaient les deux familles comme fait saillant de son enfance : « Ces soirées ont profondément enrichie nos vies, celle de mon père surtout, car il avait soif de musique et il lui manquait de ne pas avoir de piano à la maison. Les visites du samedi soir n'avaient rien à voir avec les paisibles soirées musicales du jeudi. Père et Vanderpant se mettaient mutuellement à l'épreuve dans des jeux plus exubérants les uns que les autres[247]. » Les soirées musicales avaient lieu chez les Vanderpant. Elles étaient l'occasion pour John de faire découvrir ses nouveaux disques. C'est au cours d'une de ces soirées que Varley exécute *Portrait de John Vanderpant* (v. 1930; pl. 36) et *Catharina Vanderpant* (v. 1930; fig. 33).

Selon Charles C. Hill , au début du vingtième siècle, John Vanderpant (1884–1939) était le plus important photographe de Vancouver[248]. Originaire des Pays-Bas, Vanderpant s'installe au Canada en 1911, amenant avec lui le concept européen de la haute culture[249]. À peu près du même âge, Varley et Vanderpant voient les choses de la même façon. Ils sont à la fois gentlemans du vieux monde et innovateurs. Un auteur souligne que la vie de Vanderpant est marquée de contrastes[250]. Il gagne sa vie comme portraitiste, mais trouve son exutoire dans la photographie d'art.

Ses œuvres se distinguent par la précision de leur composition et la modulation de la lumière[251]. Le portrait de sa fillette, *Toujours Eve* (1918; fig. 34), présenté dans le cadre du Salon de Londres de 1924, compte parmi ses réalisations les plus accomplies.

Au printemps 1926, John Vanderpant s'associe à un autre photographe de renom, Harold Mortimer-Lamb. Ils ouvrent les Vanderpant Galleries – studio et galerie d'art – rue Robson (fig. 35). Meublée d'antiquités et dotée d'un salon de musique, la galerie s'impose comme le lieu de rencontre de l'élite intellectuelle. Les lectures de poèmes, vernissages et conférences sur l'art et le mysticisme attirent Varley, Jock Macdonald, Harry Täuber et Philip Surrey, ainsi que les étudiants de la VSDAA. Au bout d'un an, Vanderpant met fin au partenariat et devient l'unique propriétaire de l'entreprise.

Harold Mortimer-Lamb

Varley a de nombreuses affinités avec Harold Mortimer-Lamb (1872–1970), qui à l'époque est à l'avant-garde des défenseurs du Groupe des Sept. C'est également le premier critique à reconnaître le talent d' Emily Carr[252]. Natif de Leatherhead, en Angleterre, il s'installe au Canada à l'âge de dix-sept ans. Durant son séjour à Montréal de 1905 à 1920, son talent d'écrivain et sa réputation croissante de collectionneur d'art et de défenseur des artistes contemporains lui valent le poste de critique d'art au *Montreal Star* et de correspondant au Canada de la revue *The Studio*, la plus importante revue d'art britannique de l'époque[253]. Mortimer-Lamb se fait connaître comme photographe d'art. Il participe régulièrement aux salons internationaux, y compris le Royal Photographic Salon à Londres, et se lie d'amitié avec Alfred Stieglitz, dont le studio de New-York est considéré comme le foyer de la photographie américaine d'avant-garde. Stieglitz a reproduit certaines des photographies de Mortimer-Lamb dans ses publications[254].

Portrait de H. Mortimer-Lamb (v. 1930; pl. 35) illustre avec brio le talent de portraitiste de Varley et nous offre un regard privilégié sur l'univers intérieur du modèle. En décentrant

légèrement le sujet, Varley donne au portrait l'allure d'un cliché. Le coloris et le jeu d'ombres et de lumières attirent le regard vers la tête. La touche se fait plus légère sur le visage et la tête que sur le torse et l'arrière-plan aux riches textures. Conformément à sa croyance selon laquelle la couleur de l'aura d'un individu reflète son état psychologique, Varley utilise des bleus et des mauves de même que du rouge, de l'orange et du vert clair – une palette appropriée à la nature poétique de Mortimer-Lamb.

Mortimer-Lamb est effectivement un homme passionné et original. Sa forte personnalité est jumelée à une profonde sensibilité et à un intérêt marqué pour la peinture et le portrait photographique. Comme Varley, il apprécie l'art asiatique et sa collection compte plusieurs remarquables pièces chinoises et japonaises – sculptures en jade, peintures et estmapes ukiyo-e. La fondation de la Vancouver Art Gallery doit beaucoup à la vision et au courage de Mortimer-Lamb. Vers l'âge de soixante-cinq ans, il commence à peindre et participe à plusieurs expositions couronnées de succès[255].

Le départ de Varley pour la Colombie-Britannique coïncide avec son exploration des théories de la couleur, tant scientifiques qu'ésotériques. Son étude de l'art oriental, de la philosophie bouddhique et du mysticisme hindou enrichissent sa théorie intuitive de la couleur. Ses paysages et ses portraits se distinguent par leur harmonie de couleurs hors du commun. Selon Maria Tippett, Varley était un fervent admirateur de l'artiste Statira Frame qui travaillait, elle aussi, à Vancouver. Née à Montréal et formée à San Francisco, Frame était connue pour son excellent sens de la couleur. Varley aurait fait l'éloge de ses huiles et de son utilisation du rose, du violet et du vert laiteux – des teintes qu'il aimait beaucoup[256].

Vera Weatherbie

Selon Fred Amess, Varley était fasciné par une tête orientale en plâtre dont il se servait dans ses cours de dessin. Ses traits ressemblaient à ceux d'une de ses étudiantes, plus particulièrement les yeux bridés, évocateurs du mysticisme de l'Orient[257]. Cette étudiante c'est Vera Weatherbie, une jeune femme au charme peu commun, aux grands yeux en amande et à la bouche menue. Varley est obsédé par sa beauté et son dessin *Vera*, (1926–1929; fig. 36) en est un témoignage éloquent. Dans les années à venir, la gracieuse et timide Vera allait devenir la compagne et la confidente de l'artiste. Entre 1930 et 1936, il peint une série de portraits de Vera d'une intensité incomparable dans l'art canadien. Certains, comme *Vera* (v. 1936; pl. 42), traduisent sa beauté par le biais de la spontanéité de l'aquarelle. D'autres, comme *Vera* (v. 1930; pl. 34), se veulent le reflet du caractère orageux de leur liaison. Vera était le modèle parfait, la femme qu'il cherchait depuis longtemps et un sujet qui ne cessait de l'inspirer et de le défier.

Vera Olivia Weatherbie (1909–1977) est une étudiante de seconde année à l'automne 1926 lorsqu'elle s'inscrit au cours de dessin de Varley. Elle assiste parfois avec d'autres étudiants aux soirées qu'il organise à Jericho Beach. En 1928, sa dernière année, elle tient le rôle principal dans le spectacle de Noël, *The Pageant of the Holy Grail*. Vivement impressionné par son interprétation de la Vierge Marie et par sa beauté, John Vanderpant la prend en photo (fig. 37). La photographie de Vera s'impose comme l'image de marque du studio de Vanderpant, qui la reproduit sur sa carte de visite professionnelle. C'est à ce moment que Varley décide de faire son portrait. La localisation du premier tableau de Vera portant un voile est inconnue, mais c'est un motif que Varley reprendra à maintes reprises. Dans *Tête de jeune fille* (v. 1933; pl. 39) il la représente en Madone, lui donnant un air de sainteté. La douceur de ses traits évoque, entre autres, la *Naissance de Vénus* (v. 1485; Galerie des Offices, Florence) de Botticelli ou encore *L'Adoration des Mages* (1624–1626; Koninklijk Museum, Anvers) de Rubens. Dans *Vert et or, portrait de Vera*, (v. 1933–1934; pl. 40), une autre variation sur le thème de la Madone, Varley recourt à certains de ses procédés stylistiques préférés : cadrage serré et harmonisation figure-fond.

À l'été 1929, les rapports entre Vera et Varley s'intensifient. Varley et Jock Macdonald sont installés dans leurs nouveaux ateliers de la rue Bute dans un vieil édifice majestueux dans le centre de Vancouver, communément appelé Parakantas, qui appartenait au grand-père d'un étudiant de la VSDAA. L'intérieur

est divisé en plusieurs espaces de travail attribués non seulement aux professeurs, mais à certains étudiants ayant obtenu leur diplôme. Lilias Farley, Sybil Hill et Margaret Williams partagent un atelier, tandis que Vera Weatherbie se retrouve avec Irene Hoffar Reid[258]. C'est à cet endroit que Varley aurait peint *Vera* (v. 1929; pl. 31). Il la représente assise, de face, vêtue d'un chandail à rayures. Elle a l'air rêveur et distant, ses cheveux courts, plutôt stylisés, encadrent son visage. Le modelé de la tête est soigné, par contre le corps est plat et raide. Le rendu des bras, le droit notamment, est malhabile. Le vert et le rose de l'arrière-plan visent à exprimer l'aura de Vera. Dans le coin supérieur gauche, il répète les rayures de son chandail, donnant l'impression d'une petite fenêtre d'où filtrent des rayons de lumière.

Les nombreux portraits de Vera – aux yeux bridés et à la coiffure stylisée – comptent parmi les œuvres de Varley dont on se souvient le mieux. Dans le plus accompli de ces portraits, *Vera* (1930; pl. 33), il la représente de face, occupant le premier plan de la composition, l'épaule droite légèrement rapprochée du spectateur. Ce portrait de Vera, baignant dans des tons de vert clair et de bleu, est un chef-d'œuvre[259]. La théorie de la couleur de Varley est basée sur les cinq qualités de base de l'énergie tantrique, chaque couleur ayant de bonnes ou de mauvaises connotations, selon une interprétation personnelle et karmique. Il accorde au vert une valeur spirituelle. De plus, il est convaincu que chaque personne est entourée d'une aura qui s'exprime par une couleur précise. À ses yeux, Vera est une « personne verte »[260]. À la même époque, il peint le portrait d'une étudiante, Norma Parks, en rose. Dans les années 1950, l'aura de sa compagne Jess Crosby est mordorée, tandis que celle de Kathleen McKay est généralement rouge vif.

Dans son portrait de 1930, en choisissant de représenter Vera vêtue d'un sarrau de peintre, Varley déclare qu'elle est elle même artiste – elle est sur un pied d'égalité avec lui. Dans une entrevue accordée en 1959 à McKenzie Porter, Varley fait une observation qui provoque une longue discussion à savoir si Vera avait joué un rôle dans ses nouveaux choix de couleurs. Il reconnaît que « sans le savoir elle m'a fait voir la couleur sous un jour différent[261]. » Dans une lettre datée du 8 novembre 1939, Fred écrit à Vera : « J'ai appris plus sur l'Art, le vrai Art, pendant ces années […]

qu'à tout autre moment – C'est toi qui m'a enseigné[262]. » Les recherches et les entrevues menées par Peter Varley permettent d'arriver à la conclusion que c'est Vera qui a donné à Varley son « sens de la couleur »[263].

En reconnaissant le talent de Vera, Varley fait preuve de prescience et non de condescendance. Vera entreprend des études de troisième cycle et acquiert une maîtrise rigoureuse de sa technique[264]. Elle participe régulièrement aux expositions annuelles locales et présente des œuvres dans le cadre d'expositions nationales et internationales. Lorsque son travaille figure dans l'exposition *All-Canadian Artists' Pictures* tenue à Vancouver en mai 1932, on la classe parmi « les plus doués des jeunes diplômés[265] ». Au cours de quelques décennies, Vera va produire un important corpus d'œuvres qui n'ont jamais été vues ou reconnues. Elle a été victime de circonstances qui ont fait obstacle à l'évaluation critique de son travail et qui ont obscurci sa présence.

Le portrait à mi-corps de Varley qu'elle exécute vers 1930 présente une ressemblance saisissante avec celui que l'artiste a réalisé d'elle à la même époque. Elle utilise la même nuance de vert qui confère au tableau une qualité mystique. On se demande si elle aspirait à faire le portrait de Varley ou si elle cherchait à représenter son esprit? Lorsque le portrait est exposé en mai 1932, un observateur a l'impression que son sujet a « une tête et deux profils indistincts, comme si on l'avait fait tournoyer[266] ». À la manière de son très estimé professeur et compagnon, Vera signe également ses œuvres de l'empreinte de son pouce.

Le titre du dessin préparatoire *Étude pour Dhârâna* (1932; AGO) et du tableau définitif *Dhârâna* (1932; AGO) témoigne du regain d'intérêt de Varley pour le bouddhisme. Le tableau se veut l'illustration du concept de l'unicité avec la nature. Vera, agenouillée, symbolise la communion sacrée avec le lieu. L'aura bleu-vert qui entoure le sujet fusionne esthétique et divin.

Nouvelles directions

La septième année de son existence la VSDAA subit les contrecoups de la Grande dépression. Les perspectives sont sombres pour les

artistes. En 1933, Varley et Jock Macdonald réagissent à la diminution de leurs heures de travail en démissionnant. Ils décident de fonder leur propre entreprise et s'installent dans une ancienne concession d'automobiles. L'établissement est rapidement transformé en une école d'art vouée à l'enseignement de pointe. Varley explique la raison d'être du British Columbia College of Art en ces termes :

> Conscients des immenses possibilités inévitablement offertes par un centre aussi dynamique que Vancouver, qui subit l'influence profonde de l'Occident et l'Orient, nous avons conçu l'idée du College of Art, qui a pour but de promouvoir l'éveil et le rayonnement de l'expression artistique non seulement en Colombie-Britannique mais à l'échelle du Dominion, et d'établir des liens avec l'Orient par le biais d'échanges d'expositions. Et, dans la mesure du possible, une fois notre réputation établie, de faire venir des artistes de l'Orient pour nous enseigner de nouvelles formes d'expression.[267]

L'enthousiasme des deux professeurs est contagieux. Les étudiants de la VSDDA sont nombreux à s'inscrire au College of Art. Fred Varley, Jock Macdonald et Harry Täuber exercent la fonction de directeur artistique. Beatrice Lennie, Vera Weatherbie et Margaret Williams occupent le poste d'adjointe au directeur artistique. Si le collège a vu le jour grâce à l'appui généreux de mécènes, il dépend des frais de scolarité pour sa survie. Au début, le taux d'inscription aux cours du jour et du soir, ainsi qu'aux cours du samedi destinés aux enfants, est fort encourageant. Cependant à la fin de la première année, les problèmes financiers étaient devenus insurmontables. Le British Columbia College of Art ferme ses portes en 1935.

Varley fait un croquis de son collègue et ami Harry Täuber (v. 1930; fig. 39). Originaire d'Autriche, Täuber (1900–1975) est un peintre féru de théâtre. Ce partisan de l'intégration des arts

visuels et de la scène trouve en Varley quelqu'un qui partage sa passion pour la musique et le théâtre. Täuber est un fervent admirateur du peintre d'origine russe Wassily Kandinsky (1866–1944). Il considère son œuvre comme une façon inédite d'envisager la valeur fondamentale de l'art. Varley et Macdonald s'intéressent également à l'art abstrait. À son retour de Londres, Vera Weatherbie emprunte elle aussi cette voie. Ses compositions se distinguent par leurs surfaces fragmentées et leurs colonnes de lumière diffuse aux teintes sourdes.

Varley réagit en épurant ses paysages comme en témoigne son tableau intitulé *Touffes d'arbres* (v. 1935; MBAC). Il privilégie une représentation austère et géométrique de la nature. Le purisme de Varley rejoint la quête d'un vocabulaire universel s'exprimant à travers les formes géométriques entreprise par le peintre français Amédée Ozenfant (1886–1966). Son ouvrage *La peinture moderne* (1925), écrit en collaboration avec Le Corbusier, est très populaire parmi les artistes de Vancouver dans les années 1930. Varley repense également son approche du portrait, y compris l'intégration de la figure dans l'espace[268]. Varley décrit *Complémentaires* (1933; pl. 38) comme « [...] un problème de lumière [...] Je n'ai jamais touché à une toile sans savoir à travers quel écran de couleur [je] regardais[269]. » Influencé par la théorie de Wilhelm Ostwald, il explore les « vibrations scientifiques de la couleur »[270].

Varley consacre près de six mois à la réalisation du tableau. « Dans un premier temps, j'ai utilisé le système de couleurs Munsell – ses cinq couleurs primaires. Mais ce n'était pas suffisant [...] c'était vide de sens, mais il y avait des couleurs – et je me disais, maintenant ces couleurs, mais plus claires – alors j'ai déchiffré le système Munsell de vibrations de la couleur, qui ne se présente pas sous la forme d'un cercle. Certaines couleurs vibrent beaucoup plus que d'autres[271]. » Les figures représentées dans *Complémentaires* sont celle de l'être terrestre, matériel et celle de l'être esthétique, non-matériel. L'être matériel au premier plan est peint dans des teintes de brun, tandis que l'être esthétique est peint dans des teintes de rose clair et d'ivoire, qui symbolisent le spirituel et l'éphémère. Varley recourt à un changement chromatique marqué plutôt qu'à un contraste de

valeurs pour atténuer la distinction entre le corps et le vide. La surface est répartie en formes géométriques, triangulaires ou arrondies, qui peuvent également être interprétées comme des colonnes de lumière diffuse. Bien que les seuls traits identifiables se résument aux yeux, au nez et à la bouche, il ne fait aucun doute qu'il s'agit de Vera Weatherbie.

À la fin de l'été 1934, Varley loue une maison à Lynn Valley et réintègre la nature à ses portraits. Dans un de ses portraits, il représente Vera (v. 1935; pl. 41) se découpant contre un panorama majestueux de la Colombie-Britannique. Le tableau se compare à *La fenêtre ouverte* (1932; Hart House), où Varley équilibre la même sphère chromatique avec la sérénité et la simplicité d'un paysage chinois.

Parmi les nombreux portraits de ses modèles et étudiants à la VSDAA, Varley a exécuté celui de Marie (1934; fig. 40). En 1937, alors qu'il se trouve à Ottawa, il fait le portait de Philip Surrey (fig. 41), un étudiant avec lequel il s'était lié d'amitié à Vancouver, et celui de sa mère Kate Alice Surrey (pl. 44).

Durant cette période, Varley puise également au répertoire du classicisme. Le sourire énigmatique du sujet de *Tête d'une jeune fille* (v.1936; fig. 42) n'est pas sans rappeler celui de la Joconde. Varley reprendra le motif dans son portrait intitulé *Kathy riant* (1952–1953; pl. 56). Varley lui-même avait donné au portrait le plus accompli de Vera, *Tête de jeune fille* (pl. 39), le nom de « tête florentine[272] ». On a fait remarquer à juste titre que Vera Weatherbie incarnait la femme idéale pour Varley, tout comme Dorelia McNeil pour Augustus John ou Elizabeth Siddal pour Dante Gabriel Rossetti.

Il est intéressant de comparer les portraits photographiques aux portraits peints de l'époque. Les photographies d'art des années 1930 trahissent une influence romantique par l'exotisme de leurs sujets et le caractère idyllique de leurs décors. À la fin de la décennie, la représentation de la femme comme figure allégorique ou tentatrice soumise mise en scène dans des paysages vaporeux est très populaire. Des photographes aussi célèbres que Mortimer-Lamb et Vanderpant cèdent au désir nostalgique de l'exotisme.

Chez Varley, la quête de l'idéal féminin a une réelle dimension psychologique. Enfant, il est témoin du mariage malheureux de ses parents. Selon sa sœur Ethel, leurs parents ne se s'étaient « jamais témoigné d'affection ». Alors que Fred ressentait le sentiment de frustration de sa mère, Ethel, plus proche de son père, le sentait « démoralisé »[273]. Profondément sensible aux femmes et à leurs besoins, Varley témoigne encouragement et soutien à Erica Leach, Reva Brooks et Kathleen McKay. Dans ses relations amoureuses, Varley aspire à la capitulation mutuelle qui faisait défaut à l'union de ses parents. Selon Miriam Kennedy, il « voulait engloutir une personne, l'aspirer, faire en sorte qu'elle fasse corps et âme avec lui[274]. »

Vera Weatherbie, la femme, lui témoigne un amour inconditionnel et elle croit en son potentiel de création. Vera Weatherbie, le modèle et l'artiste, se fait le reflet des émotions et des visées artistiques de Varley. Elle n'hésite jamais à lui faire part de ses opinions. De plus, Vera et Varley privilégient une démarche interdépendante. Une anecdote veut que Vera, ayant assisté en silence aux efforts de Varley pour achever *Dhârâna*, décide d'enlever la peinture à l'aide d'un racloir. Selon Bea Lennie, une camarade de classe, la réaction première de Varley en est une de stupéfaction, mais il finira par avouer que « c'était exactement ce qu'il lui fallait[275] ».

Après son départ de Vancouver en 1936, Varley écrit à Vera : « Je me suis habitué à nos échanges de critiques et de suggestions aboutissant à la production commune d'un tableau[276] ». En 1942, Vera épouse Harold Mortimer-Lamb. Malgré les potins dont ils font l'obet, ils vécurent heureux jusqu'à la mort de Mortimer-Lamb en 1970[277]. Dans les lettres qu'il échange avec Vera après avoir quitter Vancouver, et même après le mariage de cette dernière, Varley continue de se confier à elle et de lui exprimer sa reconnaissance pour l'influence qu'elle a exercée sur sa vie et son art[278].

Ottawa et Montréal, 1936 à 1944

En avril 1936, Varley se rend à Ottawa pour assister à l'inauguration de la *Retrospective Exhibition of Paintings by Members of the Group of Seven, 1919–1933* organisée par le Musée des beaux-arts du Canada. Varley y est principalement représenté par des œuvres

réalisées durant les années 1920 alors qu'il se trouvait toujours en Ontario. La sélection compte dix-huit portraits, témoignage éloquent de sa maîtrise du genre. Varley avait une autre raison de se rendre à Ottawa : Eric Brown, le directeur du Musée des beaux-arts du Canada, lui avait confié la commande du portrait de Harry S. Southam (1875–1954), le président du conseil d'administration du musée. Dès le départ, Varley peste contre les nombreuses restrictions qui lui sont imposées, notamment d'avoir à soumettre son portrait à l'approbation du conseil d'administration. De plus, il ne fait rien pour cacher son antipathie pour Southam. Dans ses lettres, il décrit les problèmes que lui pose la commande, soulignant toutefois qu'il est agréablement surpris de pouvoir faire bon usage de « la large gamme de vibrations de couleur ». Préoccupé par le rapport couleur-lumière, Varley peint Southam dans un champ de « couleurs prismatiques[279] ».

En juin 1936, Varley travaille toujours dans l'atelier que lui avait procuré le Musée des beaux-arts du Canada pour la réalisation du portrait de Southam. Sans le sou, il entreprend le plus grand et le plus ambitieux de ses tableaux, la première version de *Libération* (1936; AGO). Fermement convaincu qu'il s'agit d'un chef-d'œuvre qui établira sa réputation en Angleterre, il écrit : « Personne ne voit la peinture. On ne voit qu'un personnage de plus de deux mètres émergeant d'étranges lumières colorées, une évanescence qui dans un moment deviendra matière solide – fusion de métaux et de bijoux. J'ai peine à croire que je possède quelque chose qui me sera impossible à perdre ou à défigurer[280].» *Libération* témoigne de l'habileté de Varley à intégrer couleurs prismatiques et colonnes de lumière. À sa grande déception, le tableau est refusé par le jury de la Royal Academy en 1937. Incapable de payer la réexpédition de l'œuvre au Canada, Varley la fait entreposer à Londres, où elle reste dans l'oubli jusqu'en 1975.

Entre le mois d'avril et la fin juin 1936, Varley peint le portrait de Margot McCurry, la fille de neuf ans d'Harry McCurry, l'adjoint du directeur du Musée des beaux-arts du Canada, Eric Brown. (McCurry allait succéder à Eric Brown en 1939.) Les règlements du Musée empêchent Varley de travailler après 17 heures et le forcent même à arrêter de fumer. En juillet 1936, Eric Brown finit par lui demander de quitter l'atelier. Varley retourne à Vancouver dans

l'espoir de retrouver le bonheur tranquille de Lynn Valley et de renouer avec Vera, mais ils se brouillent. Au mois de septembre, elle quitte Vancouver pour l'Extrême-Orient et Varley est de retour à Ottawa dès le mois d'octobre.

L'été 1937 le voit de retour à Vancouver. Son épouse Maud, dont il est séparé, occupait la maison de Lynn Valley depuis l'automne précédent. Pendant son absence, elle avait hérité de sa mère et avait acheté la maison dans l'espoir de se réconcilier avec Fred[281]. Mais cela ne devait pas être. John Vanderpant présente une exposition de ses propres photographies et d'œuvres récentes de Varley. Contre toute attente, Varley vend quarante tableaux. C'est cependant la seule note positive au tableau. Le projet qu'avait Varley de s'établir de nouveau à Vancouver est voué à l'échec. Sa maison de Lynn Valley appartient maintenant à Maud, sa relation avec Vera est terminée et il n'a aucune source de revenus. C'est à ce moment de sa vie qu'il peint son deuxième autoportrait, *Miroir de la pensée* (1937; pl. 43).

Le dernier séjour de Varley en Colombie-Britannique se présente comme de longs et pénibles adieux à des endroits et des gens qu'il a aimés. Si son avenir dans l'Est du pays est incertain, il offre néanmoins la possibilité de nouvelles commandes, de la découverte d'un nouveau milieu et d'expositions qui contribueraient à sa renommée. En effet, trois de ses portraits allaient être présentés dans le cadre de l'exposition *A Century of Canadian Painting* de la Tate Gallery à Londres en 1938.

Dès qu'il pose son regard sur les scènes arctiques d'A.Y. Jackson et de Lawren Harris figurant dans l'exposition de 1931 du Groupe des Sept tenue à la Vancouver Art Gallery, Varley rêve de visiter le Grand Nord. Le 4 juillet 1938, il reçoit une lettre du sous-ministre des Mines et des Ressources, Charles Camsell, l'avisant qu'une place lui a été réservée à bord du *Nascopie* qui, dans cinq jours, entreprendrait un voyage de plus de 193 000 kilomètres vers l'Arctique orientale. Durant ses trois mois à bord du navire, Varley travaille fièvreusement, produisant de nombreuses esquisses et aquarelles du paysage aride et des communautés inuites. Son *Étude arctique* (1938; fig. 43) témoigne de son profond intérêt pour la physionomie du peuple inuit. Il garde un souvenir indélébile de son séjour dans les régions arctiques et ses œuvres en porteront

l'empreinte pendant de nombreuses années. Dans son portrait de Miriam Kennedy, *Musique océane* (v. 1939–1940; collection particulière), la toile de fond évoque à la fois sa passion pour l'Arctique et sa nostalgie de la Colombie-Britannique.

En 1939, de retour à Ottawa, Varley se voit confier la commande du portrait d'Alan Butterworth Plaunt (1904–1941; pl. 45), pionnier de la radiodiffusion publique au Canada. Originaire de la vallée de l'Outaouais, Plaunt obtient un diplôme du University College, à Toronto, en 1927 et du Christ Church College, à Oxford, en 1929. Il rentre au pays avec une nouvelle vision de l'avenir du Canada et une appréciation renouvelée de son immensité. Il s'associe à Graham Spry et fonde la Canadian Radio League. De 1932 à 1934, Plaunt et Spry publient le *Farmers' Sun*, un journal hebdomadaire qui pose un regard avisé sur les problèmes liés à la vie en milieu rural. En 1936, Plaunt est nommé au premier Conseil des gouverneurs de la Société Radio-Canada. Il manifeste un intérêt marqué pour les arts, notamment l'écriture et la peinture. Varley nous propose un portrait fidèle de Plaunt, qui laisse entrevoir son dynamisme et sa bienveillance. Selon l'honorable Brooke Claxton, Plaunt « avait une grande force de caractère et beaucoup de cœur[282]. » Plaunt s'est éteint prématurément en 1941, à l'âge de trente-sept ans, à la suite d'une maladie.

L'attrait des femmes

À l'été 1940, le lieutenant-colonel C.J. Duncan et son épouse, Rae, invitent Varley, qui souffre de dépression, à passer quelque temps dans leur chalet de la baie de Quinte, non loin de la base aérienne de Trenton, en Ontario. Le chalet est un véritable lieu de rencontre. Ulric Mignon, vieil ami et ancien modèle de Varley de la période de Vancouver, suit un cours à la base de Trenton. Mignon et son épouse Erica habitent chez les Duncan pendant quelques jours avant de s'installer dans leur logement. Les souvenirs que conservent Erica de leur arrivée au chalet des Duncan et de leur première rencontre avec l'artiste sont consignés dans la section consacrée aux « Témoignages des amis de Varley ».

Erica Leach est née à Kelowna, en Colombie-Britannique, en 1917. Au moment de sa rencontre avec Varley, elle est âgée de vingt-trois ans et vit un mariage malheureux depuis cinq ans. Pour la citer, elle « se sent de glace ». Cette jeune femme ravissante et pleine de vie est en fait très réservée et manque d'assurance. Elle ne se souvient pas s'être confiée à Varley, mais avait l'impression qu'il pouvait lire en elle. Durant une de leurs interminables conversations au bout du quai, il lui parle d'un « sentiment d'émerveillement » qui, pour elle, est une véritable révélation. Varley exécute deux portraits d'Erica alors qu'ils sont seuls au chalet. Malgré sa ressemblance avec le modèle, la première étude au fusain et à la craie, *Erica* (1940; fig. 44), ne rend pas son essence et Varley se déclare insatisfait.

Dans le cas de la seconde, *Étude de tête* (1940; fig. 45), Varley demande à Erica de lui prêter son tube de rouge à lèvres afin de reproduire la couleur de ses lèvres. Cette fois, il réussit à rendre l'essence du modèle et les deux facettes de sa personnalité. D'une part, elle a soif de vivre; de l'autre, elle est incertaine et inquiète. Cette dualité se reflète dans l'ombre et la lumière de son visage. Le côté droit est plus net et l'œil plus perçant, plus inquisiteur; le côté gauche est imprécis et l'œil plus flou. Varley propose une image qui s'impose à la conscience. Erica affirme : « J'ai toujours aimé [cette image] parce qu'il a su rendre la vérité et parce qu'elle lui plaisait. Il semble que ce soit celle qui l'a influencé lorsqu'il a réalisé le portrait à l'huile quelques années plus tard. Tout s'est déroulé de façon très naturelle. Je n'y ai pas prêté attention, j'étais si triste et si renfermée[283]. » Le mari d'Erica lui a offert les dessins, qui sont toujours en sa possession.

L'attribution de la date du troisième portrait d'Erica (1942; pl. 48) comporte sa part d'anecdote. À la fin des années 1960, alors qu'il dresse l'inventaire des œuvres de son père, Peter Varley réussit à déterminer qu'Erica est effectivement le modèle du portrait. Elle accepte de lui accorder une entrevue. Des renseignements qu'elle lui fournit au sujet d'un séjour à Montréal en novembre 1942, lui permettent de dater le portrait. Lors de son séjour à Montréal, Erica a visité Varley à plusieurs reprises à l'Hôpital St-Luc. Victime d'une mauvaise chute sur le trottoir verglacé, Varley avait subi une fracture du crâne. Erica se

souvient avoir reçu une lettre de Varley au printemps 1943 dans laquelle il décrit son portrait au visage divisé par « un rayon de lune ». Du point de vue stylistique, cette image d'Erica se rapproche davantage de ses portraits de Manya exécutés vers 1940 et de sa *Femme en vert* (v. 1939–1940). Ici, l'arrière-plan est une juxtaposition d'une vaste gamme de couleurs. À la manière de la seconde étude de 1940, un côté du visage d'Erica est baigné de lumière, tandis que l'autre est obscurci et ses yeux sont cernés d'ombres. Empruntant au répertoire du portrait hollandais du dix-septième siècle, Varley recourt au clair-obscur pour lui donner un air songeur.

De retour à Ottawa, Varley est introduit dans le cercle du Naval Art Service par son ami Tom Wood[284]. Ravis d'avoir Varley parmi eux, les jeunes artistes l'invitent à partager leur atelier et leur matériel. Il y exécute plusieurs commandes de portraits. Leonard Brooks fréquente lui aussi l'atelier communément appelé Contempo. Varley lui rend souvent visite dans son meublé où ils entreprennent d'interminables discussions sur l'art. Alors que Brooks joue du violon, Varley l'accompagne en silence sur une table devenue piano pour l'occasion[285]. À un moment donné, Varley lui demande la permission d'occuper la chambre d'amis de la résidence des Brooks à Toronto, au 39 Boswell Avenue.

Au départ, l'épouse de Leonard, Reva Brooks (née Silverman; 1913–2004), demeure plutôt hésitante. Avec le temps, elle se lie d'amitié avec Varley. Ils amorcent de longues conversations et parfois Varley joue du piano. Née de parents immigrants juifs polonais, Reva est une femme attrayante et cultivée qui aime la musique, l'art et la littérature. Selon Reva, Varley cherche à la convaincre de donner libre cours à sa nature artistique et à consacrer plus de temps aux choses essentielles à sa croissance, plutôt que de se complaire dans son rôle d'épouse. Ce qui n'est pas pour plaire à Reva : « Cela me mettait en colère, j'avais mes propres idées[286]. » En 1947, Leonard et Reva Brooks s'installent au Mexique. Et c'est là, à l'âge de trente-quatre ans, que Reva décide de s'adonner à la photographie. Du jour au lendemain, elle s'impose comme photographe de renommée internationale.

Durant son séjour de plusieurs mois chez les Brooks, Varley exécute une délicate esquisse au fusain sur papier brun intitulée *Reva Brooks* (v. 1940; collection particulière), colorant ses joues et son écharpe avec son rouge à lèvres. Il représente Reva dans un moment d'écoute – le récit de la vie de l'artiste peut-être. Elle est penchée en avant, le menton sur la main, le regard sombre et expressif. Varley réussit à rendre le naturel, l'essence du modèle[287]. Il y parvient également dans ses portraits de Nancy Cameron (v. 1940; pl. 46) et de Catherine (1943; fig. 46).

Si la Seconde Guerre mondiale lui ferme certaines portes (la charge de cours à l'Ottawa Art Association, par exemple), elle lui en ouvre de nouvelles. En 1942, Varley, âgé de soixante-et-un ans, communique avec Vincent Massey et lord Beaverbrook dans l'espoir d'obtenir des commandes de tableaux de guerre. Le Comité des artistes de guerre ne retient pas officiellement sa candidature. Cependant, il lui confie la commande de trois portraits de soldats en garnison à Kingston. À la même époque, lors d'une soirée chez les Duncan, Varley rencontre un bienfaiteur dont la largesse lui permet de retourner peindre à Montréal pour une période de six mois, à l'abri des soucis matériels. Il renoue connaissance avec Philip Surrey (fig. 41), récemment installé à Montréal, et avec ses collègues Fritz Brandtner, Louis Muhlstock et Goodridge Roberts.

À Montréal, Varley rencontre Miriam Kennedy, une jeune femme libre d'esprit qui avait été mariée au poète Leo Kennedy. L'amour de la musique compte parmi les nombreuses choses qu'ils ont en commun. Miriam se souvient que durant une de leurs discussions sur la musique, Fred s'est mis à peindre. *Musique océane* est le résultat de cette inspiration soudaine[288]. Manya, ou la Dame d'Éthiopie comme il se plaît à l'appeler, lui inspire des portraits très sensuels et très érotiques. *Manya, Portrait de Myriam Kennedy* (v. 1942; pl. 49) est lui aussi le résultat d'une inspiration spontanée. Miriam se rappelle être entrée dans l'atelier un jour de grande chaleur, les cheveux décoiffés et humides, et Varley lui demandant de ne pas bouger le temps qu'il dessine sa tête[289]. Varley a réussi un portrait aussi puissant et évocateur que ceux des années 1920.

Malgré son aversion pour l'art commercial, Varley est obligé d'accepter quelques contrats pour se maintenir à flot à Montréal. Selon Miriam Kennedy, « il n'avait pas trop de mal à

obtenir du travail, mais le cœur n'y était pas[290]. » En 1940–1941, il réalise trente-et-une illustrations pour l'ouvrage de Stephen Leacock intitulé *Canada: The Foundations of Its Future*. Le sujet de l'immigration le touche particulièrement, à témoin l'aquarelle *Bateau d'immigrants*, (1941; pl. 47), exécutée dans le cadre de ce projet.

Natalie Kessab, ou Natasha comme la surnomme Varley, est probablement la femme la plus mystérieuse à entrer dans la vie de l'artiste. D'origine libanaise ou arménienne, elle se distingue par l'exotisme de ses traits. Propriétaire d'une boutique de lingerie prospère rue Sherbrooke ouest à Montréal, elle est financièrement indépendante et récemment divorcée. Natalie est bien disposée envers Varley et lui apporte son soutien. Nous connaissons peu de choses sur sa vie, sauf qu'elle a quitté Montréal pour New York, où elle a épousé un riche négociant grec[291]. *Natalie* (v. 1943; pl. 50), le seul portrait qui nous est connu, la présente à la manière d'une femme fatale.

Toronto, 1945 à 1950

Après la Seconde Guerre mondiale, les structures à l'intérieur desquelles la plupart des portraitistes étaient habitués à travailler ont été modifiées ou ont cessé d'exister. La subvention des arts, par le biais du Conseil des Arts du Canada et de la Société des musées nationaux, ouvre aux artistes de nouvelles voies qui ne sont pas toujours compatibles avec les voies traditionnelles. L'art abstrait s'impose au détriment du portrait. Les femmes de classe moyenne que la guerre avait contraintes à intégrer le marché du travail retournent à leurs foyers. La tendance de la fonction publique à privilégier les hommes fait obstacle à la reconnaissance des femmes artistes. En effet, ce n'est que très récemment que l'histoire de l'art canadien a entrepris de mesurer la contribution de certaines des artistes les plus accomplies de l'époque.

En 1944, l'inauguration d'une exposition que lui consacre la Fine Art Gallery chez Eaton incite Varley à retourner à Toronto. Il est représenté par une remarquable sélection d'œuvres récentes, dont *Dr. T.*, un portrait pénétrant du psychiatre D. Thompson.

La fréquentation de cette exposition d'une durée de deux semaines est fort encourageante et donne une nouvelle impulsion à son travail. Il se voit également offrir une exposition à la Hart House. Varley exposera de nouveau à la Fine Art Gallery au printemps 1950.

Le fait que Varley choisisse d'exécuter son *Autoportrait, jours de* 1943 (pl. 51) en 1945 est révélateur. Il avait réalisé son premier autoportrait en 1919, une sorte de constat de son état à la fin de la Première Guerre mondiale. À la fin du second conflit mondial, il sent à nouveau le besoin de documenter son état. Les deux portraits sont exécutés dans la palette terreuse de ses tableaux de guerre. La meurtrissure sous l'œil droit peut s'expliquer par la fracture du crâne qu'il a subie à Montréal en 1942. Charles S. Band est allé voir Varley dans son atelier alors qu'il travaillait à cet autoportrait. Contemporain de l'artiste ayant vécu les mêmes événements, les souvenirs de Band, qui sont particulièrement pertinents, apparaissent dans la section consacrée aux « Témoignages des amis de Varley ». Band a rassemblé une importante collection des portraits de Varley, y compris le sien. Au début des années 1950, Varley obtient plusieurs commandes de portraits, dont celles des collectionneurs d'art Samuel Weir (fig. 47) et Frances E. Barwick (fig. 48).

Jess Crosby

Jess Crosby, la voisine de Varley rue Grenville où il louait un atelier, serait sa compagne et sa muse de 1946 à 1951. Originaire du Yorkshire, Jess partage avec Varley un amour des arts, de la musique, des livres et de la nature. Elle s'intéresse à la sculpture et aspire à devenir peintre. On a récemment découvert que Jess a exécuté un buste de Varley qu'elle aurait par la suite détruit[292]. Varley offre ce compte rendu de la création de *Jess* (v. 1948; fig. 49) : « Je reviens sans cesse au dessin que j'ai fait dimanche. Il est séduisant, intrigant plutôt. Je n'ai jamais rien fait de tel. Et lorsque je pense à toi, assise, me regardant à travers les mèches de tes cheveux – combien plus belle qu'une Joconde aux lèvres pincées – il me tarde de faire des centaines de dessins et de portraits[293]. »

Pendant deux étés, Varley enseigne à la Doon School of Fine Arts, non loin de Kitchener, en Ontario. Varley et Jess échangent des lettres et se voient régulièrement les week-ends. *Jess* (v. 1947–1952; pl. 52) a été réalisé lors d'un de ces week-ends. Cette délicate étude au crayon et à l'aquarelle se veut un témoignage éloquent de l'affection de Varley pour sa compagne. Acquis par Douglas Duncan, le portrait est demeuré dans la collection de sa sœur Frances Barwick jusqu'à ce qu'il soit légué à l'Université Queen's. Même dans son vieil âge, Jess se souvient parfaitement du moment où elle est entrée dans l'atelier de Varley, un capuchon la protégeant de la pluie[294]. Dans cette étude pénétrante, les ombres projetées par une source de lumière latérale accentuent le volume de son visage et de son cou.

Deux portraits à l'huile de Jess Crosby, réalisés la même année, proposent une intéressante étude de contrastes. *Jess* (1950; pl. 53) est un portrait tendre et ravissant, sans aucun doute une des œuvres les plus accomplies de cette période. Cette image, empreinte de sérénité, témoigne de l'élégance de la facture de Varley, particulièrement dans le modelé du visage et du châle. *Jess*

(1950; pl. 54) se distingue par sa spontanéité. L'artiste a croqué Jess sur le vif, assise devant une fenêtre ouverte, peut-être dans son chalet de Belfountain.

La scène artistique à Toronto à la fin des années 1940, début 1950 revit dans les écrits de l'artiste torontois John Gould, qui connaissait Varley et appréciait son travail. Des années durant, Gould a tenu un journal (récemment publié chez Moonstone Books) dans lequel il nous rappelle que le Toronto des années 1950 ne ressemble en rien à la métropole que nous connaissons. C'est une ville de taille moyenne aux pittoresques édifices victoriens. Un des points de repère de l'époque est Malloney's, un bar rue Grenville à quelques pas de l'atelier de Varley qui, à l'exemple d'autres artistes et écrivains, le fréquente assidûment. Gould décrit Malloney's comme « un grand ensemble de salles, mi-galerie, mi-salle de réception, mi-bar[295]. » Angelo's Tavern, le Fifth Avenue et la Pilot Tavern comptent également parmi les bars fréquentés par les artistes. De retour à Toronto, le très sociable Varley semble avoir trouvé la camaraderie et la stimulation intellectuelle essentielles à son processus de création.

LES ANNÉES DE MATURITÉ, 1951–1969

*J'aspire seulement à sortir de mon être, à élucider mon être
afin de gagner un peu de terrain.*

— Fred Varley

Vers 1951 ou 1952, Varley rencontre Kathleen Gormley McKay (1900–1996) qui allait exercer une profonde influence sur les dernières années de sa vie. À l'époque, Kathleen (fig. 50) a cinquante-deux ans, un mari, et elle cherche une façon tangible d'exprimer sa passion pour les arts. Kathleen est née à Markham, en banlieue de Toronto. Sa mère, Sarah Milne, est issue d'une riche famille d'agriculteurs de la lignée des Eckhards, une des soixante-huit familles fondatrices de Markham ou « les colons de Berczy[296] ». Diplômée du Conservatoire royal de musique de Toronto, Kathleen fait partie de la chorale d'Healey Willan. Elle épouse Donald McKay, chimiste en alimentation chez Crosse and Blackwell, et déménage aux États-Unis. Dans la cinquantaine, Donald McKay apprend qu'il souffre de la sclérose en plaques et qu'il est condamné à se déplacer en fauteuil roulant. Contrainte de prendre une retraite anticipée, il rentre au Canada avec sa famille. Ils s'installent avenue Lowther à Toronto.

Il existe plusieurs versions de la première rencontre entre Kathleen McKay et Fred Varley. On pense généralement que Kathleen ayant entendu parler du talent de portraitiste de Varley,

décide de lui demander de faire le portrait de son mari[297]. À son arrivée à l'atelier, trouvant la porte ouverte, elle s'apprête à entrer lorsque Varley lui lance d'une voix de stentor « Ne bougez plus! » Il se saisit d'un crayon et d'une feuille de papier et la croque sur le pas de la porte. L'esquisse, *Entrée de l'atelier* (v. 1952–1953), est transposée en un portrait à l'huile intitulé *Porte d'atelier* (v. 1952–1953; pl. 57)[298]. Pour sa part, Kathleen McKay affirme avoir rencontré Varley par hasard à la Roberts Gallery rue Bloor[299]. Or nous savons qu'à l'époque Varley ne connaissait pas Sidney Wildridge, le propriétaire de la galerie. Ses premières transactions avec la galerie n'ont lieu qu'en 1953–1954. Jeannie Wildridge, la bru de Sidney, ne se rappelle pas y avoir vu Mme McKay. Les dossiers de la galerie permettent d'affirmer que Kathleen McKay a commencé à fréquenter la galerie en 1954[300]. Selon des amis, avec l'âge Kathleen devient hésitante à accorder des entrevues. Une autre anecdote veut que ce soit un ami qui l'ait incitée à écrire à Varley pour lui offrir son aide[301]. Selon l'histoire la plus convaincante et celle étayée par des documents d'archives, Kathleen et Donald McKay, qui possédaient déjà une œuvre de Varley, manifestent le désir d'acheter une autre toile. Ils

aspirent à réunir une modeste collection et à l'offrir à l'Art Gallery of Toronto[302].

Indépendamment des circonstances de leur rencontre, dès le départ Kathleen McKay témoigne une grande confiance en Varley et manifeste le désir de devenir sa muse et sa collaboratrice. Dans une lettre de décembre 1955, elle écrit : « Est-ce que je peux vous dire que je crois en vous et en la grandeur de vos peintures[303]? » À l'hiver 1952–1953, les McKay proposent à Varley, qui est malade, de s'installer dans leur chambre d'amis. C'est à cette époque qu'il exécute un dessin de Kathleen, qu'elle allait conserver jusqu'à la fin de sa vie (fig. 51). La rencontre de Kathleen et son déménagement chez les McKay mettent fin à sa liaison avec Jess Crosby.

Passion et enthousiasme étaient innés chez Fred Varley. À l'instar des nombreuses amies et maîtresses de Varley, Kathleen découvre que le simple fait d'écouter de la musique ou de parler d'art avec lui est une « expérience merveilleuse[304] ». Selon certains observateurs, Varley a exécuté son dessin à la mine de plomb et à la craie *Kathy* (v. 1954; pl. 58) d'après le dessin à la pointe d'argent de Léonard de Vinci intitulé *Profil d'une dame* (v. 1485–1490; Royal Collection, Windsor). Il en aurait fait l'éloge lorsqu'il a été reproduit dans l'ouvrage de Martin Johnson *Art and Scientific Thought* (1949)[305].

Au début des années 1950, Varley fait la connaissance de Sidney L. Wildridge, qui s'était porté acquéreur de la Roberts Gallery en 1948. Originaire du Yorkshire, Wildridge est spécialiste de l'art européen. Il accepte cependant de représenter Varley en raison de ses racines et de sa formation britanniques et non pas de sa célébrité en tant que membre du Groupe des Sept[306]. Jusqu'alors, Varley avait exposé à la Picture Loan Society de Douglas Duncan, mais aucune entente n'avait été conclue entre les deux hommes et l'artiste quitte Duncan sans regret. Basée sur la confiance et la loyauté, la relation de Varley avec son nouveau représentant se transforme en une solide amitié qui en est venue à inclure le fils de Sidney, L.J. (Jack) Wildridge. En février 1957, Varley avoue à George Hulme, administrateur du Musée des beaux-arts du Canada : « J'ai la chance de l'avoir comme ami et je m'en remets entièrement à lui[307]. »

C'est par l'intermédiaire de la Roberts Gallery que Varley se lie d'amitié avec Cooper Campbell, un manufacturier et collectionneur d'art, qui lui commande les portraits de ses filles, Robin et Lexie. En mai 1955, Campbell le conduit au Cap-Breton, chez John Goldie, un médecin de Whycocomagh (fig. 52). Varley a mis du temps à accepter l'invitation de Goldie, lancée en 1954, mais lorsqu'il arrive enfin au Cap-Breton, il y passe l'été. Il entreprend le portrait de Goldie avec « le calme et l'insouciance[308] » qui lui sont naturels. Le paysage du Cap-Breton n'exerce pas sur lui le même charme que sa Colombie-Britannique bien-aimée. Les œuvres exécutées durant son séjour sont mornes et faibles. Cela dit, son portrait de John Goldie témoigne qu'il n'a rien perdu de sa perspicacité. Selon Goldie, Varley a vu au delà de « mon habituelle bonhomie et a représenté l'homme que je pensais être le seul à connaître[309]. »

À Toronto, Sidney Wildridge tente d'obtenir des commandes pour Varley. Un de ses clients, Lawrence T. Porter, accepte de lui confier le portrait de son fils, Tupper. En décembre 1955, Varley se rend à Saint-André-Est, au Québec, pour exécuter la commande. Ingénieur diplômé de Princeton, Lawrence T. Porter (1899–1960) œuvre dans les secteurs des mines et de la navigation. Il compte parmi les rares amateurs d'art moderne à collectionner les œuvres d'artistes canadiens des années 1940, dont celles de Lawren Harris, Emily Carr... et Fred Varley. L'artiste s'entend à merveille avec Porter. Il écrit régulièrement à Wildridge pour le tenir au courant de son travail et lui demander de lui envoyer du matériel ou de l'argent : « Je prends beaucoup de plaisir à discuter avec mon modèle [Tupper Porter] et à le peindre – 28 ans, mature, 1 m 90, 88 kilos lorsqu'il travaille comme géologue et prospecteur[310]. »

En 1954, l'Art Gallery of Toronto organise une importante rétrospective des œuvres de Varley. Inaugurée en octobre à Toronto, l'exposition *F.H. Varley, Paintings 1915–1954* est présentée à Montréal, Ottawa et Vancouver. Le catalogue qui l'accompagne comprend de courts textes d'Arthur Lismer, Charles Band, Jock Macdonald et Robert H. Hubbard. En janvier 1956, Fred Varley célèbre son soixante-quinzième anniversaire de naissance. Sa première exposition solo à la Roberts Gallery ouvre

en février. Si sa réputation comme artiste est assurée, Varley n'a pas l'intention de prendre sa retraite pour autant. La peinture est le moteur de son existence et le portrait demeure au centre de ses préoccupations. Avec les ans, son style perd de son audace. Il aborde néanmoins le portrait avec dynamisme et détermination.

Son portrait de Florence Deacon (1955; pl. 59) en est un témoignage éloquent. Varley avait probablement aperçu madame Deacon alors qu'elle faisait des courses dans le village d'Unionville, où il se rendait de temps en temps avec Kathleen McKay (fig. 53). (Les McKay avaient déménagé à Markham.) Il a dû faire part de son désir de peindre madame Deacon à Kathleen, qui a pris les dispositions nécessaires. Le dessin préliminaire ne le satisfait pas et il s'en débarasse, malgré les objections du modèle. Il décide de travailler à l'huile et demande à Florence de porter la robe rose corail dans laquelle il l'avait déjà vue[311].

Ce qui au départ devait être un dessin s'est transformé en un portrait à l'huile, nécessitant cinq ou six séances de pose. Selon madame Deacon, Varley travaillait vite et elle « ne voyait pas le temps passer ». Et il travaillait en silence, créant un atmosphère détendu. Florence Deacon se souvient qu'il avait peint une forêt en arrière-plan, mais se ravisant au dernier moment, il râcle la surface et la repeint en bleu. Elle était d'accord avec son choix de couleur. L'eau étant son élément, elle avait l'impression que le bleu rendait davantage son essence. Une fois le portrait achevé, Varley lui demande son avis. Plutôt que d'en faire l'éloge, elle lui demande timidement : « Est-ce que j'ai les épaules trops fortes, M. Varley? » Ce à quoi il répond sans façon : « C'est comme çà qu'elles m'apparaissent[312]. » Kathleen McKay obtient également la commande du portrait de Nancy Robinson (v. 1962; pl. 60), et peut-être de celui intitulé *Jeune fille* (v. 1964; fig. 54).

Avant de s'éteindre à l'âge de quatre-vingt-huit ans, Fred Varley connaîtra le succès retentissant de son exposition solo à la Roberts Gallery en février 1969. Presque toutes les œuvres ont été vendues, y compris les portraits *Dr. John Goldie* et *Les Dessinateurs*, et de nombreux paysages. Le vœu formulé en 1925 par Barker Fairley – que les dessins de Varley se vendent comme des petits pains – s'était enfin réalisé.

Frederick Horsman Varley meurt le 8 septembre 1969. Florence Deacon conserve un souvenir très net de la messe anniversaire célébrée à l'Église St. Anne, celle-là même que Varley et ses amis avaient aidé à décorer dans les années 1920. Barker Fairley prononce l'oraison funèbre, une main posée sur le cercueil, comme s'il s'adressait à son vieil ami.

Un visionnaire

Mes recherches sur la vie et l'art de F.H. Varley m'ont laissé de profondes impressions, dont deux prédominantes. La première, que Varley trouvait l'humanité exquise dans toutes ses variations. Une vie n'a pas suffi à en saisir les infinies possibilités dans ses portraits. La seconde, qu'il était avant toute chose un dessinateur et que ses peintures les plus accomplies sont celles qui se rapprochent le plus du dessin. La formation qu'il reçoit à Sheffield et à Anvers exerce une profonde influence sur son art – fusion du traditionnel et de l'éclectique. Ses dessins se distinguent par le brio et l'audace de leurs factures. Contrairement aux normes établies, Varley recourt rarement à des esquisses préparatoires, préférant travailler directement sur la toile. C'est au dessinateur éminemment talentueux que l'on doit les contours puissants et les formes nettes de ses peintures les plus achevées. Chez Varley, la composition – rapport entre l'ensemble et ses parties – est d'une importance primordiale.

Varley visait à exprimer la véritable nature de la couleur, à trouver lui-même la valeur et la nuance précises plutôt qu'à s'en remettre à des formules. À cet égard, son approche était moins structurée que celle des peintres académiques, qui superposaient la couleur à des dessins minutieux. Une fois qu'il avait défini les plus grandes plages de couleurs, il entreprenait de les harmoniser. Il n'envisageait jamais les couleurs séparément, mais plutôt comme un mélange harmonieux. En baignant ses portraits de couleurs et en trouvant un juste équilibre entre les teintes chaudes et froides, Varley a donné à ses œuvres une luminosité qui reste inégalée dans l'art du portrait au Canada.

Il préfère peindre dans son atelier, où l'éclairage et le cadre se prêtent davantage à son travail (fig. 55). Lorsqu'une commande exige qu'il se déplace, il tente d'accomplir le maximum en travaillant d'après modèle dans le cadre de trois ou quatre séances. Varley ne se limitait pas à rendre la ressemblance du modèle, il cherchait à exprimer son essence. Dans bien des cas, il décide de la tenue du modèle en fonction de son teint et peint l'arrière-plan d'une couleur complémentaire. Dans certains cas, le drapé de la toile de fond contribue à la subtilité des transitions chromatiques et à l'intégration figure-fond. En matière d'éclairage, il privilégie le clair-obscur. Il préfère les ombres plates qui servent de repoussoirs – une technique empruntée à la peinture académique.

Un grand nombre des portraits de Varley sont des œuvres de commande. Il a toujours accordé à ces œuvres la même importance qu'à ses autres tableaux. Si certains lui ont reproché de ne pas avoir fait preuve d'initiative à cet égard, je ne suis pas convaincue qu'il faille en rejeter l'entière responsabilité sur Varley. Il nous faut tenir compte de l'époque et de l'endroit. Les racines de l'art en général, et de la tradition du portrait en particulier, étaient peu profondes au Canada. Et l'indépendance farouche de Varley ne saurait être oubliée. Lui-même a affirmé qu'il ne pouvait pas « se permettre d'être emprisonné ou limité par la volonté des autres[313]. »

Il lui arrivait de se laisser décourager et de chercher de nouveaux sujets. Cette quête de nouveaux sujets était bénéfique en ce qu'elle favorisait une approche spontanée au portrait. Cependant, elle était désavantageuse en ce que la réaction viscérale de Varley à son modèle était le résultat d'une émotion intense et, partant, capricieuse et fugitive.

On a souvent dit que la vision des peintres tend à se généraliser avec l'âge. Chez Varley, cela se manifeste au début des années 1950, lorsque son dessin se fait plus large et plus pictural (fig. 56). Tout au long de sa carrière, il explore de nouvelles idées, techniques et méthodes sans jamais s'associer à aucun mouvement, y compris l'abstraction. À mon avis, ce n'est pas une question d'aptitude. La spontanéité et le dynamisme de sa facture ne se prêtaient tout simplement pas à l'organisation géométrique de l'art abstrait. Le tempérament artistique de Varley était celui de la génération de

portraitistes anglais incluant Augustus John et William Orpen. Les circonstances dans lesquelles il a vécues l'ont empêché de donner pleine mesure à son talent, inné et acquis, pour le portrait.

Visionnaire et profondément spirituel, Varley se souciait peu des usages et des pièges de la célébrité, préférant se consacrer à la quête de la beauté et à la réalisation de ses visées artistiques. Ses portraits constituent l'essentiel d'un remarquable corpus d'œuvres. Ils sont un témoignage éloquent du talent exceptionnel de F.H. Varley et de son respect profond pour l'humanité.

Varley et les critiques

En ce qui a trait à Fred Varley, les critiques ont rarement gardé le silence, mais il reste à déterminer si leurs reproches s'adressaient à l'artiste ou à l'homme. Réels ou prétendus, les faits de sa vie « scandaleuse » alimentaient souvent la presse. On peut se demander si les comptes rendus de ses œuvres n'étaient pas faussées par le jugement moral des critiques. Les points de vue étaient aussi nombreux que variés : réserves, éloges et dithyrambes. La documentation sur la réaction de Varley à ces critiques est lacunaire. Nous savons que dans certains cas l'accueil réservé à ses œuvres n'était pas celui qu'il espérait. On peut donc dire sans trop s'avancer qu'il a dû, à certains moments, avoir l'impression d'être reconnu à sa juste valeur. Nous avons jugé utile de vous présenter quelques critiques de l'époque.

Avant la tenue de l'exposition de Varley à la Fine Art Gallery chez Eaton en 1944, Ronald Hambleton déclare que l'opinion critique est scindée en deux camps : « Un camp affirme que Varley est le plus grand artiste du pays et l'autre qu'il a fait son temps. » Parallèlement, Hambleton reconnaît que Varley était « le plus méconnu des peintres connus du Canada[314]. » Dans sa critique de l'exposition chez Eaton, Pearl McCarthy affirme « Varley est plus grand maintenant qu'il ne l'était [lorsqu'il faisait partie du Groupe des Sept][315]. »

En 1949, Varley accepte que l'Office national du film (ONF) tourne un documentaire sur sa vie et sa carrière. Allan Wargon, le producteur, et Tom Daly, le réalisateur, relèvent le défi de

recréer l'atelier de la rue Grenville dans les studios de l'ONF à Ottawa. La première du documentaire a lieu en 1953. George Elliott nous offre ce commentaire d'une grande perspicacité : « Ici, en vingt minutes, nous est révélée la touchante tragédie d'un artiste-génie qui, abattu par le malaise du monde, parvient à se hisser aux sommets de la perfection créatrice par sa seule quête de la forme[316]. »

Les courts métrages de l'ONF consacrés à certains membres du Groupe des Sept, conjugués à la diffusion d'ouvrages à leur sujet et de lithographies de leurs œuvres emblématiques, éveillent l'intérêt du grand public. L'Art Gallery of Toronto organise une série de rétrospectives consacrées aux œuvres de Lawren Harris (1948), d'Arthur Lismer (1950), d'A.Y. Jackson (1953) et de Fred Varley (octobre 1954). Dans son compte rendu de l'exposition *F.H. Varley, Paintings 1915–1954*, George Swinton affirme : « au fil des ans Varley prendra de l'envergure en tant que gardien d'une tradition ancienne et importante[317]. »

En 1954–1955, la rétrospective de ses œuvres présentée à Ottawa, Montréal, Winnipeg et Vancouver est saluée par la critique. Dans le *Vancouver Sun*, Mildred Valley Thornton proclame Varley « l'artiste canadien le plus compétent et le plus polyvalent de son époque[318]. »

F.H. Varley atteint à la reconnaissance tant convoitée aux cours des dernières années de sa vie. En 1961, l'Université du Manitoba lui remet un doctorat honoraire. L'année suivante, il reçoit la Médaille du Conseil des Arts du Canada pour sa contribution exceptionnelle dans le domaine des arts.

Témoignages des amis de Varley

De nombreuses amitiés ont nourri Fred Varley durant sa vie. Certaines durables, d'autres brèves, mais toutes intenses, car telle était l'essence de Varley. Nous avons jugé utile de conclure en laissant la parole à ceux et celles qui l'ont connu.

Arthur Lismer sur les débuts de Varley (extrait d'Arthur Lismer, « Portrait of the Artist – An Artistic Reminiscence », *Montreal Gazette*, 8 janvier 1955) :

Il était étudiant à la Sheffield School of Art, une de ces nobles institutions fondées pour élever les normes du dessin dans les industries régionales. Les étudiants plus jeunes, dont j'étais, le connaissaient comme un dessinateur accompli. Je me souviens de ses dessins d'après nature exposés dans la classe. Je me souviens même de ma première impression de lui. Un homme aux cheveux cuivrés, mais alors là rouges, qui brûlaient comme une torche ignée sur le dessus d'une tête qui semblait avoir été taillée avec un couteau émoussé. Cette couleur était celle du feu qui dévorait son âme [...] C'était un être rebelle, tout sauf conformiste – aventureux d'esprit, changeant dans ses relations et toujours gentil avec ceux qui partageaient sa conception de la vie.

Repensant aux cinquante dernières années, on serait tenté de dire que c'est à cette époque que Varley, le personnage et l'artiste, s'est affirmé. Sa fébrilité, sa sensibilité et sa quête de quelque chose autre que le matérialisme de l'époque, autre que la forme extérieure – on les sentait déjà. L'influence et les événements de sa jeunesse lui avaient donné une perspective, une force et une vision poétique qui lui étaient propres. Depuis, nous avons tous été témoins de leur affirmation.

Erica Leach sur l'été de 1940 (en entrevue avec Karen Close, janvier 2006) :

Les Duncan avaient un ravissant chalet sur la baie de Quinte et Leo [surnom de Varley] était leur invité. Je me souviens que lorsque nous sommes arrivés, Ulric et moi, il faisait terriblement chaud. Ils tiraient à l'arc sur la pelouse au bord du lac. Nous avons décidé d'aller nous baigner et j'ai rapidement enfilé mon maillot – rose à jabot. Lorsque je suis sortie de l'eau, Leo s'est exclamé

« Oh! Vénus ». Cela peut sembler ridicule, mais j'étais très, très jeune et j'étais séduisante. La réaction de Leo était flatteuse, mais elle n'est pas venue à bout de ma gêne. Il lisait en moi comme j'étais incapable de le faire. Il pressentait mon besoin de m'épanouir. J'ai passé quatre ou cinq jours au chalet. Leo et moi nous nous promenions dans les champs. J'aimais les ormes et leurs formes inconnues dans la vallée de l'Okanagan. C'était la fin mai ou le début juin. Il faisait chaud. Il y avait des meules de foin. C'était plein de couleurs. Voir le monde à travers ses yeux fut une véritable révélation.

Je lui témoignais de l'affection, non pas parce qu'il était un artiste, mais parce qu'il était un être humain pour lequel j'éprouvais de la sympathie. Je ne saurais l'expliquer autrement. Je suppose que c'est ce qui se passe lorsqu'on se sent parfaitment à l'aise avec une autre personne. Je réagissais à sa générosité. Je suis sur la défensive lorsqu'on le qualifie de coureur de jupons. Un coureur de jupons c'est quelqu'un qui prend, qui profite. Et ce n'était pas Varley. Il donnait avec empressement par le biais de son talent. Peut-être est-ce difficile à comprendre. Voilà pourquoi on le voit sous ce jour.

L'artiste à Toronto dans les années 1950 (extrait de John Gould, *Journals*, Moonstone Books, 1996) :

Malloney's était le deuxième chez-soi du célèbre Fred Varley, dont l'atelier se trouvait à quelques pas. Varley, condamné par les critiques canadiens au stéréotype du Groupe des Sept, était perçu comme un des chefs de file de la peinture de paysage. Mais il était beaucoup plus. C'était le survivant héroïque d'un épuisement canadien précoce, un grand portraitiste – heureux mariage d'Augustus John, du mysticisme oriental et de l'expressionnisme allemand – une incarnation de la bohème, un gentleman amateur de velours côtelé, chemises foncées et cravates en drap tissé. Petit de taille, mais néanmoins fascinant : visage meurtri d'un ex-boxeur poids plume, pommettes saillantes, tignasse blanche, maigre et nerveux – septuagénaire se déplaçant avec l'agilité d'un gamin.

De nos interminables discussions chez Malloney's, je retiens sa leçon sur l'engagement : « *Il faut s'y investir corps et âme.* » Mon respect pour ses portraits dessinés est inconditionnel. La touche est légère et précise. Nous avons parfois l'impression que la lumière émane du modèle. Son trait est aussi précis que celui d'Holbein.

Si l'accent de Varley brouillait la distinction entre « form » [forme] et « foam » [mousse], son discours permettait d'affirmer que la « Forme » règnait en maître absolu.

Les fonctionnaires de Queen's Park fréquentaient eux aussi Malloney's. La meilleure conférence à laquelle j'ai assité est celle prononcée par Varley devant des bureaucrates. Le sujet: la révélation graduelle de la forme dans la nature. Dieu seul sait comment il a réussi, mais il a réussi. Varley a réussi à transformé une conversation en une performance. Tout à coup Malloney's s'est tu!

Il décrit le sommet d'une montagne en Colombie-Britannique au lever du jour. Ayant campé, il se réveille face à un sommet enveloppé de brouillard. Étendu dans l'herbe, il assiste au lever du soleil qui baigne le sommet de couleurs et nuances changeantes. Lentement, le brouillard se dissipe, faisant place au rocher escarpé. La forme surgissait devant ses yeux. Il

réussit à recréer une montagne au moyen d'une description à ce point précise qu'elle empêche quiconque de lever son verre. Il lui a fallu quatre ou cinq minutes tout au plus.

Charles S. Band sur les années de maturité (extrait de C.S. Band, « The Later Years », *F.H. Varley, 1915–1954 Retrospective*, p. 8) :

J'ai rencontré Fred Varley pour la première fois lorsque je me suis rendu à son atelier de la rue Bloor après ses séjours à Ottawa et Montréal. C'était à l'été 1945 et il travaillait à un autoportrait. Intéressé, je l'observais. Nous avons parlé de son travail et des événements troublants de la fin de la guerre.

Je savais qu'il n'avait pas la vie belle. Il dépendait de son travail pour vivre et préférait vivoter plutôt que peindre pour peindre. L'autoportrait – qui figure dans la présente rétrospective – exprime avec éloquence l'émoi et la tension de l'époque.

Depuis, certains traits de la personnalité de Varley m'ont laissé une profonde impression. Je continue de le fréquenter et de respecter son travail. J'ai la chance de posséder plusieurs de ses grandes toiles et de ses dessins.

Son intégrité se manifeste dans la peinture. Il ne cède jamais à la répétition. Varley aime la nature, les humeurs changeantes du jour, des nuages, des couchers de soleil et la magie de la couleur. Ses paysages sont empreints de romantisme, voire de spiritualité. Ses portraits, dessinés ou peints, sont autant d'expressions individuelles. Rares sont les Canadiens qui peuvent s'exprimer avec autant de sincérité et de puissance.

Lecteur avide, Varley est au fait de l'actualité. Mélomane, il aurait pu choisir d'être musicien plutôt que peintre.

Mais il y a également Fred Varley – le bohème, le fantaisiste, l'insouciant – à l'écoute de ses semblables. Fred Varley, celui qui aime échanger ses idées avec ceux et celles qui acceptent sa modeste hospitalité. Pour lui, la sécurité financière n'était pas dans l'ordre des choses.

Arrivé à maturité, Varley conserve ardeur et dynamisme. Et ses œuvres en sont un témoignage éloquent.

CHRONOLOGIE

FREDERICK HORSMAN VARLEY (1881–1969)

1881 2 janvier : naissance de Frederick Horsman Varley à Sheffield, en Angleterre.

1892–1899 Fréquente la Sheffield School of Art.

1900 Entre à l'Académie Royale des Beaux-Arts à Anvers, en Belgique.

1902 Obtient son diplôme; reçoit deux médailles d'argent dans les catégories peinture et dessin de la figure humaine; retourne à Sheffield.

1903 À l'automne, s'installe à Londres; travaille comme illustrateur pour *The Gentlewoman* et *The Sphere*.

1910 10 avril : épouse Maud Pinder et retourne vivre à Sheffield; travaille comme metteur en page au *Yorkshire Post*.

1912 Juillet : s'embarque pour le Canada et s'établit à Toronto; août : travaille chez Grip Ltd. et ensuite chez Rous & Mann; participe à la Canadian National Exhibition; novembre : devient membre du Arts and Letters Club.

1914 Débuts du Groupe des Sept; séjour au parc Algonquin en compagnie de sa famille et de Tom Thomson, A.Y. Jackson et Arthur Lismer.

1916 Février : exposition solo au Arts and Letters Club.

1918 7 février : nommé artiste des Archives de guerre du Canada; 26 mars : s'embarque pour Glasgow à bord du R.M.S. Grampian en compagnie des artistes de guerre Cullen, Beatty et Simpson; réalise des portraits dans l'atelier #5, The Mall, Parkhill Road, Londres; 1er septembre, se rend en France; au début novembre, retourne au Mall et se prépare en vue d'une l'exposition.

1919 Peint les portraits du lieutenant McKean, du capitaine O'Kelly et de l'artiste Cyril Barraud; participe à l'exposition d'œuvres commémoratives de la guerre à la Burlington House, Londres; 1er août : s'embarque pour le Canada.

1920 Travaille comme portraitiste; 31 mars : démobilisé; 7 mai : présente douze œuvres dans le cadre de la première exposition du Groupe du Sept.

1924 Participe à la *British Empire Exhibition* en Angleterre; W.J. Philips lui obtient trois commandes de portrait (une à Winnipeg et deux à Edmonton) et un poste de conférencier invité; s'absente de Toronto de la mi-janvier à la fin avril.

1926 Accepte un poste d'enseignant à la Vancouver School of Decorative and Applied Arts (VSDAA) et quitte Toronto au début septembre.

1930 Hiver : exposition solo à l'Art Institute of Seattle, où il enseigne pendant six semaines durant l'été.

1933 Quitte la VSDAA et s'associe à J.W. (Jock) Macdonald et Harry Täuber pour fonder le British Columbia College of Arts.

1936 Participe à l'exposition du Groupe des Sept au Musée du beaux-arts du Canada; obtient la commande du portrait de H.S. Southam et quitte la C.-B. pour Ottawa; partage l'atelier du photographe Alex Castonguay, au 126A rue Sparks; enseigne à l'Ottawa Art Association.

1938 Expose six toiles à la Tate Gallery, Londres, dont *Vera* (1930) et *Autoportrait* (1919); s'embarque pour l'Arctique à bord du R.M.S. Nascopie; quitte Montréal le 9 juillet et rentre à Halifax le 30 septembre.

1944 Exposition solo aux Fine Art Galleries, chez Eaton, à Toronto.

1948 Rencontre Jess Crosby à l'atelier de la rue Grenville; en juin, enseigne à la Doon School of Fine Arts près de Kitchener.

1950 L'exposition chez Eaton lui vaut des louanges (critiques dans le *Globe and Mail* et *Saturday Night*) mais peu de ventes; passe une partie de l'été à travailler dans les environs de Belfountain, où Jess Crosby a un chalet.

1952 Rencontre Kathleen McKay et peint *Porte d'atelier*; dernière lettre de l'atelier de la rue Grenville en date du 5 décembre.

1953 Hiver : emménage chez Donald et Kathleen McKay au 13 Lowther Avenue à Toronto pour des raisons de santé.

1954 En avril, effectue un voyage en Union Soviétique en compagnie d'autres artistes, écrivains et musiciens canadiens; 15 octobre : inauguration de sa première rétrospective à l'Art Gallery of Toronto alors que l'ouragan Hazel frappe la ville.

1956 Exposition solo à la Roberts Gallery.

1964 12 avril au 17 mai : rétrospective de ses œuvres à la Willistead Art Gallery à Windsor; reçoit la médaille du Conseil des Arts du Canada pour 1963.

1969 8 septembre : Varley meurt à l'âge de 88 ans.

LISTE DES ŒUVRES

La liste des œuvres varie selon les lieux de présentation de l'exposition.
Toutes les expositions citées ont eu lieu du vivant de Varley.

Cat. 1 (fig. 1)
Portrait de Samuel J.B. Varley, père de l'artiste, v. 1900
Fusain sur papier vélin chamois, 37,8 x 37 cm
Musée des beaux-arts du Canada, Ottawa
Don d'Ethel Varley, Sheffield (Angleterre), 1969, à la mémoire de l'artiste (15912)

Cat. 2 (pl. 1)
Été indien, 1914–1915
Huile sur toile, 97,8 x 95,3 cm
Collection particulière
Exposition : AGT 1954, nº 1, repr.

Cat. 3 (fig. 22)
Croquis de James, 1915
mine de plomb sur papier, 20 x 19 cm
Galerie Varley, Ville de Markham
Achat, Fondation d'art Varley-McKay (2006.4.1)

Cat. 4 (pl. 2)
Portrait du capitaine C.P.J. O'Kelly, V.C., 1918
Huile sur toile, 102,5 x 76,5 cm
Collection d'art militaire Beaverbrook, Musée canadien de la guerre (19710261078)
Expositions : MBAC 1923, nº 109; AGT 1926 (Archives de guerre), nº 233

Cat. 5 (pl. 3)
Portrait du lieutenant G.B. McKean, V.C., 1918
Huile sur toile, 102,3 x 76,7 cm
Collection d'art militaire Beaverbrook, Musée canadien de la guerre (197102610767)
Expositions : MBAC, 1924, nº 112; AGT 1926 (Archives de guerre), nº 234; AGT 1954, nº 2

Cat. 6 (pl. 4)
Cyril H. Barraud, 1919
Huile sur carton-fibre, 38,1 x 33 cm
Musée des beaux-arts de l'Ontario, Toronto
Achat, avec des fonds versés par les membres de l'AGO, 1990 (90/41)

Cat. 7 (pl. 5)
Gitane, 1919
Huile sur toile, 61,6 x 50,8
Musée des beaux-arts du Canada, Ottawa
Don de Norman M. Paterson, Fort William, Ontario, 1947 (4836)
Expositions : AGT 1925, nº 56 (*Character Study*); Paris 1927, nº 242; MBAC 1936 (Groupe des Sept), nº 183, repr.; Londres 1938, nº 215, repr.; New Haven 1944, sans numéro, repr.; Albany 1946, nº 51; Boston 1949, nº 96; Richmond 1949, nº 75; Washington, D.C. 1950, nº 84; AGT 1954, nº 7, repr.

Cat. 8 (pl. 6)
Janet, 1919
Huile sur toile, 60,9 x 50,8 cm
Don de Mme Jean Stickney, Galerie d'art Beaverbrook, Fredericton,
N.-B. (1959.267)
Exposition : Fredericton 1955, nº 38 (*Janet Gladys Aitken*)

Cat. 9 (pl. 7)
Autoportrait, 1919
Huile sur toile, 60,5 x 51 cm
Musée des beaux-arts du Canada, Ottawa
Acheté en 1936 (4272)
Expositions : CNE 1920, nº 136; RCA 1920, nº 249; AMT 1921, nº 52; WGA
1921, nº 31, repr.; Worcester 1924, nº 23; MBAC 1926, nº 167; Philadelphie
1926, nº 1556; Buffalo 1928, nº 50; New York 1932, nº 48; MBAC 1933,
nº 270; MBAC 1936 (Groupe des Sept), nº 195; Londres 1938, nº 216; AGT
1954, nº 6, repr.; Windsor 1964, nº 4, repr.; MBAC 1967, nº 45

Cat. 10 (pl. 8)
Portrait de Barker Fairley, 1920
Huile sur toile, 61,1 x 51,2 cm
Musée des beaux-arts du Canada, Ottawa
Don de Barker Fairley, Toronto, 1950 (5031)
Expositions : AMT 1920, nº 105 (*Character Sketch – Prof. Barker
Fairley*); AGT 1954, nº 8; Stratford 1967, nº 28

Cat. 11 (pl. 9)
Portrait de Vincent Massey, 1920
Huile sur toile, 120,6 x 141 cm
Collection de la Hart House, Université de Toronto (20.1)
Expositions : AMT 1920, nº 102; CNE, 1920, nº 135, repr.; Wembley
1924, nº 251, repr.; MBAC 1936 (Groupe des Sept), nº 182 (*Hon.
Vincent Massey*); London 1938, nº 182 (*Hon. Vincent Massey*); MBAC
1967 (Centenaire), nº 209, repr.

Cat. 12 (pl. 10)
John, v. 1920–1921
Huile sur toile, 61,7 x 51 cm
Musée des beaux-arts du Canada, Ottawa
Acheté en 1921 (1787)
Expositions : OSA 1921, nº 144; Wembley 1924, nº 253; Paris 1927, nº 240,
repr.; MBAC 1936 (Groupe des Sept), nº 176; MBAC 1936
(Contemporain), nº 99; New Haven 1944, sans numéro; CNE 1950, nº 52;
AGT 1954, nº 11; Windsor 1964, nº 5

Cat. 13 (fig. 20)
Mary Kenny, 1920–1921
Fusain et craie d'art sur papier, 37,5 x 29,9 cm
Collection McMichael d'art canadien, Kleinburg
Don de Mme E. J. Pratt (1969.1)

Cat. 14 (pl. 11)
Mme E., 1920–1921
Huile sur toile, 103,2 x 86,4 cm
Musée des beaux-arts de l'Ontario, Toronto
Don de Mme E.F. Ely, Toronto, 1946 (2852)
Expositions : AMT 1921, nº 49; CNE 1921, nº 256, repr.; WGA 1921,
nº 34; MBAC 1936 (Groupe des Sept), nº 180 (*Mrs. Ely*); CNE 1939,
nº 219 (*Portrait of Mrs. Ernest Ely*); CNE 1952, nº 22; AGT 1954, nº 13

Cat. 15 (pl. 12)
La fillette aux tournesols, 1920–1921
Huile sur toile, 60,1 x 50,8 cm
Collection particulière
Expositions : CNE 1921, nº 255 (*Sun Flowers*); WGA 1921, nº 28;
Worcester 1924, nº 24; OSA 1924, nº 199; MBAC 1936 (Groupe des
Sept), nº 184

Cat. 16 (pl. 13)
Margaret Fairley, 1921
Huile sur toile, 76,8 x 57,2 cm
Musée des beaux-arts de l'Ontario, Toronto
Don de Mme Fairley, 1958 (57/17)
Expositions : AMT 1921, nº 50 (*Portrait of Mrs. F.*); CNE 1921, nº 257
(*Portrait of Mrs. F.*); Buffalo 1928, nº 48 (*Portrait of Mrs. Fairley*);
Windsor 1964, nº 12; MBAC 1967, nº 46, repr.

Cat. 17 (pl. 14)
Portrait de Huntley K. Gordon, 1921
Huile sur toile, 36,4 x 26,3 cm
Collection de la Hart House, Université de Toronto
Don de la succession de Huntley Gordon à la Hart House, 1961

Cat. 18 (pl. 15)
Les Immigrants, v. 1921
Huile sur toile, 152,4 x 182,9 cm
La Collection Thomson
Expositions : AMT 1921, nº 55 (*Decorative Panel*); RCA 1923, nº 243;
RCA 1924, nº 200 (*Decorative Panel*); CNE 1926, nº 233 (*Decoration*,

"*Immigrants*"); MBAC 1936 (Groupe des Sept), n° 198 (*Decorative Panel – Immigrants*)

Cat. 19 (pl. 16)
Portrait de Primrose Sandiford, v. 1921–1922
Fusain et craie sur papier, 40 x 33,2 cm
Collection particulière

Cat. 20 (fig. 24)
Maud, le 30 août, 1922
Fusain sur papier, 22,9 x 25,4 cm
Collection particulière
Exposition : OSA 1923, n° 202 (*Woman's Head*)

Cat. 21 (pl. 17)
Peter Sandiford à Split Rock, baie Georgienne, 1922
Huile sur panneau, 21 x 26,7 cm
Musée des beaux-arts de l'Ontario, Toronto
Don de l'Art Institute of Ontario à la mémoire du Dr Martin Baldwin, 1968 (6815)

Cat. 22 (pl. 18)
Rivage rocheux, 1922
Huile sur toile, 100 x 69,9 cm
Collection particulière
Expositions : Worcester 1924, n° 22 (*Landscape and Figure*); AGT 1926 (Groupe des Sept), n° 117 (*Lake Shore with Figure*); AGT 1926 (Canadien), n° 193 (*Lake Shore with Figures*); Buffalo 1928, n° 53 (*Landscape with Figure*)

Cat. 23 (fig. 28)
Trevor Garstang, 1923–1925
Mine de plomb sur papier, 21 x 28,6 cm
Collection particulière

Cat. 24 (fig. 27)
Tête de Kathleen Calhoun, 1924
Fusain sur papier, 40 x 31,1 cm
Collection de l'Université de l'Alberta
Musées de l'Université de l'Alberta (1971.5.37)

Cat. 25 (pl. 19)
Kathleen Calhoun, 1924
Fusain et craie de couleur sur lavis de fusain sur papier, 34,2 x 24,9 cm
Collection particulière

Cat. 26 (pl. 20)
Portrait du chancelier Charles Allan Stuart, 1924
Huile sur toile, 144,5 x 124,4 cm
Collection de l'Université de l'Alberta
Musées de l'Université de l'Alberta (1965.30.02)
Expositions : AGT 1926 (Groupe des Sept), n° 110; AGT 1926 (Canadien), n° 196; MBAC 1936 (Groupe des Sept), n° 187

Cat. 27 (pl. 21)
Jeune artiste à l'œuvre, 1924
Huile et crayon sur carton, 36,2 x 30,4 cm
Fonds d'acquisition de la Vancouver Art Gallery (91.6)
Expositions : OSA 1924, n° 205; AGT 1926 (Groupe des Sept), n° 120 (*The Young Artist*)

Cat. 28 (fig. 21)
John, v. 1924
Mine de plomb sur papier, 18,1 x 11,4 cm
Collection particulière

Cat. 29 (pl. 22)
Portrait de groupe (Mme R.A. Daly et ses fils, Dick et Tom), 1924–1925
Huile sur toile, 86,5 x 101,7 cm
Musée des beaux-arts de l'Ontario, Toronto
Achat, 1989 (89/94)
Expositions : OSA 1925, n° 229, repr.; RCA 1925, n° 217, repr.; MBAC 1936 (Groupe des Sept), n° 178 (*Mrs. Daly and Children*); AGT 1954, n° 15 (*Family Group*)

Cat. 30 (pl. 23)
Portrait d'Alice Massey, v. 1924
Huile sur toile, 61,5 x 41 cm
Galerie Varley, Ville de Markham
Achat, Fondation d'art Varley-McKay Art (2003.3.1)

Cat. 31 (pl. 24)
Alice Massey, v. 1924–1925
Huile sur toile, 82 x 61,7 cm
Musée des beaux-arts du Canada, Ottawa
Legs de Vincent Massey, 1968 (15558)
Expositions : OSA 1925, nº 228 (*Portrait, Mrs. Alice Vincent Massey*);
MBAC 1926, nº 166 (*The Green Shawl*)

Cat. 32 (pl. 25)
Portrait de Viola Pratt, v. 1924–1925
Huile sur toile, 43,7 x 33,6 cm
Collection l'Art Gallery of Greater Victoria
Don de Harold Mortimer-Lamb (57.11)
Exposition : AGT 1926 (Groupe des Sept), nº 111 (*Sketch Portrait*)

Cat. 33 (pl. 26)
Portrait d'Ellen Dworkin, 1925
Huile sur toile, 43 x 33 cm
Collection particulière
Exposition : AGT 1926, nº 116 (*Jewish Girl*)

Cat. 34 (fig. 19)
Portrait d'un homme, 1925
Fusain sur papier, 43,75 x 25,63 cm
Galerie Varley, Ville de Markham
Achat, Fondation d'art Varley-McKay (2005.4.1)

Cat. 35 (pl. 27)
Portrait de Maud, 1925
Huile sur toile, collée sur panneau de fibres, 60,7 x 50,5 cm
Musée des beaux-arts du Canada, Ottawa
Acheté en 1978 (23152)
Expositions : Los Angeles 1925, nº 238 (*The Artist's Wife*); MBAC 1927,
nº 203 (*Portrait of the Artist's Wife*); RCA 1928, nº 153 (*Portrait of the
Artist's Wife*); MBAC 1929, nº 164 (*Portrait of the Artist's Wife*)

Cat. 36 (pl. 28)
Janet P. Gordon, v. 1925–1926
Huile sur toile, 81,3 x 61 cm
Musée des beaux-arts de l'Ontario, Toronto
Legs Huntley K. Gordon, Toronto, 1950, transmis en 1973 (73/9)
Expositions : OSA 1926, nº 115, repr. (*Portrait of a Lady*); MBAC 1936
(Groupe des Sept), nº 181 (*Mrs. Gordon*)

Cat. 37 (pl. 29)
Étude de Joan (Fairley), 1925–1926
Huile sur toile, 43,2 x 33 cm
La Collection Thomson
Expositions : CNE 1926, nº 232; AGT 1926 (Groupe des Sept), nº 118
(*Joan*)

Cat. 38 (fig. 31)
Eddie Garstang, 1926
Mine de plomb sur papier, 21 x 28,6 cm
Collection particulière

Cat. 39 (fig. 23)
Portrait de James, v. 1926–1927
Mine de plomb sur papier, 20,3 x 14,6 cm
Collection particulière

Cat. 40 (fig. 36)
Vera, 1926–1929
Mine de plomb sur papier, 40,5 x 30,5 cm
Collection d'Ed et Donna Andrew
Exposition : MBAC 1932, nº 290

Cat. 41 (fig. 32)
Les Dessinateurs, v. 1927
Mine de plomb sur papier, 35,4 x 39,8 cm
Collection McMichael d'art canadien, Kleinburg
Achat, 1969 (1981.33)
Exposition : RCA 1928, nº 238

Cat. 42 (pl. 30)
Tête de Vera, v. 1928
Huile sur toile, 32,2 x 35,5 cm
Collection McMichael d'art canadien, Kleinburg
Don de M. J.D. Young (1974.19.2)

Cat. 43 (pl. 31)
Vera, v. 1929
Huile sur toile, 81,8 x 66,7 cm
Musée des beaux-arts du Canada, Ottawa
Acheté en 1930 (3712)
Expositions : MBAC 1930, nº 156; MBAC 1930 (Willingdon), sans
numéro; EMA 1931, nº 20; AGGV 1967, nº 35

Cat. 44 (pl. 32)
J.W.G. Jock Macdonald, 1930
Huile sur toile, 50,7 x 45,9 cm
Collection de la Winnipeg Art Gallery
Acquis avec les fonds de la Winnipeg Foundation et d'un donateur
anonyme (#G729)

Cat. 45 (pl. 33)
Vera, 1930
Huile sur toile, 61 x 50,6 cm
Musée des beaux-arts du Canada, Ottawa
Legs de Vincent Massey, 1968 (15559)
Expositions : RCA 1930, n° 163; New York 1932, n° 49; Londres 1938,
n° 214; Washington, D.C. 1950, n° 85, repr.; MBAC 1953
(Couronnement), n° 68; AGT 1954, n° 17, repr.; VAG 1954, n° 73, repr.
coul.; MBAC 1967, n° 237, repr.

Cat. 46 (pl. 34)
Vera, v. 1930
Huile sur toile, 30,5 x 30,5 cm
Collection particulière
Expositions : AGT 1954, n° 212; Windsor 1964, n° 16

Cat. 47 (pl. 35)
Portrait de H. Mortimer-Lamb, v. 1930
Huile sur carton, 45,9 x 35,7 cm
Collection de la Vancouver Art Gallery
Don de M. H. Mortimer-Lamb (41.2)

Cat. 48 (fig. 33)
Catharina Vanderpant, v. 1930
Fusain, pastel et gouache sur papier, 33 x 27,9 cm
Collection Vanderpant

Cat. 49 (pl. 36)
Portrait de John Vanderpant, v. 1930
Huile sur panneau, 34,9 x 45,1 cm
Collection Vanderpant

Cat. 50 (fig. 39)
Portrait de Täuber, v. 1930
Craie sur papier, 28,4 x 21,5 cm
Collection de l'Art Gallery of Greater Victoria
Fonds d'acquisition Harold et Vera Mortimer-Lamb (85.9)

Cat. 51 (pl. 37)
Tête de jeune fille, v. 1931
Huile sur panneau, 47,3 x 55,5 cm
Collection de la Vancouver Art Gallery
Don de Ruth Van Dusen (98.64)

Cat. 52 (pl. 38)
Complémentaires, 1933
Huile sur toile, 101 x 85 cm
Musée des beaux-arts de l'Ontario, Toronto
Legs de Charles S. Band, 1970 (69/128)
Expositions : MBAC 1933, n° 269; MBAC 1936 (Groupe des Sept),
n° 196; Ottawa 1937, sans numéro; Londres 1938, n° 196; AGT 1954, n° 20

Cat. 53 (pl. 39)
Tête de jeune fille, v. 1933
Huile sur panneau, 30,3 x 30,3 cm
Musée des beaux-arts de Montréal
Don de F.N. Southam (1937.661)

Cat. 54 (pl. 40)
Vert et or, portrait de Vera, v. 1933–1934
Huile sur toile, 61 x 50,9 cm
Collection de Neil J. Kernaghan
Expositions : MBAC 1936 (Groupe des Sept), n° 197 (*Portrait, Green
and Gold*); Ottawa 1937, sans numéro

Cat. 55 (fig. 40)
Marie, 1934
Conté sur papier, 32,9 x 21,6 cm
Musée des beaux-arts de l'Ontario, Toronto
Achat, 1937 (2414)
Expositions : RCA 1934, n° 230; AGT 1954, n° 303

Cat. 56 (pl. 41)
Portrait de Vera, v. 1935
Huile sur toile, 92,7 x 77,5 cm
La Collection Thomson

Cat. 57 (fig. 42)
Tête de jeune fille, v. 1936
Pierre noire, fusain et lavis de fusain sur papier vélin, 23,9 x 23,1 cm
Musée des beaux-arts du Canada, Ottawa
Acheté en 1936 (4305)

Expositions : AGT 1954, n° 305, repr.; Dallas 1958, sans numéro; Windsor 1964, n° 22, repr.; MBAC 1967 (Centenaire), n° 236, repr.

Cat. 58 (pl. 42)
Vera, v. 1936
Aquarelle et fusain sur papier, 28,7 x 21,5 cm
Collection l'Art Gallery of Greater Victoria
Don de Mme Mortimer-Lamb à la mémoire de son mari (70.112)
Exposition : AGGV 1967, n° 36, repr.

Cat. 59 (pl. 43)
Miroir de la pensée, 1937
Huile sur toile, 48,8 x 59,2 cm
Collection de l'Art Gallery of Greater Victoria
Don de Harold Mortimer-Lamb (78.104)

Cat. 60 (fig. 41)
Philip Surrey, 1937
Fusain et estompe sur papier vélin, 36,8 x 29 cm
Musée des beaux-arts de l'Ontario, Toronto
Don de Philip Surrey, Montréal, 1988 (88/116)

Cat. 61 (pl. 44)
Portrait de Mme Kate Alice Surrey, 1937
Huile sur contre-plaqué, 38,1 x 30,5 cm
Collection de l'Art Gallery of Alberta
Don de M. Philip Surrey, 1981 (81.53)

Cat. 62 (pl. 45)
Portrait d'Alan Butterworth Plaunt, 1939
Huile sur toile, 60 x 40 cm
Collection particulière

Cat. 63 (fig. 44)
Erica, 1940
Fusain et craie sur papier, 30,6 x 21,5 cm
Collection particulière

Cat. 64 (fig. 45)
Étude de tête, 1940
Fusain, craie et rouge à lèvres sur papier, 30,4 x 22,5 cm
Collection particulière

Cat. 65 (pl. 46)
Nancy Cameron, v. 1940
Craie de couleur sur papier, 28,1 x 24,4 cm
Collection particulière

Cat. 66 (pl. 47)
Bateau d'immigrants, 1941
Aquarelle et gouache sur papier, 50,2 x 40,7 cm
Musée McCord d'histoire canadienne, Montréal (M2000.83.121)

Cat. 67 (pl. 48)
Erica, 1942
Huile sur toile, 28,2 x 37,1 cm
Collections du Trinity College, Université de Toronto

Cat. 68 (pl. 49)
Manya, portrait de Miriam Kennedy, v. 1942
Huile sur panneau, 30,5 x 38,1 cm
Michael et Sonja Koerner
Exposition : AGGV 1967, n° 38

Cat. 69 (fig. 46)
Catherine, 1943
Fusain sur papier, 27 x 22,6 cm
Collection de l'Art Gallery of Greater Victoria
Fonds d'acquisition Harold et Vera Mortimer-Lamb (57.9)

Cat. 70 (pl. 50)
Natalie, v. 1943
Huile sur carton-fibre, 38 x 29,8 cm
Galerie Varley, Ville de Markham
Don de Hugh A. Smyth (1998.2.1)

Cat. 71 (pl. 51)
Autoportrait, jours de 1943, 1945
Huile sur toile sur panneau dur, 49,5 x 40,7 cm
Collection de la Hart House, Université de Toronto
Expositions : OSA 1946, n° 145; CNE 1949, n° 19; AGT 1954, n° 31, repr. en couv.; Windsor 1964, n° 57; MBAC 1967, n° 45

Cat. 72 (pl. 52)
Jess, v. 1947–1952
Pierre noire et aquarelle sur papier, 27,5 x 26,5 cm
Agnes Etherington Art Centre, Université Queen's, Kingston

Legs de Mme J.P. Frances Barwick, 1985 (28187)
Expositions : AGT 1954, n° 315; Windsor 1964, n° 66

Cat. 73 (fig. 49)
Jess, v. 1948
Lavis d'encre sur papier, 37,8 x 27,3 cm
Collection particulière

Cat. 74 (pl. 53)
Jess, 1950
Huile sur toile, 55,9 x 40,7 cm
Collection particulière
Expositions : AGT 1954, n° 37; Windsor 1964, n° 65

Cat. 75 (pl. 54)
Jess, 1950
Huile sur carton, 38,1 x 30,5 cm
Roberts Gallery

Cat. 76 (pl. 55)
Portrait d'un homme, v. 1950
Huile sur toile, 69,3 x 45,5 cm
Collection McMichael d'art canadien, Kleinburg
Don des fondateurs Robert et Signe McMichael (1966.16.138)
Exposition : AGT 1954, n° 38 (*Portrait Study*)

Cat. 77 (fig. 47)
Portrait de Samuel E. Weir, 1951
Fusain sur papier, 38 x 30,5 cm
Collection de la Weir Foundation, Queenston, Ontario

Cat. 78 (fig. 48)
Frances E. Barwick, 1952
Pierre noire sur papier, 48,3 x 33 cm
Galerie d'art de l'Université Carleton, Ottawa
Collection Jack et Frances Barwick, 1985

Cat. 79 (fig. 50)
Tête de Kathy, v. 1952–1953
Fusain et crayon sur papier, 38 x 32 cm
Galerie Varley, Ville de Markham
Succession de Kathleen Gormley McKay (1996.1.77)

Cat. 80 (pl. 56)
Kathy riant, v. 1952–1953
Huile sur carton-fibre, 38,3 x 30 cm
Galerie Varley, Ville de Markham
Succession de Kathleen Gormley McKay (1996.1.78)
Exposition : AGT 1954, n° 223

Cat. 81
Entrée de l'atelier, v. 1952–1953
Crayon et craie sur papier, 34,2 x 24,5 cm
Galerie Varley, Ville de Markham
Succession de Kathleen Gormley McKay (1996.1.76)

Cat. 82 (pl. 57)
Porte d'atelier, v. 1952–1953
Huile sur toile, 101,6 x 76,5 cm
Musée des beaux-arts de Montréal
Achat, legs Horsley et Annie Townsend (1959.1216)
Expositions : AGT 1952, n° 85; MBAC 1953, n° 73 (*Studio Entrance*);
CNE 1954, n° 6 (*Studio Entrance*); Windsor 1964, n° 81

Cat. 83 (pl. 58)
Kathy, v. 1954
Mine de plomb et craies de couleur sur papier, 28,6 x 21 cm
Musée des beaux-arts de l'Ontario, Toronto
Don du Fonds T. Eaton Co. Ltd. pour l'acquisition d'œuvres d'art
canadien, 1954 (53/21)

Cat. 84 (pl. 59)
Florence Deacon, 1955
Huile sur toile, 43,3 x 53,3 cm
Famille Deacon, Unionville, Ontario

Cat. 85 (pl. 60)
Portrait de Nancy Robinson, v. 1962
techniques mixtes, 24,8 x 19,7 cm
Roberts Gallery

Cat. 86 (fig. 54)
Jeune fille, v. 1964
Fusain sur papier, 26,7 x 23,5 cm
Collection de Dan Driscoll et Paula Driscoll

LISTE SÉLECTIVE D'EXPOSITIONS

Toutes les expositions citées ont eu lieu du vivant de Varley.

AMT 1920
Group of Seven, Art Museum of Toronto, 7–27 mai 1920.

CNE 1920
Canadian National Exhibition: Paintings by Canadian Artists, Toronto, 28 août–11 septembre 1920.

RCA 1920
Royal Canadian Academy of Arts: Forty-second Annual Exhibition, Art Association of Montreal, inaugurée le 18 novembre 1920.

AMT 1921
Exhibition of Paintings by the Group of 7, Art Museum of Toronto, 7–29 mai 1921.

CNE 1921
Canadian National Exhibition: Paintings by British and Canadian Artists and International Graphic Art, Toronto, 27 août–10 septembre 1921.

OSA 1921
Ontario Society of Artists Forty-ninth Annual Exhibition, Art Gallery of Toronto, inaugurée le 8 octobre 1921.

WGA 1921
Canadian Art Today, Winnipeg Gallery of Art, 15 octobre–10 décembre 1921.

MBAC 1923
Exhibition of Canadian War Memorials, Musée des beaux-arts du Canada, Ottawa, 5 janvier–31 mars 1923.

OSA 1923
Small Picture Exhibition by Members of the Ontario Society of Artists, Art Gallery of Toronto, inaugurée le 20 octobre 1923.

RCA 1923
Royal Canadian Academy of Arts: Forty-fifth Annual Exhibition, Art Gallery of Toronto, 22 novembre 1923–2 janvier 1924.

MBAC 1924
Second Exhibition of Canadian War Memorials, Musée des beaux-arts du Canada, Ottawa, 18 janvier–30 avril 1924.

Worcester 1924
Exhibition of Paintings by Canadian Artists, Worcester Art Museum, Worcester, Massachusetts, 6–27 avril 1924. Exposition présentée dans le cadre d'une tournée inaugurée au Minneapolis Institute of Arts en 1923.

Wembley 1924
British Empire Exhibition, Canadian Section of Fine Arts, Wembley Park, Londres, Angleterre, 23 avril–31 octobre 1924.

OSA 1924
Small Picture Exhibition by Members of the Ontario Society of Arts, The Robert Simpson Co., Art Galleries, Toronto, 8–22 novembre 1924.

RCA 1924
Royal Canadian Academy of Arts: Forty-sixth Annual Exhibition, Musée des beaux-arts du Canada, Ottawa, 20 novembre–20 décembre 1924.

OSA 1925
Ontario Society of Artists Fifty-third Annual Exhibition, Art Gallery of Toronto, 1925.

AGT 1925
Group of Seven Exhibition of Paintings, Art Gallery of Toronto, 9 janvier–2 février 1925.

RCA 1925
Royal Canadian Academy of Arts: Forty-seventh Annual Exhibition, Art Association of Montreal, 19 novembre–20 décembre 1925.

Los Angeles 1925
First Pan-American Exhibition of Oil Paintings, Los Angeles Museum, 27 novembre 1925–28 février 1926

MBAC 1926
Special Exhibition of Canadian Art, Musée des beaux-arts du Canada, Ottawa, 21 janvier–28 février 1926.

OSA 1926
Ontario Society of Artists Fifty-fourth Annual Exhibition, Art Gallery of Toronto, 6 mars–5 avril 1926.

AGT 1926 (Groupe des Sept)
The Exhibitions of the Group of Seven and Painting, Sculpture and Wood Carving of French Canada, Art Gallery of Toronto, 8–31 mai 1926.

AGT 1926 (Canadien)
Summer Exhibitions of Canadian Paintings, Art Gallery of Toronto, juin–juillet 1926.

Philadelphie 1926
Paintings, Sculpture and Prints in the Department of Fine Arts, Sesquicentennial International Exposition, Philadelphie, inaugurée le 24 juillet 1926.

CNE 1926
Canadian National Exhibition: Paintings and Sculpture by British, American, Italian and Canadian Artists; Graphic Art, Applied Art and Salon of Photography, Toronto, 28 août–11 septembre 1926.

AGT 1926 (Archives de guerre)
The Canadian War Memorials, Art Gallery of Toronto, 2–31 octobre 1926.

MBAC 1927
Annual Exhibition of Canadian Art, Musée des beaux-arts du Canada, Ottawa, 11 janvier–28 février 1927.

Paris 1927
Exposition d'art canadien, Musée du Jeu de Paume, Paris, 10 avril–11 mai 1927.

Buffalo 1928
Exhibition of Paintings by Canadian Artists, Buffalo Fine Arts Academy, Albright Art Gallery, 14 septembre–14 octobre 1928 / *Paintings by Canadian Artists*, Memorial Art Gallery, Rochester, New York, 14 novembre 1928–6 janvier 1929.

RCA 1928
Royal Canadian Academy of Arts: Fiftieth Annual Exhibition, Art Gallery of Toronto, 29 novembre 1928–8 janvier 1929.

MBAC 1929
Annual Exhibition of Canadian Art; Exhibition by Members of the Society of Sculptors of Canada, Musée des beaux-arts du Canada, 28 janvier–28 février 1929.

MBAC 1930
Annual Exhibition of Canadian Art, Musée des beaux-arts du Canada, Ottawa, 23 janvier–28 février 1930.

MBAC 1930 (Willingdon)
Willingdon Arts Competition, Musée des beaux-arts du Canada, Ottawa, mai 1930.

RCA 1930
Royal Canadian Academy of Arts: Fifty-first Annual Exhibition, Art Gallery of Toronto, novembre 1930.

EMA 1931
Edmonton Museum of Arts Loan Exhibition, 19–25 octobre 1931.

MBAC 1932
Seventh Annual Exhibition of Canadian Art, Musée des beaux-arts du Canada, Ottawa, 22 janvier–23 février 1932.

New York 1932
Exhibition of Paintings by Contemporary Canadian Artists, International Art Center of Roerich Museum, New York, 5 mars–5 avril 1932 / *Exhibition of Contemporary Canadian Paintings*, Museum of Fine Arts, Boston, 8–27 avril 1932 / Kalamazoo Museum and Art Institute, Michigan, mai 1932.

MBAC 1933
Annual Exhibition of Canadian Art, Musée des beaux-arts du Canada, Ottawa, 7 février–6 mars 1933.

RCA 1934
Royal Canadian Academy of Arts: Fifty-fifth Annual Exhibition, Art Gallery of Toronto, 2 novembre–3 décembre 1934.

MBAC 1936 (Groupe des Sept)
Retrospective Exhibition of Painting by Members of the Group of Seven, 1919–1933, Musée des beaux-arts du Canada, Ottawa, 20 février–15 avril 1936 / Art Association of Montreal, 17 avril–3 mai 1936 / Art Gallery of Toronto, 1er mai–15 juin 1936.

MBAC 1936 (Contemporain)
Exhibition of Contemporary Canadian Painting, Musée des beaux-arts du Canada, Ottawa. Exposition organisée au nom de la Carnegie Corporation de New York pour présentation dans les dominions sud de l'Empire britannique, 15 septembre 1936–16 avril 1939.

Ottawa 1937
Varley, James Wilson and Company, Ottawa, novembre 1937.

Londres 1938
A Century of Canadian Art, Tate Gallery, Londres, 15 octobre–15 décembre 1938.

CNE 1939
Canadian National Exhibition: Canadian Painting and Sculpture, Canadian Water Colours, Canadian Graphic Art, British and Canadian Applied Art, Canadian Photography, Toronto, 25 août–9 septembre 1939.

New Haven 1944
Canadian Art, 1760–1943, Yale University Art Gallery, New Haven, Connecticut, 11 mars–16 avril 1944.

Albany 1946
Painting in Canada: A Selective Historical Survey, Albany Institute of History and Art, Albany, New York, 10 janvier–10 mars 1946.

OSA 1946
Ontario Society of Artists Seventy-fourth Annual Spring Exhibition, Art Gallery of Toronto, 9 mars–13 avril 1946.

Boston 1949
Forty Years of Canadian Painting from Tom Thomson and the Group of Seven to the Present Day, Museum of Fine Arts, Boston, 14 juillet–25 septembre 1949.

CNE 1949
Canadian National Exhibition, Toronto, 26 août–10 septembre 1949.

Richmond 1949
Canadian Painting 1668–1948, Virginia Museum of Fine Arts, Richmond, Virginie, 16 février–20 mars 1949.

Washington, D.C. 1950
Canadian Painting, National Gallery of Art, Washington, D.C. Exposition organisée par le Musée des beaux-arts du Canada et présentée à travers les É.-U., 29 octobre 1950–6 mai 1951 / présentée à Vancouver, 15 mai–11 juin 1951.

CNE 1950
Canadian National Exhibition, Toronto, 25 août–9 septembre 1950.

CNE 1952
Canadian National Exhibition, Toronto, 22 août–6 septembre 1952.

AGT 1952
Canadian Group of Painters, Art Gallery of Toronto, novembre 1952 / Musée des beaux-arts de Montréal, janvier 1954.

MBAC 1953
Annual Exhibition of Canadian Painting, Musée des beaux-arts du Canada, Ottawa, 11 mars–7 avril 1953.

MBAC 1953 (Couronnement)
Exhibition of Canadian Painting to Celebrate the Coronation of Her Majesty Queen Elizabeth II, Musée des beaux-arts du Canada, Ottawa, 2 juin–13 septembre 1953.

AGT 1954
F.H. Varley: Paintings, 1915–1954, Art Gallery of Toronto, octobre–novembre 1954 / Musée des beaux-arts du Canada, novembre–décembre 1954 / Musée des beaux-arts de Montréal, janvier–février 1955 / présentée dans les provinces de l'Ouest, février–mai 1955.

VAG 1954
Group of Seven, Vancouver Art Gallery, 1954.

CNE 1954
Canadian National Exhibition, Toronto, 27 août–11 septembre 1954.

Fredericton 1955
Paintings by Old and Modern Masters at the Bonar Law-Bennett Library, Université du Nouveau-Brunswick, Fredericton, 1955.

Dallas 1958
A Canadian Portfolio, Dallas Museum for Contemporary Arts, 4 septembre–2 novembre 1958.

Windsor 1964
F.H. Varley Retrospective 1964, Willistead Art Gallery, Windsor, Ontario, 12 avril–17 mai 1964.

Stratford 1967
Ten Decades, 1867–1967: Ten Painters, Rothman's Art Gallery of Stratford and New Brunswick Museum, Saint-Jean, 1967.

AGGV 1967
Ten Canadians – Ten Decades, Art Gallery of Greater Victoria, 25 avril–14 mai 1967.

MBAC 1967 (Centenaire)
Trois cents ans d'art canadien, Musée des beaux-arts du Canada, Ottawa, 12 mai–17 septembre 1967. Exposition organisée pour marquer le centenaire de la Confédération du Canada.

MBAC 1967
La peinture canadienne, 1850–1950, Musée des beaux-arts du Canada, Ottawa. Exposition présentée à travers le Canada, 8 janvier 1967–18 avril 1968.

NOTES

1. Barker Fairley, « F.H. Varley », *Our Living Tradition: Second and Third Series*, sous la dir. de Robert L. McDougall, University of Toronto Press en collaboration avec l'Université Carleton, 1959, p. 151–169.

2. Maria Tippett, *Stormy Weather: F.H. Varley, A Biography*, Toronto, McClelland & Stewart, 1998, p. 11.

3. Maria Tippett affirme qu'il existe une photocopie de ce dessin dans les Archives de la ville de Sheffield.

4. MBAC, Bibliothèque et Archives, Collection Varley, entrevue de Peter Varley avec Ethel Varley, 4–5 février 1969.

5. Michael Tooby, *Our Home and Native Land: Sheffield's Canadian Artists*, Sheffield, Mappin Art Gallery, 1991, p. 2.

6. *Loc. cit.*

7. *Loc. cit.*

8. Michael Tooby, *op.cit.*, p. 3.

9. Maria Tippett, *op. cit.*, p. 16–17.

10. Arthur Lismer, « Portrait of the Artist — An Artistic Reminiscence », *The Gazette* (Montréal), 8 janvier 1955.

11. John Hayes, *The Portrait in British Art: Masterpieces Bought with the Help of the National Art Collections Fund*, Londres, National Portrait Gallery, 1992, p. 12–16.

12. AGO, fonds Varley, lettre d'Ethel Varley à F.H. Varley, 18 janvier 1967.

13. *Loc.cit.*

14. Peter Varley, *Frederick H. Varley*, préface de Jean Sutherland Boggs, commentaire de Joyce Zemans, Toronto, Key Porter Books, 1983, p. 81.

15. Maria Tippett, *op.cit.*, p. 288, n. 44.

16. Christopher Varley, *F.H. Varley : Une exposition centenaire*, Edmonton, The Edmonton Art Gallery, 1981, p. 21.

17. John Hayes, *The Portrait in British Art*, p. 28.

18. Dianne Sachko Macleod, « Art Collecting and Victorian Middle-Class Taste », *Art History*, vol. 10, n° 3 (septembre 1987), p. 345.

19. Maria Tippett, *op. cit.*, p. 40–42.

20. *Ibid.*, p. 41.

21. AEAC, entrevue de Lawrence Sabbath avec F.H. Varley, septembre 1960 (tapuscrit).

22. Michael Tooby, *op. cit.*, p. 15.

23. *Ibid.*, p. 11.

24. Peter Mullen, *The Group of Seven*, Toronto, Montréal, McClelland & Stewart, 1970, p. 18–19.

25. Charles C. Hill, *Le Groupe des Sept : l'émergence d'un art national*, Ottawa, MBAC, 1995, p. 63.

26. Maria Tippett, *Art at the Service of War: Canada, Art and the Great War,* University of Toronto Press, 1984, p. 45.

27. *Ibid.*, p. 67.

28. Archives du MCG, dossier du captaine C.P.J. O'Kelly.

29. *Loc. cit.*

30. Archives du MCG, dossier du lieutenant G.B. McKean.

31. Peter Varley, *op. cit.*, p. 86.

32. A.Y. Jackson, « The War Records », *F.H. Varley: Paintings, 1915–1954*, Toronto, AGT, 1954, p. 5.

33. Andrea Kirkpatrick, « The Portraiture of Frederick H. Varley, 1919 to 1926 », mémoire de maîtrise, Queen's University, 1986, Ottawa, Bibliothèque nationale du Canada, 1988, p. 17.

34. Maria Tippett, *Art at the Service of War*, *op. cit.*, p. 81.

35. Sir Claude Philips, *Daily Telegraph*, Cahier des arts, 7 janvier 1919.

36. Lord Beaverbrook, « Portrait of a Daughter », *Maclean's Magazine* (tribune libre), 13 février 1960, p. 50.

37. Maria Tippett, *Art at the Service of War, op. cit.*, p. 94.

38. BAC, MG30-D401, fonds Varley, lettre de F.H. Varley à Maud Varley, 13 avril 1924.

39. Augustus Bridle, « E. Wyly Grier, R.C.A. », *Sons of Canada, Short Studies of Characteristic Canadians*, Toronto, J.M. Dent, 1916, p. 205.

40. Dennis Reid, *Le Legs MacCallum*, Ottawa, MBAC, 1969, p. 31.

41. Dorothy M. Farr, *J.W. Beatty 1869–1941*, Kingston, AEAC, 1981, p. 33.

42. Claire Bice, « Conflicts in Canadian Art », *Canadian Art*, vol. 16, n° 1 (février 1959), p. 31.

43. Charles C. Hill, *op. cit.*, p. 92.

44. AEAC, entrevue de Lawrence Sabbath avec F.H. Varley, septembre 1960 [tapuscript].

45. A. Lismer, « The Twenties », *F.H. Varley: Paintings, 1915–1954*, Toronto, AGT, 1954, p. 6.

46. AEAC, entrevue de Lawrence Sabbath avec F.H. Varley, septembre 1960 [tapuscript].

47. Peter Varley, *op. cit.*, p. 25.

48. Dans une entrevue accordée en 1954, Fred Varley dit avoir effectué un voyage à Kingston pour la réalisation de ce portrait. Dans sa recherche en vue de la rétrospective de 1981, Chris Varley avance que le portrait du doyen Cappon a été peint dans la cabane de Tom Thomson, que Varley louait depuis qu'il était rentré de la guerre. Christopher Varley, *op. cit.*, p. 57.

49. W.E. McNeil, « James Cappon, Some Great Men of Queen's », sous la dir. de R.C. Wallace, Toronto, Ryerson, 1941, p. 83. La vente de la reproduction de ce portrait est annoncée dans le *Queen's Journal*, 16 décembre 1920, p. 2.

50. « Many Pictures by Canadians on Exhibition », *Toronto Globe*, 6 mai 1920, p. 10.

51. Varley aborde le portrait du docteur Cameron à la manière de celui du doyen Cappon, c'est-à-dire selon les canons du portrait traditionnel favorisant la reproduction de la physionomie et du caractère du sujet. Le fond sombre contribue à la présence de la figure. Dans sa critique de l'exposition de l'OSA, « M.L.F. » affirme qu'il trouve le portrait de Varley « tout à fait remarquable »; voir « Some Surprises in the Art Exhibition », *Toronto Star*, 18 mars 1922, p. 3. Stansfield suggère 1922; voir Herbert H. Stansfield, « Portraits at the OSA », *Canadian Forum*, vol 5, n° 56 (mai 1925), p. 239.

52. Barker Fairley, « Some Canadian Painters: F.H. Varley », *Canadian Forum*, vol. 2, n° 19 (avril 1922), p. 594–596.

53. MBAC, Bibliothèque et Archives, dossier F.H. Varley, lettre de F.H. Varley à Eric Brown, 7 décembre 1935.

54. Andrea Kirkpatrick, *op. cit.*, p. 203.

55. E.A. Corbett, *Henry Marshall Tory: Beloved Canadian*, Toronto, Ryerson, 1954, p. 123.

56. Archives de l'UAB, lettre non signée, 1922, n° 74-24-52. La note sur le cachet de 1 000 $ se trouve dans le dossier des collections de l'UAB.

57. James Adam, « The Portrait of Dr. Tory: A Criticism », *The Trail*, vol. 7 (juillet 1923), p. 6.

58. Allan Barr, un portraitiste de la région de Toronto, avait obtenu la commande du portrait de Richard Pinch Bowles, chancelier et président de l'Université de Victoria. Dans le portrait de Barr, exécuté vers 1922, Bowles est représenté debout, très droit, sur fond neutre. Il affiche un air de franchise et d'autorité qui n'est pas sans rappeler celui du docteur Tory. En 1919, Lawren Harris peint le portrait du professeur D. Bruce MacDonald de l'Université de Toronto à la manière de Varley.

59. Daniel McIntyre, éducateur émérite et ancien registraire, avait été nommé docteur honoris causa par l'Université du Manitoba en 1912. Membre de commissions gouvernementales au Manitoba et en Saskatchewan, il a joué un rôle de premier plan dans l'établissement de la Winnipeg Children's Aid Society, du Children's Home et de l'Institut des aveugles. Voir « Pioneer Educationalist Dies » et « City Leaders in Education Pay Tribute », *Winnipeg Tribune*, 16 décembre 1946, p.1 et p. 4.

60. Duncan Campbell Scott, *Walter J. Phillips*, Toronto, Ryerson, 1947, p. 14.

61. Nous ne possédons aucune preuve que Varley et Phillips s'étaient rencontrés avant 1923, on peut supposer sans trop s'avancer qu'ils avaient déjà entendu parler l'un de l'autre par l'intermédiaire de leur ami commun, Cyril Barraud, l'artiste de guerre qui avait été portraituré en France par Varley. Phillips et Barraud s'étaient liés d'amitié à Winnipeg avant le début de la Première Guerre mondiale [entrevue de Chris Varley avec Roger Boulet].

62. Lettre de F.H. Varley à Maud Varley, le mardi 15 janvier 1924, dossier Dr. D. McIntyre file, tapuscrit, Dr. Daniel McIntyre Collegiate Institute, Winnipeg.

63. Lettre de F.H. Varley à Maud Varley, 21 janvier 1924, dossier Dr. D. McIntyre, tapuscrit, Dr. Daniel McIntyre Collegiate Institute, Winnipeg.

64. Lettre de F.H. Varley à Maud Varley, 2 février 1924, dossier Dr. D. McIntyre, tapuscrit, Dr. Daniel McIntyre Collegiate Institute, Winnipeg.

65. *Loc. cit.*

66. « To Paint Portrait of Chancellor Stuart, Council Favours Proposal », *Gateway*, vol. 14, n° 17 (19 février 1924), p. 1.

67. Lettre de F.H. Varley à Maud Varley, 2 avril 1924.

68. Dossier des collections de l'UAB.

69. Lettre de F.H. Varley à Maud Varley, 15 avril 1924, dossier Dr. D. McIntyre, tapuscrit, Dr. Daniel McIntyre Collegiate Institute, Winnipeg.

70. James Adam, « The Chancellor's Portrait », *The Trail*, vol. 10 (juillet 1924), p. 18.

71. Le portrait du chancelier Allan Stuart a été présenté dans le cadre de l'exposition du Groupe des Sept de 1926 à l'AGT. Voir Augustus Bridle, « Group of Seven Betray No Sign of Repentance », *Toronto Star Weekly*, 8 mai 1926, p. 5.

72. Selon James Adam, lors de la cérémonie le chancelier Stuart portait la toge noire aux revers violets et aux passements or de l'Université de Toronto. Voir James Adam, « The Chancellor's Portrait », p. 18.

73. Andrea Kirkpatrick, *op. cit.*, p. 223.

74. Lettre de F.H. Varley à Kathleen Calhoun, 15 avril 1924, Marlborough Hotel, Winnipeg, collection particulière, Toronto. L'auteure tient ici à exprimer sa reconnaissance aux membres de la famille de Kathleen Calhoun.

75. « Dr. Daniel McIntyre's Portrait Is Unveiled », *Manitoba Free Press*, 31 mai 1924, p. 4.

76. Lettre de F.H. Varley à Maud Varley, 13 avril 1924, dossier Dr. D. McIntyre, tapuscrit, Dr. Daniel McIntyre Collegiate Institute, Winnipeg.

77. Lettre de F.H. Varley à Kathleen Calhoun, 8 avril 1924, Banff (Alberta), collection particulière, Toronto.

78. *Gwen John and Augustus John*, sous la dir. de David Fraser Jenkins et Chris Stephens, Londres, The Tate Gallery, 2004, cat. n° 77.

79. Augustus John était convaincu que les gitans possédaient cette chose rare et inaccessible que l'on nomme liberté. Voir John Rothenstein, *Augustus John*, Londres, Phaidon, 1945, p. 11.

80. Augustus John, *Chiaroscuro: Fragments of Autobiography, First Series*, Londres, Jonathan Cape, 1952, p. 14.

81. Brian Vesey Fitzgerald, *Gypsies of Britain: An Introduction to Their History*, Londres, Chapman & Hall, 1944, p. XVI.

82. Au cours d'un entrevue avec les petits-enfants de madame Goldthorpe en 2005, j'ai appris qu'il n'était pas impossible qu'elle ait rencontré Varley durant son voyage au Canada en 1912 à bord du « Corsican », et qu'ils aient gardé contact jusqu'aux débuts des années 1920. L'auteure tient ici à exprimer sa reconnaissance aux membres de la famille de madame Goldthorpe.

83. Cette quête de l'« immigrant idéal » en étonnera plus d'un dans notre société multiculturelle, mais au tournant du siècle la politique du gouvernement canadien n'était pas plus raciste que la culture de l'époque. Ayant du mal à recruter le nombre voulu d'immigrants, les autorités canadiennes n'ont eu d'autre choix que de faire appel à d'autres groupes ethniques, en commençant par les Scandinaves suivis des Allemands et des Ukrainiens. Avec le temps, même les groupes considérés comme les moins assimilables, notamment les Juifs, Italiens, Slaves du Sud, Grecs, Syriens et Chinois, ont été ajoutés à la liste.

84. Le *Toronto Star Weekly* a publié une série d'articles sur la population gitane de Toronto (3 mars–14 avril 1923).

85. Le portrait de Varley intitulé *Étude de personnage* et celui de J.W. Beatty sont reproduits dans le catalogue qui accompagne l'exposition (n°s 317 et 194).

86. Peter Varley, *op.cit.*, p. 58.

87. Hector Charlesworth, « The Group System of Art », *Saturday Night* (24 janvier 1925), p. 3.

88. Martha Kingsbury, « The Femme Fatale and Her Sisters », *Woman as Sex Object: Art News Annual*, vol. 38, 1972, p. 182.

89. *The British Portrait 1660–1960*, introduction de sir Roy Strong, Londres, The Antique Collectors' Club, 1991, p. 331–333.

90. Charles C. Hill souligne la ressemblance entre le modèle de Varley et celui de Brangwyn. Voir Andrea Kirkpatrick, *op. cit.*, p. 98. Le tableau de Brangwyn a été vendu chez Christie's, Londres, 7–8 novembre 1985, lot 23, repr.

91. *Ibid.*, p. 309.

92. Peter Varley, *op. cit.*, p. 15.

93. Ian Montagnes, *An Uncommon Fellowship, The Story of Hart House University of Toronto*, University of Toronto Press, 1969, p. 5.

94. J.W.L. Forster était le portraitiste officiel de la Toronto Methodist Church et du Victoria College, deux institutions étroitement associées à la famille Massey.

95. Dossiers des membres de l'ALC.

96. Archives du MBAC, entrevue de Peter Varley avec Barker Fairley, 23 avril 1969.

97. McKenzie Porter, « Varley », *Macleans Magazine* (7 novembre 1959), p. 33.

98. Peter Varley, *op. cit.*, p. 99.

99. *Canadian Courier*, vol. XXV, n° 17 (22 mai 1920), p. 6; « Seven Painters Show Some Excellent Work », *Toronto Daily Star*, 7 mai 1920, p. 3.

100. Rupert Lee, *Canadian Forum*, vol. 4, n° 47 (août 1927), p. 339.

101. Archives du MBAC, lettre de F.H. Varley à Eric Brown, 1er juin 1920.

102. Archives du MBAC, lettre de F.H. Varley à Eric Brown, 11 juin 1920.

103. Lettre de David R. Porter à sir George Parkin, 17 août 1921, BAC, fonds George R. Parkin, MG30-D44, vol. 54, p. 14663.

104. Archives du MBAC, lettre de Raleigh Parkin à J.R. Harper, conservateur de l'art canadien, 10 novembre 1960. William L. Grant, lui aussi gendre de sir George Parkin, avait été nommé agent de liaison canadien auprès du comité des boursiers Rhodes. Il a sans doute consulté son beau-frère, Vincent Massey, au sujet du choix de l'artiste.

105. Lettre de David R. Porter, 13 mai 1921, Bac, MG30-D 44, vol. 54, p. 14458, fonds George R. Parkin.

106. MBAC, Bibliothèque et Archives, dossier F.H. Varley, lettre de F.H. Varley à Eric Brown, 27 juin 1921.

107. Lettre de David R. Porter à sir George Parkin, 17 août 1921, BAC, MG30-D 44, vol. 54, p. 14663, fonds George R. Parkin.

108. « Progress of Canadian Art Splendidly Demonstrated at Annual Academy Show », *Toronto Globe*, 18 novembre 1921, p. 13.

109. Claude Bissell, *The Young Vincent Massey*, University of Toronto Press, 1981, p. 57.

110. Voir George Elliott, « F.H. Varley: Fifty Years of His Art », *Canadian Art*, vol. 12, n°1 (automne 1954), p. 7.

111. Lettre de F.H. Varley à Kathleen Calhoun, 14 juin 1924, collection particulière, Toronto. L'adresse de l'expéditeur indiquée par Varley dans sa correspondance avec Kathleen Calhoun entre le 1er mai et le 14 juin atteste qu'il louait un atelier dans le Lombard Building, au 90 Lombard Street. Il est tout à fait possible que madame Massey y soit allée pour des séances de pose.

112. Claude Bissell, *op. cit*, p. 57.

113. Andrea Kirkpatrick, *op. cit.*, p. 230.

114. *Loc. cit.*

115. Janet Tenody suggère que la modulation chromatique du vert au bleu est caractéristique des certains paysages de Vancouver exécutés par Varley à compter de 1926 et qu'elle devient le sujet virtuel de ses tableaux de la période de Vancouver 1926–1936. Voir Tenody, « F.H. Varley, Landscapes of the Vancouver Years », mémoire de maîtrise, Queen's University, 1983, p. 169.

116. « In the Art Galleries », *Mail and Empire*, 14 mars 1925.

117. Hector Charlesworth, « Ontario Society of Artists », *Saturday Night*, vol. 40, n° 17 (14 mars 1925), p. 3.

118. Herbert H. Stansfield « Portraits at the OSA », p. 239; Katsushika Hokusai (1760–1849) est connu pour ses estampes aux couleurs audacieuses.

119. MBAC, Bibliothèque et Archives, dossier F.H. Varley, lettre de F.H. Varley à Eric Brown, 19 décembre 1925.

120. Hugo McPherson, « The Resonance of Batterwood House », *Canadian Art*, vol. 21, n° 2 (mars/avril 1964), p. 100.

121. « Dr. Tovell Arranges Fine Exhibit of Manuscripts », *Varsity*, 26 octobre 1926, Archives de l'Université de Toronto, dossier Tovell.

122. Dossiers des membres de l'ALC.

123. Andrea Kirkpatrick, *op. cit.*, p. 322.

124. À compter de 1921, Varley se montre moins préoccupé par les effets de contrastes lumineux prononcés des portraits récents, dont *Cyril H. Barraud* (1919; pl. 4), *Autoportrait* (1919; pl. 7) et *John* (v. 1920–1921; pl. 10).

125. Archives du MBAC, Bibliothèque et Archives, Collection Varley, entrevue de Peter Varley avec Barker Fairley, 23 avril 1969.

126. Percy J. Robinson, « The OSA Exhibition », *Canadian Forum*, vol. 6, n° 67 (avril 1926), p. 223.

127. Charles C. Hill, *op. cit.*, cat. n° 45, p. 315.

128. Andrea Kirkpatrick, *op. cit.*, p. 241.

129. *Ibid.*, p. 245, n. 3. Bien que Daly ne soit devenu membre du Arts and Letters Club qu'en 1935, les membres de sa famille maintiennent que Varley lui a été recommandé par un membre du Club. Le nom de Charles S. Band a également été suggéré comme celui qui aurait présenté Daly à Varley. Or Band n'est devenu membre du Club qu'en 1931.

130. « R.E. Eaton Re-elected Art Gallery President », *Toronto Telegram*, 3 mai 1927, p. 22. Le Dr Harold Tovell et Vincent Massey étaient également membres du conseil.

131. Lettre de R.A. Daly Jr., 12 août 1984, citée dans Andrea Kirkpatrick, *op. cit.*, p. 242.

132. Peter Varley, *op. cit.*, p. 10.

133. Christopher Varley, *op.cit.*, p. 69.

134. MBAC, Bibliothèque et Archives, Collection Varley, entrevue de Peter Varley avec Jim Varley and Dorothy Sewell, 10 juillet 1970. Les enfants de Varley, Dorothy et Jim, se rappellent avoir vu madame Daly arriver en voiture pour les séances.

135. Christopher Varley, *op. cit.*, p. 67.

136. Herbert H. Stansfield, « Portraits at the OSA », *Canadian Forum*, vol. 5, n° 56 (mai 1925), p. 240.

137. Peter Varley, *op. cit.*, p. 104.

138. Les portraits vénitiens des XVe et XVIe siècles se distinguent par leur style linéaire. Les artistes flamands du XVe siècle partagent la préoccupation de leurs contemporains italiens en matière de réalisme, mais accordent une plus grande importance aux détails.

139. MBAC, Bibliothèque et Archives, Collection Varley, entrevue de Peter Varley avec Barker Fairley, 23 avril 1969.

140. Andrea Kirkpatrick, *op. cit.*, p. 303, n. 1.

141. En 1919, l'Université de Toronto avait octroyé la commande du portrait du Dr McPhedran à Curtis Williamson. Voir « Dr. McPhedran Honoured as a Teacher », *University of Toronto Monthly*, vol. 21, nº 1 (octobre 1920), p. 72. Les McPhedran connaissaient peut-être les Varley par l'intermédiaire du Dr Irving Heward Cameron, dont Varley avait fait le portrait à la demande de la Faculté de médecine en 1922, ou encore en tant que membres du Madawaska Club et amis du Dr James MacCallum.

142. « Mrs. Alexander McPhedran Philanthropist Dies », *Toronto Daily Star*, 23 mars 1927, p. 11; Andrea Kirkpatrick, *op. cit.*, p. 307–308.

143. Barker Fairley, « The Group of Seven », *Canadian Forum*, vol. 5, nº 53 (février 1925), p. 147.

144. *Loc. cit.*

145. Hector Charlesworth, « The Group System in Art », *Saturday Night*, vol. 15, nº 10 (24 janvier 1925), p. 3.

146. Peter Varley, *op.cit.*, p. 24.

147. Peter Mellen, *Group of Seven*, Toronto, McClelland and Stewart, 1979, p. 21.

148. MBAC, Bibliothèque et Archives, Collection Varley, entrevue de Peter Varley avec Philip Surrey, 15 et 20 juillet 1969.

149. Robert Stacey, *Hand Holding the Brush: Self Portraits by Canadian Artists*, London Regional Art Gallery, 1983, p. 59.

150. Barbara Dayer Gallati, *Children of the Gilded Era: Portraits by Sargent, Renoir, Cassatt, and Their Contemporaries*, Londres, Merrell, 2005, p. 8.

151. *Ibid.*, p. 10.

152. Fondé durant la Première Guerre mondiale, le Women's Conservation Committee de Sarnia est voué au rayonnement de l'art canadien contemporain.

153. Norman Gurd était un ami proche du Dr James MacCallum. Ils avaient tous deux fréquenté l'Université de Toronto.

154. Lettre de Norman Gurd à Barker Fairley, 30 novembre 1920, Lambton County Library, fonds Gurd, nº 535.

155. Lettre de Norman Gurd à Barker Fairley, 7 décembre 1920, Lambton County Library, fonds Gurd, nº 538.

156. Lettre de Normand Gurd à James MacCallum, 16 décembre 1920, Lambton County Library, fonds Gurd, nº 543.

157. Andrea Kirkpatrick, *op. cit.*, p. 274.

158. *Loc. cit.*

159. Christopher Varley, *op. cit.*, p. 29.

160. Billie Pike, un ami chez qui Varley se rendait régulièrement à Ottawa, serait à l'origine de son intérêt soudain pour la nature morte. MBAC, Bibliothèque et Archives, Collection Varley, entrevue de Peter Varley avec Billie Pike, 10 et 18 mai 1969. *Les tournesols* repr. dans Peter Varley, *op. cit*, p. 163.

161. Andrea Kirkpatrick, *op. cit.*, p. 182.

162. MBAC, Bibliothèque et Archives, Collection Varley, entrevue de Peter Varley avec Barker Fairley, 23 avril 1969.

163. Lettre de Normand Gurd à William Kenny, 19 mars 1921, Lambton County Library, lettres Gurd, nº 568.

164. La correspondance de Norman Gurd fait état de la commande du portrait de son ami et associé feu James Henry Kittermaster. Il avait envoyé à Varley une photographie de Kittermaster, accompagnée de directives quant au format du portrait. Cependant, aucune documentation ne permet d'affirmer que Varley a obtenu une autre commande à Sarnia ou dans la région.

165. *Toronto Star*, 31 mars 1921, p. 12. La pièce a également été publié dans le *Canadian Magazine*, p. 58.

166. Voir Christopher Varley, *F.H. Varley: A Centennial Exhibition*, fig. 53, p. 66.

167. G. Blair Laing affirme à tort que ce portrait a été exécuté vers 1923. G. Blair Laing, *Memories of an Art Dealer*, Toronto, McClelland and Stewart, 1979, fig. 42.

168. Entrevue de l'auteure avec le fils d'Ellen Dworkin, août 2006. L'auteure tient ici à exprimer sa reconnaissance aux membres de la famille de madame Dworkin.

169. Voir Stephen A. Speisman, *The Jews of Toronto: A History to 1937*, Toronto, McClelland and Stewart, 1979.

170. Entrevue de l'auteure avec le fils d'Ellen Dworkin, août 2006.

171. *Loc cit.*

172. Frère du célèbre aquarelliste anglais John Varley, un des membres fondateurs de la Society of Painters in Watercolour à Londres en 1804, Cornelius Varley est l'auteur du *Treatise on Zodiacal Physiognomy* (1828).

173. *Gwen John and Augustus John*, sous la dir. de David Fraser Jenkins et Chris Stephens, Londres, The Tate Gallery, 2004, pl. 53. Voir également Mark Evans, *Portraits by Augustus John: Family, Friends and the Famous*, Cardiff, National Museum of Wales, 1988.

174. *Christian Science Monitor*, 28 mars 1921, p. 12.

175. « Press Comments on the Canadian Section of Fine Arts », *British Empire Exhibition*, 1924–1925, Ottawa, Musée des beaux-arts du Canada, 1926, p. 41–42.

176. MBAC, Bibliothèque et Archives, Collection Varley, entrevue de Peter Varley avec Barker Fairley, 23 avril 1969.

177. Dorothy Varley est née le 18 août 1910. La littérature récente fixe l'année de sa naissance à 1909, soit avant le mariage de ses parents en 1910. Voir les chronologies dans Peter Varley, *op.cit*, p. 197, et Christopher Varley, *op. cit.*, p. 191.

178. AGO, fonds Varley, lettre d'Ethel Varley à F.H. Varley, 7 mai 1964.

179. Reproduit dans Christopher Varley, *op. cit.*, fig. 40, p. 54.

180. *Ibid.*, fig. 49, p. 62.

181. *Canadian Forum*, vol. 2, n° 24 (septembre 1922), p. 751.

182. Reproduit dans Christopher Varley, *op. cit.*, fig. 56, p. 68.

183. Cité dans Charles C. Hill, *op. cit.*, cat. n° 56, p. 317.

184. Reproduit dans Peter Varley, *op. cit.*, p. 94.

185. Andrea Kirkpatrick, *op. cit.*, p. 251.

186. Peter Varley, *op. cit.*, p. 19.

187. Reproduit dans Christopher Varley, *op. cit.*, fig. 61, p. 70. Lorsque les Varley perdent leur maison de Toronto au printemps 1923, ils vont vivre sous une tente près du chalet d'E.J. et Viola Pratt à Bobcaygeon. Selon David Pitt, l'arrangement est venu en aide aux Varley alors qu'ils se trouvaient dans « une situation extrêmement difficile. Assez fréquemment, Pratt payait la facture d'épicerie pour nourrir cinq personnes supplémentaires de sa maigre poche. » Voir David G. Pitt, *E.J. Pratt: The Truant Years 1882–1927*, University of Toronto Press, 1984, p. 226.

188. Reproduit dans Christopher Varley, *op. cit.*, fig. 64, p. 71. Selon David Pitt, une grande tente de l'armée dressée sur une plateforme en bois protégeait la famille contre les éléments, et le chalet des Pratt offrait le confort moderne.

189. MBAC, Bibliothèque et Archives, Collection Varley, entrevue de Peter Varley avec Barker Fairley, 23 avril 1969.

190. Gary Michael Dault, *Barker Fairley Portraits*, Toronto, Methuen, 1981, p. xi.

191. MBAC, Bibliothèque et Archives, Collection Varley, entrevue de Peter Varley avec Barker Fairley, 23 avril 1969.

192. *Loc cit.*

193. Gary Michael Dault, *op. cit.*, p. xii.

194. AEAC, entrevue de Lawrence Sabbath avec F.H. Varley, septembre 1960 [tapuscrit].

195. Barry Lord, *The History of Painting in Canada: Toward a People's Art*, Toronto, NC Press, 1974, p. 178.

196. Gary Michael Dault, *op. cit.*, p. x.

197. *Loc. cit.*

198. Claude Bissell, *op. cit.*, p. 78.

199. Andrea Kirkpatrick, *op. cit.*, p. 295.

200. Dossiers des membres de l'ALC.

201. « Appointed in Charge of Clinical Department R.C.D.S. », *Toronto Telegram*, 24 septembre 1921 (fonds Mason, Archives de l'Université de Toronto).

202. Peter Varley, *op. cit.*, p. 96. Curtis Williamson a également peint un portrait du doyen Mason qui se trouve dans la collection de l'Université de Toronto.

203. Selon Primrose Sandiford son père et Varley se seraient rencontrés lors d'un événement à l'ALC. Voir Andrea Kirkpatrick, *op. cit.*, p. 277, et les dossiers des membres de l'ALC.

204. Durant l'année universitaire 1921/22, Peter Sandiford est membre du comité artistique de la Hart House, auquel siège également Barker Fairley, et participe à la prise de décision en matière d'acquisitions.

205. MBAC, Bibliothèque et Archives, Collection Varley, entrevue de Peter Varley avec Barker Fairley, 23 avril 1969.

206. MBAC, Bibliothèque et Archives, Collection Varley, entrevue de Peter Varley avec Barker Fairley, 23 avril 1969.

207. Dans une lettre datée du 8 juin 1924, Varley écrit à Kathleen Calhoun qu'il enseigne à l' OCA, collection particulière, Toronto.

208. Andrea Kirkpatrick, *op. cit.*, p. 237 et 238, n. 10.

209. Voir *E.J. Pratt: His Life and Poetry*, sous la dir. de Susan Gingell, University of Toronto Press, 1983, p. 150.

210. C.B. Sissons, *A History of Victoria University*, University of Toronto Press, 1952, p. 248.

211. David G. Pitt, *op. cit.*, p. 122–123.

212. E.J. Pratt, *Newfoundland Verse*, Toronto, Ryerson, 1923.

213. Il se peut que le portrait présenté dans le cadre de l'exposition du Groupe des Sept à l'AGT en 1926 sous le titre de « Étude de la collection de l'artiste » (cat n° 111) ait été celui de Viola Pratt.

214. Claire Pratt se souvient que son père avait vu le tableau chez les Varley à Vancouver à l'été 1927. Viola également se souvient de l'avoir vu à la même occasion. On peut donc dire sans trop s'avancer que le portrait a été exécuté avant le départ de Varley pour Vancouver. Voir Andrea Kirkpatrick, *op. cit.*, p. 238, n. 5.

215. Varley a peut-être fait la connaissance de Kathleen Calhoun lors d'une conférence qu'il donne à Edmonton en 1924. Voir « Sees Vision of Golden Age of Expression on the Horizon », *Edmonton Journal*, 27 mars 1924, p. 7. Le frère de Kathleen et son épouse connaissaient W.J. Phillips et son épouse, chez qui Varley habitait à Winnipeg. Dans une de ses lettres de Winnipeg, Varley mentionne avoir revu le frère de Kathleen durant son séjour.

216. Entrevue non datée avec John MacEachran, dossier des collections de l'Université de l'Alberta. Voir Andrea Kirkpatrick, *op. cit.*, p. 315.

217. Lettre de F.H. Varley à Kathleen Calhoun, 1ᵉʳ mai 1924, collection particulière, Toronto.

218. *Loc cit.*.

219. Herbert H. Stansfield, « Trevor Tremain-Garstang: Artist, Actor and Stage Director », *ETCETERA,* novembre 1930, p. 10.

220. Andrea Kirkpatrick, *op. cit.*, p. 330–331.

221. Mazo de la Roche affirmait que le portrait exécuté par Varley était son œuvre d'art préférée. Voir Peter Varley, *op. cit.*, p. 13, et Ronald Hambleton, *Mazo de la Roche of Jalna*, New York, Hawthorn Books, 1966.

222. L'auteure tient ici à exprimer sa reconnaissance au fils de Trevor et Nan Garstang.

223. Les portraits ont été publiés dans les livraisons suivantes du *Toronto Star Weekly* : du Le Edmund Scheuer, , 10 juillet 1926, p. 19; George A. Warburton, 17 juillet 1926, p. 21; Ralph Connable, 24 juillet 1926, p. 21; portrait composit des deux soldats, 31 juillet 1926, p. 20.

224. *Toronto Star Weekly*, 31 juillet 1926, p. 33.

225. Charles C. Hill, *op. cit*, p. 224.

226. Frederick B. Housser, *A Canadian Art Movement, The Story of the Group of Seven* , Toronto, Macmillan, 1925, p. 214.

227. MBAC, Bibliothèque et Archives, fonds A.Y. Jackson, lettre d'A.Y. Jackson à Eric Brown, 30 novembre 1920.

228. Charles Hill, *Le Groupe des Sept : l'émergence d'un art national*, p. 224.

229. A. Lismer, *op. cit.*, p. 6.

230. MBAC, Bibliothèque et Archives, dossier F.H. Varley, lettre de F.H. Varley à Eric Brown, 17 août 1926.

231. MBAC, Bibliothèque et Archives, Collection Varley, entrevue de Peter Varley avec Barker Fairley, 23 avril 1969.

232. Harold Mortimer-Lamb, « The Modern Art Movement in Canada », *The Daily Province* (Victoria), 15 septembre 1922.

233. J.W.G. (Jock) Macdonald, « Vancouver », *F.H. Varley: Paintings, 1915–1954, op. cit.*, p. 7.

234. *Loc cit.*.

235. Robert Stacey, « Heaven and Hell: Frederick Varley in Vancouver », *The Group of Seven in Western Canada*, Calgary, The Glenbow Museum, 2002, p. 66.

236. Joyce Zemans, *Jock Macdonald: The Inner Landscape, A Retrospective Exhibition*, Toronto, AGO, 1981, p. 22.

237. Entrevue de Gerald Tyler avec Ann Pollock, janvier 1969. Voir Joyce Zemans, *op. cit.*, p. 31.

238. Cité dans Christopher Varley, *op. cit.*, p. 91.

239. Cité dans Maria Tippett, *Stormy Weather, op. cit.*, p. 159.

240. MBAC, Bibliothèque et Archives, Collection Varley, entrevue de Peter Varley avec Fred Amess, 22 juin 1970.

241. MBAC, Bibliothèque et Archives, Collection Varley, entrevue de Peter Varley avec Jack Shadbolt, 27 mai 1970.

242. MBAC, Bibliothèque et Archives, Collection Varley, entrevue de Peter Varley avec Orville Fisher, 8 juillet 1970.

243. MBAC, Bibliothèque et Archives, Collection Varley, entrevue avec Fred Amess [tapuscrit], avril 1955.

244. Entrevue de l'auteure avec Luciana Benzi, 2005, dont les beaux-parents, Vito Cianci et Sybil Hill, avaient travaillé sous la direction de Varley à la VSDAA.

245. MBAC, Bibliothèque et Archives, Collection Varley, entrevue de Peter Varley avec Fred Amess, 22 juin 1970.

246. A. Lismer, *op. cit.*, p. 7.

247. Peter Varley, *op. cit.*, p. 17.

248. Charles C. Hill, *John Vanderpant Photographs*, Ottawa, MBAC, 1976.

249. VAG, entrevue de Lorna Farrell-Ward avec Anna Ackroyd, transcription, s.d.

250. Sheryl Salloum, *Underlying Vibrations: The Photography and Life of John Vanderpant*, Victoria, Horsdal & Shubart, 1995, p. 1–4.

251. Lilly Koltun (sous la dir. de), *Private Realms of Light: Amateur Photography in Canada 1839–1940*, Markham, Fitzhenry and Whiteside, 1984. Voir aussi Petra Rigby Watson, « John Vanderpant », *C Magazine* (septembre 1990), p. 64.

252. Maria Tippett, « Who Discovered Emily Carr », *Journal of Canadian Art History* vol 1, nᵒ 2 (automne1974), p. 30–35.

253. À Montréal, Mortimer-Lamb a très probablement travaillé sous la direction de Laura Muntz et de Maurice Cullen.

254. *Arts Victoria*, vol. 4, nᵒ 1 (mars 1978), p. 12–14.

255. « Art Gallery Pioneer Photographer – Artist », *Vancouver Sun*, juillet 1952.

256. Maria Tippett, *Stormy Weather, op. cit.*, p. 171.

257. MBAC, Bibliothèque et Archives, Collection Varley, Fred Amess, « Varley » [tapuscrit], avril 1955.

258. Eswyn Lyster, « Norma », *Westworld*, (jan./fév. 1982), p. 82.

259. Après avoir vu le portrait de Vera au Musée des beaux-arts du Canada, John Vanderpant écrit à Eric Brown : « Ne pensez-vous pas que le portrait de Vera Weatherbie compte parmi ce que Varley a fait de mieux depuis qu'il se trouve dans l'Ouest? » MBAC, Bibliothèque et Archives, fonds Eric Brown, lettre de John Vanderpant à Eric Brown, 6 janvier 1931.

260. MBAC, Bibliothèque et Archives, Collection Varley, entrevue de Peter Varley avec Miriam Kennedy, 19 juillet 1969.

261. McKenzie Porter, « Varley », *Maclean's*, vol. 72, n° 23 (7 novembre 1959), p. 66. Dans une entrevue accordée en 1987 à Letia Richardson, Irene Hoffar Reid, une des étudiantes de Varley, laisse entendre que Vera échangeait des idées sur les techniques d'art avec Varley et Mortimer-Lamb. Selon elle, « La transformation de la palette de Varley durant son séjour à Vancouver est le résultat de l'influence de Weatherbie. » Cité dans Jill Pollack, « Portrait Captures Art Legend », *Vancouver Courier*, 25 août 1991, p. 17.

262. Voir Christopher Varley, *op. cit.*, p. 101.

263. MBAC, Bibliothèque et Archives, Collection Varley, entrevue de Peter Varley avec James Varley et Dorothy Sewell, 18 mai 1970.

264. Letia Richardson, *First Class: Four Graduates from the Vancouver School of Decorative and Applied Arts, 1929: Lilias Farley, Irene Hoffar Reid, Beatrice Lennie, Vera Weatherbie*, Vancouver, Floating Curatorial Gallery, Women in Focus, 1987, p. 9.

265. « All-Canadian Artists' Pictures on Exhibition », *Vancouver Sun*, 11 mai 1932.

266. *Loc cit.*.

267. *Vancouver: Art and Artists 1931–1983*, VAG, 1983, p. 59.

268. MCAC, fonds Varley, « Varley, Information re: Paintings, derived from meetings with Varley Apr. 2nd and 6th », 1954, p. 2.

269. Cité dans Christopher Varley, *op. cit.*, n. 139, p. 185.

270. Ann Davis, *The Logic of Ecstasy: Canadian Mystical Painting 1920–1940*, Toronto, 1992, p. 84–86.

271. AEAC, entrevue de Lawrence Sabbath avec F.H. Varley, septembre 1960 [tapuscrit], p. 11.

272. Art Gallery of Alberta, lettre de F.H. Varley à Vera Weatherbie, mai 1937.

273. MBAC, Bibliothèque et Archives, Collection Varley, entrevue de Peter Varley avec Ethel Varley, 4–5 février 1969.

274. MBAC, Bibliothèque et Archives, Collection Varley, entrevue de Peter Varley avec Miriam Kennedy, 19 juillet 1969.

275. MBAC, Bibliothèque et Archives, Collection Varley, entrevue de Peter Varley avec Bea Lennie, 4 juillet 1970.

276. AEAC, lettre de F.H. Varley à Vera Weatherbie, s.d. 1936.

277. Arhcives provinciales de la Colombie-Britannique, fonds H. Mortimer-Lamb, MS 2834.

278. McKenzie Porter, *op. cit.*, p. 66.

279. MCAC, lettre de F.H. Varley à John Varley, 14 mai 1936.

280. *Loc. cit.*

281. Peter Varley, *op. cit.*, p. 29.

282. *Visions of Canada: The Alan B. Plaunt Memorial Lectures 1958–1992*, sous la dir. de Bernard Ostry et Janice Yalden, Montréal, McGill-Queen's University Press, 2004, p. 565–568.

283. Entrevue de l'auteure avec madame Erica Leach, septembre 2005.

284. MBAC, Bibliothèque et Archives, Collection Varley, entrevue de Peter Varley avec Leonard et Reva Brooks, 24 avril 1969. Tom Wood fut artiste de guerre durant la Seconde Guerre mondiale.

285. John Virtue, *Leonard and Reva Brooks: Artists in Exile in San Miguel de Allende*, Montréal, McGill-Queen's University Press, 2001, p. 81.

286. *Ibid.*, p. 84.

287. Karen Close, *Unfinished Women: Seeds from My Friendship with Reva Brooks*, Shanty Bay, Ontario, Yinward Bound, 2001.

288. MBAC, Bibliothèque et Archives, Collection Varley, entrevue de Peter Varley avec Miriam Kennedy, 19 juillet 1969.

289. Il s'agit très probablement de *Manya* (1941; collection particulière), repr. dans Christopher Varley, *op. cit.*, fig. 170, p. 152.

290. MBAC, Bibliothèque et Archives, Collection Varley, entrevue de Peter Varley avec Miriam Kennedy, 19 juillet 1969.

291. MBAC, Bibliothèque et Archives, Collection Varley, entrevue de Peter Varley avec Louis Muhlstock, 12 juillet 1969.

292. Entrevue de l'auteure avec Gloria Varley, août 2006. L'auteure tient ici à exprimer sa reconnaissance à madame Varley.

293. LAC, MG 30, D 401, fonds Varley, lettre de F.H. Varley à Jess Crosby, 21 juin 1949.

294. MBAC, Bibliothèque et Archives, Collection Varley, entrevue de Peter Varley avec Jess Crosby, 11 décembre 1969.

295. *John Gould Journals*, Moonstone, Ontario, Moonstone Books, 1996.

296. *Berczy*, sous la dir. de Rosemarie Tovell, Ottawa, Musée des beaux-arts du Canada, 1991, p. 92–97.

297. Peter Varley, *op. cit.*, p. 45.

298. Entrevue de l'auteure avec l'artiste torontois Gus Weisman, printemps 1999. Weisman, qui avait un atelier dans le même édifice que Varley, se rappelle avoir vu l'esquisse et le portrait à l'huile.

299. Entrevue de Maria Tippett avec Kathleen McKay, 27 septembre 1995, cité dans *Stormy Weather*, p. 252.

300. Entrevue de l'auteure avec Jeannie Wildridge, juillet 2006. L'auteure tient ici à exprimer sa reconnaissance à madame Wildridge et à son fils, Paul Wildridge, l'actuel directeur de la Roberts Gallery.

301. McKenzie Porter, *op. cit.*, p. 66.

302. AGO, fonds Varley, lettre de Kathleen McKay à F.H. Varley, 5 janvier 1952.

303. AGO, fonds Varley, lettre de Kathleen McKay à F.H. Varley, 6 décembre 1955.

304. Entrevue de Maria Tippett avec Kathleen McKay, 27 septembre 1995, cité dans *Stormy Weather*, p. 252.

305. Maria Tippett, *Stormy Weather, ibid.*, p. 255.

306. Entrevue de l'auteure avec madame Jennie Wildridge, juillet 2006.

307. Le 31 janvier 1957, George Hulme écrit à Varley pour obtenir l'autorisation de reproduire à dix mille exemplaires son célèbre tableau *Tempête, baie Georgienne* (1920). Les reproductions seraient imprimées à Montréal et distribuées dans tous les grands magasins. Dans sa lettre du 15 février 1957, Varley lui demande de s'adresser à S.L. Wildridge. Archives de la Roberts Gallery, dossier Varley.

308. AGO, fonds Varley, lettre de J.S. Goldie à Kathleen McKay, 17 octobre [1955].

309. VAG, lettre de J.S. Goldie à Cooper Campbell, 31 janvier 1956.

310. Archives de la Roberts Gallery, lettre de F.H. Varley à S.L. Wildridge, 14 décembre 1955.

311. Entrevue de l'auteure avec Florence Deacon, juillet 2006. L'auteure tient ici à exprimer sa reconnaissance à madame Deacon et à ses fils.

312. *Loc. cit.*

313. LAC, MG 30, D 373, fonds John Vanderpant Papers, lettre de F.H. Varley à John Vanderpant, lundi de Pâques [1936].

314. Ronald Hambleton, « The Return of Varley », *Mayfair*, vol. 18, n° 12 (décembre 1944), p. 104.

315. Citée dans Christopher Varley, *op. cit.*, p. 163.

316. « Varley – A Film Review by George Elliott », *Canadian Art*, vol. 10, n° 3 (printemps 1953), p. 60.

317. George Swinton, « Our Lively Arts – Painting in Canada », *Queen's Quarterly*, vol. 62, n° 4 (hiver 1955–1956), p. 543.

318. Mildred Valley Thornton, « Varley Paintings on Display Here », *Vancouver Sun*, 13 avril 1955.

BIBLIOGRAPHIE SÉLECTIVE

Art Gallery of Toronto. *F.H. Varley: Paintings, 1915–1954*, Toronto, AGT, 1954.

Cayzer, Elizabeth. *Changing Perceptions: Milestones in Twentieth-Century British Portraiture*, Brighton, Alpha Press, 1999.

Christensen, Lisa. *A Hiker's Guide to Art of the Canadian Rockies*, Calgary, Fifth House Publishers, 1999.

Christensen, Lisa. *A Hiker's Guide to the Rocky Mountain Art of Lawren Harris*, Calgary, Fifth House Publishers, 2000.

Christensen, Lisa. *The Lake O'Hara Art of J.E.H. MacDonald and Hiker's Guide*, Calgary, Fifth House, 2003.

Davis, Ann. *The Logic of Ecstasy: Canadian Mystical Painting, 1920–1940*, London, Ontario, London Regional Art and Historical Museums, 1990.

Duval, Paul. *A Vision of Canada: The McMichael Canadian Collection*, Toronto, Clarke, Irwin, 1973.

Duval, Paul. *A Heritage of Canadian Art: The McMichael Collection*, Toronto, Clark, Irwin, 1979.

Elliot, G.H. « F.H. Varley — Fifty Years of His Art », *Canadian Art*, vol. 12, n⁰ 1 (1954).

Hill, Charles C. *Le Groupe des Sept : l'émergence d'un art national*, Ottawa, Musée des beaux-arts du Canada, 1995.

Housser, F.B. *A Canadian Art Movement: The Story of the Group of Seven*, Toronto, MacMillan, 1974 [réimp. éd. de 1926].

Hunkin, Harry. *A Story of the Group of Seven*, Toronto, McGraw-Hill Ryerson, 1976.

MacTavish, Newton. *The Fine Arts in Canada*, introduction de Robert McMichael, Toronto, Coles Publishing, 1973.

Mastin, Catharine (sous la dir. de). *Group of Seven in Western Canada*, Toronto, Key Porter Books, 2002.

Mellen, Peter. *The Group of Seven*, Toronto, McClelland and Stewart, 1979.

Murray, Joan. *The Best of the Group of Seven*, Edmonton, Hurtig, 1984.

Musée des beaux-arts du Canada. *Retrospective Exhibition of Painting by Members of the Group of Seven, 1919–1933*, Ottawa, MBAC, 1936.

Newlands, Anne. *The Group of Seven and Tom Thomson: An Introduction*, Willowdale, Ontario, Firefly Books, 1995.

Reid, Dennis. *Le Legs MacCallum*, Ottawa, Musée des beaux-arts du Canada, 1969.

Reid, Dennis. *Le Groupe des Sept*, Ottawa, Musée des beaux-arts du Canada, 1970.

Reid, Dennis. *The Group of Seven: Selected Watercolours, Drawings, and Prints from the Collection of the Art Gallery of Ontario*, Toronto, Musée des beaux-arts de l'Ontario, 1989.

Russell, John (of London). *British Portrait Painters*, Londres, W. Collins, 1944.

Silcox, David P. *The Group of Seven and Tom Thomson*, Toronto, Firefly Books, 2003.

Stacey, Robert et Sharon Gaum-Kuchar. *Varley: A Celebration*, Markham, Ontario, Varley Art Gallery of Markham, 1997.

Tippett, Maria. *Stormy Weather: F.H. Varley, A Biography*, Toronto, McClelland and Stewart, 1998.

Tooby, Michael. *Frederick Varley*, Kingston, Ontario, Quarry Press, 1995.

Vann, Philip. *Face to Face: British Self-Portraits in the Twentieth Century*, Bristol, Sansom & Company Ltd., 2004.

Varley, Christopher. *F.H. Varley*, Ottawa, Musée des beaux-arts du Canada, 1979.

Varley, Christopher. *F.H. Varley : une exposition centenaire*, Edmonton, Edmonton Art Gallery, 1981.

Varley, Peter. *Frederick H. Varley*, préface de Jean Sutherland Boggs, commentaire de Joyce Zemans, Toronto, Key Porter Books, 1983.

Wendorf, Richard. *The Elements of Life: Biography and Portrait-Painting in Stuart and Georgian England*, Oxford, Clarendon Press, 1990.

LISTE DES FIGURES

Fig. 31
F.H. Varley
Eddie Garstang, 1926
Collection particulière

Fig. 32
F.H. Varley
Les Dessinateurs, v. 1927
Collection McMichael d'art canadien, Kleinburg

Fig. 33
F.H. Varley
Catharina Vanderpant, v. 1930
Collection Vanderpant

Fig. 34
John Vanderpant
Toujours Eve, 1918
Collection particulière

Fig. 35
Le studio-galerie de John Vanderpant, rue Robson, à Vancouver, années 30.
À gauche on aperçoit le panneau décoratif de Varley, *Les Immigrants*, qui
servait de toile de fond à certains portraits de Vanderpant.
Collection particulière

Fig. 36
Vera, 1926–1929
Collection de Ed et Donna Andrew

Fig. 37
John Vanderpant
Vera, 1928
Collection Vanderpant

Fig. 38
Vera Olivia Weatherbie
Portrait de F.H. Varley, v. 1930
Vancouver Art Gallery

Fig. 39
F.H. Varley
Portrait de Täuber, v. 1930
Art Gallery of Greater Victoria

Fig. 40
F.H. Varley
Marie, 1934
Musée des beaux-arts de l'Ontario, Toronto

Fig. 41
F.H. Varley
Philip Surrey, 1937
Musée des beaux-arts de l'Ontario, Toronto

Fig. 42
F.H. Varley
Tête de jeune fille, v. 1936
Musée des beaux-arts du Canada, Ottawa

Fig. 43
F.H. Varley
Étude arctique, 1938
Collection particulière

Fig. 44
F.H. Varley
Erica, 1940
Collection particulière

Fig. 45
F.H. Varley
Étude de tête, 1940
Collection particulière

Fig. 46
F.H. Varley
Catherine, 1943
Art Gallery of Greater Victoria

Fig. 47
F.H. Varley
Portrait de Samuel E. Weir, 1951
The Weir Foundation, Queenston, Ontario

Fig. 48
F.H. Varley
Frances E. Barwick, 1952
Galerie d'art de l'Université Carleton, Ottawa

Fig. 49
F.H. Varley
Jess, v. 1948
Collection particulière

Fig. 50
F.H. Varley
Tête de Kathy, v. 1952–1953
Galerie Varley de Markham

Fig. 51
Kathleen McKay dans sa résidence de Toronto dans les années 1980
Archives de la Galerie Varley de Markham

Fig. 52
Fred Varley à Whycocomagh, 1955
Photo: Dr John Goldie

Fig. 53
Kathleen McKay devant sa demeure du 197 Main Street, Unionville, fin des années 1950
Archives de la Galerie Varley de Markham

Fig. 54
F.H. Varley
Jeune fille, v. 1964
Collection de Dan Driscoll et Paula Driscoll

Fig. 55
L'artiste dans son atelier à Unionville, milieu des années 1960
Photo : Gabriel Desmarais (1926–1991) dit Gaby; Succession Gaby

Fig. 56
F.H. Varley à Unionville, milieu des années 1960
Photo : Catharina Vanderpant-Shelly